Glass Art

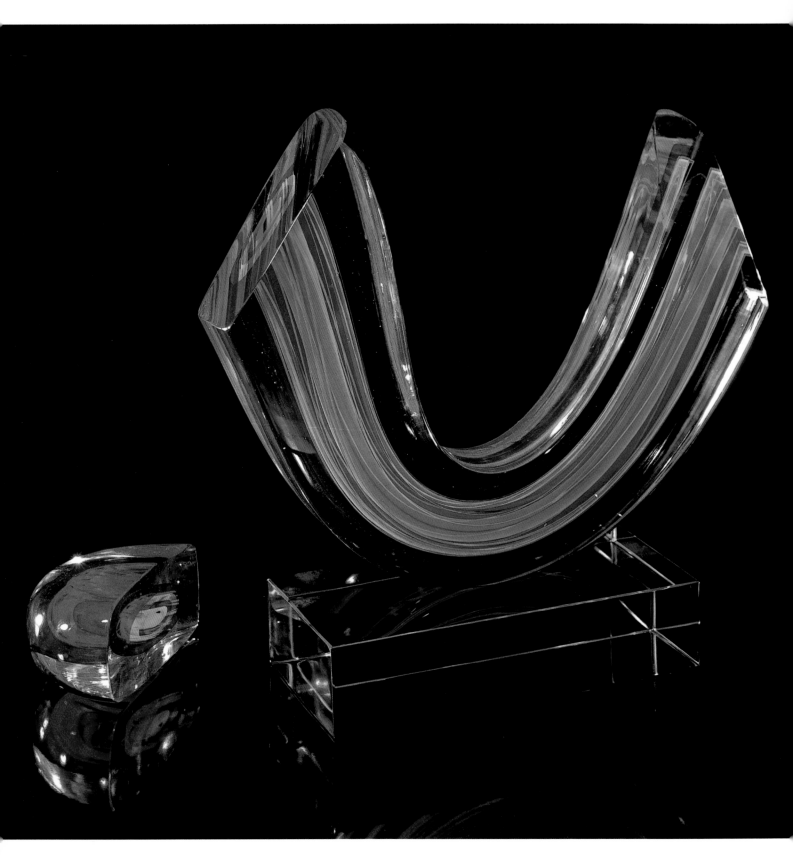

Harvey K. Littleton, USA: *Ruby Mobile Arc*, 1988
approx. 14in. × 2½in. × 11¾in. high + base; multiple
cased overlays, cut and polished

Glass Art

PETER LAYTON

A & C Black · London
University of Washington Press · Seattle

First published 1996
by A & C Black (Publishers) Limited
35 Bedford Row, London WC1R 4JH
ISBN 0–7136–3866–4

Published simultaneously in the USA
by University of Washington Press
P.O. Box 50096, Seattle, Washington 98145
ISBN 0–295–97565–2

CIP catalogue records for this book are available from the British Library and the Library of Congress.

Typeset in Great Britain
by Fakenham Photosetting Limited, Norfolk
Printed in Great Britain
by Jarrold Book Printing Ltd, Thetford, Norfolk

Acknowledgements

For one reason or another it has taken me rather a long time to write this book, demanding the patient support and forbearance of a great many people. First of all I would like to thank the many artists who have so very generously contributed material and especially those whose work I have been unable to include because of lack of space.

Then my colleagues at the London Glassblowing Workshop, both past and present, my family and many others who have given unstinting support and encouragement – to name but a few: Ann and Jean Ashmore, Ben and Nina Essex, Gilly McKay, Mike and Suzanne Schneideman, and Phyllida Shaw. Also, for visual material and information, Cathérine Vaudour, Sylva Petrova, Louis Mériaux, Laurence Bouquin, Jean Luc Olivier, Dan Klein, Serge Lechaczynski, Kaj Martin, Brenda Moor and Gabriel Urbanek; Galerie B, Baden-Baden, Galerie Nakama, Tokyo, Galérie Nadir, Annecy, The Studio Glass Gallery, London, Charles Cowles Gallery and The Heller Gallery, New York.

Finally but by no means least, I would like to thank Judith Warren, Linda Lambert and my editor Anne Watts of A & C Black, without whom this project would not have been realised.

Contents

Illustrations

For my children – Bart, Sophie and Ben

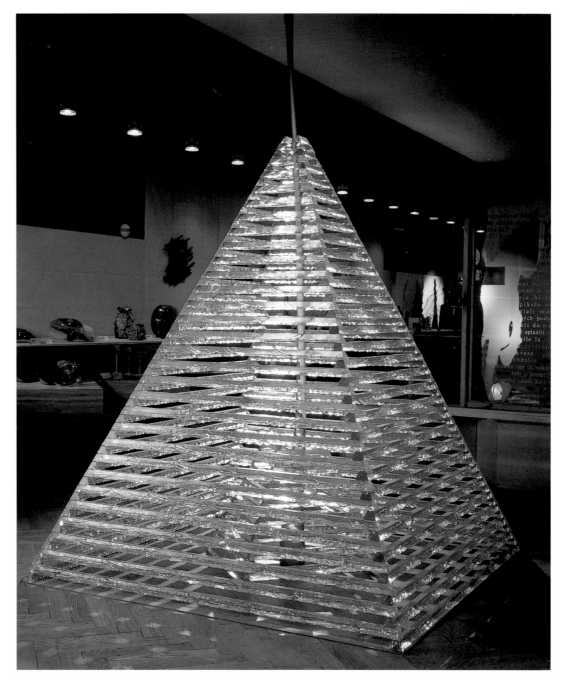

Peter Layton, UK: *Pyramid*, 1988
1m × 1.6m × 2.5m high; hot cast bars, stacked; blown el-
ement made by René Roubicek and Petr Novotny (photo:
Lumir Rott, courtesy: Lemberg Castle, Czech Republic)

Preface

In 1965/6, I was teaching ceramics at the University of Iowa when, along with some of my students, I enrolled in its summer school's first glassblowing workshop. We put together a rather primitive glassblowing studio, built the furnace, gathered and made the necessary equipment within a few days, arranged a rota for running the 'shop' and got to work. The course, organised by Tom McGlauchlin, one of the participants in the Toledo Seminars set up by Harvey Littleton in 1962 to explore the potential of hot glass, was hardly more than an introduction, simply a taste of the new medium as we vied for precious furnace-working time. There was little or no formal instruction – we just picked up hints and pointers wherever we could.

In those early days it was so much a case of the blind leading the blind that there were several near disasters. My own involvement with glass nearly came to an untimely end when, trying to retrieve a hand tool I had dropped, I rolled the freshly gathered molten glass across the back of my hand, taking the skin with it. I already knew that no-one could call himself a glassblower until he had burnt himself, so my initial reaction was to save the 'priceless' piece. I worked on until pain jolted me into sanity and I finally abandoned the glass and fled in search of treatment.

That accident caused me to dismiss any thoughts of a career in glass for several years, but it is a seductive medium and I had found the whole experience marvellously stimulating. What had attracted me to clay was its immediacy, so imagine the excitement of discovering the spontaneity of hot glass – a material with a life and will of its own, constantly in motion and requiring instant decisions in its manipulation and control!

Some years later I held a summer school at my pottery in the Scottish Highlands and included a weekend glassblowing session. One of my students later wrote about the course:

> ... although glass is as unlike clay as straw is unlike wood it has the common need when blown to be centred and shaped, on a rotating piece of metal. There the similarity ends!

What beauty and grace in the expert handling of the blowing irons, the punties, blocks, paddle and tongs! How disciplined and demanding a craft, as we discovered when we made our first tentative 'gather' from the fiercely glowing molten glass! How hilarious the struggle to blow life into the refractory 'gob', to keep the damned thing centred, to swing the long iron and to move nimbly from furnace to chair, with the left hand constantly rotating the iron while the right hand feverishly sought the relevant tool for the next step in the procedure! And how remarkable the progress as confidence and knowledge grew!

This description captures perfectly the anguish and pleasure gained from those early endeavours, when we thought that our wobbly bubbles and 'globby' shapes were works of art. Until then no-one had seen much free-formed glass; thick sections, uneven forms and a wild use of colour predominated. The work was primitive, perhaps crude, but with a vitality and strength frequently lacking in the more refined and 'professional' work which is produced today.

Those were pioneering days. The budding glassmaker had to design his furnace and equipment, find out about glass, formulate recipes, re-invent and develop techniques, educate his customers and thereby create a market for his work. Luckily there were some enlightened galleries, craft shops and members of the public who responded and encouraged those early fumbling efforts.

The main purpose of this book is to illustrate the versatility of this extraordinary medium, as well as the vision and vitality of those who work and 'play' with it – there is such breadth and diversity in contemporary glass activity. A global 'glass family' does exist, not merely cosily, but achieving a rare and significant level of communication that spans both national and political boundaries. It has been said that 'Society is worth saving, and the arts and crafts are agents of positive change'. *Glass Art* is intended as an affirmation of this outlook.

Introduction

Magic, like miracle, is a word that one hesitates to use in normal conversation, for fear perhaps of overstatement or that familiarity may dilute its potency. Yet 'magical', 'mysterious' and 'illusory' are words freely used to describe glass, its extraordinary properties and the processes by which it is formed. A mixture of the most common materials (sand, chalk and wood ash) can be transformed by fire into a unique transparent solid with marvellous optical qualities.

Glass is also an amazingly versatile material and it is unusual in that it is essentially non-crystalline in structure. It becomes less viscous (or more fluid) as temperature rises, until at around 1000°C it can be manipulated in a variety of ways. Molten glass can be blown, stretched and drawn into threads, poured, rolled flat or cast into sheets or blocks. These can then be fused, bent or moulded in a kiln and, when cold, can be cut, sawn, drilled, carved, etched, engraved, polished, painted or laminated.

Glass has become so commonplace that we scarcely notice it, yet life without it is unimaginable. Totally recyclable, it is being hailed as the material of the twenty-first century for, in some form or other, it touches on virtually every aspect of modern life, from containers, utensils, light bulbs, mirrors, windows and insulating material to the ubiquitous television screen, optics and communications – the list is endless. Forms and images can be suspended within it, or magnified through it. It can be toughened and coloured, and it has the ability to hold, transmit, bend, refract, diffuse or reflect light.

The term 'studio glass' has differing connotations, depending on where and by whom it is used. At first it generally meant, as does 'studio pottery', limited serial production and one-off pieces with some reference to the vessel form. Originally it described objects, mainly blown, that were designed and made individually by an artist-craftsperson, often working single handed with quite primitive facilities. Later, the term was used to describe the worldwide phenomenon known as the Studio Glass Movement. While never truly a movement in any stylistic sense, it has played an essential part in the extraordinary revival of art and craft activity that began in the late 1950s. Studio glassmaking developed as an outgrowth of the revolutionary ceramics that were produced in California during the early 1960s; they, in turn, were inspired by the works of Picasso, Miro and the Abstract Expressionist School of Painting emanating from New York.

There are many artists working in glass today who question the continued existence of any such movement, and others who firmly reject what they perceive as a 'glass ghetto' mentality, viewing it as an expression of a narrow and suffocating parochialism that constrains the acceptance of their work within a wider 'fine art' context. For the public the complex schism between art and craft is largely irrelevant, but for those involved it raises

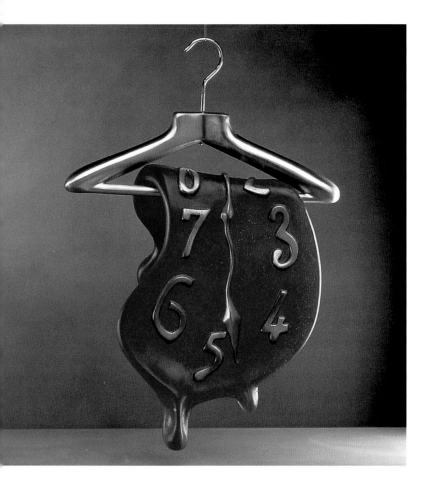

Salvador Dali, Spain, for Daum: *Montre molle*, c. 1970 *pâte de verre* (courtesy: Collection Daum, France)

the question of status and is therefore a frequent source of irritation and anguish.

The interminable debate 'art or craft?' may never be satisfactorily resolved although, as aesthetic conventions break down, issues concerning the hierarchy of certain media have begun to dissipate. A 'pile of bricks' becomes a provocative and dynamic sculptural statement; paintings are often three dimensional; 'traditional' craft skills and materials are now widely utilised in fine art, alongside new technology. The exacting precision and minute tolerances required within the high technology industries of space, medical and electronic engineering provide an entirely new context and role for 'craftsmanship'. Recognising this, one may perceive that the so-called crafts are, regardless of medium, simply other forms of art, of greater or lesser quality.

Nevertheless, criteria do remain contentious. In the West, a commonly held view of craft is often of works displaying superb skill that are deficient in content or spirit while, in Japan, certain pots have for centuries been far more highly prized than paintings. A vessel, while possessing decorative, symbolic or metaphorical functions, can, as any other work of art, be complete in and of itself. Herbert Read, the art historian and critic, noted that 'a simple pot can be the purest form of abstract'. The idea of non-utility, i.e. the negation of function, has in itself assumed an ideological significance in the struggle to liberate formal and visual possibilities in the so-called minor or decorative arts.

The Yugoslav sculptor Raoul Goldoni, who worked extensively in glass, always maintained, 'We should seek the arts within the crafts and the crafts within the arts', and it is in this spirit that the terms art, craft and design are used interchangeably throughout this book.

Toots Zynsky, USA/France

As a student, Toots Zynsky was actively involved in helping to establish the Pilchuck Glass School and later the New York Experimental Glass Workshop (now Urban Glass). Her work from that period comprised blown forms covered with fine trailing that became ever more thorny and gradually took over, ending as small black prickly nests.

Some two decades later, influenced by years spent in West Africa, she continues to refine this theme and her forms, which may loosely be called bowls, have evolved into an entirely original and unique statement. They are composed of thousands of brilliantly, or on occasion subtly, coloured filaments arranged in overlapping bundles whose undulating movements resemble the gestural quality of three-dimensional brush strokes.

Her ingenious and unconventional production methods involve drawing the threads on a machine specially made for her (originally they were hand-drawn), and arranging them in flat compositions of vibrant colour before fusing them. The next stage is to slump the resulting thatches over metal or ceramic fibre moulds and finally, with adequate heat protection, to open the hot kiln and manipulate the softened glass by 'hand'. There is no other way of imparting the wonderfully rich wave-like motion and colour rhythms they possess.

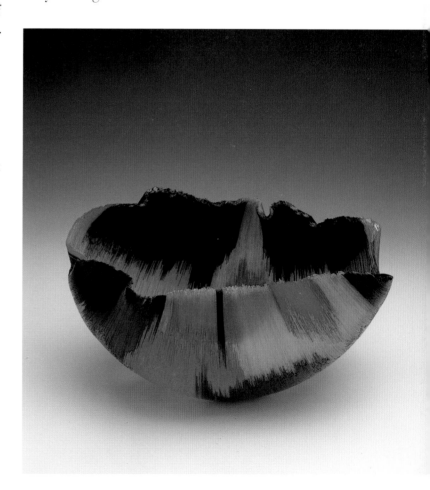

Toots Zynsky, USA/France: *Red Beauty*, 1990
32cm diameter × 14cm high; drawn threads of coloured glass, fused, slumped and hot-formed (photo: Ernesto Aparico)

11

Historical Background

Origins

Where and how glass was first produced is largely a matter of conjecture. Pliny, the Roman historian, described how Phoenician traders, camping on a sandy shore, took blocks of natron (soda used in the embalming process) from their cargo to balance their cooking pots. The natron melted in the fire and fused with the sand to form a glass. This may be legend but there is no doubt that the Phoenicians were accomplished glassmakers. The earliest recorded glass finds are beads of around 2500 BC, reputedly from Mesopotamia.

The Egyptians set great store by the magical potency of colour. Using copper and cobalt oxides, they made brilliant turquoise and blue glass for use as inlays in artifacts and furniture or to be moulded and carved as beads and amulets. The moulding processes they devised predated French *pâte de verre* by some three thousand years and involved fusing powdered glass in clay moulds. In this way small solid blocks or ingots could be produced for subsequent carving.

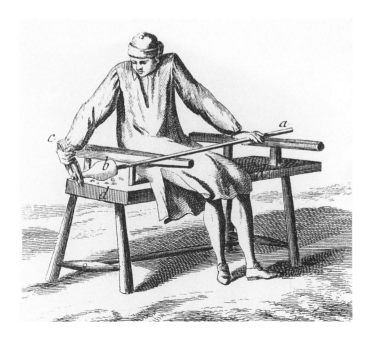

Glassmaking illustration from Diderot's Encyclopedia, 18th century

Glass objects were rare luxury items that were considered even more valuable than the gems they replaced. The first surviving vessels are three small jug-shaped phials from the tomb of Tuthmosis III *c* 1500 BC. These were made to contain rare and precious perfumes, unguents and other cosmetics, such as kohl, the forerunner of mascara or eyeshadow, rare commodities possessed only by royalty, the priesthood and the privileged classes. These tiny and charming vessels were made by a method known as the sand core or core-forming technique, most probably derived from the bead-making process.

During the Hellenistic period the major glass-making centres were Sidon (Lebanon) and Alexandria (Egypt), the latter renowned for the variety of its luxury glasswares. These made extensive use of established lapidary techniques and, though for the most part utilitarian, were regarded as objects of great aesthetic value.

Rome

The art of glass flourished under the Romans. The revolutionary discovery of glassblowing, attributed to Syrian glassmakers working in Sidon or Israel around 50 BC, was an event comparable with the invention of the potter's wheel. Blowing glass on the end of a metal tube, at first into moulds and later freehand, was one of the greatest steps in a long history of innovation, and gave rise to a technological, artistic and commercial explosion. Vast quantities and varieties of wares could now be produced, and reproduced, easily and cheaply.

At this point the art of glassmaking divided into two streams – luxury glass to satisfy the continuing demand for rare and precious objects, and utilitarian glass to supply the everyday needs of the home. Ordinary containers, such as bottles, bowls, beakers, jars and jugs, were commonly available for the first time. When Vesuvius erupted in AD 79, the kitchens of Pompeii were well stocked with glassware of every description, for by this time virtually all known hand-making skills had evolved. With

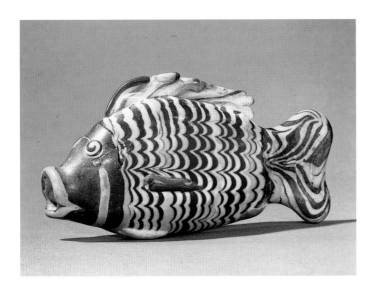

Egypt: *Bulti-fish container for aromatic oil or other cosmetic*, 18th dynasty, c. 1352–1336 BC
14.5cm long; coreforming technique; decoration of combed threading (courtesy: Trustees of the British Museum)

Roman Empire: *Mouldblown flask (amphoriskos)* in the form of a bunch of grapes (similar flasks in the form of scallop shells), AD 1st-3rd century
17cm high; freeblown neck and mouth with applied trailing and side handles (the two small loops at the rim may have been intended for a carrying strap) (courtesy: Römisch-Germanisches Museum, Cologne)

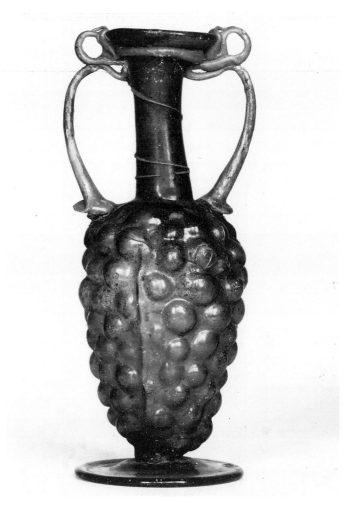

few exceptions, they remain very little changed today.

Blowing into moulds was a natural derivation from pottery and enabled Roman glassblowers to achieve fine relief decoration. Later, free-blown wares expressed a more exuberant spirit with an extensive use of trailed and other applied decoration.

During the first centuries of the Christian era the rapid expansion of the Roman Empire created a vast market. With the spread of commerce and culture in the wake of the conquering armies came the dissemination of glassmaking skills from the eastern provinces to Gaul, Britain and the Rhinelands.

The waning of the Roman Empire caused European glassmaking to fall into decline. Until the late Middle Ages, glass workshops were often attached to monasteries and skills survived only in the preparation of tesserae for the rich mosaics of Byzantium and in the production of stained glass for the windows of great cathedrals and churches, their coloured panes radiating visions of splendour.

Venice

The rise of Islam in the seventh century saw the development of more diverse and elaborate styles. Early pieces employed superb relief cutting and wheel engraving of ornate geometric and scroll designs as well as of animal and plant motifs. The Moorish influence spread to Spain and also to Venice. This city had, by the fourteenth century, become a major commercial centre and was to dominate glass production for several centuries.

In an effort to protect the city from the attendant fire hazard and to control more closely the movements of the glassmaking community, thereby guarding its secrets, a Senatorial decree in 1291 outlawed the use of glass furnaces within the city boundary and forced the glass industry to move to the nearby island of Murano. Fearing competition, the Venetians instituted a strict code of conduct which forbade anyone to communicate his knowledge of furnace construction, glass formulae and techniques or, on pain of death, to leave Murano. Tempted by the prospect of wealth and status else-

where, many did flee but they were hotly pursued by gangs of hired assassins – even, on occasion, to the gates of Prague.

By the sixteenth century and the Renaissance, Venetian glassmakers were vying to make ever thinner, more fantastic and intricate blown shapes and patterns. They worked both in coloured glass and Cristallo, a new glass of great purity, so named for its resemblance to rock crystal. Cristallo proved ideal for the development of the art of diamond-point engraving and also to meet the increasing demand for medical and optical apparatus. Venetian glassware was exported throughout Europe and demand was such that it was widely imitated. *Façon de Venise*, or the Venetian style, as these imitations were called, was of such high quality that it was often hard to distinguish from glass actually produced in Venice.

Northern Europe

During the Middle Ages, *Waldglas*, or forest glass, was the common product of itinerant glassmaking families who lived and worked in the forests of Northern Europe, setting up their furnaces wherever they found abundant fuel together with suitable local materials. Burnt ashes from the furnace provided potash for the flux which was mixed with local sand. The high iron content of these ingredients gave a characteristic greenish tint to the direct and sometimes primitive wares. These were often decorated with applied dots or buttons in relief known as prunts or with trails (or threads) of glass wound round the piece, so that drinking vessels, being shared and passed from hand to greasy hand, could be more easily grasped.

Britain

During the reign of Elizabeth I, an *émigré* Italian named Verzellini established a successful glasshouse producing glass in the Venetian style in the City of London, and it was through him that diamond-point engraving was introduced to England. However, in 1615 there was a total ban on the use of wood for fuel, construction of the naval fleet taking priority. The subsequent transition to coal-fired furnaces led ultimately to higher temperatures and was responsible for a boom in the bottlemaking industry. The Venetian style continued for about a century amid complaints about brittle and crizzled glasses from England. By 1676, extensive research, largely sponsored by the Glass Sellers Company, enabled an analytical chemist named George Ravenscroft to perfect his version of Cristallo by introducing oxide of lead as the main flux in his recipe. A revolutionary step, it heralded the beginning of the great tradition of English lead crystal.

Germany and Bohemia

A highly developed aspect of Venetian influence was the use of overpainted enamels and gilding to

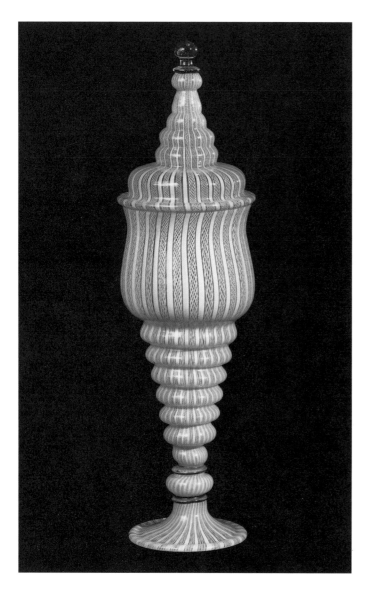

Venice: *Façon de Venise covered goblet*, late 16th or early 17th century
35cm high (with cover); by this period, applied enamels or gold were less in fashion; this *latticino* decoration was carried out as part of the making process (© 1979 The Corning Museum of Glass)

Nineteenth Century and Art Nouveau

In the mid nineteenth century, the British Museum acquired the Portland Vase, the finest extant piece of Roman cameo work, and offered a prize of £1000 for the best copy. John Northwood completed his replica against great technical odds, using a combination of simple hand tools and copper-wheel engraving. This achievement made him a celebrity, and initiated a major development of cameo-cut glassware throughout the Stourbridge area.

Paving the way for the extensive use of glass in modern architecture, and by far the most adventurous and innovative construction of its day, was Paxton's Crystal Palace, built in Hyde Park, London, to house the Great Exhibition of 1851. This and successive major international exhibitions stimulated and inspired artists and industrialists alike.

The late nineteenth century in Britain was a period of intense technological and aesthetic activity in virtually every sphere. A revolutionary new style, Art Nouveau, swept away the heavy over-elaboration of Victorian design. Reaching its peak around the turn of the century, it sprang from powerful and varied sources, the mysticism of William Blake (through his influence on the Pre-Raphaelites) and the revivalist ideals of John Ruskin, William Morris and the Arts and Crafts Movement. Their credo fostering the highest quality in design and craftsmanship and an awareness of nature and the value of hand-made objects in everyday use, strove to redress the negative aspects of industrialisation, thereby restoring pride and dignity to the individual worker. Access and exposure to Oriental, and especially Japanese, art with its liberating emphasis on asymmetric composition and simplicity of line, had a profound effect on painting, graphics, architecture and all aspects of the applied arts. Glass, in turn both elegant and exotic, seemed the perfect and natural material through which to express the organically flowing and graceful rhythms inherent in Art Nouveau.

By the late 1820s in the United States of America, a major contribution to glass processing was made with the invention of the mechanical glass press to facilitate the mass production of standard items.

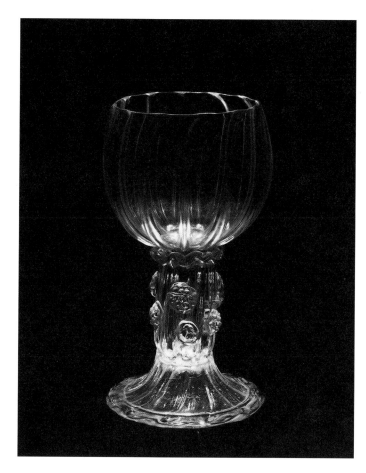

George Ravenscroft, UK: *Lead-glass goblet*, 1676–81 18.5cm high; form derived from medieval German Waldglas Römers with their typical applications of raspberry prunts; mouldblown ribbing on bowl and foot; raven's head seal (courtesy: Trustees of the Victoria & Albert Museum)

depict heraldic, mythological and religious themes. Such images, together with hunting and landscape scenes, were also used extensively by the school of wheel engravers led by the Prague gem and hardstone engraver Caspar Lehmann, a technique for which the region became particularly noted.

The New World

It has been said that with the establishment of the Jamestown glasshouse in the early seventeenth century glassblowing became America's first industry. However, the venture failed and more than a century passed before émigré Germans were able to set up commercially viable concerns which produced glass largely within the European tradition.

Some thirty years later nearly seventy-five per cent of all American glass was pressed. Ultimately extremely complex and intricate relief designs were produced of sufficiently high quality to imitate expensive cut glass.

Sadly for English glass, Frederick Carder, the most talented of John Northwood's disciples, emigrated to the United States of America in 1903 to set up the Steuben glass works at Corning. There he was responsible for initiating an astonishing range of designs produced largely in the Art Nouveau style. His skilful use of iridising for the Aurene range, was in direct competition with the work of Louis Comfort Tiffany and led to a long and bitter lawsuit between the two men, which was finally settled out of court in Tiffany's favour. Perhaps the most successful of his many designs, Intarsia, was a precursor of the Graal technique.

Louis Comfort Tiffany

Louis Comfort Tiffany (1848–1936) was another of the great leaders of the Art Nouveau period. The son of a wealthy New York jeweller, he began his career as a painter and travelled extensively in Europe, North Africa and the Mediterranean area. By the time he returned to New York in 1879 he had decided to devote his talents and energies to the field of interior design. He rapidly became the most sought-after designer of the time, his flair in providing clients with exotic interiors in which he coordinated every detail earning him a wealthy and enthusiastic following.

The decorative potential of leaded windows interested him increasingly but he was dissatisfied with available colours and rejected the painted and etched effects currently in vogue. At the Universal Exhibition of 1889 in Paris, Tiffany saw early attempts to iridise glass by such firms as Lobmeyr, Pantin and Webb. He was particularly fascinated by the lustrous effects and, seeking to emulate them, he employed a team of chemists to research and develop ways of achieving richer more jewel-like effects by treating the glass with metallic oxides.

Inspired both by ancient glass seen on his travels and by the later works of Emile Gallé, he determined to manufacture his own glass, establishing a factory at Corona, Long Island, in 1893, to produce both cathedral glass for leaded windows and free-blown work. With Tiffany as artistic director,

working in close collaboration with his manager, an Englishman, Arthur J. Nash, the factory produced a vast range of designs, varying and combining colour, style and technique to such effect that few fashionable homes were without at least one of his leaded table lamps or vases. Output continued to expand, and a foundry and metal workshop were created to produce bases for the beautiful leaded lampshades, of which 'Dragonfly' and 'Wisteria' were especially successful and popular designs. A glass mosaics studio was added under the control of Joseph Briggs, later to become the benefactor of the Haworth Art Gallery in Accrington, England, which houses his outstanding collection of Tiffany glass.

In 1895, to great acclaim, Samuel Bing opened his 'Maison de l'Art Nouveau' in Paris as the prime showcase for artists and designers. As part of the magnificent display it contained a number of commissioned windows by Tiffany, made to designs by Bonnard, Vuillard and Toulouse-Lautrec.

Tiffany's free-blown art glass was named 'Favrile', derived from an old English word meaning 'hand-made'. The iridising techniques he had developed were used extensively and imaginatively to produce sumptuous results, his spectacular creations winning prizes at all the major international exhibitions. It is reported that at any one time there were at least five thousand colours and varieties in the stockroom. Amongst the most typical and popular series were 'Peacock', with combed decoration emulating feathers, 'Cypriote', inspired by the naturally eroded iridescence of ancient and buried glass, and 'Jack in the Pulpit' vases, slender, delicate and sinuous forms, entirely in the spirit of Art Nouveau. Perhaps the most freely creative and exceptional of all was the 'Lava' series. These asymmetric forms with dark blue or black textured surfaces overlaid with heavy gold trailing express apparently accidental, almost crude qualities and yet they are amongst the most vital and timeless of all Tiffany's creations.

The demand was huge and inevitably there were many who imitated in both Europe and America. By far the most accomplished was the Bohemian Company, Loetz Wittwe, who produced a wide and imaginative range of exceptionally high quality. The Quezal Art Glass Company set up by Martin Bach, a former Tiffany employee, Durand glass from the Vineland Glassworks and Steuben glass under the directorship of Frederick Carder, all

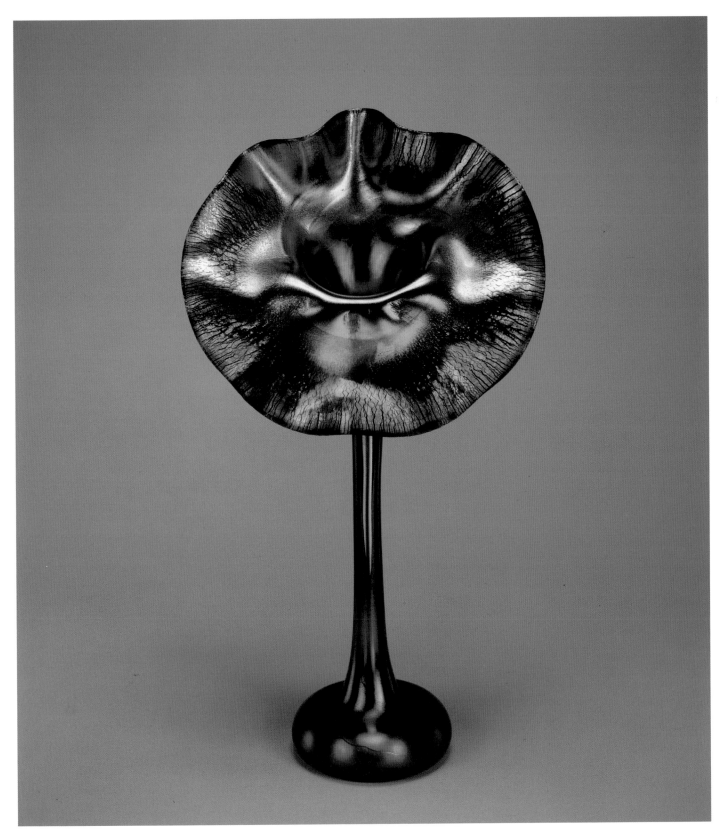

Louis Comfort Tiffany, USA: *'Jack in the Pulpit' vase* [an American woodland flower), c. 1912
52cm high; *Favrile* glass in a variety of iridescent colours, here dark blue (© 1987 The Corning Museum of Glass)

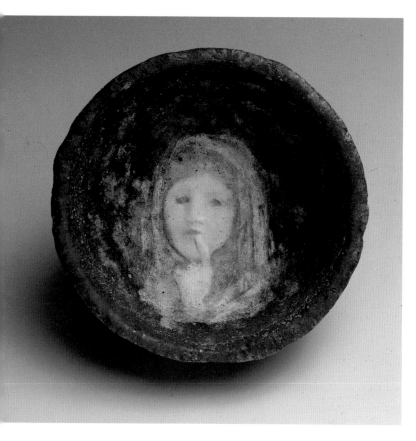

Henri Cros, France: *Le Silence*
14cm high; *pâte de verre* (photo: Jaulmes, courtesy: Musée des Arts Décoratifs, Paris)

produced outstanding iridised glass. Sadly, Tiffany lived to see his work become unfashionable, although within twenty years of his death a revival was well under way. Apart from the visionary 'Tiffany Foundation' for the further education and encouragement of American artists, his legacy lies in the spectacular body of work he created, itself the product of the exceptional ability he possessed, in common with Gallé, to inspire his glassmakers to work creatively at the furnace.

In the spirit of research that existed late in the nineteenth century a number of French artists dreamt about and began experimenting with a new medium, a translucent polychrome vitreous material suitable for sculpture, which came to be known as *pâte de verre*.

Originally known in Ancient Egypt and described by Pliny, this technique was rediscovered by Henri Cros, (1840–1907), as a result of painstaking experimentation at the Sèvres porcelain factory. As ceramicist, painter and sculptor he worked in a variety of media including terracotta, plaster, bronze and wax. Searching for a material with similarly translucent qualities, though more permanent, than wax, he concentrated for over twenty years on developing *pâte de verre*, through a series of delicately-coloured allegorical and idealised plaques and medallions in bas relief. Although the secrets of his technique disappeared with the death of his son Jean, the only person in whom he confided, his achievements had inspired a number of contemporaries to pursue *pâte de verre* independently and in entirely personal directions.

Albert Dammouse (1848–1926), a ceramicist, developed a masterful technique for making very thin and subtly coloured vessels including a series in which he created open *cloisonné* patterns of flowers and leaves which were later filled with another paste, termed *pâte d'émail* (enamel paste) before being refired at a lower temperature. In order to achieve areas of translucence within an opaque matrix, it is probable that each additional colour had to be fired separately, a painstaking and time-consuming process.

His contemporary Almeric Walter established the *pâte de verre* studio at the Daum Glassworks in Nancy. He worked there for a number of years developing the models of various designers and sculptors with whom he collaborated, a practice he later continued in his own workshop where he incorporated figurines, animals, fish and insects into bowls and trays. An interesting aspect of his work was the inclusion of *pâte de verre* panels or tiles in stained glass window installations.

Like Henri Cros, François Décorchement (1880–1971) came from a highly cultured background and worked in a variety of media. Inspired by Cros' work, his own experiments with *pâte de verre* formed the basis of a lifelong obsession. He settled in his birthplace, Conches in Normandy, rarely ever to leave it again. Making all his own subtly-coloured glasses he developed a technique derived from the *cire perdue* ('lost wax') bronze casting process to achieve more monumental pieces. These were high fired at around 1200°C for more complete fusion, and subsequently polished. Initially firing with coke, he later installed an oil-fired kiln for greater control.

In 1921 Gabriel Argy-Rousseau, also from Sèvres, set up a successful workshop for series production of *pâte de verre*. He evolved a clearer, more resonant form known as *pâte de cristal*.

Emile Gallé and his contemporaries

Amongst the industrial giants of the period, such as Edison, Bell and Ford, stand the artist industrialists Emile Gallé and Louis Comfort Tiffany. To Gallé, credit must surely go for the flowering of French art glass. Artist, poet, scientist and manufacturer, he was undoubtedly the most innovative and sensitive glassmaker of the age. An acknowledged leader of the Art Nouveau movement, he initiated the Ecole de Nancy, a group dedicated to the creation and expression of a modern ornamental style based on the absolute harmony of nature and the integration of art and industry.

He was born in Nancy in 1846, and studied philosophy, botany and drawing at Weimar. He then spent four years learning glass technology and chemistry at Meisenthal, a factory in Alsace, with further periods of study at the Louvre and Victoria and Albert Museums. He was fortunate to inherit the family business manufacturing faïence pottery and crystal, and although he later added the making of fine furniture and designed actively in all three areas, his great love was for glass and it was through this medium that he was ultimately to realise his poetic and artistic aspirations. From his earliest childhood an obsessive fascination with nature was to provide a source of concrete and spiritual inspiration that was to sustain him throughout his life.

Early works, decorated with painted enamel and gilding show a variety of classical and historical influences, particularly Islamic and Oriental art, as seen in the work of his contemporaries Eugène Rousseau and Joseph Brocard. At the Universal Exhibitions of 1878 and 1884 in Paris, the exhibits of both Rousseau and Gallé attracted great attention and praise. Rousseau's large sculpted forms, deeply influenced by the Japanese, although simple in contour express a rich monumentality. The use of colour is subtle and restrained, delicate internal veining and bubbles combine with surface crackle to achieve effects reminiscent of tinted quartz crystal.

Gallé, too, soon developed a highly personal style based on a complex and subtle fusion of colour and

Emile Gallé, France: *Coloured bowl*, c. 1900
12.4cm diameter × 6.8cm high; clear glass, cased colour, wheel-engraved decoration (courtesy: The Corning Museum of Glass, gift of Ellen D. Sharpe)

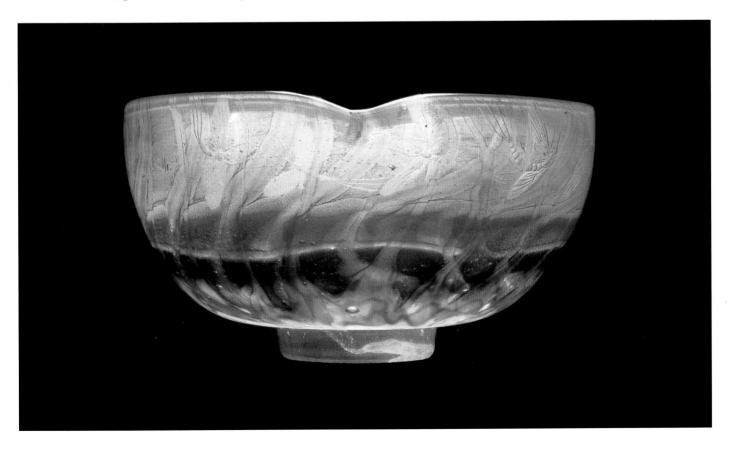

relief. One aspect of his genius lay in his ability to distil the essence of perceived sources of inspiration, as in the works of his friends the Symbolist poets and writers, Verlaine, Baudelaire, Proust and Mallarmé. He frequently inscribed quotations on his more individual pieces, known as 'Verreries Parlantes', or vitrified poems.

Within his factory he created a large central design studio from which he directed continuous and avid research into new effects, constantly seeking richer and yet more subtle modes of expression. Extensive gardens were cultivated to provide the plants and flowers that he insisted should be distributed throughout the workshops. These, together with his own exquisitely detailed nature studies in watercolour, were constant reference for the high degree of realism in colour and proportion that he demanded of his talented craftsmen. He encouraged their active and creative participation in the making processes, believing, like William Morris, that their commitment, spontaneity and self respect were vital to the quality of the finished work.

Continuous exposure and critical acclaim through the Universal Exhibitions, particularly those of 1889 and 1900, brought him international fame and an eager public. He experienced some conflict between his desire to produce beautiful works cheaply enough not to be exclusive and his wish to create ever more ambitious and complex individual pieces through which to express the mystery and power of his literary and artistic fantasies.

The dilemma was resolved by establishing levels of production. First came the basically commercial 'industrial cameo', with which people are most familiar, extremely competent but relatively uninspired work manufactured in vast quantity. Sometimes known as Standard Gallé, it consists of forms composed of various thin layers of colour over clear glass, the unresisted parts of which are eaten away by exposure to hydrofluoric acid to leave a coloured relief decoration, usually leaves, flowers and insects, often further embellished by wheel engraving.

Next came serial production pieces, limited editions of more complex versions using such varied techniques as marquetry and patination.

Marquetry, as the name suggests, is a form of inlay. Shaped fragments, flakes or laminations of coloured glass or metallic foil are attached to the surface of the hot 'metal' as part of a predetermined design. Inherent in this method are the flowing movement and distortion imparted as the form expands during the blowing process, and enhanced by work in the cold state, by wheel engraving for example. This process was sometimes used in conjunction with 'patination' which involved the application of impurities such as wood ash, coal or brick dust to the surface of the hot, unformed glass probably by rolling on the marver to achieve a dense, dry, textural quality. Metallic inclusions, controlled bubbles and fuming were also used, often developed from some initially accidental effect or flaw.

Artistically, the most important group is that consisting of the unique sculpted pieces made under Gallé's personal supervision during the last fifteen years of his life. Technically superb, these works are breathtaking in their power and complexity, and in the degree to which form, colour and imagery are fully integrated. The exhibition of this body of work, shown at the Corning Museum of Glass in 1984, was exceptional both in presentation and content. Richly symbolic, at times surreal, these pieces validate his deep conviction that a glass vessel could be so much more than a mere functional container. Gallé's importance lies not only in the enormous influence he had upon his time but in the significance of so many of his ideas and attitudes to the glass art of today.

Amongst the most dynamic of his contemporaries were the brothers Auguste and Antonin Daum, who were also staunch members of the Ecole de Nancy. A versatile and eclectic company, Daum enjoyed great commercial success producing work largely in Gallé's style, although from the outset they pursued an active policy of collaboration with noted artists. At the turn of the century Almeric Walter's first *pâte de verre* workshop was at the Daum Glassworks, and this is an area of production in which they have continued to excel, sometimes in combination with blown work. More recent collaborations were with Salvador Dali and the French sculptor César, and currently with the American glass artist Dan Dailey and concept designers Hilton McConnico and Philippe Starck.

René Lalique

Another exceptional figure of the Art Nouveau movement was René Lalique who by the 1890s had established a reputation for the most innovative and distinctive jewellery of the period. His work

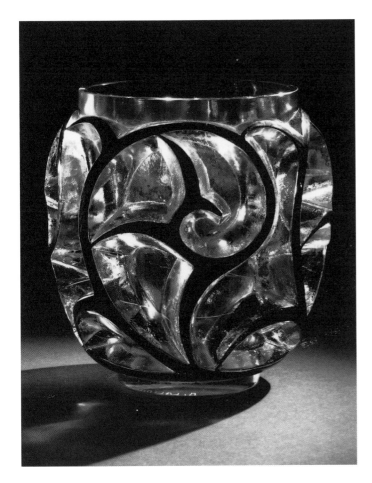

René Lalique, France: *Tourbillons*, Art Deco vase ['tour-billons' = whirlwind or whirlpool], c. 1925
20.4cm high; moulded clear glass with applied black enamel; deep relief and spiralling movement evoke the opening of a fernlike plant (© 1991 The Corning Museum of Glass)

moulded glass to unprecedented levels. Proving commercially successful, he moved in 1918 to larger premises in Alsace where, in reaction to the great mass of coloured glass currently being produced, he concentrated on form and finely-detailed relief decoration. Colour, when used, was restrained and for the most part confined to transparent and opalescent self-coloured glasses. The most characteristic and frequently imitated works are the translucent milky-blue opalescent pieces with figurative elements in sharply defined relief.

Lalique's range and output were vast, demonstrating enormous versatility and technical brilliance. Intended primarily for a luxury market, his production included everything from tableware, perfume bottles, imposing vases and light fittings, to superb car mascots as well as major private and public architectural commissions. Lalique's glass, daring in its form and colour, exceptional in quality and, like Gallé's, achieved through a rare integration of art and industry, ensured his international renown. The firm continues to thrive under the direction of his granddaughter Marie-Claude Lalique.

Twentieth Century

In reaction to the 'excesses' of Art Nouveau, the architect and designer Josef Hoffman, together with other Secessionist artists and craftsmen, founded the Wiener Werkstatten in 1903, as a centre for the production of progressive design in the applied arts, in Vienna. It was inspired by the example of C. R. Ashbee's Guild of Handicrafts Workshop in the East End of London, and manifested great empathy for the elegant and restrained work by Charles Rennie Mackintosh and the Glasgow School.

Hoffman designed in a mainly geometric style for various German and Austrian glass manufacturers, notably the firm of J & L Lobmeyr in Vienna, whose progressive policy of commissioning and sponsoring artists fortunately continues.

The horrors of the First World War brought great changes in attitude and taste. The sugary sweetness of Art Nouveau seemed inappropriate, giving way to a tougher, perhaps harsher philosophy which claimed stridently that function determines form.

was highly sought after in fashionable circles and Sarah Bernhardt, the famous French actress, owned a number of pieces. He became renowned for the way in which he incorporated unusual and non-precious elements such as enamel and glass into his work.

A growing fascination with glass was stimulated by a commission from the noted perfumier René Coty to design high quality scent bottles. In 1908 he acquired a small glasshouse which enabled him to experiment further, drawing upon his outstanding modelling skills and his experience as a jeweller. Lalique's interest lay in developing the use of moulds for series production of blown and cast pieces, and his skilful exploitation of the *cire perdue* ('lost wax') process raised the quality of

Functionalism, though by no means a new idea, was now expressed with a fresh commitment to purity of form and freedom from ornament. Modernist architects such as Adolf Loos, Le Corbusier, Walter Gropius and Mies van der Rohe, were dedicated to the creation of rational, clean, simple lines and surfaces, and the exploration of new materials and technology. In their hands, glass took on a new and symbolic significance and Van der Rohe's 'crystal skyscrapers' revolutionised building concept and practice.

The Bauhaus was established in Weimar in 1919, with Walter Gropius as director and such avant-garde artists as Klee, Kandinsky, Moholy-Nagy, Breuer and Albers on the staff. Its aim was to integrate all kinds of design activity and to realise an art form which transcended the traditional separation of the disciplines in art and craft. Highly influential, it was considered subversive by the Nazis and was closed in 1933.

In the evolution of modern glass the vital roles of Gallé and Tiffany are undisputed; however, it is the life and work of the French artist Maurice Marinot which more than any other exemplifies the spirit which so inspired the pioneers of the Studio Glass Movement.

Born in 1882 at Troyes, he was nineteen years old when he enrolled at the Ecole des Beaux Arts in Paris for classes in drawing and painting in the studio of Fernand Cormon under whom Van Gogh and Toulouse-Lautrec had previously studied. Almost at once, he was expelled as a dangerous non-conformist but his fellow students rallied round, enabling him to continue, by hiding him whenever Cormon appeared in the studio. He participated in the notorious Salon d'Automne of 1905 when, along with Matisse, Derain, Vlaminck, van Dongen and others, he was branded as a Fauve (or Wild Beast). Soon afterwards he returned to Troyes, rarely ever leaving the district again, although he continued to exhibit at both the Salon d'Automne and Salon des Indépendants for several more years.

In 1911 his life took a radical turn when, during a visit to friends, the Viard brothers, who owned a glassworks at nearby Bar-sur-Seine, he first witnessed glassblowing. He was captivated by the spectacle, the beauty of the molten glass, the stark contrasts of heat, light and colour and the drama of the men's efforts to control such elemental forces.

His was, he wrote, 'a violent desire for this new game' and he became determined to learn 'the trade'. At first he was allowed the use of tools and a chair only during work breaks although he later took every available opportunity to cycle the fifteen kilometres from his home to the factory in order to work in the evening and at weekends.

His enlistment during the Great War halted progress but by 1922 he was blowing all his own pieces, frequently working at night in the darkened factory long after the final shift had departed. Marinot worked alone, realising his designs entirely through his own efforts. Making his glass for no other purpose than his personal fulfilment, he said that 'the mere thought that his glass should have any useful purpose would inhibit his creative powers'.

It was typical of Marinot's independent nature and integrity that he himself developed the chemistry necessary to prepare all his own colouring oxides. These were rolled between layers of transparent glass and sometimes combined with areas of controlled bubbles trapped within the thick walls of his pieces. Each piece was the outcome of a creative struggle, the forms kept simple to enhance the rich interiors. Although many were quite small in scale they invariably possessed monumental qualities.

With scant concern for his health he began to etch his pieces, cutting deep abstract angular patterns by lengthy and frequent immersion in dangerous acid baths. He achieved beautiful surface textures in the etched areas, suggestive of melting and breaking ice, running water or hoar frost.

In 1927 he began a phase of work called *modelage à chaud* – 'my final and best manner of glass', a method of manipulating the hot glass surface with specially-made tools to create surface relief and thereby emphasise the optical qualities and visual interplay between internal and external surfaces and volumes. His work in glass continued until 1937 when the Viard Glassworks closed down and ill health forced him to retire. He resumed painting in earnest, working figuratively until his death in 1960. Any leanings towards abstraction found expression in his glasswork, through which he created a powerful and poetic language of pure form, exerting a major influence on contemporary design as an originator of the Art Deco style. He rejected any such notion, writing: 'I revolt against the words decorator and decorative art. My work as a glassmaker is as honourable as painting or sculpture'.

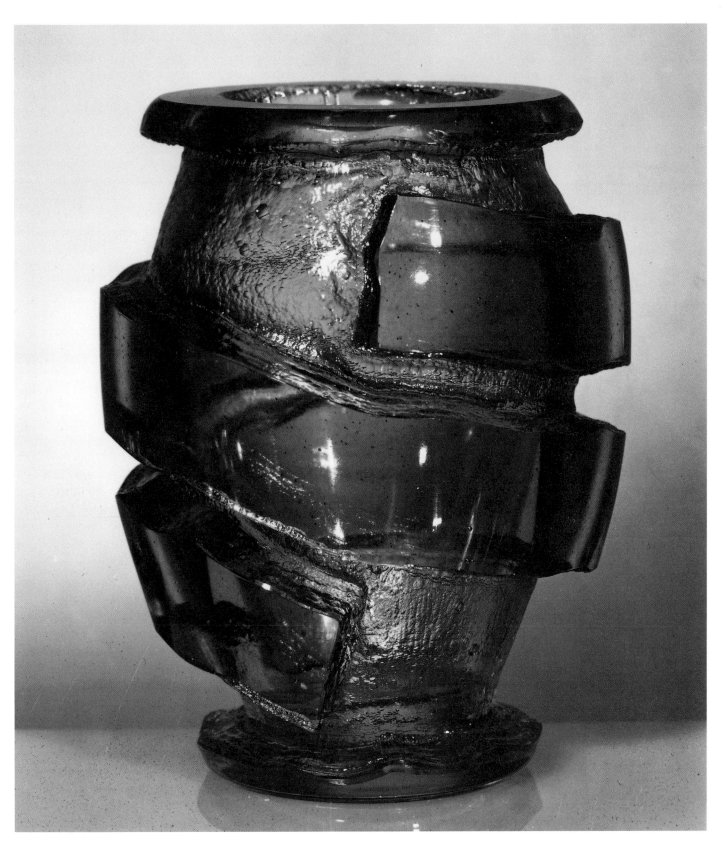

Maurice Marinot, France: *Acid-cut vase*, c. 1928
19.8cm high; remarkably deep cutting produces a carved
spiral (helical) motif (courtesy: Musées Royaux d'Art et
d'Histoire, Brussels)

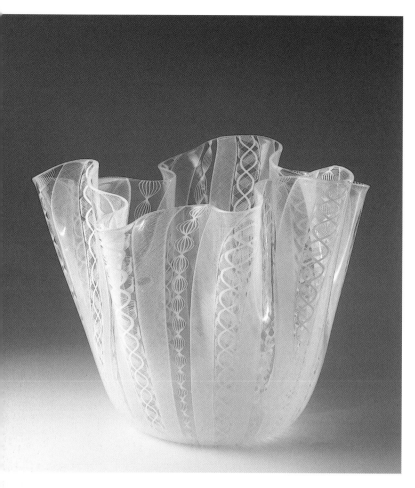

Fulvio Bianconi for Venini, Italy: *Handkerchief vase,*
c. 1955
approx. 11cm diameter × 28.3cm high; blown puntied and
spun into a bowl; folds formed in hot glass which is re-
heated and swung (courtesy: Venini)

John Cook from the UK, providing an experience
which has had a significant effect on the develop-
ment of contemporary glass art.

The glassworking region of Sweden lies in the
south-east of the country, deep in the forests of
Småland, once an abundant source of fuel. Kosta
was the oldest glassworks, having been established
in 1742, and the other major factory was Orrefors;
they recently merged. Towards the end of the First
World War, in an effort to expand their range from
tableware to more decorative glass, Orrefors hired
two artists Simon Gate (1883–1945) and Edward
Hald (1883–1980). Despite their lack of previous
experience in glass (Hald, for instance, had studied
painting under Matisse), they were quick to ap-
preciate its potential and their presence brought a
freshness and vitality to the company. Their early
designs were simple in form with lyrical, naturalis-
tic decoration, and they were soon involved in the
development of two important techniques, derived
from cameo-work, namely 'Graal' and 'Ariel'.

At the World Fair of 1925 Swedish glass received
international acclaim, largely in response to the
light airy engraving by Gate and Hald, and this
success signalled the beginnings of an exceptionally
enlightened relationship between the Swedish glass
industry and artists recruited as designers. Rather
than pursuing the often restrictive attitudes of com-
mercial management, based on caution, blatant
conservatism or the desire for instant financial re-
turn, a progressive policy was pursued that encour-
aged designers to 'play': to explore and to exploit
fully the wide-ranging technical and aesthetic pos-
sibilities that an industrial facility could provide.
The factories provided the resources – studios, ma-
terials, a unique reservoir of craft skills and tech-
niques – and gained in return an important asset, a
measure of international prestige. The value of this
policy can be seen in the high regard for Swedish
glass during the past fifty years.

In Italy the glass 'Renaissance' was led by Paolo
Venini (1895–1959) and Ercole Barovier (1889–
1974). They were appalled by the endemic over-
elaboration and imitative nature of the declining
Venetian glass trade. Venini wanted to make
simple, elegant forms with a restrained use of
colour and texture; and his sophisticated and inno-
vative ideas, unswerving aesthetic integrity and
superior standards set the work apart. The list of
celebrated artists and designers with whom Venini
collaborated includes Gio Ponti, Tapio Wirkkala,
Tyra Lundgren, Napoleone Martinuzzi, Toni
Zucherri, Lucio Fontana, Fulvio Bianconi and
many others. In the late 1960s the Venini factory
was host for workstudy periods to a number of stu-
dio glass artists, among them Dale Chihuly, James
Carpenter and Richard Marquis from the USA and

Furniture and glass by the Finnish architect Alvar
Aalto were important expressions of functionalist
ideology. His 'Savoy' vase, often known as the
Aalto vase and designed for the Iittala Glassworks
was first shown at the Paris World Fair in 1937. It
is a timeless and classic form, still in production
and continuing to look avant-garde some fifty years
on. In 1947, Iittala held a competition which
brought several major designers to the fore, namely

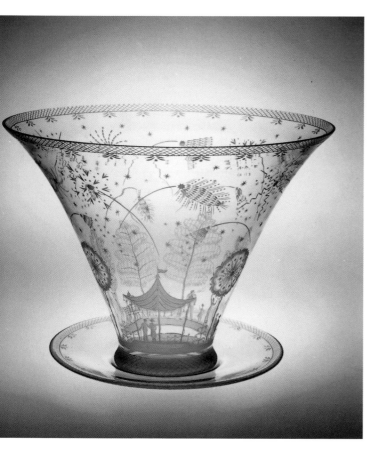

▲ **Edward Hald** for Orrefors, Sweden: *Fireworks bowl*, 1921
27.6cm diameter × 20.3cm high; engraved by Karl Rössler (courtesy: Trustees of the Victoria & Albert Museum)

Alvar Aalto for Iittala, Finland: example from *Savoy Vase* series, also known as the 'Aalto Vase', 1936 ▶
mouldblown in clear and coloured glass into meandering forms originally inspired by 'the Eskimo woman's leather breeches' (photo: Iittala-Hackman)

Tapio Wirkkala (1915–1985), Kaj Franck (1911–1989) and Timo Sarpaneva (born 1926). Their bold experimental approach to the medium earned them well-deserved international reputations during the 1950s.

Influenced by the ideas of the Dutch modernist movement 'De Stijl', the 'Unica' department of the Royal Dutch Glassworks at Leerdam was established to develop modern design and to produce unique experimental pieces. Under the inspired direction of Andreas Dirk Copier, from 1930 for some fifty years, the department thrived, with the active participation of such noted artists as Floris Meydam, Willem Heesen and Sybren Valkema.

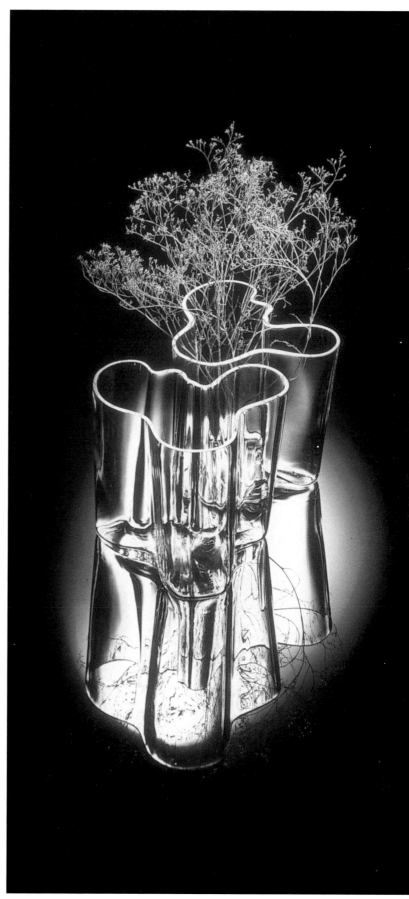

25

The Studio Glass Movement

The realisation (in the 1960s) that it was possible to work alone, directly and creatively with glass, caused an explosion, a mushrooming of interest and activity worldwide. The introduction of 'small furnace' technology provided a stimulus for the phenomenal growth of glass as a new and unusual medium with an increasingly vital role in contemporary art.

At 'Glass 1959', an important landmark exhibition at the Corning Museum of Glass, nearly ninety per cent of the objects on display were factory glass while only ten per cent were made by individual artists/craftsmen. Twenty years later at the same venue, in one of the major international exhibitions to date, 'New Glass', the proportions were entirely reversed.

The factors which stimulated this extraordinary phenomenon were many and varied. The Second World War influx into America of émigré artists and craftworkers fleeing from Nazi oppression in Europe introduced new ideas and influences: the sophistication and classic purity of the Bauhaus ideology and the power of German expressionism. Many of the new immigrants found teaching positions within a university system rapidly expanding to meet the needs of returning ex-servicemen. Brilliant interdisciplinary experiments took place, like that at Black Mountain College in North Carolina which brought together philosophers, poets, writers, musicians and artists of the calibre of Buckminster Fuller, John Cage, Merce Cunningham, Franz Kline, Jackson Pollock, the de Koonings, Bernard Leach, Shoji Hamada and Peter Voulkos. Mass production, the abundant provision of cheap, useful, machine-made articles – 'untouched by human hand' – liberated the craftsman from the need to create functional objects. Access to new materials and technology, expanded levels of communication and the diverse cultural influences of a multi-ethnic society gave rise to a fresh and experimental approach.

The 1960s abounded in images, currents and directions. It was an exuberant, irreverent and optimistic period. A nation of immigrants restlessly searched for an identity within a brash urban culture. The Blues, Soul, surrealism, kitsch, Flowerpower, the Beatles, soft sculptures by Claes Oldenburg, soup cans and Brillo pads by Warhol, Op, Pop, Minimal, Funk and Junk Art, tv dinners, cartoons, underground movies, moon landings, fallout shelters and 'happenings' were rampant.

The adventurous spirit of Abstract Expressionist painting emanating from New York during the 1950s had had a liberating effect on other visual arts. The art of Picasso, Miro, Isamu Noguchi and the Action Painters inspired Peter Voulkos to express the same vitality in clay, thereby initiating the liberation of ceramics from the straightjacket of the vessel. Teaching in Los Angeles in the early 1960s, Voulkos gathered around him a group of artists, many of whom were unfamiliar with clay but whose energetic experiments demolished the traditional limitations of material, process and scale. These activities in turn gave rise to the Funk (Pop) school of ceramics, led by Robert Arneson at the Davis campus of the University of California, exploring and celebrating clay as history, legend, fetish, illusion and protest.

At the same time there were artists in various parts of the world independently excited by the expressive potential of glass and quite unaware of each other's ideas and efforts. Among those already exploring the medium were Benny Motzfeldt in Norway, Raoul Goldoni in Yugoslavia, Arieh Bar-Tal in Israel, Kyohai Fujita in Japan, Erwin Eisch in Germany, and Stanislav Libensky and his Art Group in Czechoslovakia. In the USA Edris Eckhart, Maurice Heaton and Michael and Frances Higgins were pioneering the use of kilnforming techniques.

Littleton and the USA

At the biennial conference of the American Crafts Council at Lake George in 1959, there was considerable discussion on the subject of glass, particularly hot glass as a possible medium for the artist. The Higgins challenged Harvey Littleton, an

exhibiting potter and teacher who had developed an early 'infatuation with glass', to prove his cherished theory that hot glass was a viable medium that could be worked by an individual.

Littleton had grown up in the glassmaking community of Corning where his father was a director of research at the Corning Glassworks and instrumental in the development of Pyrex. As a boy, he made frequent visits to his father's laboratory and was acquainted with Frederick Carder, founder of the Steuben Glassworks and a leading citizen in the town. During summer vacations from his studies in Industrial Design, he worked at Steuben where he made his first pieces in glass, casting torsos by a technique similar to *pâte de verre*. He sensed possibilities in glass beyond those evidenced by industrial production and urged a more experimental and artistic approach. He was, however, discouraged by his father's technological bias and turned to pottery as a career. Working independently in his studio as a potter, and also as a teacher of ceramics, he became convinced that it *must* be feasible to work as creatively with glass as with clay.

From 1951 Littleton taught at the University of Wisconsin, settling on a farm near Madison and funding his early experiments in glass through the sales of his pottery. For years he searched for the means to realise his vision, travelling to Europe in 1957 to visit the Spanish glassmaker Jean Sala in his Paris workshop and to visit Murano where, in spite of being coolly received by the glassmakers anxious to safeguard their methods, he gleaned enough, watching hour upon hour, to convince him of the validity of his ideas. There, too, he saw the small demonstration furnaces used to produce souvenirs for tourists.

An opportunity to prove his theories came in 1962 when, with support from Otto Whittman, the influential director of the Museum of Art in Toledo, he staged a two-week working seminar in a disused building in the museum grounds. The first attempts to melt glass in a small pot furnace failed miserably because of a miscalculation in the glass formula.

The situation was salvaged by Dominick Labino, a renowned glass technologist. Littleton produced a prototype furnace based on those that Labino had previously used in his laboratory for experimental and test purposes. This 'day-tank', in essence a simple update of itinerant pre-Roman glassmaking, consisted of a box-like container made up of refractory bricks. Heat was injected through a port above,

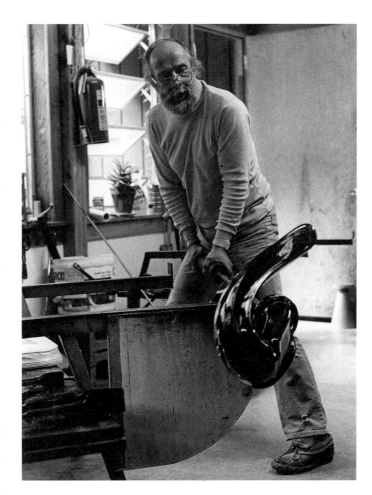

Harvey K. Littleton, USA, in his studio swinging a solid piece with multiple cased overlays, 1983 (photo: Diane Ralston)

from a single gas burner. An opening on one side allowed molten glass to be gathered and at the end of the day the container was refilled through the same opening with cold glass that melted overnight for the next day's use. Labino also provided a suitable glass to melt and demonstrated basic techniques with the assistance of a friend, Harvey Leafgreen, a retired glassmaker.

A second, more organised workshop followed later the same year; Littleton and Labino, again shared the teaching, although it has often been said that Littleton was himself the most avid student.

The collaboration of these two men with widely differing viewpoints and experience, Littleton providing the inspiration and Labino the technical know-how, showed that glass could be produced with simple equipment. This may be obvious enough today, some thirty years or so later but, at the time, the results seemed quite miraculous and

this was reflected in the enthusiasm and excitement that they generated. The advent of the one-man day-tank furnace in itself constituted the breakthrough that would transform glassmaking from the hitherto exclusive domain of the skilled factory 'gaffer' and his team into an activity for practically anyone who desired to melt and blow glass.

Littleton's next visit to Europe, this time to visit schools offering glass studies, proved disappointing in that the courses available were entirely vocational and he was unable to find even a single student working creatively with hot glass. On a visit to the Glass School in Zweisel, deep in the Bavarian forest close to the Czech border, Littleton did, however, see some unusual and compelling works which evoked his immediate and positive response. These, he discovered, came from the Eisch Glasshouse in the nearby village of Frauenau. His subsequent meeting with Erwin Eisch was the beginning of a deep and lasting friendship that has had a profound effect on both their lives. It was also the start of a continuing and intense exchange of ideas that has helped to shape the course of the contemporary glass movement.

Already obsessed, a galvanised Littleton returned to the USA where, under the aegis of the Ceramics Department of the University of Wisconsin, he established the first hot glass programme to be offered at an American University.

Within a year, at the 1964 World Crafts Council Conference in New York, Littleton and his students were able to provide a portable studio with which to demonstrate hot glass techniques. Many of the students went on to establish important new glass facilities in Art Departments in other parts of the country and abroad. Among them were Marvin Lipofsky who set up programmes at the University of California at Berkeley and the California College of Arts and Crafts, Oakland; Sam Herman who brought 'small furnace' technology to Britain; Fritz Dreisbach, Dale Chihuly and many others, several of whom travelled to Europe to glean further methods and insights from established glassworking traditions.

While there were numerous sceptics who dismissed Littleton's experiments as having little more than novelty value, there were also many converts. Amongst those who handled glass for the first time and who, recognising its creative potential, found their lives changed by the experience, were Sybren Valkema and Willem Heesen of the Netherlands,

Dominick Labino, 1910–1987, USA

Although renowned as a leading technologist, responsible for many important patents including some related to the development of glass fibre and the protective tiles used on spacecraft, it is likely that Dominick (Nick) Labino will be best remembered for his essential contribution to the emergence of studio glass. His timely intervention and participation in the Toledo Seminars of 1962, where he provided advice, equipment, materials and even funds, proved catalytic for the new movement. Following this experience he took an early retirement in order to concentrate on his own art, building a fine studio with extensive research facilities on his farm near Toledo.

Throughout his long involvement with studio glass he continued to stress the vital importance of 'proper' technical practices in, for example, the areas of compatability and durability of the glass compositions in use. Despite current preoccupations with ephemeral art forms, he was appalled that pieces made during the 1960s might not survive beyond the 1980s – a situation born of inexperience, ignorance and, in his view, misplaced enthusiasm. He possessed a dry humour and could be scathing if he felt that the highest standards were not being upheld, but he is remembered with great affection by the many who profited from his encouragement and experience.

An inveterate and ingenious inventor, he devised simple, inexpensive but effective equipment for the studio and enjoyed reproducing ancient techniques (e.g. the Egyptian core method) and historical pieces (e.g. a glass harmonica). His major interests lay in the formulation of rare colours, such as dichroics and rubies based on precious metals, and these he put to good use in his work.

At its best, contemporary glass is frequently a marriage of technological and artistic invention. Dominick Labino had no quarrel with this, for him it was merely a question of balance.

Dominick Labino, USA: *Emergence XV*, 1973 ▶
17cm × 24.4cm high; paperweight method with internal veiling from gold in the molten glass (courtesy: Trustees of the Victoria & Albert Museum)

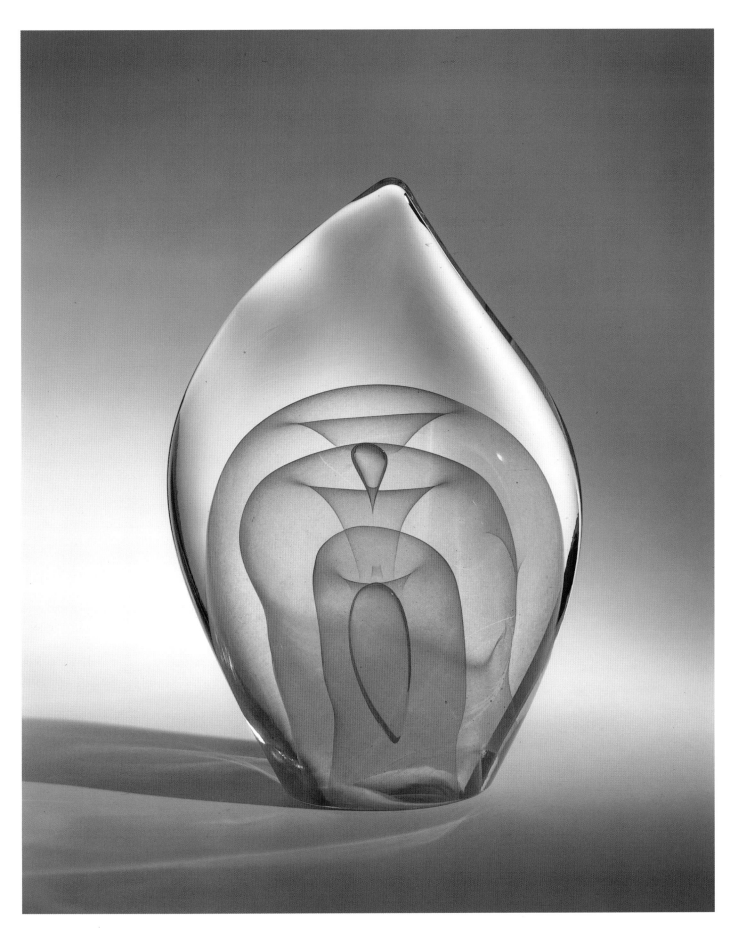

both designers from the Royal Leerdam factory. Within a year, Valkema who was also Associate Director of the Gerrit Rietveld Akademie in Amsterdam, had opened the first studio in Europe at the school. Another participant, Professor Robert Fritz, was similarly inspired to create a glass facility within the ceramics department at San Jose State College – the first of many in California.

Littleton's special guest at the 1964 conference was Erwin Eisch, upon whom the event also had a profound effect. He delivered an inspirational paper on his philosophy and work, and in him the audience of aspiring young glassmakers found a man of courage and sensitivity who, despite years of working in the factory nevertheless appeared unfettered by its traditions. His response was immediate and unequivocal: 'The little furnace *is* the future.'

By 1971, there were more than fifty glass departments in schools, colleges and universities throughout the USA. That year, in an effort to create a context in which the glass movement could further expand and flourish, Littleton published *Glass – a search for Form*, an appreciation of the medium

and its possibilities. His celebrated and controversial dictum 'technique is cheap' has withstood repeated interpretation. My own understanding is that virtually anyone can learn technique but what really matters is how well it is used to express ideas.

Littleton's crusading spirit and energy and, in particular, the high level of communication and exchange that he has engendered, have characterised the Studio Glass movement from the outset, contributing greatly to its rapid international growth. Today there are over a hundred glass programmes on offer at colleges, universities and craft schools and more than two thousand glassmakers working in the USA. The Glass Art Society, founded in 1971, now has over one thousand members including a strong body of collectors and dealers.

To demonstrate the viability of the medium to his graduates, Littleton gave up teaching in 1977 to concentrate on his creative work. He established his home and studio at Spruce Pine, a magnificent location in the Blue Ridge Mountains of North Carolina. Situated near the Penland School of Crafts it provides a focus for an active community of glass artists in the area. He remains firmly at the forefront of the glass movement and his own work continues to evolve as he strives to 'get at the essence of glass', something he has long felt could best be achieved by removing the functional element. Exploring a variety of sculptural approaches he has been increasingly involved with complex multiform compositions while also experimenting with the use of intaglio glass etching plates in his printmaking studio, as well as introducing new technologies for the workshop such as pelletised batch, electric furnaces and the like.

Many of his former students are now long-established contemporaries, and he is generous in acknowledging them for the part they have played in motivating and inspiring him. Nevertheless, there can be little doubt that access to glass as a valid medium for artistic self expression and the vibrant state of glass art are tangible results of his unwavering vision. The activity and influence of the dynamic American Scene will be evident in the notes on individual artists.

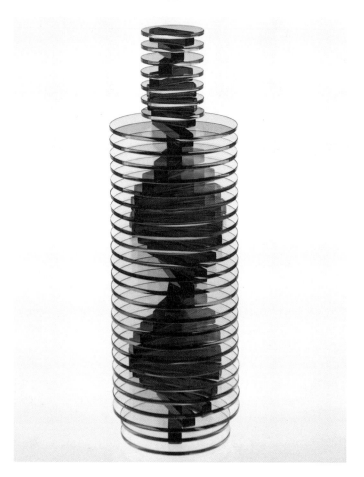

◀ **Sidney Hutter**, USA: [untitled], c. 1983
approx. 50cm high; sheet glass, cut and polished, stacked and glued

Marvin Lipofsky, USA

Perhaps the most salient feature of Lipofsky's organic abstracts is their capacity to express the sensual qualities of glass. Sexual and phallic references abounded in early works, emphasised in some of the *California Loops* by additional 'flocking' to give the glass a soft furry surface – a nice touch! Later works display more delicate attributes, soft silken surfaces, fluid curves, inviting edges and openings, and rhythmic movements.

Lipofsky's work has much in common with that of Dale Chihuly, although there are marked differences in process. There are also distinct parallels in their careers – both were graduates of Harvey Littleton's first glass programme at the University of Wisconsin. Both have actively and effectively promoted glass as an art form, and both have worked and lectured peripatetically and are acknowledged internationally for their important contribution to the development of glass art. Lipofsky is a founder member and Past President of the Glass Art Society and was founder editor of the estimable GAS Journal.

In 1964, following his graduation and imbued with enthusiasm for the new medium, Lipofsky established the second major glass course in the USA, at the University of California, Berkeley, and later another at the California College of Arts and Crafts in nearby Oakland. The Bay Area was a vibrant and exciting place to live and work during the mid 1960s, as the home of flower-power, pop, funk and other mind-blowing music, film and abstract expressionist ceramics; it was also a great time 'to get into glass'.

Nevertheless, as a teacher he has tended towards a confrontational approach: 'It's a tough world out there and you have to be tough to survive as an artist.' Some did not survive, but many who did swear eternal gratitude for the experience, and are themselves celebrated today as artists working in glass.

Since 1970, Lipofsky has travelled extensively, working with master glassmakers around the world. 'A new environment forces me to change my set patterns – I like working with industry, adapting my aesthetic to what is going on around me.' Despite pursuing a consistent theme, each new workplace stimulates a fresh response, to local colour, climate and culture. For example, his choice of colours will dictate a certain character, mood, form or texture pertinent to that situation.

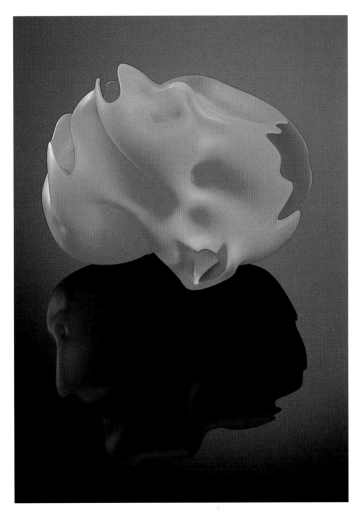

Marvin Lipofsky, USA (with help from Eric Bladholm): *Haystack Summer Series 18*, 1987
12in. × 10in. high; blown into *ad hoc* wooden mould constructed from found objects; coldworked, cut, ground, sandblasted and acid etched (photo: M. Lee Fatherree)

The 'work pattern' involves distinct phases: the dynamic interplay of hot glass, fire, smoke and sweat at the furnace as the pieces are blown into large, spontaneously arranged moulds made of bits of timber and metal; the use of large carved trident-like hand tools to shape and penetrate the glass, restraining, flattening and smoothing until the desired biomorphic form emerges.

Much later, usually in the sanctuary of his own studio, the pieces are laboriously finished by sandblasting, sawing, grinding and polishing, to open the forms and expose their gleaming interiors – transformed, like shells or seapods worn and broken on the shoreline, revealing voluptuous and hidden places.

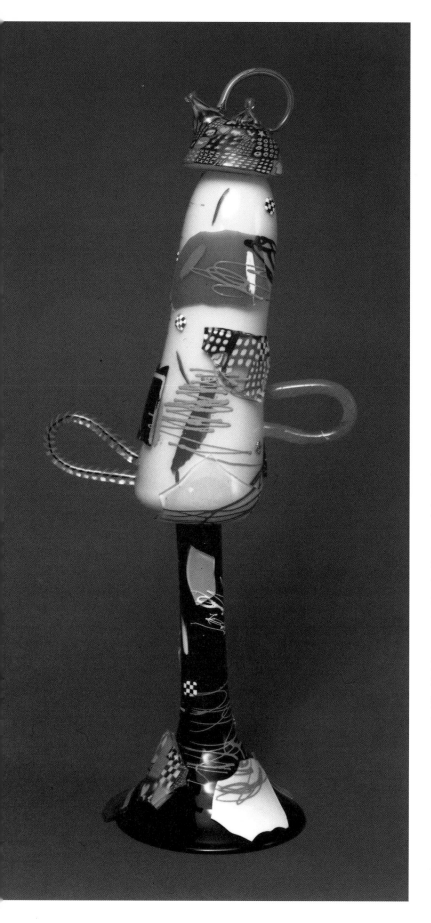

Richard Marquis, USA

During the 1960s when Pop Art was at its peak, painters like Jasper Johns, Andy Warhol and Roy Lichtenstein had a great following, and 'Americana', already a popular and potent source of imagery, took on a special significance. In California, cups became the thing to make, sometimes as presents for other artists – the wilder, funnier, more arty, the better. Robert Arneson, Ron Nagle, Kenneth Price and other well-known ceramicists elevated the 'humble' cup to the status of art object.

Dick Marquis made amusing glass versions complete with stars and stripes, before moving on to another more complex archetype, the teapot – a motif that has often recurred in his work, generally incorporating intricate murrini patterns. Murrini techniques involve embedding mosaics of sliced *millefiori* canes in the hot parison. This process, which Marquis absorbed while working at the Venini factory during 1969, is highly demanding yet remains a firm favourite.

His composite forms and installations are often outrageous, though not without charm, combining found elements such as plastic ducks and tin cars with exquisitely blown parts. Many consider his work quirky and irreverent, even heretical, and so it may be by some standards, but all the more refreshing and stimulating for it, stemming from his desire to challenge traditional ways of working and seeing. It is nevertheless based on superlative skill, a deep understanding of and respect for art history, and an irrepressible humour that delights in demolishing the sacred cows of the art establishment.

Richard Marquis, USA: *Teapot Trophy*, 1987
22in. high; constructed from blown glass parts with applied shards, paint, *murrini*-patterned elements; drawn *latticino* handles (photo: Marquis)

Susan Stinsmuehlen-Amend, USA

Her work epitomises the vitality of American glass. There can be no doubt about her professionalism, for she can execute meticulous drawings and windows if required, and does so regularly to commission, but she also has the spirit and flair to break 'all the rules'. She makes sumptuous reliefs that combine all manner of dazzling colour and bizarre materials, as well as unusual vessels blown at Pilchuck with

Susan Stinsmuehlen-Amend, USA: detail from *Faith must be Sought*, 1983
whole piece 30in. × 30in.; etched and painted glass; painted metals

William Morris and Lino Tagliapietra, two of the world's best glassmakers. Her multi-layered panels, asymmetric 'collages of pattern' are constructed from stained glass, mirror, glitter, costume jewellery, brass, copper, paint, plastic and other found objects, in fact anything that serves her purpose or flamboyant vision.

The most ordinary materials take on singular qualities when viewed in a new context and new ways of looking may be needed to appreciate fully her irreverent compositions. Some will cry 'brash, vulgar, garish' while others delight in their raw energy and enthusiasm. They may be eclectic and outrageous, audaciously walking a tightrope over the sea of kitsch, but breathtaking, too, and utterly convincing.

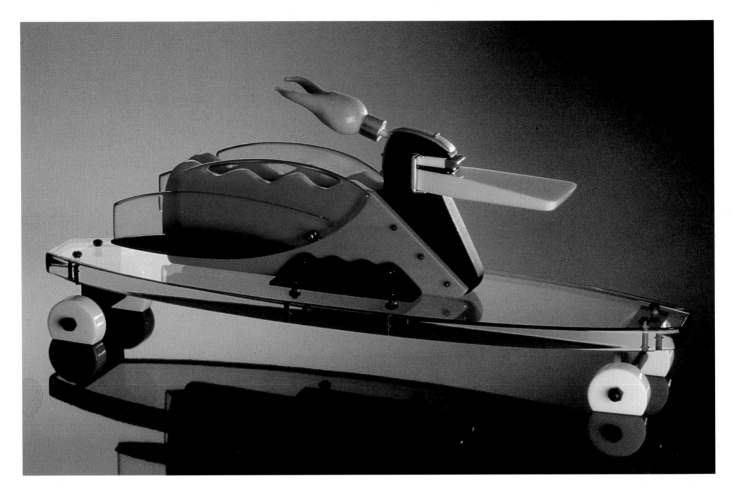

Dan Dailey, USA

Dan Dailey is one of the most imaginative and versatile artists on the international glass scene, with a range of interests that encompasses most facets of glassmaking activity.

On graduating from the Rhode Island School of Design where he learned to blow glass with Dale Chihuly, he went to Murano to work for a period at the Venini factory, an experience that gave him a taste for the possibilities inherent in an industrial setting. It stimulated an approach to Cristallerie Daum, for whom he now designs functional and decorative items, while using Daum's industrial expertise to produce pieces of his own.

Cartoon-like drawings form the basis of all his work from Art Deco-ish designs for Daum, blown vases, fabricated sculptures, cast-glass screens and murals (e.g. the Rainbow Room of the Rockefeller Centre) to the hysterically funny, bitingly incisive caricatures of everyday situations portrayed in his celebrated Vitrolite wall reliefs. Linda MacNeil, his wife, herself a gifted jeweller and glass artist, helps Dailey to achieve the meticulous finish and

Dan Dailey, USA (with Linda McNeil): *Odd Duck*, 1983 15in. long; Vitrolite, plate glass, gold plated brass

sophisticated qualities he requires, often combining glass and fine metalwork in unlikely juxtaposition. His unconventional forms and bizarre 'pictures' are invariably both elegant and unsettling in their perspicacity.

Ricky Bernstein, USA

Imagine being attacked by your household appliances, strangled by the telephone or sucked into the vacuum cleaner – scenarios worthy of Hitchcock, and Bernstein revels in them. His large wall reliefs are pure and potent satire, incisive frenetic caricatures lampooning our passion for technology and asserting our potential for self destruction. These absurd slices of life, presented as hilariously funny situations, leave one sober and uneasy at the notion of humanity overwhelmed by its own inventions.

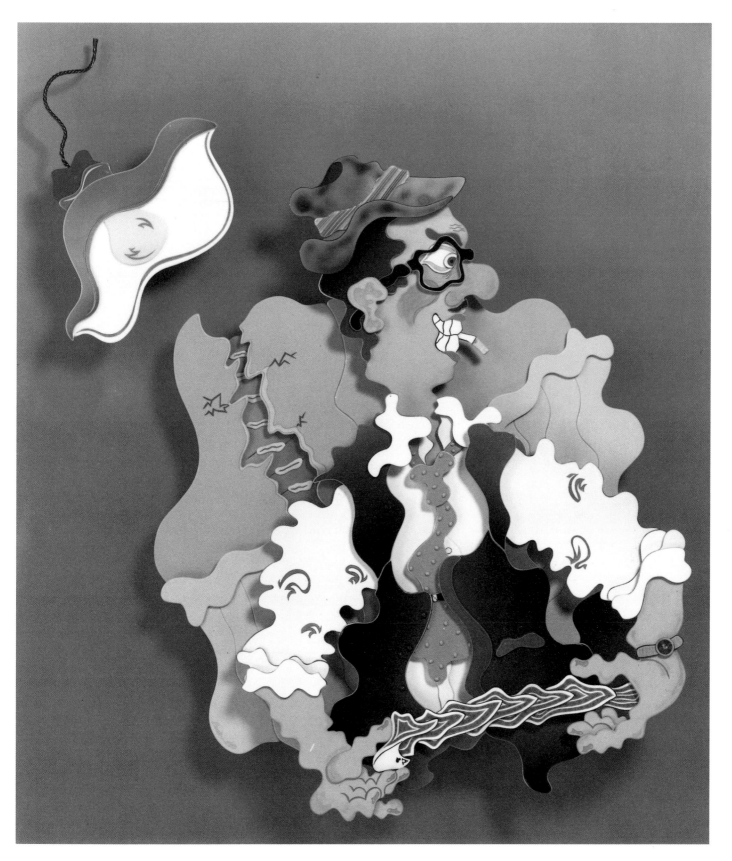

Ricky Bernstein, USA: *Fast Eddy*, 1988
48in. × 10in. × 60in. high; glass on aluminium with plastics, paint, coloured pencil (photo: Barnaby Evans)

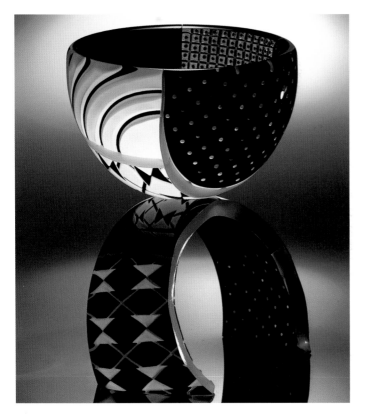

Concetta Mason, USA: *Black Tie*, 1988
7in. diameter × 10in. high; blown, thermally fractured, sandblasted, enamelled and re-assembled

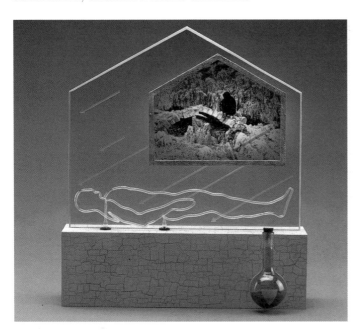

Mary van Cline, USA: from the *Healing Series*, 1988
30in. × 9in. × 26in. high; photosensitive glass block, sand-blasted glass, neon, blown glass with sand and painted wood

Concetta Mason, USA

Consider that moment of excruciating, delicious anticipation felt by Dr Frankenstein as he pulled the lever that could bring his monster to life – perhaps this is not so uncommon an experience as one might imagine, particularly among artists. Why else, one might legitimately ask, would anyone blow pairs of bowls, break them – albeit in a controlled fashion, using thermal shock – elaborately decorate the fragments and then reassemble them, jigsawlike, into a new configuration?

Concetta Mason sets out to confound our preconceptions by giving a simple functional object a totally new dynamic, an extra dimension. Fragility, a hoary old standard that will follow glass to its grave, is grabbed by the throat and shaken. The effect is kaleidoscopic – layers of colour, pattern and texture, shapes and spaces are transformed into extraordinary new icons, ritual vessels for an opulent age.

Mary van Cline, USA

Life is temporal – or so it seems! For many artists matters of life and death, life after death, immortality, reality and illusion, time and space are crucial issues that form the basis of their research. Mary van Cline is one of them. In her mixed-media pieces, figures wait in limbo, frozen in a time warp, metaphorically suspended in time. Familiar symbols and archetypes abound, made surreal by their juxtaposition and by her choice of medium and technique.

The substance of van Cline's allegories is the sad paradox that few people actually live in the present, moment by moment, being far too bound up in their history and imagined future to know themselves, find peace and merge with God during this lifetime – or another.

Steve Tobin, USA: detail from *The River*, 1991–92 ▶
1800cm long on a framework 600cm high; site-specific installation made of thousands of glass filaments, photographed at Le Verre exhibition, Rouen, 1992 (photo: G. Erml, courtesy: Cathérine Vaudour, Région de la Haute Normandie)

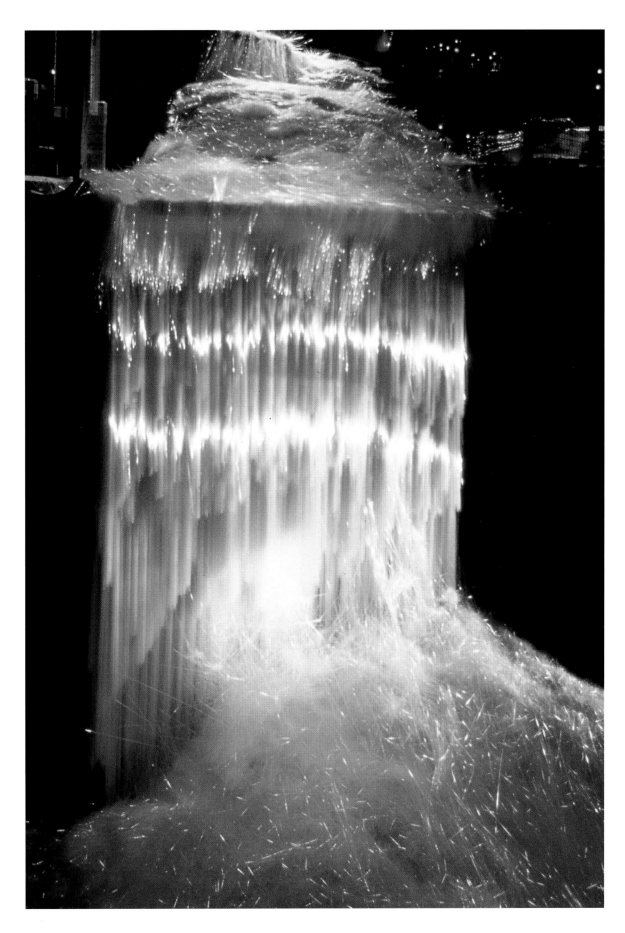

International Development

The wealth of contemporary glass activity throughout the world is overwhelming. The 'movement' continues to gain adherents as the impetus grows, making it virtually impossible to keep pace with the range of concepts and approaches being explored as far apart as Iceland, Japan and Mexico. 'Stars' undoubtedly do exist, some by virtue of their historic and pioneering contribution and others through the sheer power of their creations. However, the very intensity of development ensures that bright new talents are constantly emerging.

Netherlands

The first of the new 'small' furnaces in Europe was built during the mid 1960s by Sybren Valkema (1916–96) at the Rietveld Academy of Art in Amsterdam. As assistant director there, with a special interest in glass from his work as a designer at the Royal Leerdam factory, he was able to initiate

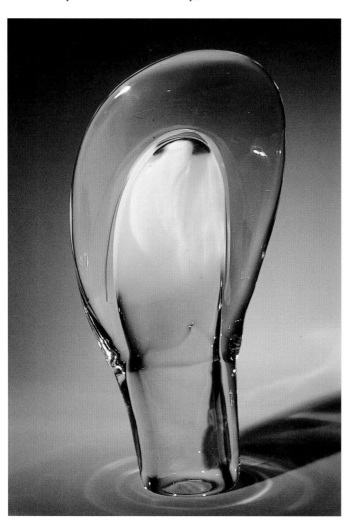

a new glass department. Consistently strong and now enjoying an established international reputation, it numbers amongst its graduates many influential artists including Richard Meitner who, in conjunction with Meike Groot, is its current director.

Since the 1960s Valkema and, latterly, his son Durk have been highly instrumental in the development of European Studio Glass, actively encouraging aspiring glassmakers in mainly practical ways by building and installing furnaces and equipment for them.

Andreas Dirk Copier was one of the grand old men of European glass. Born in 1901, he was still actively involved in creating his own individual works when he died in 1991. As design director at the Royal Leerdam factory he promoted a progressively 'modern' approach, predating the Studio Glass Movement by several decades in initiating the 'Unica Series' of one-off free-blown pieces. Amongst his protégés at Leerdam were the talented designers Floris Meydam and Willem Heesen. Wanting to work the glass himself, Heesen left the industry in 1977 to set up his own studio, a courageous decision because until then his designs had always been realised by skilled glassworkers at the factory. His work generally has a delicate, lyrical quality that derives from a deep affinity with nature together with an irrepressible sense of humour.

Dutch glass appears to embody quality rather than quantity and, perhaps largely owing to Meitner's influence, is amongst the strongest and most innovative in Europe. It also enjoys the staunch support of an enthusiastic group of collectors active in the Society of Friends of Modern Glass and of a network of good galleries.

United Kingdom

The introduction of the 'small furnace' technology in the late 1960s by Sam Herman, a graduate from Littleton's first course and a Fulbright scholar, heralded the beginnings of Studio Glass in Britain. As tutor in charge of the glass department at the Royal College of Art, London, he exerted a major influence. His infectious 'hands-on' approach was a revelation to the stale drawing-board oriented design departments then in existence, notably at

◀ **Sybren Valkema**, Netherlands (with Gary Beecham at Spruce Pine Studio): [untitled], 1983
32cm high; freeblown, cased colour

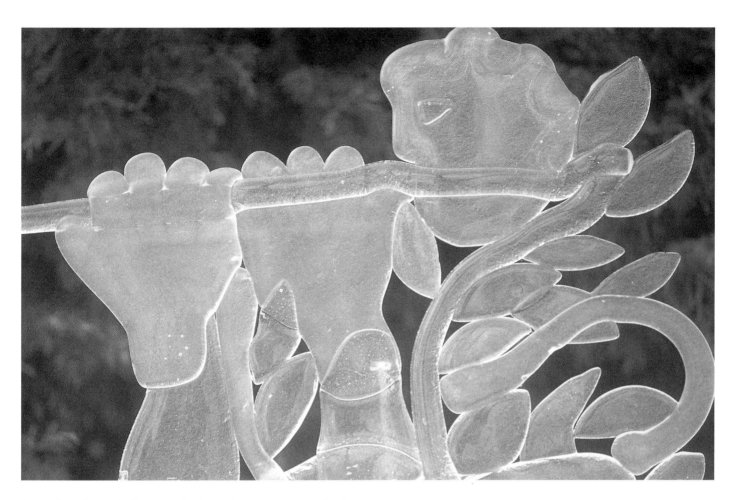

Willem Heesen, Netherlands: *Orpheus*, 1994
47cm × 30cm high; blown and fused clear glass (photo: René Koster)

Stourbridge College of Art (now part of the University of Wolverhampton), Edinburgh College of Art (now part of Heriot-Watt University) and the Royal College of Art. The vitality and spontaneity of his pieces, both in terms of their form and his use of rich fluid colour, inspired an entire generation. Many noted glass artists today are his former students including Jane Bruce and Jon Clark in the USA, Jiri Suhajek in Czechoslavakia, Yoshi Hamada in Japan, and in Britain: Pauline Solven, John Cook, Annette Meech, Steven Newell and many others.

In 1969 Sam Herman was instrumental in setting up the 'Glasshouse' in Covent Garden, London. Initially it was intended as a transitional facility for his graduate students but it also provided the first public access to a glassblowing studio and this, together with a major exhibition of his work at the Victoria and Albert Museum, gained vital public visibility for the emerging craft.

The next major landmark occurred in 1976. At the instigation of John Cook, who was by then Head of Ceramics and Glass at Leicester Polytechnic (now De Montfort University), the Crafts Council and the Royal College of Art together staged 'Working with Hot Glass', the most ambitious international glass symposium to date. One of its highlights was a memorable presentation by Professor Stanislav Libensky, which provided the first comprehensive view of work by Czechoslovakian glass artists and came for many participants as a total revelation. The beneficial effects of 'Working with Hot Glass', which attracted delegates from all over the world, were felt throughout the European glass scene, and especially in Britain as the host country. One tangible result was the formation of a professional association known as British Artists in Glass or BAG, whose aim was 'to encourage and promote the highest standard of creative work in glass and communicate this work to a wide public', an ongoing task.

Since that time a great many studios have been

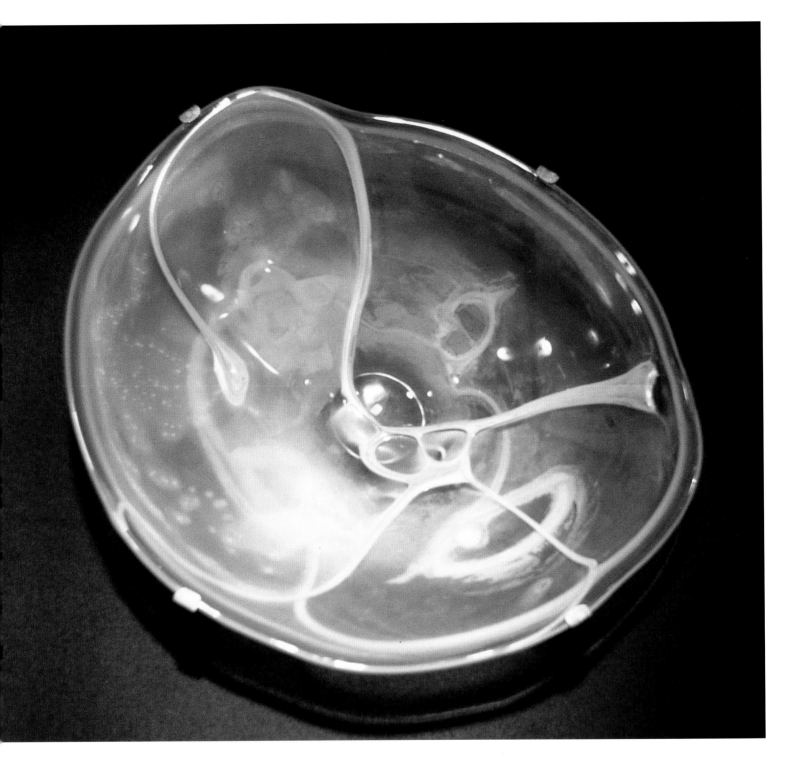

Sam Herman, USA: *Freeblown Plate*, 1970
approx. 45cm diameter; cased glass with applied trailing,
silver lustred in a reducing flame (photo: Peter Layton)

established, largely as the outcome of active educational policies pursued in the art colleges – notably at the West Surrey College of Art and Design, Farnham, at the University of Sunderland and at the University of Wolverhampton. Edinburgh College of Art (Heriot-Watt University) and the Royal College of Art offer postgraduate studies, while the International Glass Centre at Dudley College of Further Education in Brierley Hill provides an excellent one-year vocational course.

Specialist galleries have tended to come and go, despite the level of activity in studio glass and the high standard of the work produced. No substantial body of serious collectors yet exists, as it does in the USA and on the Continent. Although Britain has many exciting and talented artists working in glass, several of whom boast major international reputations, all too often they seem to be better appreciated abroad than they are at home.

Belgium

The Studio Glass Movement received prompt support in Belgium through the interest of Dr J. Philippe, the founder of the International Association for the History of Glass and a former director of the Curtius Museum in Liège, which houses a fine collection of both antique and contemporary glass. He was also responsible for initiating the exhibition of European Sculpture in Crystal and Glass, held triennially in Liège and recently in Luxembourg.

One of Philippe's protégés, Louis Leloup, after more than twenty years as blower and designer at the Val Saint Lambert Glassworks, set up his own studio near Liège in 1971. Some of his sculptural forms involve the simultaneous use of two or more blowpipes, a feat demanding exceptional skill. Colour, both cased and surface inlay, plays a major role in the various distinctive styles in which he works.

J. P. Umbdenstock is an itinerant Parisian, who settled for some years near Namur where he shared a studio with his partner, the glassblower Véronique Lutgen. He blows large, powerful forms, which are heavily overpainted with enamels. He has actively supported the Glass Centre of nearby Sars Poteries and has helped to create new glass facilities at Meisenthal (on the Franco-German border) and also in Portugal and Mauritius.

Based in Antwerp, at the heart of the world's

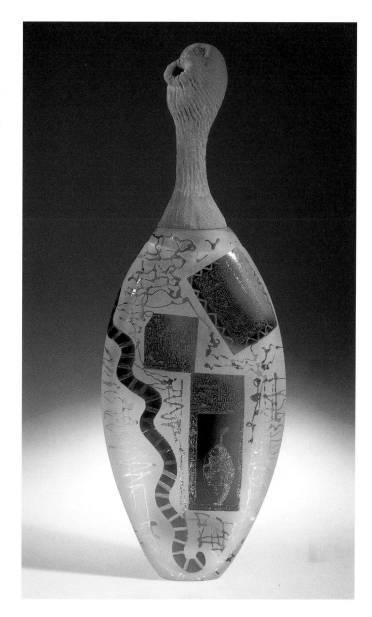

Jean-Pierre Umbdenstock, France/Belgium: *Vase Canope VII*, 1993
30cm × 80cm high; freeblown, enamelled and sandblasted; carved sandstone head (photo: Michel Wirth)

diamond-cutting trade, Edward Leibovitz has devised special diamond tools that enable him to carve blocks of glass with ease. Originally from Romania and fluent in many languages, he is an inspired and inventive draughtsman in a Chagallesque idiom, although he himself prefers to identify with Ionesco's 'Theatre of the Absurd'. He produces an unending stream of fantastic imagery, largely self portraits, in the form of carvings, lithographs, paintings and vibrant stained glass windows.

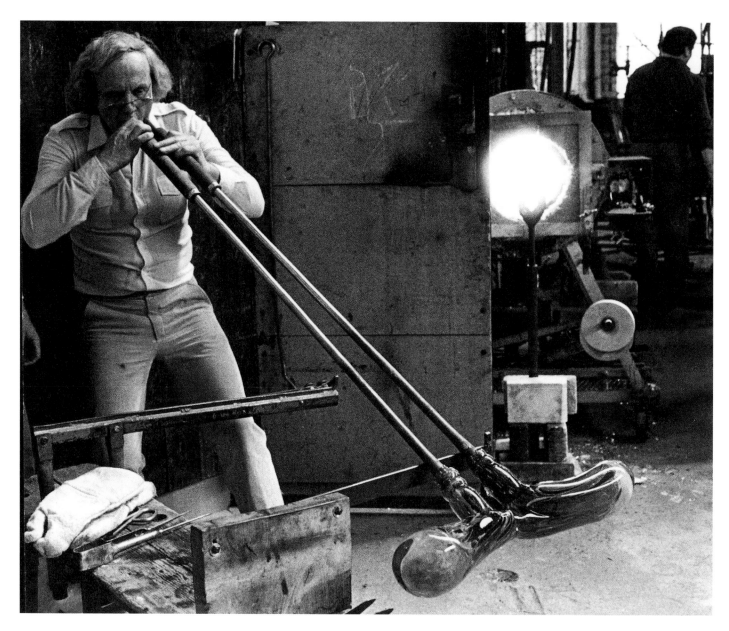

Louis Leloup, Belgium, working on *Totem*, a piece 51cm long, involving the simultaneous use of two blowpipes (courtesy: Hergiswiler Glas)

France

Rather surprisingly, in view of the illustrious history of French art glass, contemporary glass has taken longer to develop in France, although currently the movement there appears to be strong, with active governmental support for institutions such as the Centre du Verre at the Musée des Arts Décoratifs in the Louvre, and the important Centre International de Recherche sur le Verre et les Arts Plastiques – CIRVA, in Marseille. The former maintains an international archive and collection, while the latter

offers invited artists, largely from other disciplines, the opportunity for intensive practical research into aspects of glassworking, in the form of short residencies.

The movement in France was pioneered by Claude Morin, who gave up a successful career as a textile engineer and, with the help of the Valkemas, set up his first studio in Dieulefit in 1970. Some years later he founded the Association pour le Développement de la Création Artistique en Verre – ADCAV – along with the Monod family, Claude and his wife Isabelle and sister Véronique.

Another founder member, Louis Mériaux, has been consistently active throughout this period. Some thirty years ago he arrived as the newly ordained parish priest of Sars Poteries, a village in

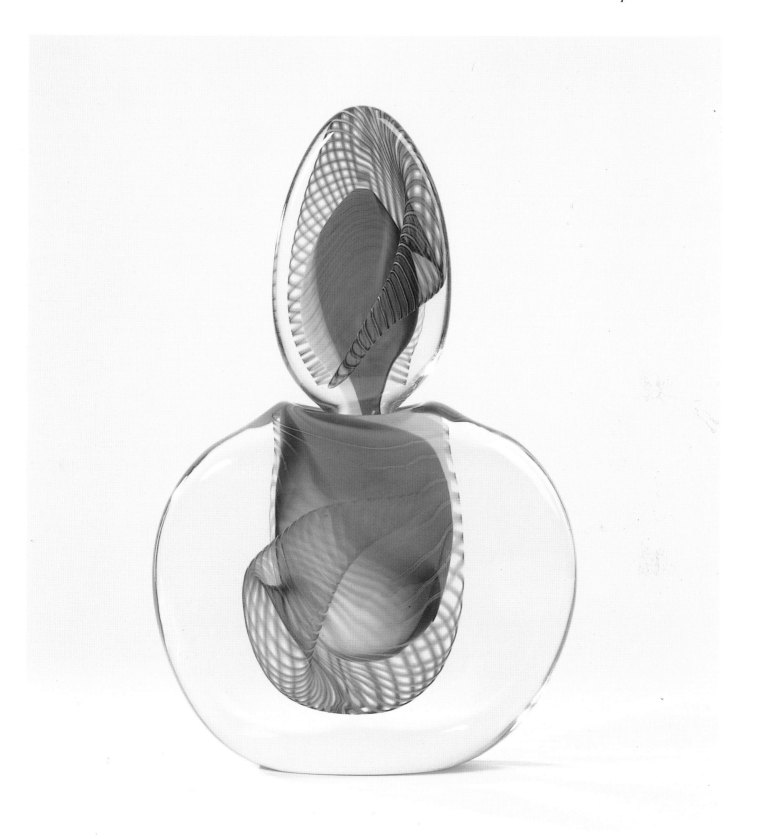

Claude Morin, France: *Spirale itinérante* [wandering spiral]
32cm high; freeblown perfume bottle, cased colour

Northern France close to the Belgian border and famous in the nineteenth century for its pottery and glass. There he discovered disused glass factories lying derelict, wares and tools discarded, and amongst his unemployed parishioners glassmakers only too anxious to revive their dormant skills. Changing vocation he dedicated himself to creating a museum to house the artifacts he had rescued and by so doing to support the new and burgeoning glass movement. With the aid of the ubiquitous Valkemas, he also established an active glass centre with a well-equipped 'atelier' for hot and cold-working techniques.

Over the years the Centre du Verre at Sars Poteries has hosted a number of important symposia and exhibitions. It houses a substantial collection and a further development has been its highly successful summer school.

Monica Damian, a Romanian émigrée, initiated L'Association pour le Renouveau du Verre in Normandy. She and Yan Zoritchak from the Slovak Republic have been instrumental in promoting contemporary glass, as have a number of important galleries, including several in Paris. Doyen of French glassblowers is Jean-Claude Novarro of Biot, one of a host of fine makers that includes Alain Begou, Joel Linard, Jean-Paul Raymond, Nicolas Morin, Eric Schamshula, Raymond Martinez and Cathérine Zoritchak, as well as sculptors of the calibre of Pascal Morgue and Bernard Dejonghe.

Two major international exhibitions have been organised by Cathérine Vaudour in Rouen, in 1984 at the Musée des Beaux-Arts and in 1992 at the Espace Duchamp-Villon. The latter, perhaps the most ambitious and important exhibition in Europe to date, presented glass as a sculptural medium with an emphasis on large-scale installation pieces.

Spain

Joaquin Torres-Esteban (1919–1988) was one of the great characters of the European glass scene. Among the first to explore the possibilities of laminating sheet glass, he devoted considerable energy to developing graphic effects from fracture lines, which he achieved by the application of localised thermal shock, sometimes by such simple expedients as dripping boiling water onto cold glass.

The major focus of Spanish contemporary glass art is the new Centro del Vidrio in Barcelona. It has well-equipped hot, cold and stained glass work-shops, a gallery and archive. It is currently running an international programme that brings eminent visiting lecturers and artists in residence to Barcelona, each to produce a major work for the city. Amongst its regular instructors is the glass-blower Per Ignaci, whose home and studio are on the island of Majorca. Pedro Garcia and Javier Gomez specialise in cut and laminated structures resonant with fantasy and light.

Italy

The Studio Glass Movement has had a less radical effect in Italy where, on the island of Murano, small furnaces have been in use for centuries. The enlightened and creative design policies pursued by Paolo Venini and Ercole Barovier in the early part of this century have largely given way to commercial interests, notwithstanding the prodigious talents of makers such as Alfredo Barbini and Archimede Seguso.

A notable exception was the series of glass sculptures initiated by Egidio Constantini during the 1950s, sponsored by Peggy Guggenheim and displayed in her Palazzo Vernier in Venice. Produced entirely in Murano, it included designs by such prominent artists as Arp, Picasso, Ernst, Moore, Cocteau, Braque and Chagall.

Set apart also by virtue of their strength and individuality are the works of Gianni Toso, Paolo Martinuzzi, Fulvio Bianconi, Luciano Vistosi, Livio Seguso, Federica Marangoni and Laura de Santillana.

Quite the most refreshing approach to design in the 1980s came from the Milan-based 'Memphis Group' led by Ettore Sottsass, the inspirational chief designer at Olivetti. The group launched its first collection at the Milan International Furniture Fair in 1981. Bright, quirky and extravagant, its irreverent and shocking style challenged accepted notions of 'taste and function', exerting a powerful influence on virtually all aspects of contemporary design. The liberating effect of this uninhibited and eclectic style, while perhaps less radical in glass than in other design areas, has nevertheless been

Joaquin Torres Estaban, Spain: *Sculpture* for museum garden at Sars Poteries, 1984 ▶
2m cube made up of 1600 one-metre square sheets of 5mm thick glass, cut and stacked (courtesy: Musée-Atelier du Verre, Sars Poteries)

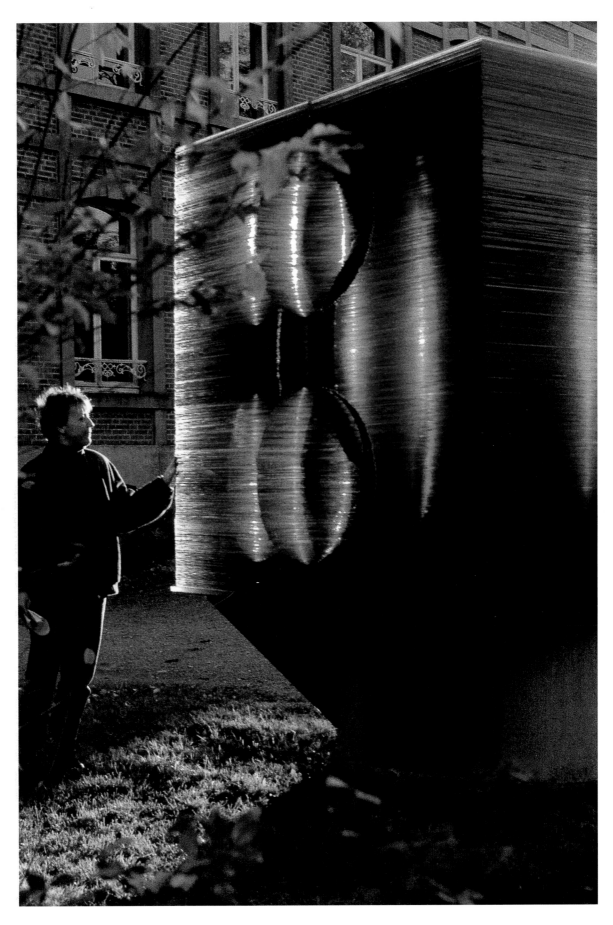

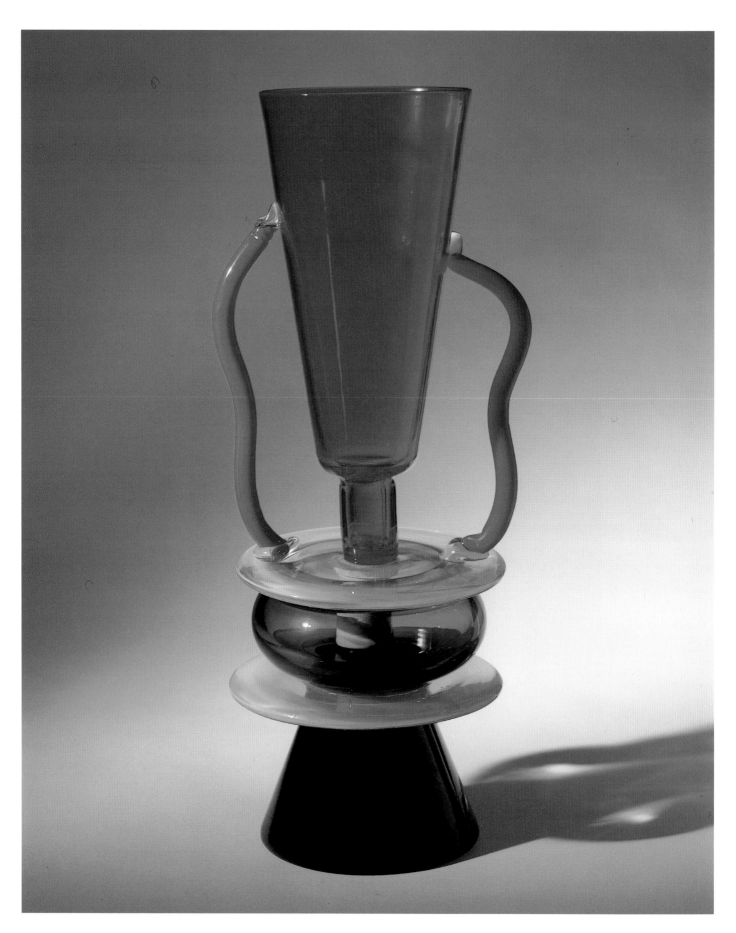

significant. Memphis glass, produced in limited editions, often at Toso Vetri d'Arte in Murano, is unconventional in its playful use of primary colours and 'irrational' forms. Sottsass, Marco Zanini and Matteo Thun, together with Czech-born Borek Sipek, a master of improvisation, have been the most active 'post-modern' designers in glass.

Austria

In 1975, under the patronage of Peter and Harald Rath of the renowned firm of Lobmeyr, and with the invaluable technical assistance of an American, Jack Ink, the disused spa of Franzenbad in Baden bei Wien was converted into an excellent glass-working facility. This was made available to visiting artists: Joel Philip Myers, Dale Chihuly, Stephen Procter and many others worked there for periods. In its heyday the studio hosted a number of important symposia, whose purpose was to explore technical and aesthetic matters, and in particular the less fashionable areas at that time such as lamp-working and engraving. The Lobmeyr mantle has now been taken over by Rolf and Felicitas Klute, whose small but active gallery in Vienna provides a focus for glass art in the region. They have also created an ongoing 'working dialogue' between invited artists and the local glass factory at an annual symposium in Bärnbach.

A director of the Vienna Academy of Art and a former member of the Memphis Design Group, Matteo Thun runs a successful architectural practice in Milan. He determined to establish a glass department of international standing and to this end engaged staff of high calibre, including the itinerant Irishman Killian Schurmann, who has taught both lampwork and hot glassworking there.

Switzerland

The Swiss glassmaking community is small, with a strong bias towards stained glass, focused on the excellent museum at Ronchaux. There is also a strong lampworking presence in Switzerland. Roberto Niederer (who died 1988), a Swiss-Italian with lampworking interests in Calabria, was a

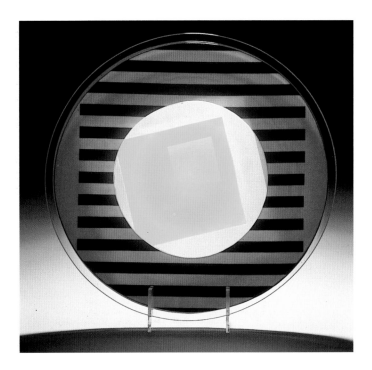

Monica Guggisberg, Switzerland, and **Philip Baldwin**, USA: *Yellow Square*, 1988
approx. 5.5cm deep × 42cm diameter

prime contributor to the European Studio Glass movement from its earliest days. He initiated the first international symposium at the Bellerive Museum in Zurich in 1972, on the theme 'Glass Today – Art or Craft?', a debate that continues some decades later. He sponsored several major exhibitions including the Hergiswiler Glaspreis, and also established the Glasgalerie in Lucerne as one of the first galleries in Europe to specialise in contemporary glass. Periodically he invited exhibiting artists to utilise the facilities of his glassworks nearby. His was a rare and practical form of patronage and his inspiration and humour are sorely missed.

Outstanding in the younger generation of glass artists are Monica Guggisberg and her American-born partner, Philip Baldwin. The influence of their training at the Orrefors School in Sweden is obvious in the clean, well-proportioned design of their functional wares. Similar concerns are echoed in large individual plates and architectural elements, such as room dividers where precise compositions are sandblasted through brilliantly coloured under and overlays producing an effect akin to hard-edge painting, with the added dimension of transmitted light.

◄ **Ettore Sottsass**, Italy, at Vetreria Vistosi for Memphis: *Sirio*, 1983
15cm × 36cm high; mould and freeblown parts, assembled hot (courtesy: Trustees of the Victoria & Albert Museum)

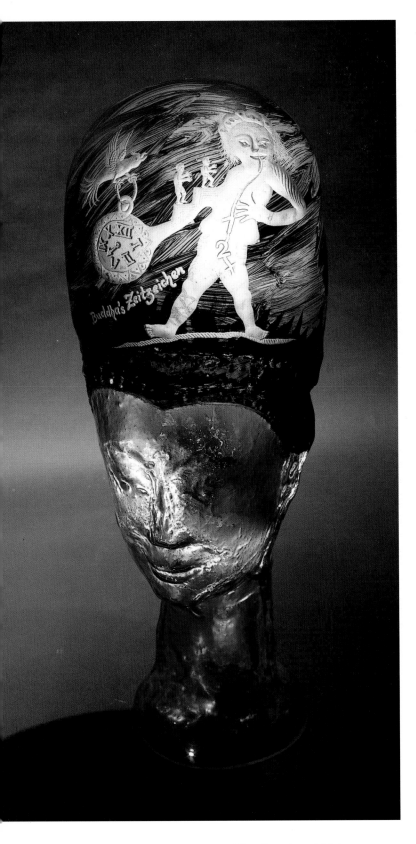

Erwin Eisch, Germany: *Buddha Head*, c. 1984
approx. 60cm high; mouldblown form engraved and
painted with enamels and lustres (courtesy: Urban Glass,
New York)

Germany

One of the great pioneers of the international Studio
Glass Movement is Erwin Eisch. Trained originally
as an engraver before studying Fine Art in Munich,
he draws and paints avidly, frequently exhibiting
paintings and glass together and increasingly ex-
ploiting the glass form as a canvas for painting with
enamels. He is a provocative and visionary artist
whose engaging works often flout established taste
and rationality, in turn puzzling, irritating and de-
lighting his audience. While his choice of glass as a
medium may be expedient (his family own a glass
factory), his message is emphatic: only if art (and
glass) have heart and a powerful wholeness of
spirit, will it truly express the personal realities and
fantasies of the artist.

Early freeform pieces gave way to pop imagery as
a means of challenging preconceptions regarding
function. Two large mixed-media installations of
1968/9, *The Fountain of Youth* and *Narcissus* were
visual metaphors for the human condition: the
alienation of modern man in society, the crisis of
a machine-made culture immersed in over-
production and over-consumption. Later works rely
heavily on highly personal dreamlike graphic im-
agery, engraved and gilded, or enamelled.

Eisch's home lies in the picturesque glassmaking
township of Frauenau, high in the Bavarian forest
close to the Czech border. Affectionately claimed to
be the 'glass heart of the world' by its ebullient
singing mayor Alphonse Hannes, it has indeed be-
come something of a Mecca for visiting glass artists.
Hannes, a union leader and politician, has con-
sistently championed the studio glass movement,
realising from the outset its potential value in
revitalising the dying hand-working trade. The ex-
cellent Glasmuseum founded in 1975, with its
substantial collection of contemporary glass, is a
tribute to his energy and vision. Not merely con-
cerned with conserving the past, it plays a vital and
active role as a centre for the local community. It
has a challenging exhibition programme and also
hosts a large and important international sym-
posium every three years. A recent and successful
development is the annual summer school,
'Bildwerk', which, while offering experience in a
variety of media, has glass as its major focus.

Despite the lead given by Eisch there are rela-
tively few independent hot glass studios in
Germany. Rather, the studio glass movement there
has advanced on a broad front based on its vo-

cational schools and a strong guild or apprenticeship system, for example in cutting, engraving, glass painting, lampwork and particularly stained or flat glass.

German architectural glass is deservedly renowned for its innovative design, restrained use of colour and renunciation of the traditional lead line. It is dominated by such key figures as Ludwig Schaffrath, Jochem Poensgen, Johannes Schreiter and Joachim Klos, as well as by a host of important artists centred round the Stuttgart Academy, formerly directed by H. G. von Stockhausen, including Johannes Hewel, George Frey, Angelica Muller, Ursula Huth, Albrecht Pfister and many others.

At one time Charlotte Hennig's small gallery in Darmstadt was alone in showing studio glass, but today Germany has a number of major galleries and important public and private collections specialising in international glass art. Of particular significance has been the work of Dr Helmut Ricke as curator of the Düsseldorf Kunsthistorische Museum and as founder/editor of *Neues Glas*, an impressive bilingual bi-monthly publication.

A long tradition of glassmaking has existed in the territory known until recently as East Germany, most importantly around Lauscha in the Thuringian Forest, an area which is best known for its lampworked artifacts. There a number of established artists and their families (notably the Precht and Knye families) split their time between lampwork, furnacework and a combination of the two techniques. Just prior to the reunification of Germany, after many years of hiring occasional worktime in factories, Thomas and Ulrike Oelzner established a hot glass studio at their home in Leipzig. Originally goldsmiths, they work together, jointly planning, executing and signing the pieces. Their current preoccupation is to exploit the graphic use of colour.

Northern Europe (Scandinavia, Finland and Iceland)

The success of the Scandinavians and Finns in developing excellent working relationships between the artist-designer and the factory has earned great acclaim for their glass since the 1950s. Paradoxically this has in turn both stimulated and inhibited the establishment of independent studios, for while their great flexibility in design and production, and the experimental use of form and colour have been recognised as a source of exciting and innovative developments, most of the leading figures in glass have continued to maintain strong personal affiliations with industry. The list is long and illustrious and includes Benny Motzfeldt in Norway, Oiva Toikka, Tapio Wirkkala and Timo Sarpaneva in Finland, Erik Höglund, Göran Warff, Ann Wolff, Gunnar Cyren, Eva Englund, Lars Hellsten, Olle Alberius, Monica Backstrom, Bertil and Ulrica Vallien and many others in Sweden.

Nordisk Glass is an association of glass artists from the five Northern European countries, started in 1978 by Finn Lynggaard of Denmark and Asa Brandt of Sweden. It has met informally every few years in one of the member countries.

Sweden

While studying at the Konstfackskolen in Stockholm, Asa Brandt had wondered, to the great amusement of fellow students and staff alike, why glass could not be freely worked in a studio in a similar way to clay. Study periods at the Rietveld Academy in Amsterdam with Sybren Valkema, and at the Royal College of Art in London with Sam Herman, convinced her that she was on the right track. So in 1968, with the help of fellow graduate Pauline Solven, she established her studio, the first in Europe, at Torshalla, which despite early public acceptance of her work remained the only one in Sweden until 1976. Initially she had to rely heavily on the ubiquitous schnapps glass for income, but she now has an efficient production studio, that enables her to devote more time to ambitious sculptural and architectural projects.

Brandt's work is often light and fanciful, expressing a somewhat dry wit. Her pieces derive from commonplace imagery – a row of washing on a line blowing suggestively in the wind or a line of kites expressing gaiety, lightness and movement.

In the past some antipathy existed between the Swedish Society of Freeblowers and the glass industry following the introduction of factory 'studio' ranges, but that situation has changed with the establishment of more independent studios, amongst them those of Ulla Forsell, Ann Wolff and Klas-Göran Tinbäck.

Denmark

Denmark has many studios – seven or eight on the island of Bornholm alone. They are largely production oriented, their designs, deriving in the main

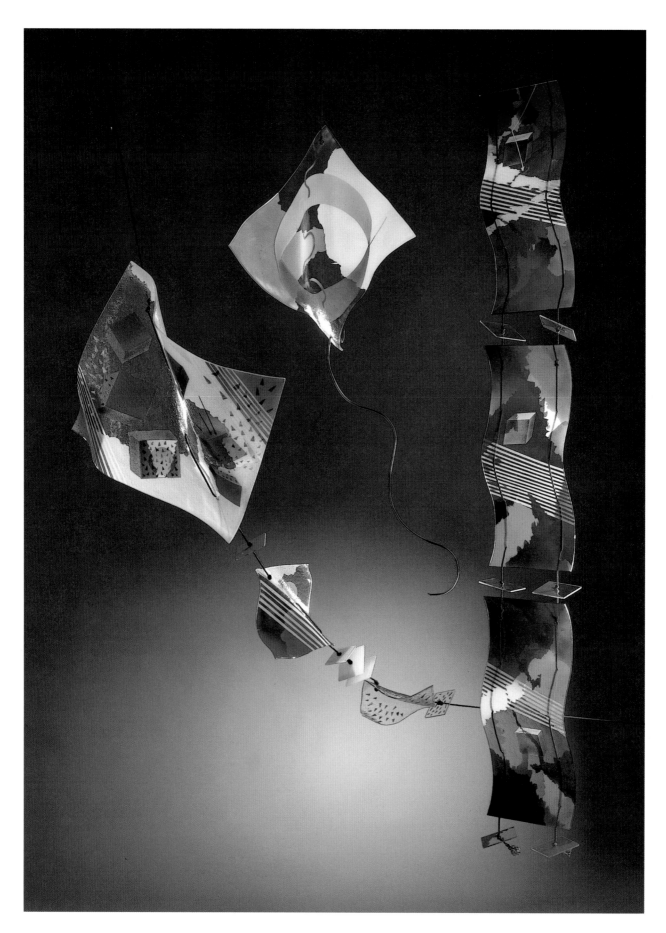

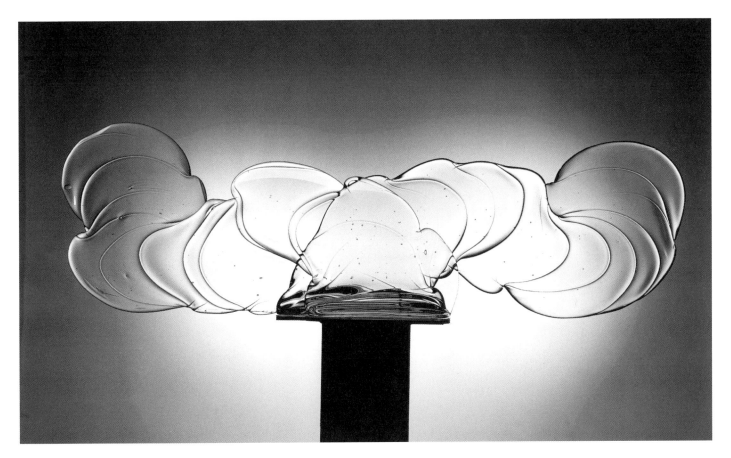

▲ **Timo Sarpaneva**, Finland: *Seraphim*, 1987
215cm × 40cm × 70cm high; sculpture in clear glass
(photo: Markku Luhtala, pf-studio)

◄ **Asa Brandt**, Sweden: *Kite Forms*, 1988
left 42cm × 42cm × 170cm high; centre 33cm × 33cm;
right 22cm × 180cm high; slumped flat glass, sandblasted
and painted (photo: Anders Qwarnstrom)

from traditional forms, in clear or delicately-coloured 'metal', which sometimes incorporates engraved decoration. Daryl Hinz, an American who trained at Orrefors, and his partner Anja Kjaer, produce bright, elegant functional wares. They specialise in a blowing technique in which they make separate coloured parisons that are joined (end to end) and then blown out as a single piece with distinct bands of colour.

Tchai Munch shares a studio with Finn Lynggaard in Ebeltoft. Her slumped dishes are carefully composed from intricate arrangements of rods and sections drawn from coloured and patterned glass. Bente Bonne, who trained as an engraver, also uses slumping techniques to make her torso-like sculptures.

Finland

Finnish glass caused a sensation at the Milan Trienniales in 1951 and 1954. The thick clear textured vessels by Tapio Wirkkala, and the purity of line of Timo Sarpaneva's forms, presented radical contrasts. Their genius is legend, and many of the designs they produced for Iittala Glassworks have become modern classics.

In later years, Wirkkala (1915–1985) conceived and planned the splendid Finnish Glass Museum in the old glassmaking community of Riihimaki. Situated in a reconstructed glasshouse it has operated since 1980, as a 'living' museum, with a working furnace.

Sarpaneva has concentrated on developing several sculptural series. 'Claritas' explores absolute form, Brancusi-like, but with the added dimension of transparency. 'Seraphim' is a sequence of fluid shapes created by the controlled pouring of molten glass onto a marver. In this series, his *Madonna of the Grotto* is a voluptuous masterpiece reminiscent of the Venus of Willendorf. In *Glass Age*, massive and jagged slabs hewn from discarded furnace pots are dramatically mounted on granite. These shattered and fissured monoliths seem fashioned by volcanic or glacial pressures rather than by the human

51

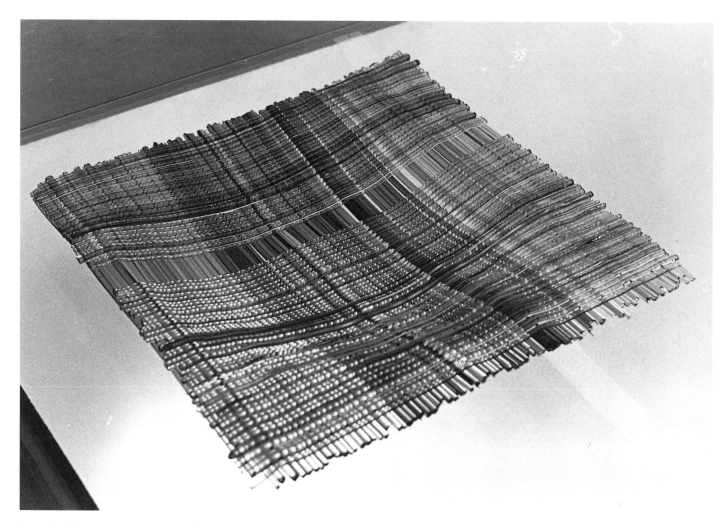

▲ **Mikko Merikallio**, Finland: *Chequered Carpet*, 1984
50cm square × 5cm thick; plate of pulled rods fused
together and sagged

Oiva Toikka, Finland: *In a Way*, 1995 ▶
85cm × 10cm × 118cm high; made on the blowing iron by
the 'paperweight' method; solid blocks of glass with applied
colour, gathered over, ground and polished (photo: Timo
Kauppila/INDAV, courtesy: Amos Anderson Art Museum)

hand. Their complex refractions and powerful
energy express a range of elemental and random
qualities that symbolise nature, vicious and threat-
ening and at the same time fragile and vulnerable.

Oiva Toikka was the protégé and successor to Kaj
Franck at Nuhtajarvi Glass (an offshoot of the
Iittala glassworks which recently celebrated their
bicentenary) and is the best known of the group of
artist-designers currently associated with the glass
industry, which includes Heiki Orvola, Pertti
Santalahti and Bjorn Weckstrom. He is extremely
prolific, working in a variety of styles and always
with a light imaginative touch. The playful use of
coloured inclusions within multiple composite
forms that combine blown and cut elements, is
characteristic of Toikka's experimental approach.
Contrary to the received (Bergmanesque) view of
gloomy Nordic attitudes, the glass here often seems
blithe and spirited. Markku Salo's work bubbles
with fun, as does that of Vesa Varrela and of the
Swedish artists Ulla Forsell and Asa Brandt – albeit
serious fun!

The first independent studio was set up in the
early 1970s by Mikko Merikallio. He is completely
self-taught, initially melting glass in his pottery kiln
as an experiment. An uncompromising and ingeni-
ous glassmaker, he constantly nibbles at the edges
of technological and aesthetic possibility. As the ad-
visor to a development aid project in Kenya, the
energy-conscious Merikallio helped to set up the
'Harrambee Glassblowers', basing their production
entirely on locally-trained labour and recycled ma-
terials.

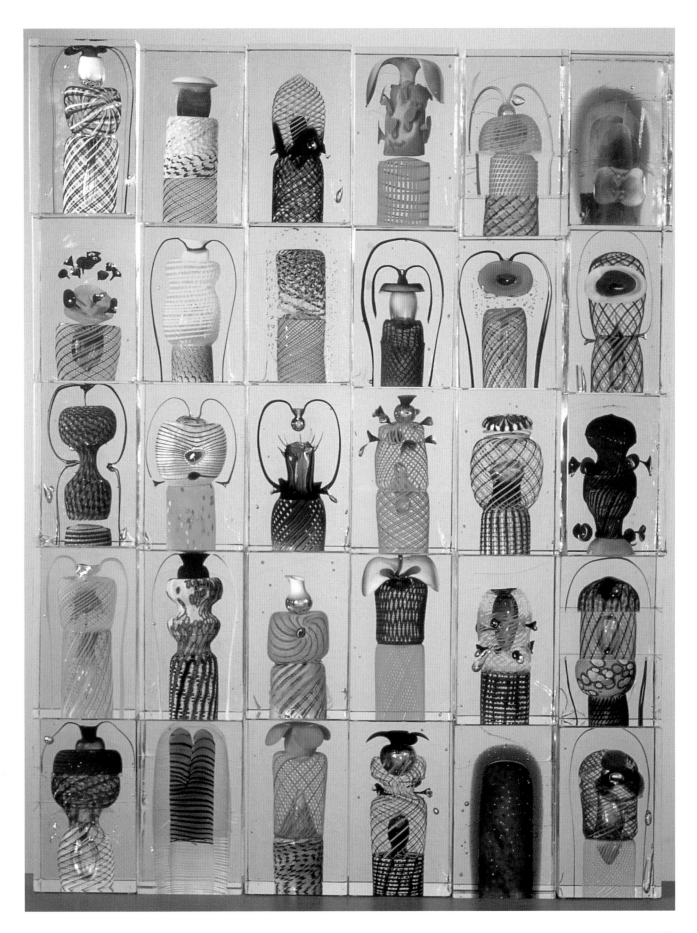

Iceland

In glass terms, Iceland is the youngest member of the Northern European Group, and is still evolving through its pioneering period. In 1981 Sigrun O. Einosdottir, a graduate of the School of Applied Arts in Copenhagen, and her partner Soren S. Larsen set up the first glassblowing workshop. Icelandic glass is characterised by a bold and imaginative imagery.

Eastern Europe

It is said that 'art has no frontiers' and my experience of attending international symposia, especially those in Czechoslovakia and Russia bears this out. The love of glass and a desire to communicate, the intensity and excitement of the work and the shared experience of the creative process clearly transcend any national and political barriers.

For the artists and others, confined for decades behind the Iron Curtain and so often repressed by intolerant and restrictive regimes, the rapid turn of events since the demolition of the Berlin Wall has brought new freedoms of expression and opportunity, new convictions and challenges.

Czechoslovakia (historically Bohemia with Moravia and Slovakia; now the Czech and Slovak Republics)

Bohemia had been associated with glassmaking since the Middle Ages and many techniques, including engraving, cutting, enamelling and gilding on crystal and coloured glass, were developed there, as were gold ruby and other specialised glasses. During the Art Nouveau period, iridising became a Bohemian speciality, with one manufacturer, Loetz Witwe, the leading European glassmaking enterprise of the period.

As early as the mid nineteenth century, technical high schools and apprenticeship centres were established in the major glassworking areas, at Kamenicky Senov and Novy Bor, followed in 1920 by the school at Zelesny Brod, an area of thriving cottage industries with miniature furnaces for the production of beads and costume jewellery.

The post 1945 shift to socialism brought about the nationalisation and mechanisation of the glass factories, but fortunately a visionary policy was adopted that recognised Bohemian hand-working skills as a national resource. Talented students from high schools and centres were selected for graduate studies at the Academies of Applied Arts in Prague and Bratislava, where glass studies lasting six years were fully integrated with Fine Art, Graphics and Architecture. Their objective was a broad all-round education rather than a narrow craft-based one, with a primary emphasis on life drawing, painting and sculpture.

Arts and Crafts centres, usually allied to major glassworks, were also founded to raise the standard of utilitarian production. Contrary to expectations, automation gave the designer an opportunity to pursue new directions, much as photography had liberated the painter from slavish representation, and these centres soon became a focus for artistic and experimental work.

In particular, the Central Art Centre in Prague (later the Institute of Fashion and Interior Design), provided a forum for the emerging generation of artists and designers, many of whom were graduates of the Academy of Applied Arts in Prague. Led by Stanislav Libensky, Pavel Hlava, René Roubicek and Vladimir Kopecky, the search began for new forms of expression beyond purely functional or decorative applications.

For many years the technical high school at Zelesny Brod was under the benign direction of Jaroslav Brychta, renowned for the fantasy and humour of his lampworked figurines. It was here, with his help, that his daughter Jaroslava Brychtova, a sculptor, began to experiment with glass casting techniques.

In 1953 Brychta was succeeded as director of the school by his son-in-law Stanislav Libensky. Libensky fostered a close relationship with industry to the extent that the furnaces of a local glassworks were actually situated within the school, enabling students to work alongside professional glassblowers and costs to be shared. (A similar arrangement has operated successfully at the Tokyo Glass Art Institute.) Many of the school's graduates ultimately find work at the local glassworks or at those in other regions, whilst some are selected to go on to further studies at the Academies in Prague or Bratislava.

At Zelesny Brod, Libensky and Brychtova began to collaborate on their work. Libensky approaches his work as a painter, often producing full-scale paintings as designs for architectural projects, with Brychtova interpreting them into three-dimensional models. All the work, including the model and mould-making, melting and finishing, is carried out at the Art Centre attached to the Zelesny Brod

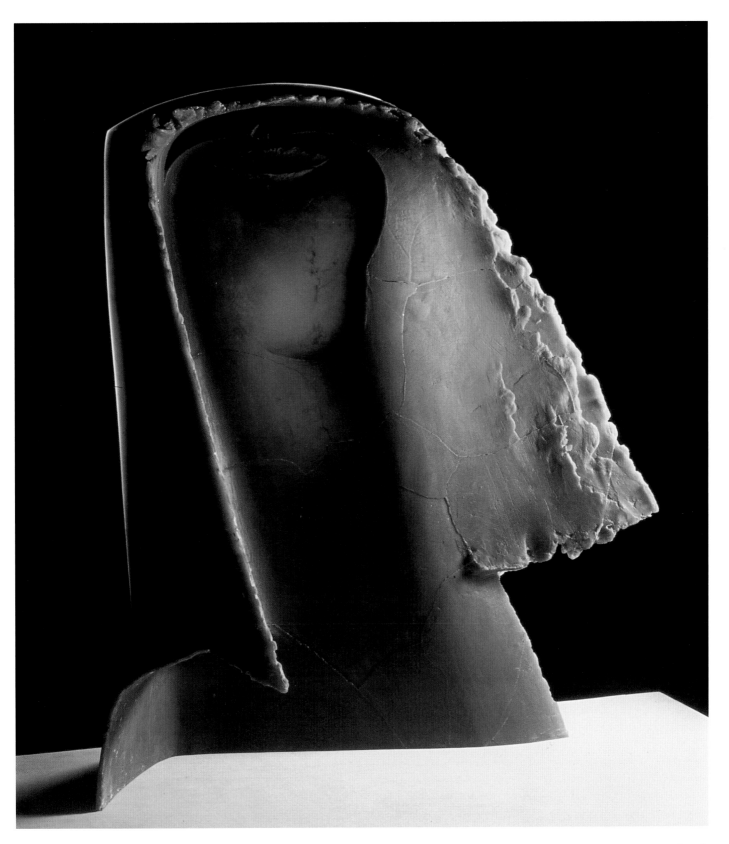

Stanislav Libensky and **Jaroslava Brychtova**, Czech
Republic: *Head* cast at Pilchuck, 1990
65cm × 27cm × 70cm high; kiln-cast in Saphirin glass
(photo: G. Urbanek, courtesy: Umprum, Prague)

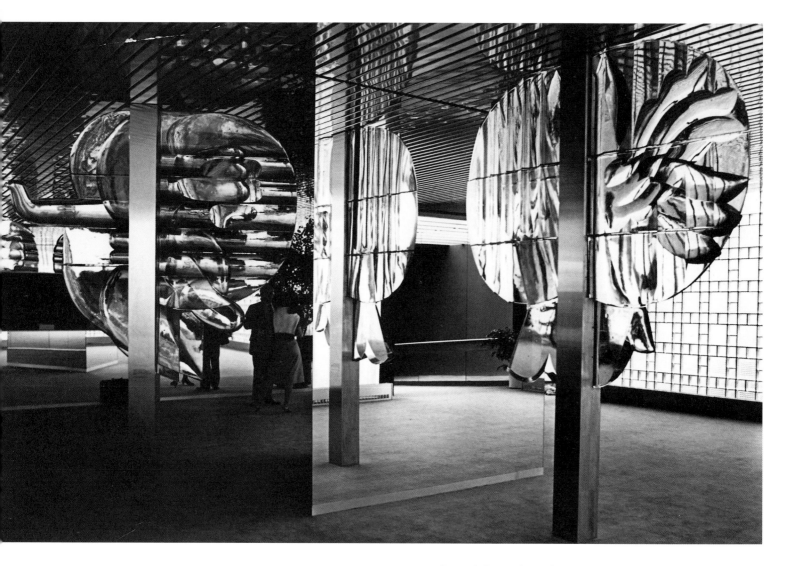

Stanislav Libensky and **Jaroslava Brychtova**, Czech
Republic: *Flower* (right) and [untitled], installed at the
Corning Museum by the architect Gunar Birkerts 1978–80
Flower 290cm high (right)

glassworks, by a team of assistants with whom the
couple have worked over many years.

Their work during the 1970s and 1980s using
optical crystal has been of consummate quality. A
highly sophisticated though formal approach re-
veals an acute awareness of the way in which glass
elements can function to alter space and has pro-
duced unconventional and innovative solutions to
the challenge of creating monumental glass sculp-
tures for specific architectural settings. These in-
clude large foyer pieces for the Corning Museum,
the Parliament building in Prague, the Czecho-
slovakian Embassy in Delhi, and the 22 metre long
River of Life at the Osaka '70 World Fair.

In 1963 Libensky was appointed Professor in
charge of the Glass Studios at the Academy of
Applied Arts in Prague where he taught for many
years with remarkable effect. Clearly a powerful in-
fluence, Libensky's effectiveness as a teacher is
shown by the strong individual directions that his
students have taken and the high regard they have
for him. In 1987 Libensky relinquished his post.
Since then he and Brychtova have devoted them-
selves to their collaborative work in a new creative
phase which is proving to be the most vital to date.

In later works light and colour are carefully mod-
ulated by controlling the thickness of relief in the
cast object, subtle colour and simple abstract im-
agery being employed to synthesise the sculptural
and painterly values of these elegant and powerful
compositions.

There can be little doubt of the significance of
the Libensky/Brychtova contribution to glass art.
As teacher and pioneer Libensky is held in the

Dana Vachtova, Czech Republic: from the *Lost Homes Series*, 1989
kiln-cast and assembled (photo: G. Urbanek, courtesy: Umprum, Prague)

highest esteem and affection by his contemporaries and by his ex-students, many of whom have become close friends. Disarmingly modest yet authoritative, he is universally respected and admired in his field.

In 1965 his former colleague Vaclav Cigler took the Professorship of the Glass Studio at the Academy of Fine Art and Design in Bratislava, where he was similarly influential. Their complementary approaches gave rise to the so-called 'Optical School' of glass art for which Czechoslovakia became so renowned as one country.

Art Centrum, the government body charged with the task of handling and promoting the work abroad successfully highlighted a strong national identity in the work and consequently many Czechoslovakian glass artists enjoyed a standard of living and a freedom of expression that were well above average, deriving their income from designs for the industry, exhibitions abroad and public commissions. By law a percentage of the budget for construction work on public buildings had to be allocated for art works, so there were frequent state sponsored commissions and competitions for installations (lighting, murals, sculpture, signs, fountains) in public buildings and spaces. Although such sponsorship is now somewhat restricted in the new market economy, new commercial galleries have been established in Prague. Both Czech and Slovak glass continues to be well promoted throughout the world.

In 1982, largely at the instigation of Stanislav Libensky and Pavel Hlava, the first international glass symposium was held at the Crystalex factory

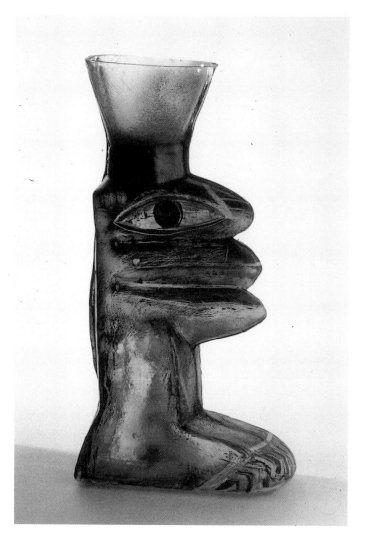

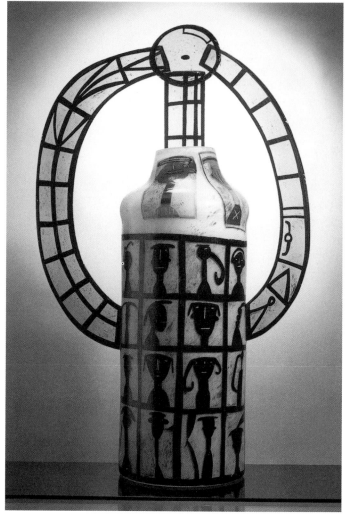

Ivana Solcova-Sramkova, Czech Republic: *Neugierige* [inquisitive person], 1988
30cm × 15cm × 67cm high; mouldblown; painted with enamels, then fired (courtesy: Eliska Stölting Gallery)

Michal Machat, Czech Republic: *School*, 1989
30cm diameter × 100cm high; mouldblown and flat glass, glued and painted (photo: G. Urbanek, courtesy: Umprum, Prague)

in Novy Bor. Conceived as a working symposium its object was to emphasise the creative aspects of glass art. It provided a unique forum through which participating artists were challenged to realise projects, which perhaps by virtue of scale or complexity, they were unable to consider within the confines of their own studios. The Crystalex factory, one of the largest producers of utilitarian and decorative glass in the world, provided the venue giving over its main furnace room containing a dozen or so large furnaces. Top glassblowing teams from all over the country were brought to Novy Bor as assistants in an effort to create the optimum conditions for the artists to combine their ideas and flair with the virtuosity of the Czechoslovakian glassmakers.

An exceptionally high standard of work was achieved and the exhibition of completed works which marked the end of the symposium went so far beyond anyone's expectations in both quality and concept that a triennial event was established. Many of the pieces from the first and subsequent symposia have been selected to form the basis of the permanent collection of a new glass museum at the Lemberg Castle near Novy Bor. Miraculously the 'velvet revolution' in November 1989 occurred without bloodshed, but rapid changes have affected every sphere of life, not least the community of glass artists which despite its subversive stance enjoyed an exceptionally favoured status.

At present three loosely-knit generations exist.

The pioneers and 'old masters' include Libensky, Cigler, Harcuba, Hlava, Roubicek, Kopecky, Jellinek, and Jitka Foretjova.

The second or middle generation consists of their students and protégés, Zamecnikova, Karel, Sabokova, Zacko, Vasicek, Trnka, Suhajek and a host of other important figures, among them, Oldrich Pliva, Franticek Janak, Milan Handl, Bohumil Elias, Jaroslav Matous, Ivo Rozsypal, Jaromir Rybak, Ilja Bilek and Jan Fisar. Blanka Adensamova, Vaclav Machac, Dana Vachtova, Jirina Zertova and Eliska Rozatova are also in this group. Their work is often compared favourably and bears some relationship, particularly in mixed-media installations that sometimes include large hotworked elements and in the case of Zertova and Rozatova, a common painterly approach.

The third or new generation includes Ivana Masitova, Michal Machat, Zdenek Lhotsky, Martin Velisek, Ivana Solcova-Sramkova, Jaroslav Rona and Ivan Mares amongst other 'rising stars'. Several of this group, reacting against the innate 'prettiness' of the medium, employ glass-painting as a means of achieving a more direct imagery and less 'glassy' values. Layers of opaque enamel cover massive mould-blown vases or kiln-cast forms that can be fanciful, primitive, figurative, often self-consciously crude and invariably powerful. The confident and provocative message, while not without humour, is a refreshing denial of 'arty' formalism.

Throughout Eastern Europe glass artists have tended to operate within the factory structure, either as designers or by somehow managing to beg, borrow or hire worktime for their personal and creative work. The institutes of higher education have often provided the only alternative, by allowing a far greater proportion of experimental and creative work.

Hungary

The Institute of Applied Arts in Budapest has had a Glass Department since 1965. Its current director Zoltan Bohus has helped to create a small but powerful group who have frequently shown together both at home and abroad – it includes his wife Maria Lugossy, Gyorgy Buczko, Agnes Kertezfi and Maria Meszaros who now lives in the Netherlands.

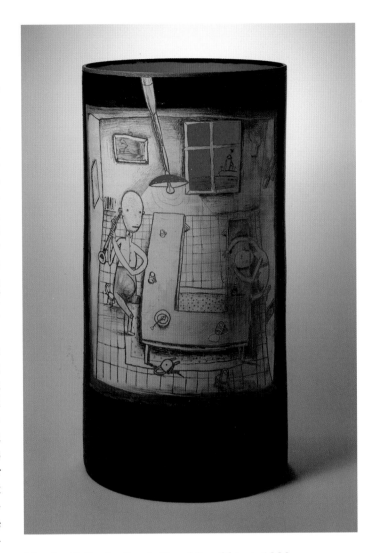

Martin Velisek, Czech Republic: *Object*, 1990
60cm high; mouldblown and painted glass (photo: G. Urbanek, courtesy: Umprum, Prague)

Poland

The main artistic thrust has come from graduates and associates of the Academy of Fine Arts and the State College of Plastic Arts in Wroclaw, including such established figures as Stefan Sadowski, Malgorzata Dajewska, the Puchalas, Ludwick Kiczura and many others. Well-known expatriates include Alina Görny in Austria, Czeslaw Zuber in France, the virtuoso engraver Stanislav Borowski in Germany and Janusz Walentynowicz in the USA.

Romania

The well-established glass departments at the Institutes of Fine Arts in Bucharest and Cluj-Napoca (Klansenburg) provided the focus for a group producing strong surreal works. Dan

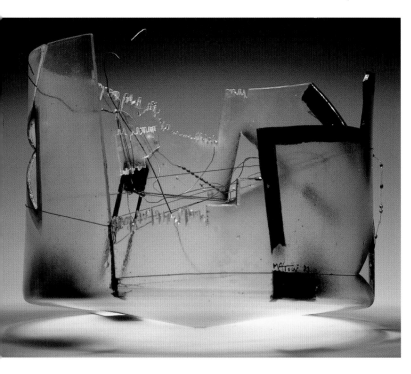

Jaroslav Matous, Czech Republic: *Green Pink*, 1990
22cm diameter × 26cm high; mouldblown, sawn, drilled and enamelled; wire and beads (courtesy: Kunstmuseum, Düsseldorf)

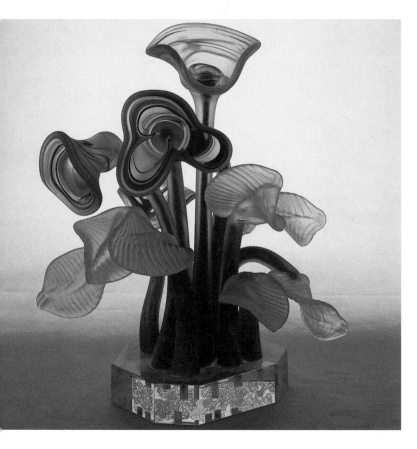

Bancila, Valerio Semenescu, Silviu Dancea, Adreana Popescu, Dionisie Popa and Michai Topescu are among those who have consistently made important contributions to major international competitions such as the Coburg Glass Prize and 'Young Glass' at the Ebeltoft Glass Museum.

Former USSR

During the 1960s, 'art laboratories' and museums were established at major glass plants throughout the USSR in an effort to encourage a more experimental and creative approach to glass design. The most active of these, the Experimental Ceramic and Sculpture Factory at Lvov in the Ukraine, specialised in producing large scaled-up versions of artist's models, many designed by artists associated with the Lvov State Institute of Decorative and Applied Arts. Andrei Bocotey, its current director, together with Franz Tcherniak, chief artist of the 'factory', has organised several important symposia in Lvov to date. The first Russian Symposium, organised for the Union of Artists by members Vladimir Filatov and Adolf Kurilov at the Gus Khrustalny glassworks in September 1990 was attended by some seventy participating artists – thirty from various parts of Europe and America and the rest from all over the USSR. Among the many fine works produced, the freely hotworked objects of R. Aksenov and V. Shevtoshenko, a marvellous cut and polished multi-piece composition by Olga Pobedova, lustre-painted panels by Yuri Manelis and the blown pieces, some with deeply-cut sandblasting, by Konstantin Litvin and Elena Esikova were exceptional. Much of the blown work showed a liberal

Dan Bancila, Romania

For more than twenty-five years Dan Bancila has been one of the stalwarts of a beleaguered though active Romanian glass community. He has throughout maintained an open, experimental approach concentrating on expressing the organic possibilities of glass form and surface. More recent pieces have exploited electroforming processes as a way of combining metal with glass

Dan Bancila, Romania: *Flower Forms*, 1982
approx. 30cm × 22cm × 50cm high; freeblown, sandblasted and glued to cut and polished base

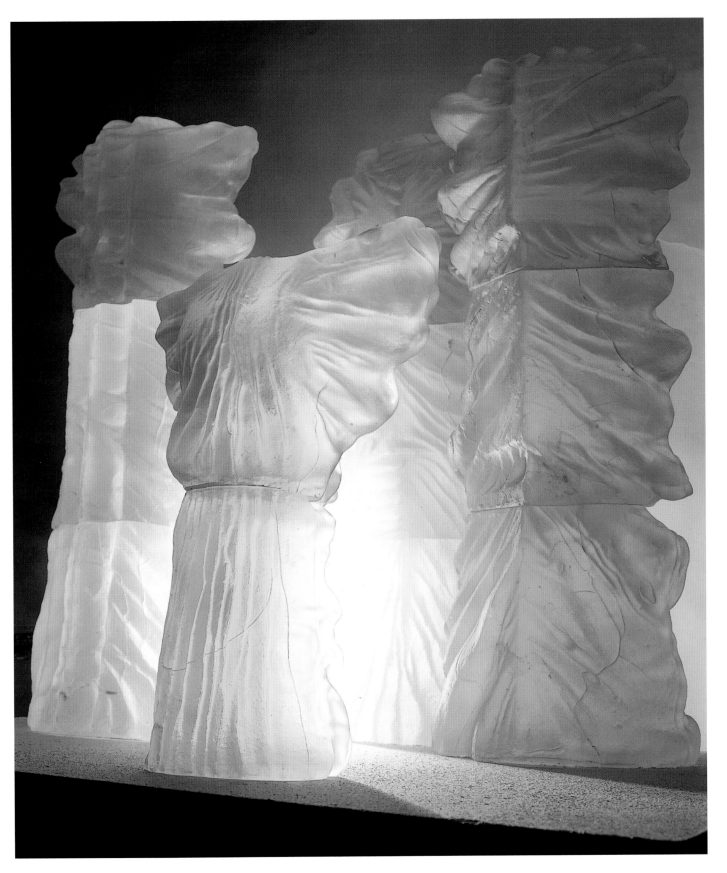

Fidail Ibraghimov, Russia: *Victory*, 1990
kiln-cast, assembled, sandblasted

use of bold, bright fluid colour in rich and some- times garish combinations that echoed the exotic quality of genuine folk art.

My own contribution, a five metre wide arch of metal and mould-blown modules was sceptically dubbed 'Arka Perestroika'; its problems came to symbolise the colossal difficulties besetting that am- bitious programme of reforms.

Apart from Bocotey, who makes wonderful Heath-Robinson contraptions in glass, the two artists who are best known in the West are Fidail Ibraghimov, originally from Kazakhstan, and his wife Lubova Savelieva, who has exhibited at the Corning Museum and was awarded its coveted Rakow Prize in 1990.

Pacific Rim

Australia

The vibrant light and colour, so celebrated by its painters, that suffuse the magnificent Australian landscape, have also inspired a longstanding ro- mantic tradition in stained glass. From the early 1960s Klaus Zimmer pursued an experimental ap- proach that has influenced the younger generation in his field, giving rise to a strong and expressive architectural glass movement.

Exchanges, workshops and exhibitions, led to valuable contact with leading European figures such as Ludwig Schaffrath, Jochem Poensgen and Johannes Schreiter, the cool restraint of the German School providing a counterpoint to the more flamboyant Australian glass. Emphasis lies on secular work in the form of rich, autonomous panels whose very portability provides an instant means of enhancing both domestic and public en- vironments.

While other Australian crafts developed rapidly during the 1950s and 1960s amidst the world crafts revival, no similar tradition existed there for glassmaking. Although a few 'backyard' workshops were run by blowers made redundant in the wake of factory closures, it was not until the early 1970s that Studio Glass began to gain ground, largely through the persistence of Stephen Skillitzi. 'Hooked' like so many others, while studying cer- amics in the USA, he began enthusiastically to pro- mote the 'new' craft on his return. His unflagging efforts to raise the level of public interest, to gain

all-important visibility and consequent funding were ultimately successful through the support of a number of visiting artists.

One of them, Bill Boysen, a former student of Harvey Littleton, constructed a miniature furnace fired by propane gas as part of a mobile studio mounted on a trailer, with which he toured the country. Richard Marquis, made a lasting impact during his teaching spell in Melbourne, memorable for his humour and the expertise he shared of intri- cate Venetian glassmaking techniques gleaned while working at the Venini factory as a Fulbright scholar.

As part of an initiative in South Australia to es- tablish a glass studio at the Jam Factory Craft Centre in Adelaide, Sam Herman was invited to be artist in residence and, as in Britain, his provoca- tively free-wheeling stance had a major influence. The workshop continued to thrive under the direc- tion of an Englishman, Peter Tysoe. Several promi- nent glassmakers trained there including Con Rhee and Gerry King.

Others travelled abroad. Maureen Cahill com- pleted her studies at Stourbridge College of Art (now part of the University of Wolverhampton) in Britain and the Rietveld Academy, Amsterdam, before returning to establish a new glass depart- ment at Sydney College of Art. The programme originally concentrated on kilnworking, with fur- nace time hired from a local studio when required. The dynamic Cahill, together with Giselle Courtney, who is best known for her jewellery and wearable glass art, also set up the excellent Glass Artists Gallery in Glebe, Sydney, as a major showcase for Australian glass.

The years between 1978 and 1983 proved a key period for Australian glass. The very size of the country engendered a sense of isolation that made it imperative for glassworkers in all fields to meet and share their experience. The Australian Associ- ation of Glass Artists, affectionately known as Ausglass, was founded and several important sur- vey exhibitions followed in quick succession. Of

Maureen Cahill, Australia: *Willy Willy*, suspended glass installation at the House of Representatives, New Parliament House, Canberra, 1988 ▶ display space 8m square × 12m high; slumped, laminated glass components with stainless steel (courtesy: Parliament House Construction Authority, Canberra)

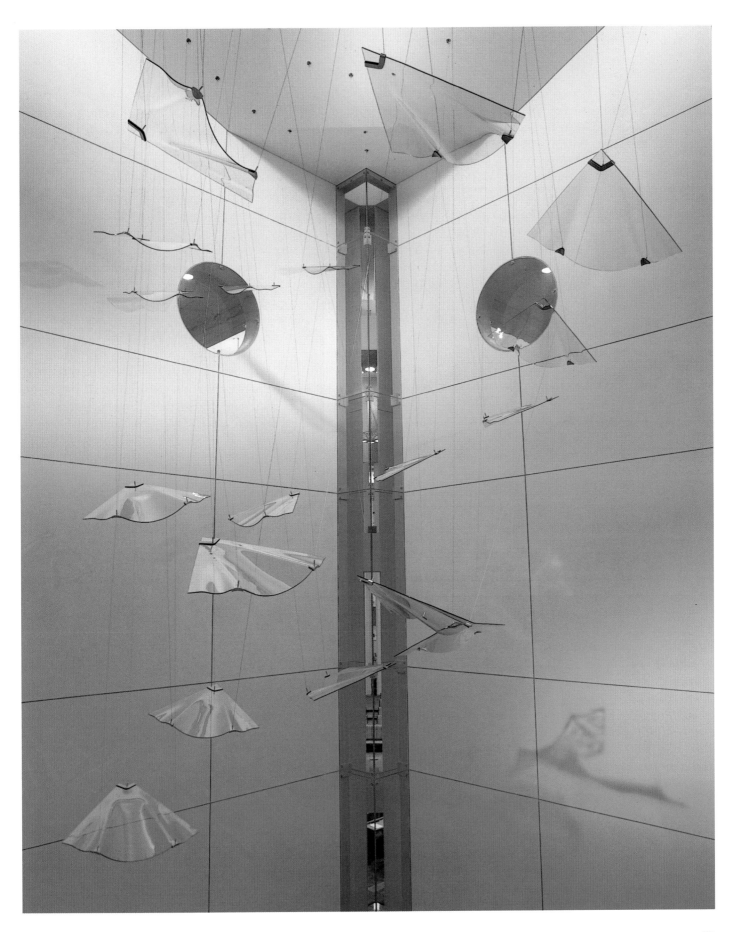

these, the most influential was an invitational entitled 'International Directions in Glass' that toured the country. For many, it provided a first view of the broad spectrum of contemporary glass art and its diverse aesthetic possibilities.

In 1983 Klaus Moje arrived from Germany to head the glass programme at Canberra College of Art. Well known for his revival and development of the 'mosaic' technique, he has made a significant contribution to the Australian glass scene, particularly in the fast-growing area of kiln-worked glass. In conjunction with the World Crafts Council Conference in 1988, he arranged highly successful international master classes in kilnforming. It is evident, too, that Australia has had a profound effect on his own creativity – Australian light, sunsets and skies radically influencing his choice and use of colour. In order to concentrate on his own work, he relinquished his college position in 1991 to Stephen Procter, who was ably supported by Elizabeth McClure from Scotland and later by Jane Bruce.

Amongst those producing fine blown work are Dennis O'Connor, Chris Pantano, Nick Mount and Robert Wynne; Richard Clements in Tasmania is notable for his lampwork.

New Zealand

The 'Land of the Long White Cloud' has long enjoyed a strong crafts tradition, particularly in the areas of pottery and fibre arts (textiles), perhaps stemming from the magnificent Maori woodcarvings and tattoos (cicatrices). Glassworking is a recent addition during the past two decades and, as elsewhere, American influence was seminal – US-born Tony Kuepfer set up the first glassblowing studio and Mel Simpson, returning from postgraduate studies in the USA, established the first glass programme at the Elam School of Fine Arts, Auckland.

The degree of isolation from the international stage could be considered a drawback, although this may well have encouraged the development of indigenous styles but, in any case, the problem has been offset by the expansive policies of the New Zealand Society of Artists in Glass (SAG for short) which, with the help of the Queen Elizabeth II Arts Council, has invited a number of internationally acclaimed artists over the years. These have included Ed Carpenter, Johannes Schreiter and Joachim Klos in flat glass, Makoto Ito, Dante Marioni, Richard Marquis, Lino Tagliapietra and Fred

Daden (the former chief technician of the Royal College of Art, London) to demonstrate their skills with hot glass.

In 1990, Colin Reid spent a fruitful year as artist-in-residence at Carrington Polytechnic, Auckland, and of course many New Zealanders travel abroad for workstudy periods – recently John Leggott worked with Tagliapietra and Marquis, and Mike McGregor worked at the London Glassblowing Workshop for three years.

There are several active production studios, notably Sunbeam Glass where Garry Nash and Ann Robinson have worked. Robinson's inventive large-scale kiln-cast pieces have been received with great acclaim. John Croucher, Peter Raos and Peter Viesnik are highly respected as blowers, as are the influential Swedish couple, Ola and Marie Höglund. Holly Sanford and James Walker have carried out large-scale architectural commissions. There is growing public awareness and support for the dynamic and creative approach of the small but dedicated New Zealand glass community, which has recently been joined by the energetic Elizabeth McClure.

Japan

Ceramics, metal, wood, paper and textile arts have played important decorative and ceremonial functions within Japanese culture for centuries but there was no great tradition of glassmaking largely because it was considered an industrial process. The exquisitely cut Satsuma glass, produced in the mid nineteenth century, was an example of historical influence drawn mainly from Europe and reinterpreted with typical Japanese sensibility.

During the 1920s two separate directions developed, Toshichi Iwata spent his entire working life exploring and promoting the concept of blown glass as a decorative medium, striving to introduce glass vessels as utensils for the tea ceremony. He himself produced daring sculptural vessel forms. His contemporary, Kozo Kagami, studied cutting and engraving in Stuttgart under the great German engraver Wilhelm von Eiff (1890–1943). His legacy was an emphasis on the production of a perfect crystal and the development of a school of optical cutting second only to that of the Czechoslovakians. In the 1930s, following studies in France, Sotoichi Koshiba introduced *pâte de verre*.

Iwata's son, Hisatoshi, and his pupil, Kyohai Fujita, carried the mantle forward, Hisatoshi

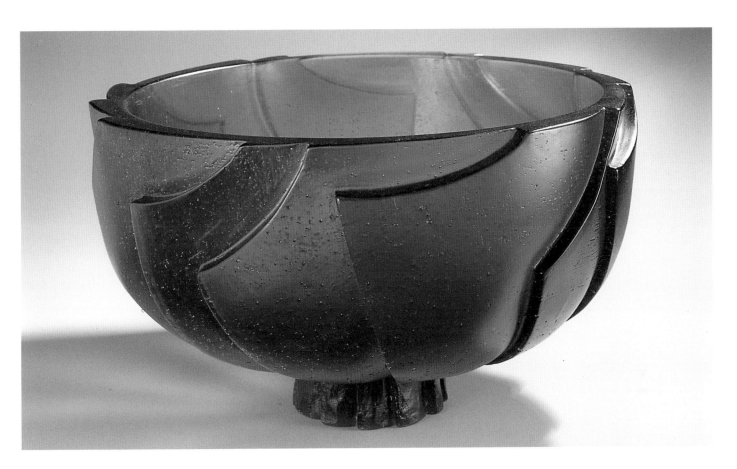

▲ **Ann Robinson**, New Zealand: *Ice Bowl*, 1994
38cm diameter × 23cm high; kiln-cast in 45% lead crystal
by *cire perdue* process (photo: Howard Williams)

Hisatoshi Iwata, Japan: *Pine Tree*, 1984 ▶
23cm × 46cm high; freeblown, cased and overlaid colour,
etched

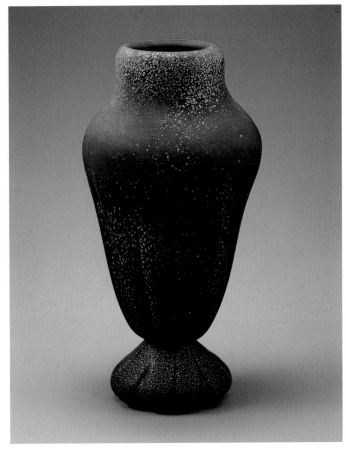

founding the Japan Glass Art-Crafts Association in
1972. Until recently most of its members have been
closely allied to industry, often as designers, able to
develop personal artworks with the support and
patronage of their factory. In the able hands of the
secretary, Mrs Itoko Iwata, and the president,
Kyohai Fujita, the Association has become an ac-
tive and powerful organisation that has sponsored
important national and invitational biennial exhi-
bitions during the past two decades. Beautiful
catalogues and superb presentation have raised
the national and international profile of Japanese
Glass.

The American influence has been strong here,
too. Ms Takako Sano, a resident of San Francisco,
organised a series of international selling exhibi-
tions for the Yamaha Corporation. In 1986, also

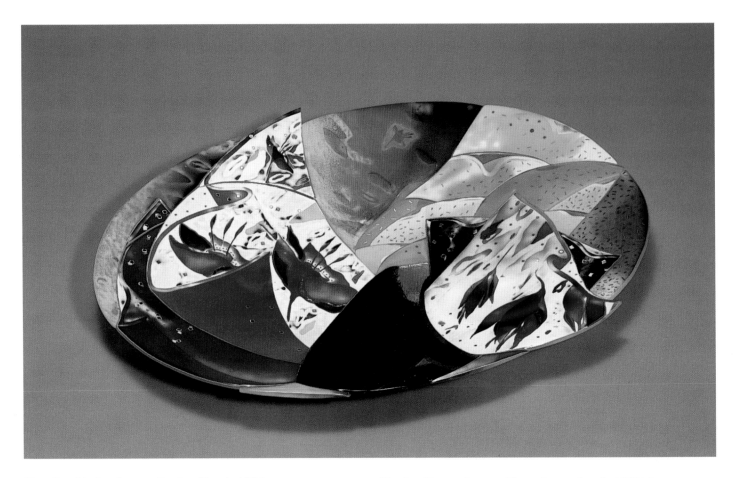

Yumiko Noda, Japan: *Spring Feast*, 1990
67cm × 48cm × 7cm high; blown, sandblasted, cut, fused and slumped

Nyoko Ikuta, Japan: *Transformation 8*, 1987 ▶
approx. 65cm × 40cm × 70cm high; cut and glued float glass; (photo: Yoshio Nakatsuka)

with Yamaha's patronage, she instigated the first Glass Symposium in Japan, bringing many leading international glass artists to Japan and creating a forum for dialogue in the Japanese glass community.

Established in 1981, the role of the Glass Art Institute of Tokyo has been of considerable importance. A private school, housed in a disused hospital, it ingeniously shared its hotworking facility with a commercial enterprise in order to reduce costs and to allow its students contact with glassblowers. *Pâte de verre* is the particular obsession of its founder, Tzuneo Yoshimizu, and the school's emphasis has been on kilnforming techniques. Yoshimizu also founded the active 'Glass Loving People's Association', partly to support the school's activities, and is now Professor at the Waseda University, Tokyo.

As the head of the oldest glass department in the country, at Tama Art University in Tokyo, and as an

Nyoko Ikuta, Japan

Nyoko Ikuta's laminations stretch to extremes the physical limitations of flat glass and modern adhesives. Despite their obvious physical weight, her pieces express a remarkable lightness and elegance.

artist, Makoto Ito has been highly influential amongst the younger generation of glass artists.

Until recently there were few opportunities to study glass in Japan and many studied abroad. Now, however, two of Ito's former students and members of his teaching staff, Osamu and Yumiko Noda, have established the Niijima Glass Arts Centre on a small semi-tropical island of some three thousand inhabitants situated two hundred miles by ferry from Tokyo. The ultra-modern architect-designed studio is built from a local stone. Abundantly available, this stone which can also be melted to form an unusual greenish glass, was itself

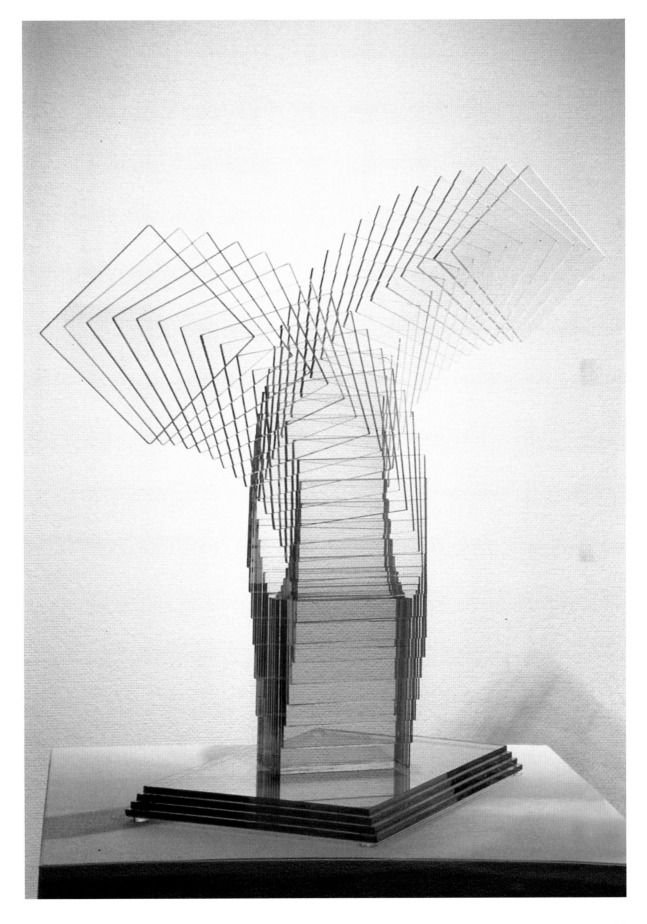

the inspiration for the project. Though just a few years old the Centre has already attracted international attention through the beauty of its location, overlooking the Pacific, its purposeful design and its cultural programme. This includes the production of a unique local glassware and the development of educational and cultural links between Niijima and the glass world at large.

Canada

At Expo '67 in Montreal, the massive queues confirmed that the best show in town was at the Czechoslovakian pavilion. An elegant environment, it was designed to exhibit its contents to advantage, the revolutionary approach to glass art and the dazzling artifacts on display catching the public imagination. Among those on whom it made an indelible impression were Gilles Desaulniers and François Houdé.

At the earliest opportunity Desaulniers went to study with Libensky in Prague, returning in 1971 to establish a coldworking department in the School of Fine Arts of the University of Quebec at Trois Rivières.

In the meantime, a Californian potter, Robert Held, who was teaching ceramics at Sheridan College School of Crafts and Design in Mississauga, Ontario, had persuaded the authorities to support him in setting up the first hot glass facility there. Within a year, in 1970, the new glass studio was in operation. Early encouragement and technical support came from Marvin Lipofsky and other visiting artists of international standing, including Mark Peiser, Richard Marquis and Bertil Vallien. In 1975 Robert Held was joined by Karl Schantz from the American School of Craftsmen at Rochester, New York State. He introduced 'warm' and coldworking technologies and an interest in researching historical methods such as iridising and cameo-work. Together they generated enormous enthusiasm and excitement, staff and students sharing the spirited adventure that made the department the focus of the Canadian studio glass movement. Norman Faulkner, the technician, and several of the students went on to develop new courses and studios across the country.

Robert Held left to establish a production workshop and Schantz followed in 1979 to set up his own studio and also a fine art-oriented course at the Ontario College of Art.

The department at Sheridan College continues to

François Houdé, Canada

Espace Verre – the Montreal Glass Centre – was established in 1987 as the focal point for Canadian glass art. Its founder and director François Houdé is an innovative and dedicated artist who constantly strives to extend the preconceived limits of glass form and content.

In the late 1970s, blown spheres, eroded and pierced with the diamond saw and sandblaster gave way to slumped, 'shattered' and reconstructed vessels, and these in turn to the recent large mixed-media assemblages.

Art historical images have become popular commodities and, like Clifford Rainey, Houdé borrows widely and courageously, creating a rich cultural context in order to evoke memory and connect time and space. He favours the horse as an ancient and universal archetype to represent power, dignity and freedom, while exploiting the ephemeral qualities of glass, in the form of recycled industrial and architectural fragments (windows, grids and so on), to make his poetic and many-layered constructions.

François Houdé, Canada: *Ming VII*, 1986
122cm × 60cm × 122cm high; sandblasted, engraved, cast and plain window glass; wood (photo: Jocelyn Blais)

flourish under Daniel Crighton, a purposeful and sensitive teacher and maker, who in 1988 supervised the move to a new 5000 sq.ft. glass studio at the college's Oakville campus.

This coincided with a major change in direction for the new generation. During the 1980s there was a shift away from a total preoccupation with the innate beauty of glass the material, to a deepening concern with concept and content, and the discovery or creation of a context in which glass might function as one expressive medium among many.

Important landmarks were the incorporation of the Glass Art Association of Canada in 1983 to organise regular national and regional seminars, conferences and exhibitions and the opening of L'Espace Verre (Le Centre des Métiers du Verre) in Quebec in 1987. The latter, an ambitious project, co-founded by François Houdé and Ronald Labelle, has had a profound effect. Along with the

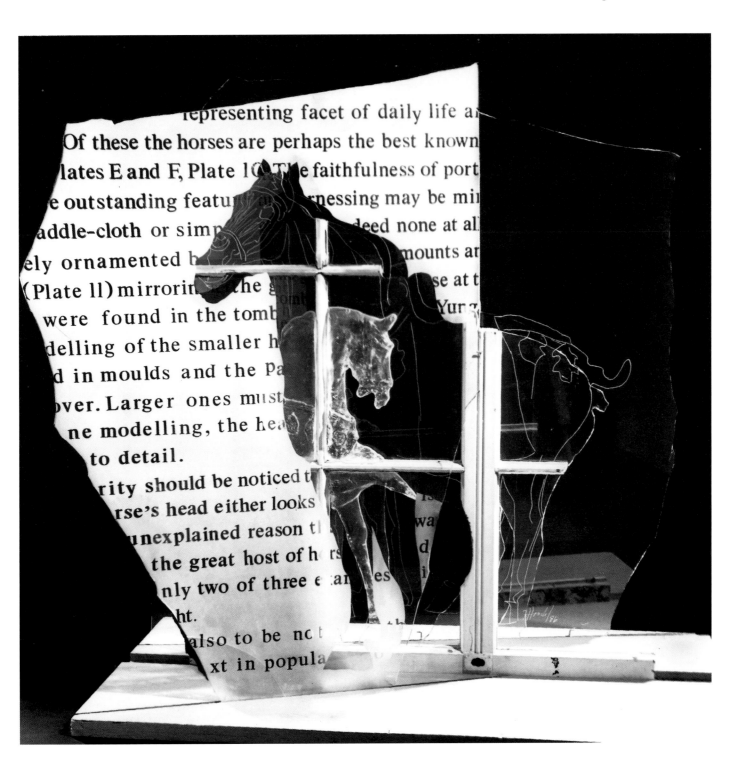

Harbourfront studio in Toronto, it provides well-equipped studios covering the entire range of techniques and acts as a forum for both professionals and students. Several prominent artists are employed there as instructors, including Lisette Lemieux and Susan Edgerley.

In 1990 the GAAC hosted the annual conference of the American Glass Art Society (GAS) in Toronto, with approaching seven hundred delegates this event gave a major fillip to the already burgeoning Canadian scene. Despite obvious American influence, a strong Canadian identity has emerged based on a fresh and uninhibited approach to materials, and a powerful and intrinsic connection to the culture and mythology of the land.

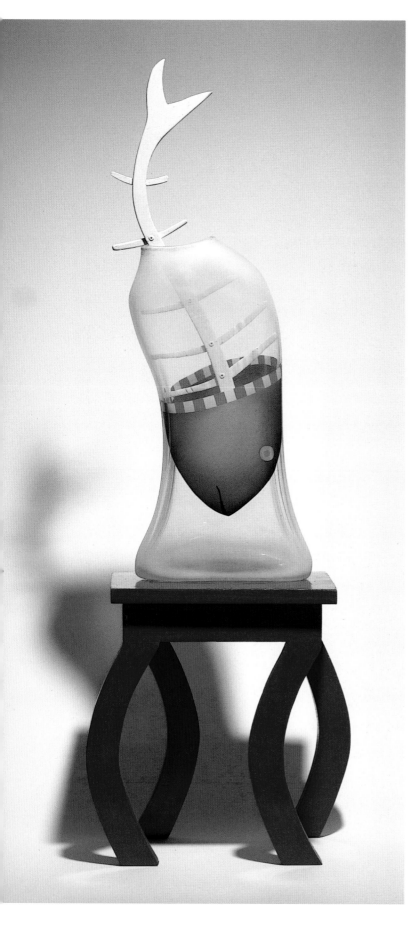

Richard Meitner, USA/Netherlands

Richard Meitner is an American who completed his studies in the Netherlands under Sybren Valkema at the Rietveld Academy, Amsterdam, and stayed on. When Valkema retired he took over as director of the glass department, together with his partner Meike Groot. He is an excellent and provocative teacher, as shown in the work of his former students, and he is amongst the most articulate and probing of artists working in glass.

His dry satirical humour is often expressed in clever visual puns, sophisticated images that stimulate and challenge our ways of looking, seeing and thinking, a form of multi-dimensional *trompe l'oeil*. A vessel is clearly just a vessel – or is it? And are the painted images of contained objects less real than the actual objects they represent? And what is 'man' anyway, other than the ultimate receptacle for information and ideas, emotions and beliefs? A frequent question to students is, 'Why?' Why glass?

For his own part, Meitner has found the glass vessel to be an ideal vehicle for an imaginative exploration of graphic themes and enamelling techniques. One intriguing series consists of blown glass containers that appear to be distorted by bizarre painted wooden inserts, e.g. being devoured by a mad dog's head. Another series pokes fun at arty trends, and includes a priceless example, *Memfish*.

Some recent works result from an interesting development in which editions of his designs are serially produced in collaboration with industry without, one may add, any compromise on quality – or wit. Meitner's images are often disquieting but invariably compelling and beautiful.

Richard Meitner, USA/Netherlands: *Memfish*, c. 1984 90cm high; mouldblown and freeformed glass, enamelled on front and back surfaces; table and fish skeleton of lacquered wood (photo: Robert Schlingemann, Amsterdam)

Sien van Meurs, Netherlands

I consider the iconoclastic works of Richard Long and Andy Goldsworthy, the British 'land' artists, to be amongst the most important in contemporary sculpture. Although such spontaneous and temporary phenomena are often preserved only in photographs, they convey a rare authenticity, perhaps the ultimate expression of the truth-to-material ethic.

Sculptures by the young Dutch artist Sien van Meurs reveal similar concerns and convey her deep feeling for the land and for the natural, earthy materials (slate, stone, lead, pebbles) she selects to combine with glass. As Paul Seide's neons are wholly the product of the city, Sien van Meurs' pieces emanate from her long sojourns in close communion with the landscape of Ireland and elsewhere.

Contrasting elements of colour, shape and texture are meticulously and sensitively controlled, tensions and dualities are reconciled with a sensibility that is never allowed to impinge on the inherent qualities of her materials. Like stone circles, her enigmatic objects symbolise some mystic truth; they stand as markers in time and space, forms of concrete poetry.

Meike Groot, Netherlands

Meike Groot is one of the long list of illustrious graduates of the Gerrit Rietveld Academie of Art in Amsterdam, which includes Frans Willebrands, Vincent van Ginneke and Hanneke Fokkelman from the Netherlands; Richard Price, Liz Swinburne and Tatiana Best-Deveraux from England; Daniel Verbain from Israel; Nikos Trioulinos from Greece and many others. She now helps to run the department with Richard Meitner, with whom she shares a studio and she also teaches regularly at the summer school in Sars Poteries.

Her early 'vessels' were blown and painted with enamels, while later versions have been constructed from miniature brick-like modules. These stem from her participation in 1986 in the Glass Sculpture Symposium at the ancient Fort Asperen in Leerdam. She produced an inspired installation for her allocated room – filling a large window space with cast-glass bricks. This simple concept worked on many levels: dealing with interior/exterior space, completing the enclosure, a non-transparent window, a barrier, a 'fragile' material 'posing' as a structural one, and not least as a brilliant and satisfying visual pun.

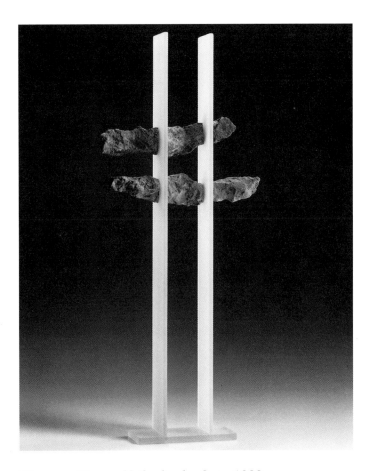

Sien van Meurs, Netherlands: *Gate*, 1989
13cm × 9cm × 60cm high; sandblasted flat glass; Irish limestone (photo: Foto Smit, Almelo, courtesy: Stichting Beeldrecht)

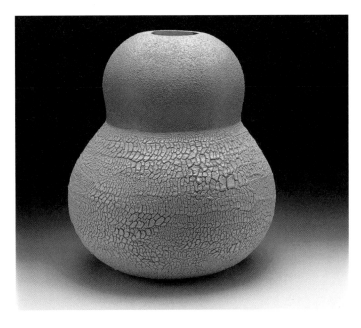

Meike Groot, Netherlands: *Blown Form*, 1994
25cm diameter; freeblown glass with thickly applied enamel

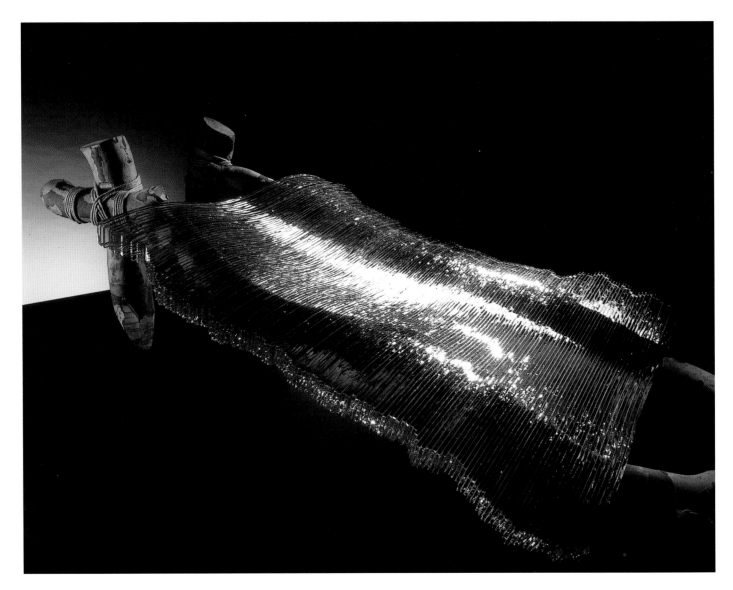

Danny Lane, USA/UK: *Angaraib*, 1987
250cm × 120cm × 80cm high; 213 float glass shapes
(10mm thick) locked into position by shape and gravity;
rope and wood (photo: Peter Wood)

Danny Lane, USA/UK

Perhaps more than anything, apart from his obvious
ability, the phenomenal rise from selling mirrors at
street markets to universal acclaim at the major
international design fairs of Milan, Paris and
elsewhere, demonstrates Danny Lane's extraordinary
motivation and energy. His aggressively experimental
attitude and flair enable him to realise extravagant
and ambitious ideas that range from massive glass
and steel tables and chairs made from stacked glass,
to large-scale murals, fountains and screens for a
variety of architectural applications. A recent success
has been the staircase of the new glass gallery at the
Victoria & Albert Museum, London.

The punkish boldness of his work, while indicating
a healthy disregard for establishment attitudes, is
nonetheless tempered by a romantic and poetic
content revealed in a fine sense of context and
traditional form. Inspired by a Sudanese rope bed,
Angaraib is a powerful, purely sculptural entity
consisting of slabs of float glass stacked and draped
across two sturdy branches from a storm-damaged
tree, and locked into position by their shape and
weight. The interplay of contrasting textures,
compelling shapes and dynamic movement illustrate
the potency of Lane's assertive and idiosyncratic
style.

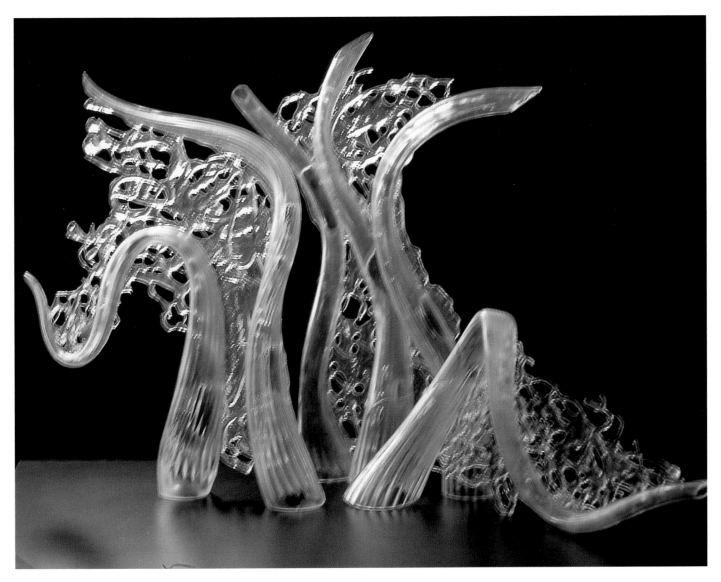

Keiko Mukaide, Japan/UK: from the *Shiranui Series*, 1994
60cm × 10cm × 48cm high; blown tubes and hot-drawn fibres assembled and fused together

Keiko Mukaide, Japan/UK

While completing her postgraduate studies at the Royal College of Art, London, Mukaide explored the combination of blown form and *pâte de verre*. Smooth tubes grew feathery, frondlike appendages, their cool, frosted translucence contributing to a wonderfully calm, contemplative elegance, as in the beautiful *Form of the Wind*. Later works, consisting of stacks of alternating earthenware pillows and slumped nests of hot-drawn glass threads, displayed similar attributes. Her quest continues for a synergistic harmony through the sensitive balance of disparate elements.

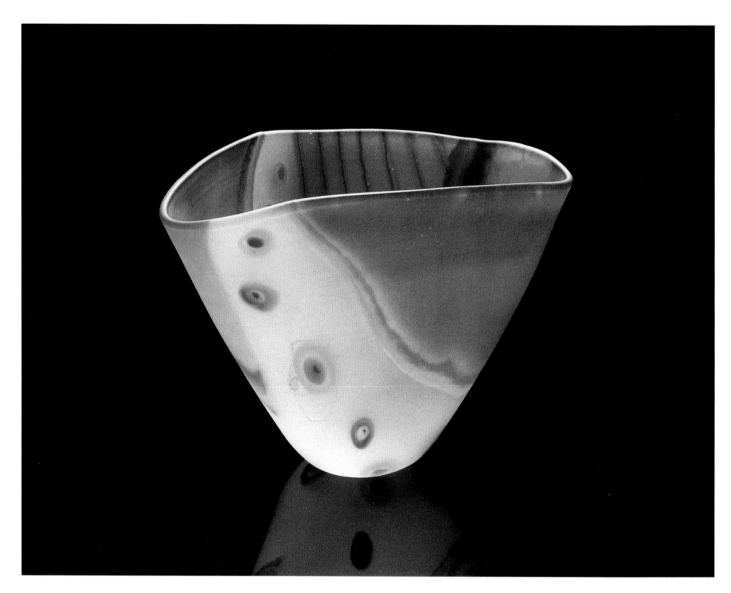

Pauline Solven, UK: *Three-cornered Bowl*, 1990
19.5cm × 15cm × 16cm high; freeblown glass; colour
picked up and inlaid, etched

Pauline Solven, UK

Since completing her studies at the Royal College of
Art, London, in 1969, as one of the first students to
graduate under Sam Herman's tutorship, Pauline
Solven has been among the most creative of British
glass artists. After helping fellow-student Asa Brandt
to set up her studio in Sweden, she returned to
London to become the artist-manager of the original
Glasshouse in Covent Garden. Eventually she left to
design for her own company, Cowdy Glass, and
nowadays concentrates entirely on making individual
pieces.

These are frequently stimulated by nature, views of
a furrowed landscape, sails seen against the sea and
sky, or the shore itself. A series of shellforms with
tantalising cut and polished openings invite the
viewer to explore inner spiralling movements, circles
within circles, and archaic symbols drawn in
luminous colour suggesting a 'ribbon of seaweed, a
darkening tideline, a glint of light on water'. Solven
often uses a method of colour application in which
flat compositions of glass powders and drawn threads
are picked up from the marver and sandwiched
between gathers of clear glass prior to blowing. A
recent series of 'Stacked Forms', inspired by Pisan
architecture involves cutting up mould-blown tubular
vessels, rearranging and reassembling them as
'structures based on ascending rhythms of colour'. A
painterly approach has been a consistent hallmark in
the purposeful evolution of her work.

Liz Lowe, UK,

There is a rare charm and generosity of spirit in Liz Lowe's tiny exquisitely-patterned vessels that give them great visual and tactile appeal. Asymmetric lead crystal blanks, blown into simple sandmoulds, are painted and repainted with lustres and enamels. Prior sandblasting ensures a clean matt surface that imparts a more subtle and unusually delicate range of colour effects.

Liz Lowe, UK: *Pierrot*, 1981
3in. diameter on approx. 6in. square base × 5in. high; blown into sandmould, sandblasted, painted with lustres; base slumped (photo: Frank Thurston)

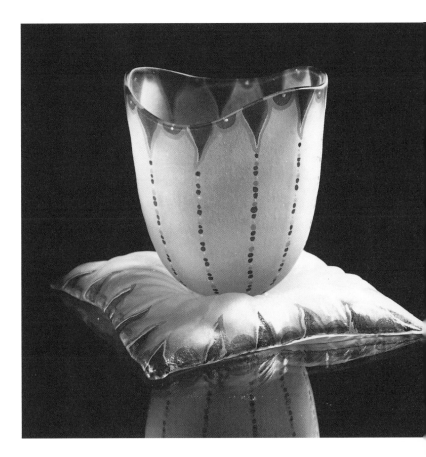

Alain and Marisa Begou, France

After a brief spell at the Biot factory, Alain Begou's glassmaking career followed a long and rigorous self-apprenticeship to attain, with his partner, their current masterful style and technique.

The sheer scale of the pieces, monolithic variants of strong simple flattened forms, is awe-inspiring, especially when one considers the weight of the glass on the blowing iron. They provide the perfect vehicle for beautifully articulated rhythms and textures applied in painterly fashion at the marver. Two or three overlays of colour (powder, granules and fine threads) are encased in a final clear gather.

Images are drawn from nature: the colours and patterns of butterfly wings, waves, clouds, erupting volcanoes, surreal land and seascapes are depicted with a rich intensity that fully exploits the sensuality of the medium.

Alain and Marisa Begou, France: *Freeblown Glass*, 1993
36cm × 7.5cm × 32.5cm high; blown with several overlays of powdered enamel and granules of coloured glass (photo: Frederic Jaulmes)

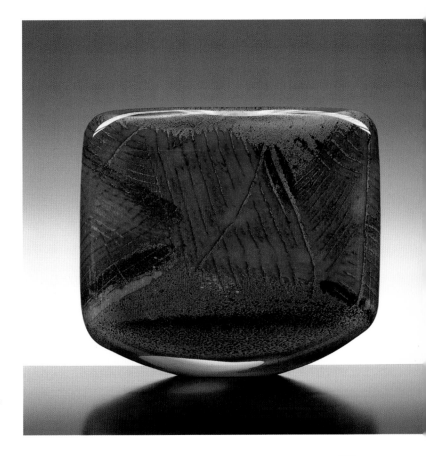

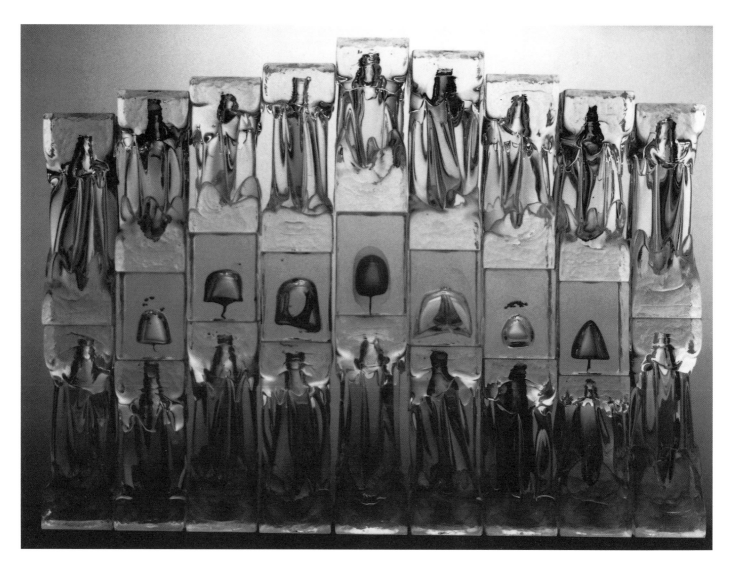

Claude and Isabelle Monod, France

Until his tragic and premature death in 1990, Claude Monod shared a beautiful studio high in the Alpes Maritimes, not far from Vence, with his wife Isabelle. His family background was glassmaking, the famous Biot factory was started by his father in the early 1950s and his sister Véronique is well established as a glassmaker in her own right. Monod was best known for consistently fine blown-work, classic forms with graphic effects derived from inclusions of fibre glass dipped in silver solution.

Later, following a period of working with Bertil Vallien at Pilchuck, he developed a technique that successfully combined blowing and sandcasting.

Isabelle delights in playing visual games. Her transparent walls composed of blown and cast blocks contain air and colour traps that float jellyfish-like and seem to defy both gravity and reason.

Isabelle Monod, France: *Mur* [wall], 1988
50cm × 5cm × 37cm high; blown and hot-cast (poured) into a mould; 25 elements of which 7 are ground and polished on the front face (photo: Denis Rigault)

Matei Negreanu, Romania/France: *Thème sur l'Espace X.L.II.E.* [space theme], 1988 ▶
42cm high; float glass, cut, glued and sandblasted (photo: Laurent Sully-Jaulmes)

Matei Negreanu, Romania/France

A graduate of the Bucharest Academy of Plastic Arts, Negreanu has lived in France since 1981. Perhaps by virtue of his varied and colourful background in the world of theatre he acquired a reputation as the 'master of metamorphosis'. Certainly he has taken a rigid transparent material and transformed it into flowing, sensual, dancing forms that evoke visions of Isadora Duncan. The formula is simple and he has exploited it brilliantly, cutting, stacking and gluing sheet glass, orchestrating successive elements to create a rhythm, and finally modifying form and surface by sandblasting to achieve swelling, undulating and soaring motion, 'translucent wavelike rhythms frozen in space'.

The pendulum swings, the artist moves on, forwards or backwards, for move he must or stagnate. It takes courage to abandon the comfort of producing work that is in demand, familiar ideas, formulae and techniques, to strike out in a radical new direction, risking failure and perhaps poverty. Matei Negreanu's recent works cast off all assertions of grace and explore a more brutal, earthy vein, to reveal massive chunks of 'solid light'. Crystal in its matrix, the hewn fractured brilliance is sheathed in opacity by a skin of textured and patinated lead foil.

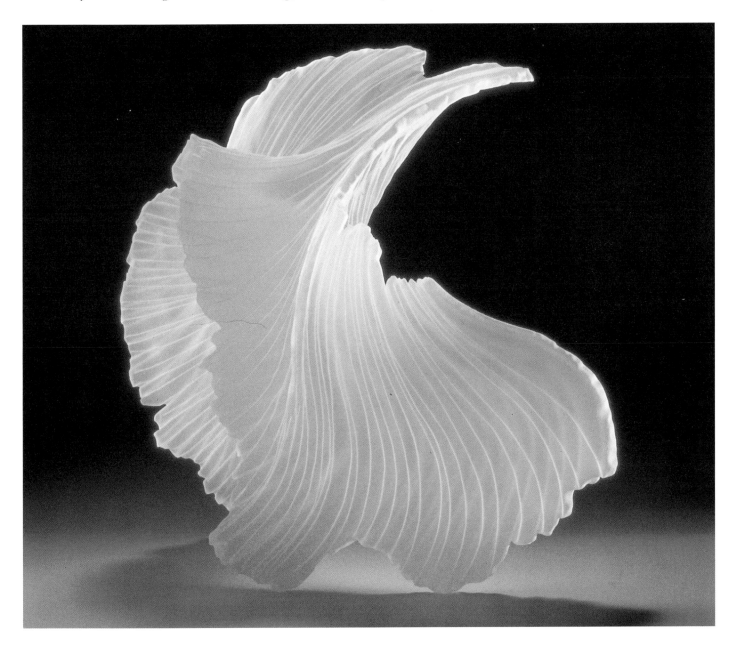

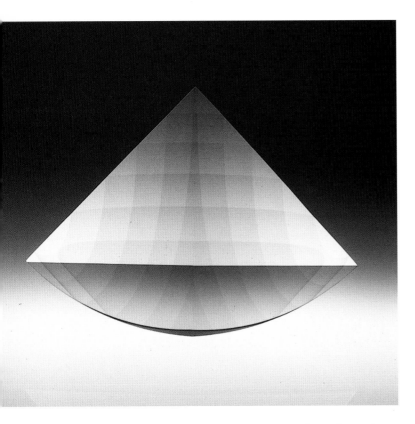

Yan Zoritchak, Slovak Republic/France: *Signal cosmique*, 1981
9cm × 7cm × 17cm high; fused lamination, cut and polished

Yan Zoritchak, Slovak Republic/France

Since emigrating from Czechoslovakia in 1970, Yan Zoritchak, one of Libensky's former students, has played an influential and seminal role in the progress of contemporary glass art in France. He became actively involved in the artist glassmakers organisation ADCAV (Association pour le Développement de la Création en Verre) and was therefore well placed to advise the French Ministry of Culture on matters relating to glass. In some measure, he was instrumental in the foundation of CIRVA (Centre International de Recherche sur le Verre et les Arts plastiques) and the admirable Centre du Verre at the Louvre.

Timelessness is an essential quality that Zoritchak endeavours to manifest through his art. For many years he worked in the precise analytical manner of the 'optical school' of cutting, with particular emphasis on generating internal structures, delicate tracery produced by the kinetic play of refracted light through fused laminated forms. Latterly he has adopted a more organic approach, incorporating coloured inclusions, veiling and liberal amounts of gold and silver foil into massive and elegant kiln-cast pieces.

Paolo Martinuzzi, Italy/Germany

A Venetian now living in Germany, he works in a variety of media: wood, metal, stone and glass. Although glass is 'in his blood', he shows little concern for prevailing considerations of hierarchy in the media, seeking out the most appropriate material to produce haunting images that symbolise the human predicament: the futile and obsessive fear of being seen for whom one really is while desiring above all else to be truly recognised.

His allegories are graphically illustrated by the engraved graffiti-like archetypes, primitive and childlike, whose mouths silently scream and whose outstretched arms and hands are suppliant in surrender. The huge imploring eyes of these figures, isolated within a teeming crowd, testify to the paranoia of our times.

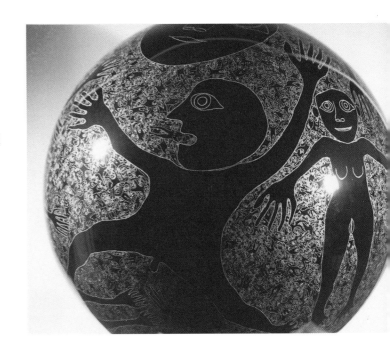

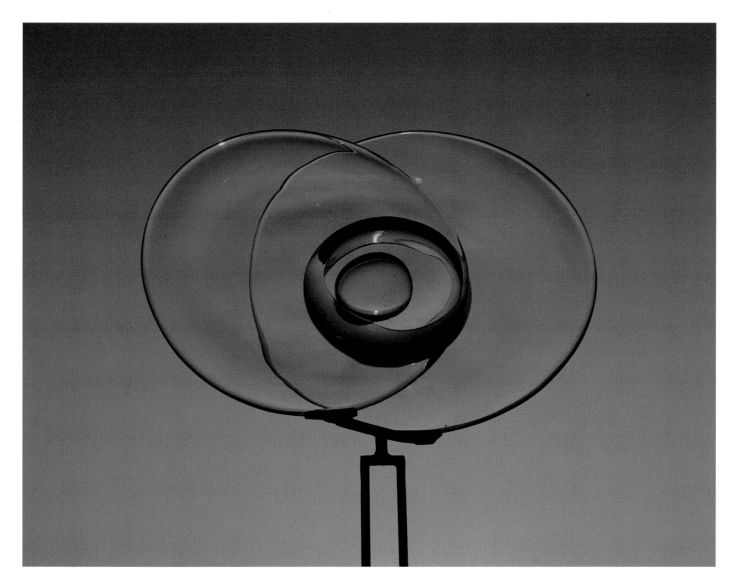

Livio Seguso, Italy: *Piccole Ellisi* [small ellipses], 1980
46cm × 13cm × 65cm high; lead crystal freeblown in two
parts and joined hot

◀ **Paolo Martinuzzi**, Italy/Germany: detail from *Grande
Sfera Nero* [large black sphere]
50cm diameter; freeblown black glass, engraved (courtesy:
Galerie B)

Livio Seguso, Italy

Bearing the prestigious name of a centuries-long line
of glassmasters carries great responsibility. So too
does choosing to become an independent artist-
glassmaker in a community as sceptical and
inward-looking as the Muranese glassmakers. For
twenty-five years, from the age of fourteen, Seguso
worked in the famous workshops of Barbini and
Salviatti – until 1969 when he established his own
studio. Since then, alongside his production work, he
and his team have created a stream of immaculate
unique pieces.

Most impressive is the series of variations based on
the circle or ellipse, in which huge discs are joined at
the thick, almost solid centres. They express
beautifully his prime concerns, to communicate the
fluidity and flawless clarity of his metal and to
exploit its interplay with ambient light.

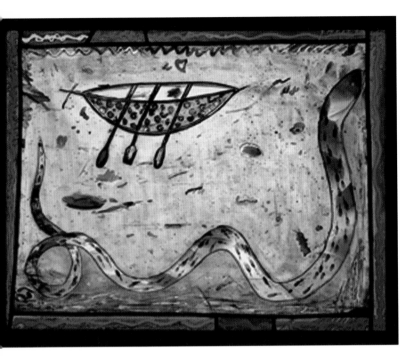

Ursula Huth, Germany: *Glasbild* [glass picture]
65cm × 55cm high; glass paint, lead, sandblasting and
acid treatments

Ursula Huth, Germany

Like Johannes Hewel, Albrecht Pfister, Angelika
Muller, Ada Isensee, George Frey and many others of
the successful younger generation of German stained
glass artists, Huth trained at the Stuttgart Academy
of Fine Arts under the great Hans Gottfried von
Stockhausen. These formal studies were followed by
periods as a teaching assistant first at Rhode Island
School of Design and later at Pilchuck. She is
extremely versatile and talented and is equally happy
working in two or three dimensions, sometimes
combining blown or cast elements with flat glass and
painting, as in a series of boats made in collaboration
with Helga Reay. Her visual language is rich in
colour, contrast and image. Certain archetypal motifs
recur frequently: fish, serpents, ladders, boats, and
houses and shelters in various forms (e.g. castles and
tepees). These palpable references to personal
experiences, convictions and fantasies are a form of
visual exorcism in her sanguine quest for self
discovery.

Jack Ink, USA/Austria: *Casket*, 1989 ▶
approx. 25cm × 10cm × 14.5cm high; mouldblown and
iridised with brass metalwork

Johannes Schreiter, Germany

Johannes Schreiter is one of the most innovative and
respected figures in contemporary stained glass.
Frequently provocative, invariably original, his
abstract works are spare, even austere, their economy
of means reflecting a zealous purity of vision that is
at once powerful and intense, harmonious yet
absolute. His visual and philosophical stance is
uncompromising, and materials are employed in
courageous, almost heretical combinations, such as
glass with perspex. He has developed a gestural,
calligraphic use of the leadline which has been
revolutionary, allowing it to function as a free visual
element, largely divorced from its former structural
role.

Jack Ink, USA/Austria

Jack Ink maintains a highly successful studio in
Baden near Vienna. A painter and engraver as well as
a glassblower he has long been preoccupied with
portraying landscape. Simplifying and stylising his
imagery, he is able to use hot glass in a painterly
fashion. His mastery of colour application and
iridising techniques enables him to achieve rich
vibrant effects that are most successfully realised on
the rectangular slabs and boxes that serve as his
canvases.

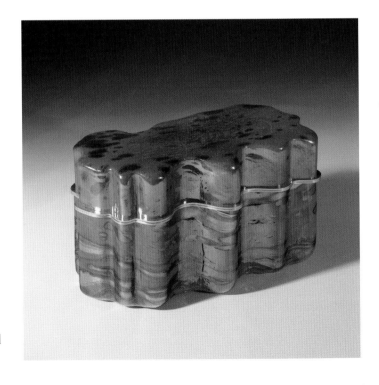

Johannes Schreiter, Germany: *Fazit 13/1993/F* – window
in architect's residence, Kassel, 1993
114cm × 115cm high; stained glass

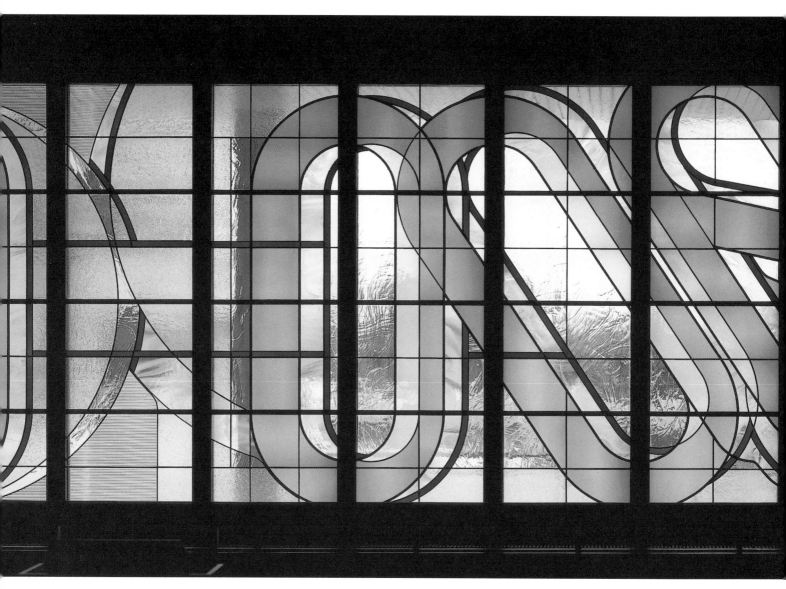

Ludwig Schaffrath, Germany

The influence on the international stained glass community of this patriarchal figure, both as an artist and as a teacher, has been immense. His powerful graphic use of leadline drawing in near-monochromatic compositions created a new and dynamic visual and symbolic language in which sweeping expansive movements are countered by areas of stillness and clarity. These in turn are punctuated by brilliant and intricate detail achieved by the extensive use of lenses, bevels and prisms.

The contemporary nature of his glasswork and its absolute affinity to modern architecture has been a major factor in gaining increased acceptance for stained glass in secular work, and to some extent in overcoming the continuing divisions between the fine and applied arts.

Ludwig Schaffrath, Germany: detail from [untitled], 1978
910cm × 360cm high: realised by Glasmalerie H. Oidtmann and installed at the Anne Frank School, Aachen (photo: Inge Bartholomé)

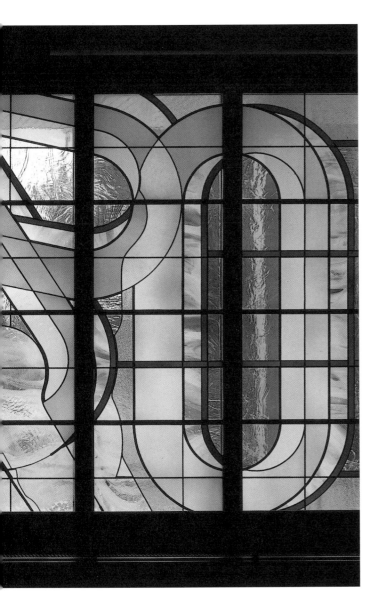

Benny Motzfeldt, Norway

One of the pioneers of contemporary glass, the Norwegian designer Benny Motzfeldt experimented extensively during the 1960s and 1970s with metallic inclusions in blown forms, embedding copper, brass and aluminium foils, threads and gauzes as well as glassfibre mesh saturated in enamel and underglaze colour. The escaping gases from the melted alloys created myriad layers of fine bubbles, while the entrapped linear structures caused spontaneous and organic distortions of shape, and gave rise to an extraordinary range of graphic effects.

Benny Motzfeldt, Norway: *Cylinder*, 1976
approx. 20cm high; clear glass with glass fibre and metallic thread inclusions arranged on and picked up from the marver on the first gather; the design expands with the glass (photo: Kjell S. Stenmarch)

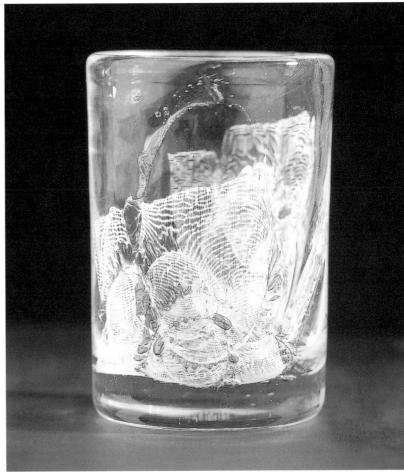

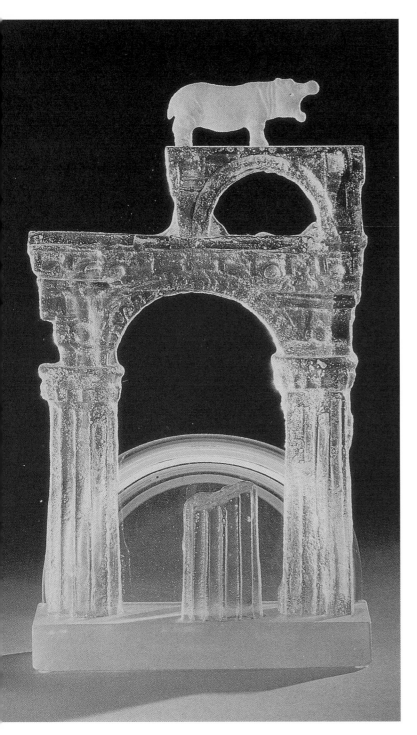

Finn Lynggaard, Denmark

Originally a potter, Finn Lynggaard was an early convert to Studio Glass and has been one of the founding fathers of the European Movement. Widely respected as an author, jurist, lecturer and exhibitor, he is perhaps best known for creating virtually single-handed the superb International Glass Museum at Ebeltoft in Denmark. Established in 1985 and based entirely on the loan or donation of work by artists, it now forms one of the finest collections of contemporary glass in the world. The unusual concept of a 'living' museum, where artists can exchange or supplement their work as it progresses has fired the imagination of the glass community. So, too, have several significant international exhibitions held there, such as 'Young Glass '87'.

In recent years Lynggaard has concentrated on sandcasting to produce his most important works. Architectural elements (architraves, lintels, arches and pedestals) are sometimes additionally cut and polished prior to assembly as miniature shrines or tabernacles, wry comments on modern society's preoccupation with fetishism and idolatry.

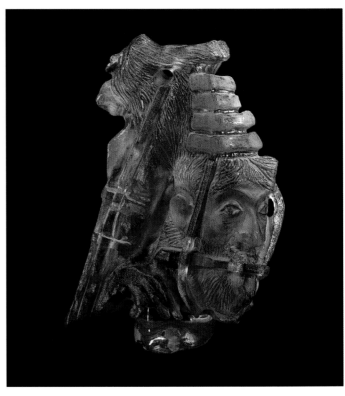

Finn Lynggaard, Denmark: *Archaic Scenery*, 1985
25.5cm × 9.5cm × 44cm high; sand-cast in parts, assembled, sandblasted and acid polished

Edward Leibowitz, Romania: *Package Deal*, 1975 ▶
22cm × 16cm × 25cm high; carved glass

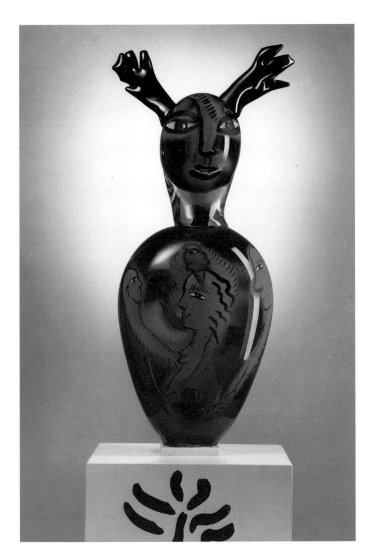

Ulrica Hydman-Vallien, Sweden: *Love Lady*, 1986
19cm diameter × 48cm high; freeblown, red underlay,
enamelled and fired (photo: Anders Qwarnstrom)

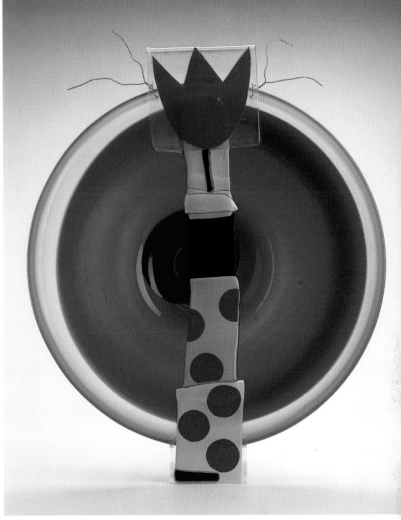

Ulla Forsell, Sweden: *Tulip Tree*, 1988
approx. 50cm diameter; blown dish in cased blue glass with
tulip tree of fused glass inlaid with fired-in transfers and
copper wire (photo: Anders Qwarnstrom)

Ulrica Hydman-Vallien, Sweden

Looking at Ulrica Hydman-Vallien's work, whether it
be the delicate flower patterns designed for
production at Kosta Boda or her own bold primitive
icons, one has a sense that her painting flows
spontaneously, as naturally as breathing. It speaks
directly and with great intensity, arousing mixed
emotions of menace and vulnerability, pain and
separation, fear and desire, love and ecstasy. Her
vessels and sculptures manifest both pure fantasy
and celebration, often serving as cogent metaphors
for the enduring and incongruous roles of
womanhood.

Ulla Forsell, Sweden

Ulla Forsell was frustrated at not being able to work
with hot glass herself, as she could with clay. Nor
was she aware of the pioneering efforts of her
compatriot Asa Brandt although she followed an
almost identical route. Once again, the Valkemas,
already so active in the development of studio glass
in Europe, provided the essential encouragement and
practical support to help her to establish a studio in
Stockholm in 1974.

Her bright, colourful fantasies communicate a
bubbling energy and optimism, a willingness to play
and, when necessary, flout or puncture conventional
attitudes.

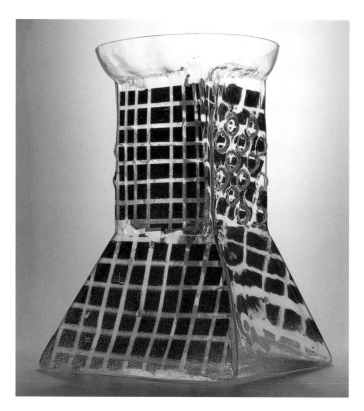

Ivana Masitova, Czech Republic: *Vase*, 1988
30cm diameter × 50cm high; mouldblown glass, painted
with enamels

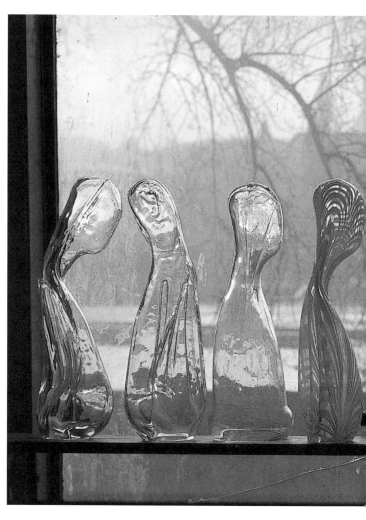

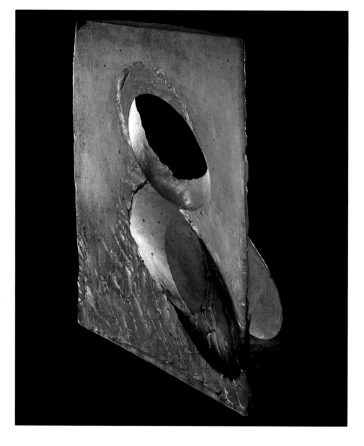

◀ **Zora Palova**, Slovak Republic: *Morning Grass*, 1994
43cm × 12cm × 50cm high; kiln-cast by *cire perdue*
method (photo: Daniel Zachar, courtesy: Studio Glass
Gallery, London)

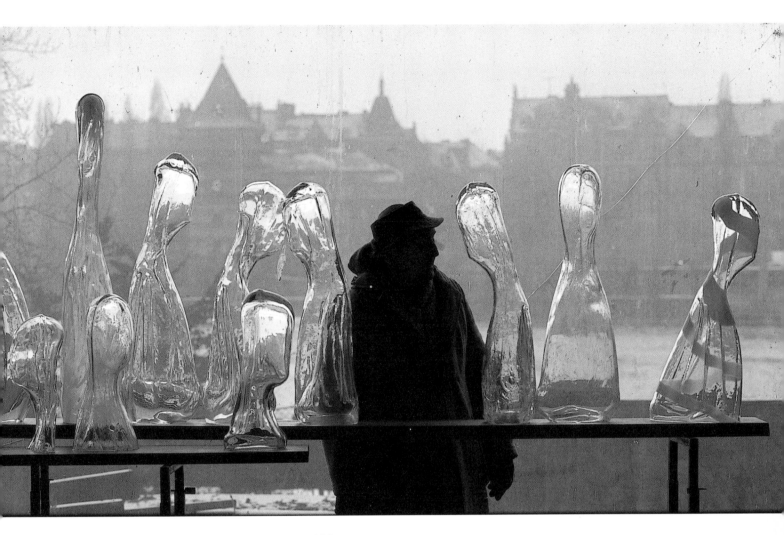

René Roubicek, Czech Republic: *Glass Figures*, 1980
70-90cm high; mouldblown glass, manipulated while hot;
figures featureless yet expressive in their movement (photo:
Arnost Korinek)

René and Miluse Roubicek, Czech Republic

Through their playful and witty production they have
continually expressed an inspiring zest for life, a
seemingly unending flow of creative energy and
youthful enthusiasm. 'Pop' images abound in their
separate works: series of flowers, vegetables, cakes,
sweet or pasta-filled jars, bags, books, clarinets,
oboes and figurines that border on the baroque
without ever becoming overly self-indulgent.

Over the years Roubicek has carried out numerous
large-scale architectural works, notably a series of
modern chandeliers which wholly capture and exploit
the fluidity and reflective qualities of glass. It was a
group of his sculptural columns, displayed in the

excellent Czechoslovakian pavilion at the Montreal
Expo in 1967, that fired my own awakening interest
in glass.

An accomplished and versatile designer, Roubicek
has developed exceptional rapport in his working
relationships with the master glassmakers who
translate his ideas into three-dimensional form. For
many years he has worked with Petr Novotny, whose
calm skill in the face of challenging demands have
earned the respect of the international glass
community.

René Roubicek and his wife, both born in 1922,
were among the first champions of the new glass art
movement in Czechoslovakia.

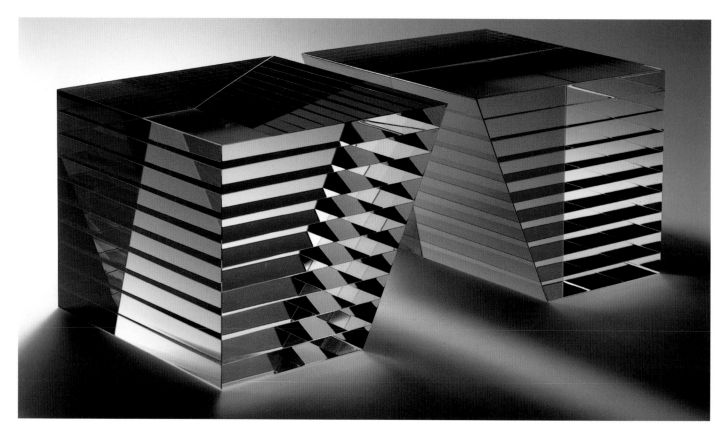

Vaclav Cigler, Czech Republic: *Object* (two parts), 1985 each block 15cm × 15cm × 15cm; laminated, cut and polished glass; (photo: G. Urbanek, courtesy: Umprum, Prague)

Vaclav Cigler, Czech Republic

As the acknowledged leader and inspiration of the 'optical school', Vaclav Cigler has had a profound influence on the 'middle' generation of Czechoslovakian glass artists. Modest, reserved and uncompromising, he views the object as wholly integral to its environment, rejecting any notion of autonomy and disregarding superficial decorative values.

Precisely cut and polished blocks or laminations, each taking many months to hand-grind and polish are specifically arranged in tectonic compositions that function to alter our perceptions of space by focusing the inherent kinetic properties of the optical glass. The added dimension of absolute transparency enhances the interplay of light, reflections and shadow, spectral colour and the materialisation and distortion of images as the viewer moves or the illumination changes.

A number of his projects have successfully been transposed into large permanent architectural structures for public spaces.

Pavel Hlava, Czech Republic

'Artist of Merit' Pavel Hlava has been one of the most influential figures since the Second World War in the development of Czech glass. He has contributed both his artistic talents and organisational skills in virtually every sphere of glassmaking and has sat on countless national committees and juries. He moves naturally from producing award-winning designs for the industry to personal creative work or large architectural commissions such as the spectacular 15m high light sculpture in the stairwell of the National Theatre in Prague.

Hlava trained as an engraver and cutter, and his early appreciation of glass as a sculptural medium enabled him to develop new and innovative techniques, consistently extending the vocabulary of glass practice. An early series involved penetrating the hot surface of mould-blown forms and pinching layers of cased colour towards the interior to create complex internal structures. The relationship of 'inner' to 'outer' form and space are fundamental to the thematic character of his cycles of production.

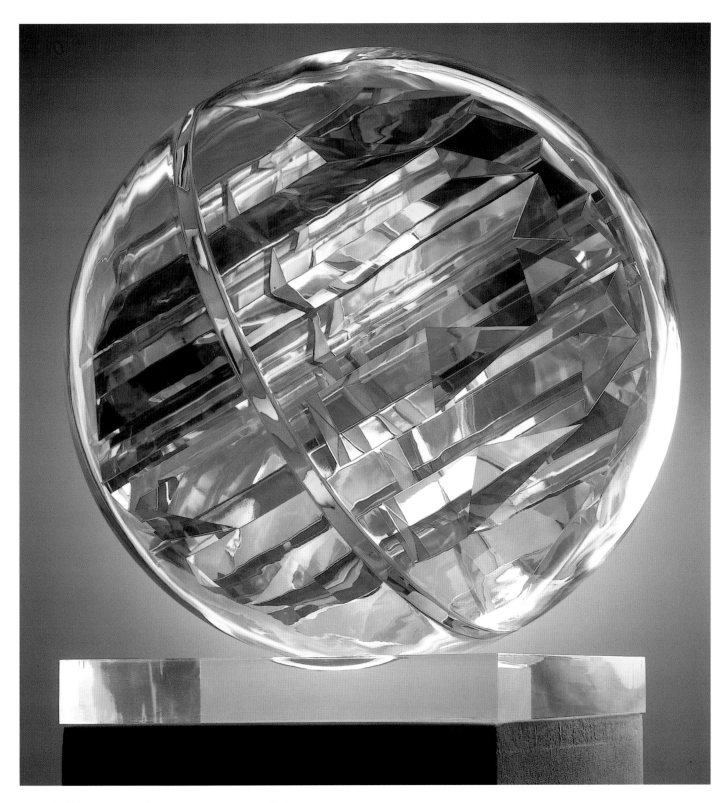

The Cell, *Energy* and *Nature* are some of the series titles he has worked through in countless variations.

More recent works involve solid hot-worked glass sections containing massive bands of pure colour. These are cut, polished and reassembled, to constitute engaging exercises in formal abstraction.

Pavel Hlava, Czech Republic: *Atomic Era*, 1985 45cm high; blown glass with cut and polished glass inclusions, glued (photo. G. Urbanek, courtesy: Umprum, Prague)

Pavel Trnka, Czech Republic

Trnka explores both the obvious and the unpredictable qualities of glass in his provocative 'non-vessels'. These consist of a series of mould-blown containers that are systematically sabotaged by the application of a flame. Cracking, fractures, splintering and ultimate collapse ensue, denying continued function while asserting the dangerous fragility of the material. Light strikes the fine networks of fissures and beauty emerges, a fortuitous by-product of the destructive process, demanding a reappraisal of aesthetic values and expected functions.

Another major concern is the making of multi-part compositions of precisely shaped and coloured blocks of optical-quality glass. These may be assembled as a whole or as any one of a series of configurations. Where surfaces touch or overlap they form a kind of permeable mirror allowing optical absorption and the projection of light and colour from one section to another, giving rise to new and unexpected colours which change according to the viewpoint.

Trnka also has an established reputation for large architectural works.

Pavel Trnka, Czech Republic: *Cube Spectrum Cycle 1*, 1985
16cm cube; cube composed of three parts, each in 30% lead crystal cut and polished, one purple, one yellow and one blue; the three parts can be combined in several different ways to produce colour variations (Photo: G. Urbanek, courtesy: Umprum, Prague)

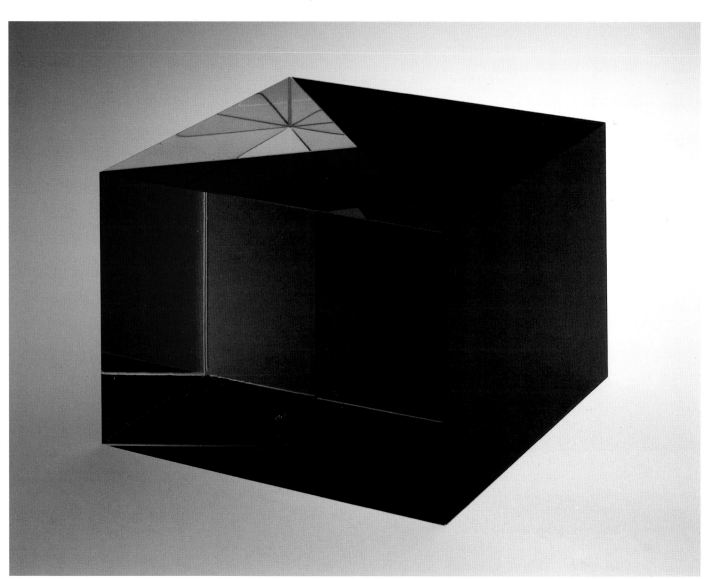

Vladimir Kopecky, Czech Republic

Kopecky's output is amongst the toughest and most avant-garde in glass. His work is clearly the product of a totally uninhibited approach to concept and material and as such will surely continue to be both provocative and iconoclastic.

Early works consisted of painted abstracts in enamel on vessel forms, an area to which he has lately returned though in a more aggressively gestural fashion. Another potent theme involved the application of identical hard-edge images, repeated on stacked or leaning glass sheets, a form of 3D painting that creates spatial and tonal perspectives as the depth increases and the image recedes, contrasting actual and illusory space.

Kopecky's later pieces are also highly confrontational. They combine metal, wood and flat

Vladimir Kopecky, Czech Republic: *Blind Track*, 1987 200cm × 600cm × 100cm high; glass, wood and metal, painted (photo: G. Urbanek, courtesy: Umprum, Prague)

glass with paint stridently used to 'unify' the whole, raising again amongst other issues, the largely irrelevant question of whether one is looking at painting or sculpture. Either way they are remarkably powerful and direct statements.

In 1987 Libensky retired as Professor in charge of the Glass Faculty at the Academy in Prague. Kopecky was popularly elected to the post following the Velvet Revolution in 1990. His nonconformist attitudes and role as innovator bode well for the future of this great department.

Jiri Suhajek, Czech Republic

Like so many of his compatriots Suhajek is equally happy producing award-winning designs for industry, complex blown vessels and sculptures, or paintings. When he leads a team of ten or so in the production of one of his huge composite figures, the bravura scale, complexity and drama recall Chihuly in action. The speed, timing and precision required to blow and assemble the multiple parts before any of them cracks, make for a spectacularly demanding performance, one in which he clearly revels.

1984 was perhaps the first year that glass was shown extensively at the Venice Biennale and Suhajek's sculptures thronged the Czechoslovakian pavilion. I actually helped to deliver some of them to the Lido, and recall copious head-turning and eye-popping as the larger-than-life glass ladies sailed by, jaunty and sparkling in their gondolas.

Jiri Suhajek, Czech Republic: *Sitting Figures*, 1984 150cm and 155cm high; freeblown glass (photo: G. Urbanek, courtesy: Umprum, Prague)

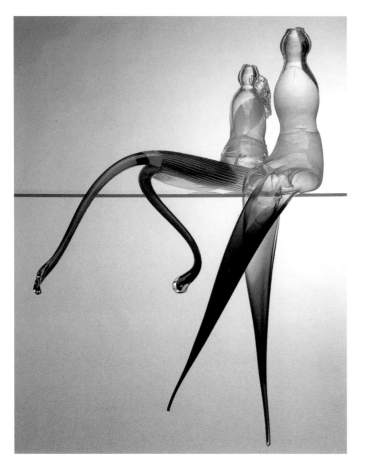

Dana Zamecnikova, Czech Republic

Her early training as an architect and her work in the theatre as a set designer have contributed a new and refreshing approach to glass as an expressive medium. Her early pieces were constructed as layered sheet-glass picture boxes. Each level carried etched or painted parts of a figurative composition that became complete in space as the sheets were stacked, a kind of spatial collage.

These contemplative objects, whose narrative is drawn diary-like from her observation of people, situations and events in her life, contain mysterious, ephemeral images that recur as if in dreams or nightmares. Glass seems a strangely appropriate medium through which to explore their meaning although at times rather transparent as a metaphor, e.g. vulnerable, fragile, dangerous.

An open-air exhibition held at Vsemina in 1986 was one of a series of important shows organised by the art historian and critic Kristian Suda. Set in challenging locations, they invited new responses and radical solutions from the participating artists. For Zamecnikova, Vsemina provided the stimulus to develop large surreal installation pieces – dramatic sets one can enter. They contain life-sized glass cut-outs, often female figures of varying ages painted in bright, sometimes brutal colours. Her personae protest behind their smiles at the rampant folly of man's savagery.

Dana Zamecnikova, Czech Republic: *Sinking Deeper and Deeper*, 1990 ▶
90cm × 312cm × 146cm high; sheet glass, cut and painted, metal (courtesy: Musée des Beaux Arts, Rouen)

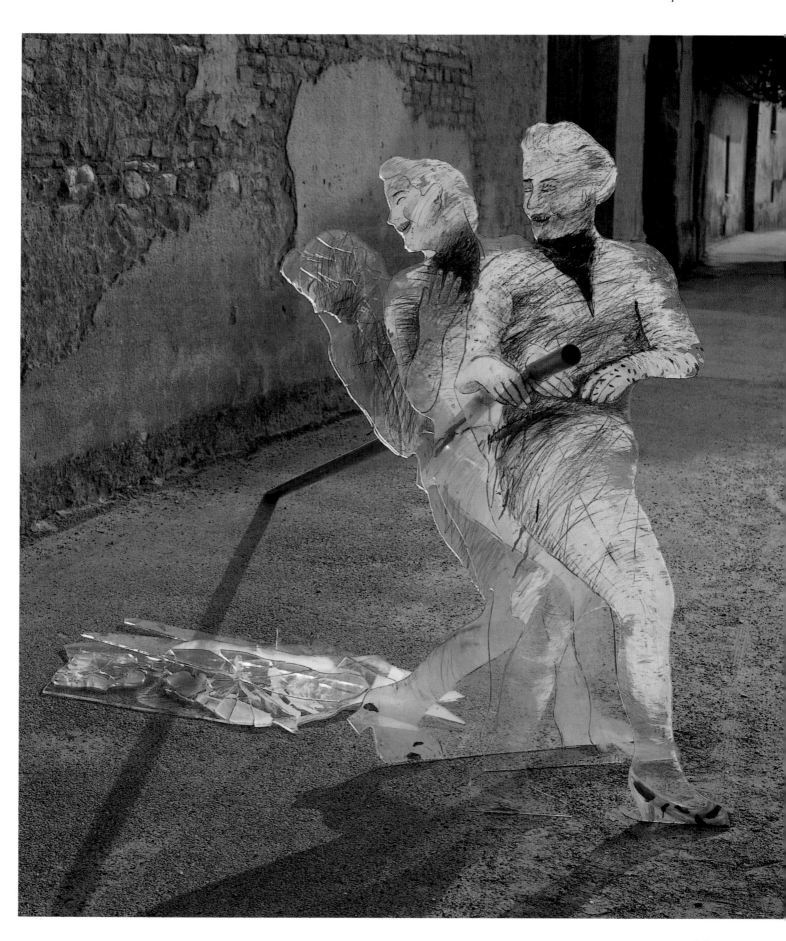

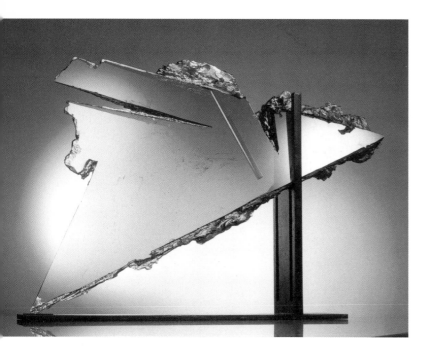

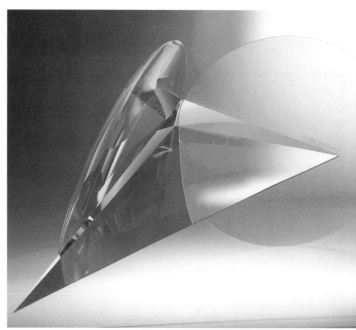

Askold Zacko, Slovak Republic: *Head with Big Eyebrow*, 1989
37cm × 4.5cm × 30cm high; kiln-cast glass, cut, ground and polished; metal framework (photo: Daniel Zachar)

Stepan Pala, Slovak Republic: [untitled], 1995
47cm × 88cm × 37cm high; cut and polished optical glass (photo: Daniel Zachar, courtesy: Studio Glass Gallery, London)

Askold Zacko, Slovak Republic

Historically Slovak glass tended to look to Italy for inspiration but the establishment of the glass faculty at the Bratislava Academy of Fine Art and Design in 1965 provided a totally fresh impetus. The new orientation was towards the use of glass in architecture and an emphasis on coldworking.

The 'search for a symbiosis of object and architectural space' was focused through the strong personality and intellect of its director Vaclav Cigler, and the quest for 'visual and stylistic purity' took the form of all-over cutting of solid high-lead optical glass, largely in a geometric vein. A later phase exhibited an increased complexity, a multi-layered more lyrical approach, as seen in the work of Askold Zacko and Zora Palova. The works of Stepán Pala, Juraj Oprsal, Milos Balgavy and many others continue to sustain the so-called Optical School.

Zacko attracted considerable attention at Interglas '85 at Novy Bor when he attacked his perfectly executed, cut and polished form with a hammer. It is hardly surprising, therefore, that since then his work has become increasingly free, latterly taking the form of organic kiln-cast sculptures that are cut and etched.

Ales Vasicek, Czech Republic

Time and again those in the 'middle' generation of Czechoslovakian glass artists, many of them Libensky's students, have proved their ability to handle any design project that comes along, whether it be signage, lighting, decoration, tableware, a mural, fountain or free-standing sculpture in an architectural setting. The aesthetician and critic Kristian Suda organised a series of important exhibitions entitled 'Prostor', which translates as 'Space'. The invited artists were challenged to reassess concepts of scale and content in relation to specific and dissimilar environments. For many the experience proved crucially stimulating and heralded major developments in their work.

Vasicek, like so many others of his 'generation', works in a variety of techniques, exploring diverse aspects of the medium. A consummate cutter, he concentrated on the 'circle' or 'ring' theme for a number of years, first rough kiln-casting, then cutting and polishing. A more recent development, partly the result of his having installed his own kilns, has been a much greater emphasis on the cast form together with a freer approach to surface quality and texture, with little or no subsequent cutting.

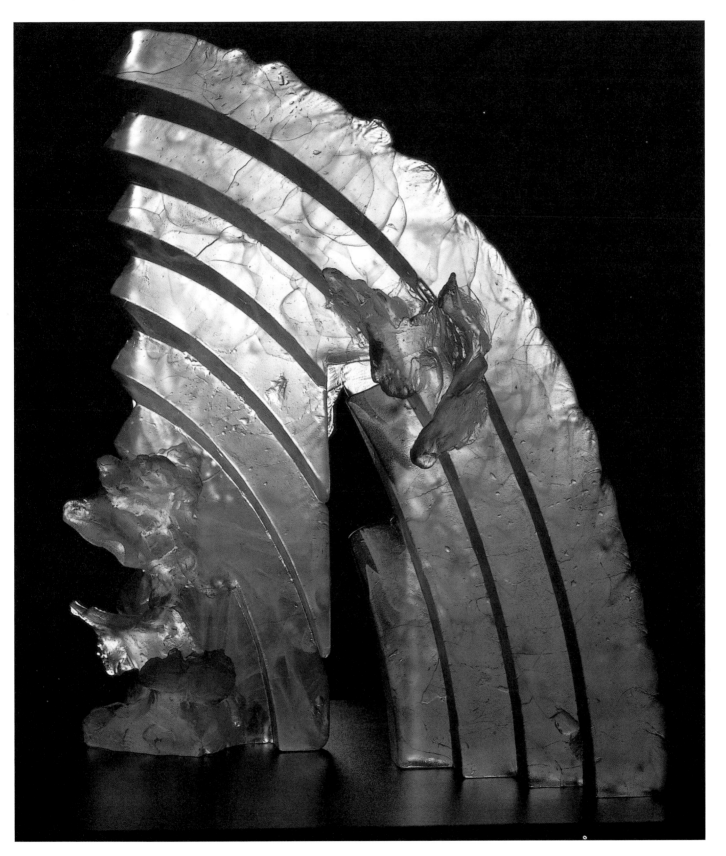

Ales Vasicek, Czech Republic: *Ice Field*, 1994
60cm × 13cm × 70cm high; kiln-cast, cut and acid polished (photo: G. Urbanek, courtesy: Umprum, Prague)

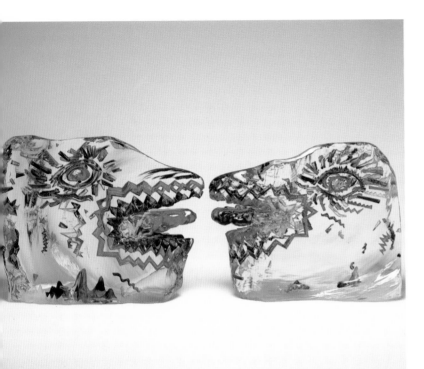

Czeslaw Zuber, Poland/France

Czeslaw Zuber is an émigré Pole living in Paris whose works are among the most dynamic and uninhibited in glass. Attacking large blocks of a special lead glass used to make the viewing windows at atomic test sites, he crudely carves and paints the fantastic bright punk-like heads for which he has become celebrated. Metamorphosed from birds to dogs to humans to primeval monsters, they are at once menacing (as in totemic imagery) and capricious, almost comical, evoking the savage irony of the caricature.

◀ **Czeslaw Zuber**, Poland/France: *Beasts*, 1987 left: 39cm × 17cm × 30cm high; right 36cm × 16cm × 28cm high; carved from blocks of optical crystal and painted with cold-setting glass paints (photo: Dominique Brossard)

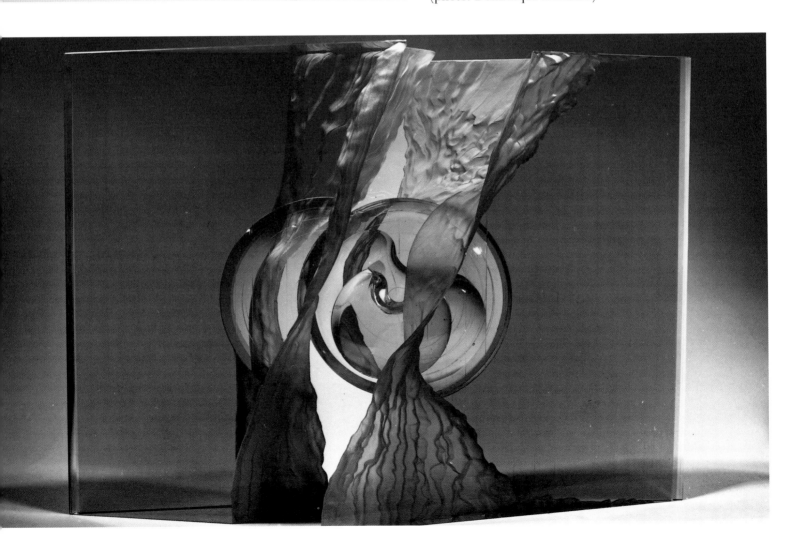

Zoltan Bohus, Hungary

Constructed from laminated sheets of plate glass with anodised metallic coatings, Zoltan Bohus' small carved sculptures are elegant contemplative objects. Comprising infinite mathematical progressions, whose linear rhythms and subtle tones harmonise in soft curves and silken matt surfaces, these exquisite luminous volumes allude to mysterious architectonic space. Never austere, they are formal and restrained, epitomising absolute purity and equilibrium.

Bohus has also completed a number of commissions for large-scale sculptures in stainless steel and glass, some incorporating water.

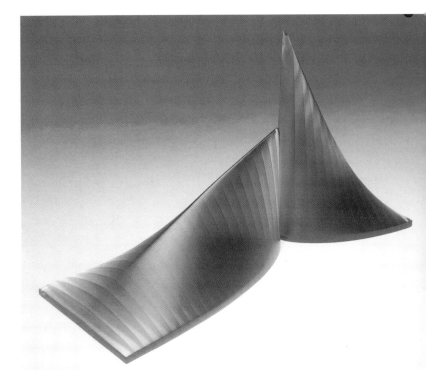

Zoltan Bohus, Hungary: *Parabolic Composition*, 1988 ▶
26.5cm × 46cm × 17cm high; laminated flat glass, metallised coating, wheel cut, ground and acid etched to satin finish

Maria Lugossy, Hungary

The source of life, the metamorphosis of chaos into order, the space/time dichotomy, are recurrent themes that manifest a powerful emotional and symbolic content in Maria Lugossy's work. Carved areas, apparently eroded, the product of internal sandblasting, denote time encapsulated. In the 'cell series', embryo-like internal spaces within hard crystalline structures sometimes contain deadly mercury. Is this simply an organic kinetic element to counterpoint static grids embedded in the glass and to symbolise an elemental energy emanating from within? Or is it a fearful indictment of futile schemes such as the incarceration and burial of nuclear waste?

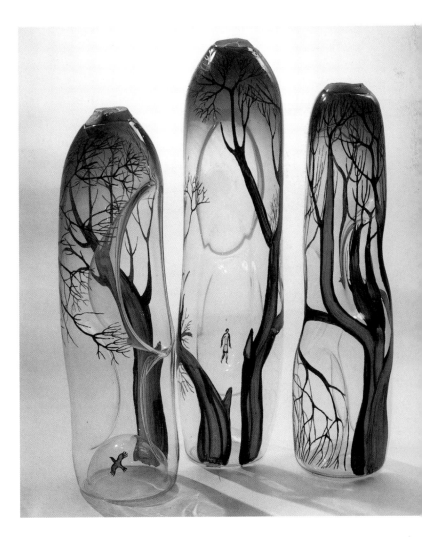

◀ **Maria Lugossy**, Hungary: *Tektit I* (two parts), 1987 54cm × 18cm × 40cm high; laminated, glued, sandblasted, polished; optical lens incorporated (photo: Zoltan Bohus)

Lubova Savelieva, Russia: *Sokolniki* (name of Moscow park), 1975 ▶
50-60cm high; freeblown opalescent glass; enamels painted on, then fired

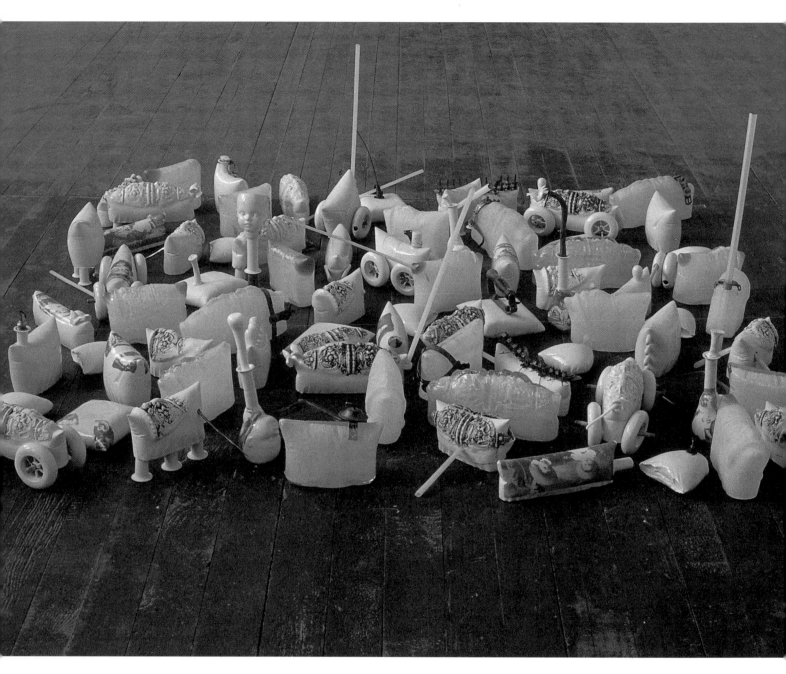

Adreana Popescu, Romania: *Fragile Dream* (assemblage
of utopic objects), 1994
200cm × 200cm × 50cm high; glass, metal, porcelain
assemblage with freeblown opaline glass, sandblasted

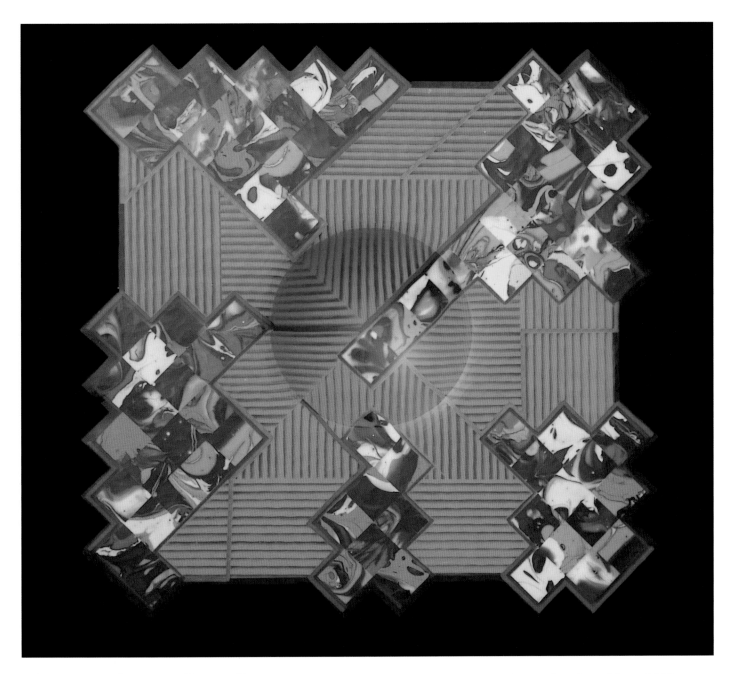

Klaus Moje, Germany/Australia

One of Germany's most celebrated glass artists, Klaus Moje now resides permanently in Australia where until recently he was head of the glass department at Canberra School of Art. Trained as a cutter, he is best known for the bold colouring and dynamic patternwork of his brilliant kilnformed pieces. He makes them using basically the same techniques as the Romans used in the production of mosaic bowls.

 Arrangements of coloured rods are fused into blocks that are then drawn to a required length, in much the same way as peppermint rock is made in

Klaus Moje, Germany/Australia: *Song Lines*, 1995
49cm square × 5.5cm high; mosaic glass, fused, kiln-formed and wheel cut

some seaside towns. If necessary, this process can be repeated, the image or pattern being further reduced until the desired size is achieved. Thin cross sections are then cut and laid out in patterns to be fused as flat sheets before they are fired again and slumped into, or over, a mould. During the finishing stages, these pieces may be ground on a cutting lathe to remove irregularities and impart a smooth matt surface.

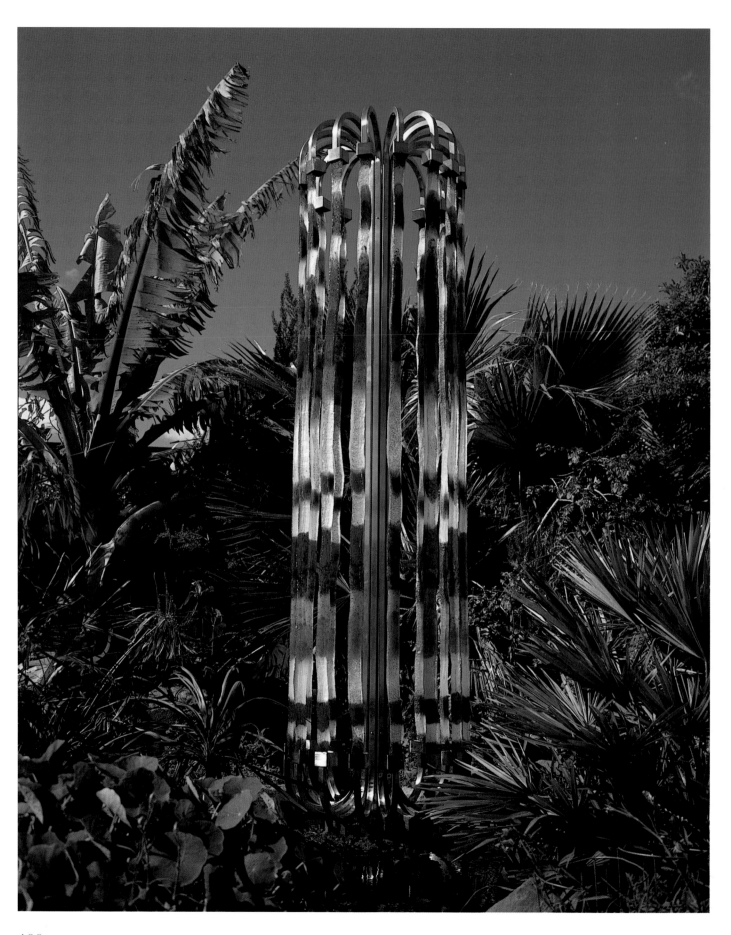

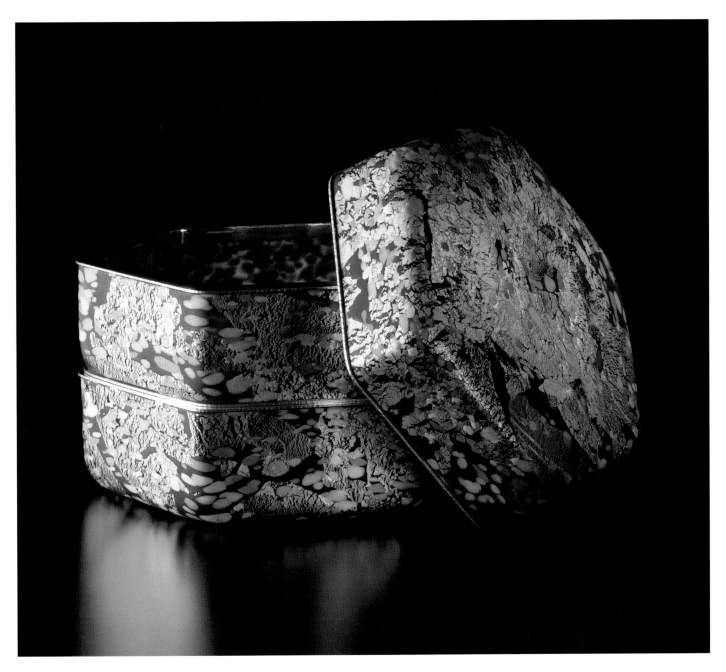

▲ **Kyohai Fujita**, Japan: *Spring of Tempyo* (casket), 1988 approx. 22.5cm × 22.5cm × 22.5cm; mouldblown, coloured with powdered and granulated glass, and gold and silver foils; acid etched; silverwork
(photo: Gakuji Tanaka, courtesy: Heller Gallery)

◀ **Stephen Skillitzi**, Australia: *Column Fountain*, 1989 300cm high (above surface of pond); coloured kiln-cast glass, stainless steel, water and low-voltage lighting

Kyohai Fujita, Japan

Among the pioneering works of contemporary glass, Kyohai Fujita's early pieces predate the Studio Glass Movement in America and Europe by more than a decade. For him it was a period of intense isolation during which he developed highly personal techniques to explore and express his unwavering vision. The masterful organisation of precious metal foils trapped within clear and coloured glasses provides his sumptuous mould-blown boxes with richly textured surfaces that entirely capture the essence of the Japanese artcraft tradition and sensibility.

Naoto Yokoyama, Japan

Naoto Yokoyama regards himself as a Post-Modernist, and indeed his fanciful works have some affinity with those of sometime Memphis designer Peter Shires. They are similarly imaginative and quirky while expressing a more folksy humour in their form and colour.

Kinuko Ito, Japan

The Tokyo Glass Art Institute was a remarkable private college housed in an old hospital. Some of its activities, including excellent graduation show catalogues, were funded by sharing its hot glass facility with a production team from whom the students learn glassblowing. The school was founded by Tzuneo Yoshimizu, whose speciality is *pâte de verre*, and his students have clearly taken full advantage of his expertise. Kinuko Ito is a graduate of the Institute. She makes delicately sculpted vessel forms whose calm restraint and unity render function superfluous.

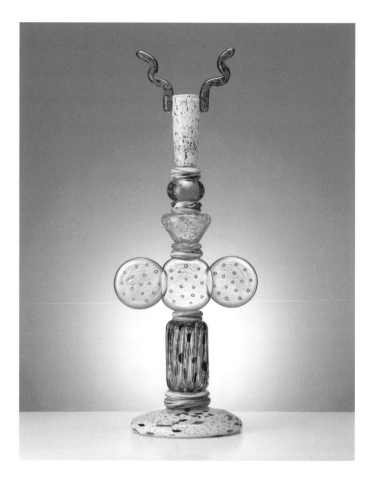

▲ **Naoto Yokoyama**, Japan: *Poseidon*, 1987
26cm × 33cm × 89cm high; blown and hotworked glass, assembled (photo: Shoichi Kondo)

▼ **Kinuko Ito**, Japan: vase from *Yours Sincerely* series, 1988
18cm wide × 14cm high; *pâte de verre* cast by *cire perdue* method; hand polished with sandpaper

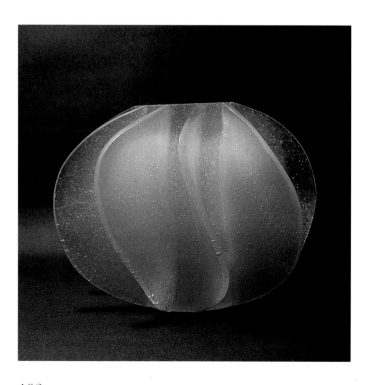

Makoto Ito, Japan

In the past, most glass artists in Japan have tended to work in association with factories, and the Japan Glass Artcraft Association is itself industrially based.

In setting up his own studios and as Director of the Glass Department in the Faculty of Art at Tama University in Tokyo, Makoto Ito has played an influential role in encouraging the rise of a new generation of independent young artists.

Although he is perhaps best known for his sensitive blown and sandblasted work, he has also produced innovative slumped pieces, and recently a series of castings in lead crystal.

Makoto Ito, Japan: *Businessman*, 1995 ▶
13cm × 10cm × 54cm high; freeblown, cased colour, sandblasted (photo: Philippe Robin, courtesy: Musée-Atelier du Verre, Sars Poteries)

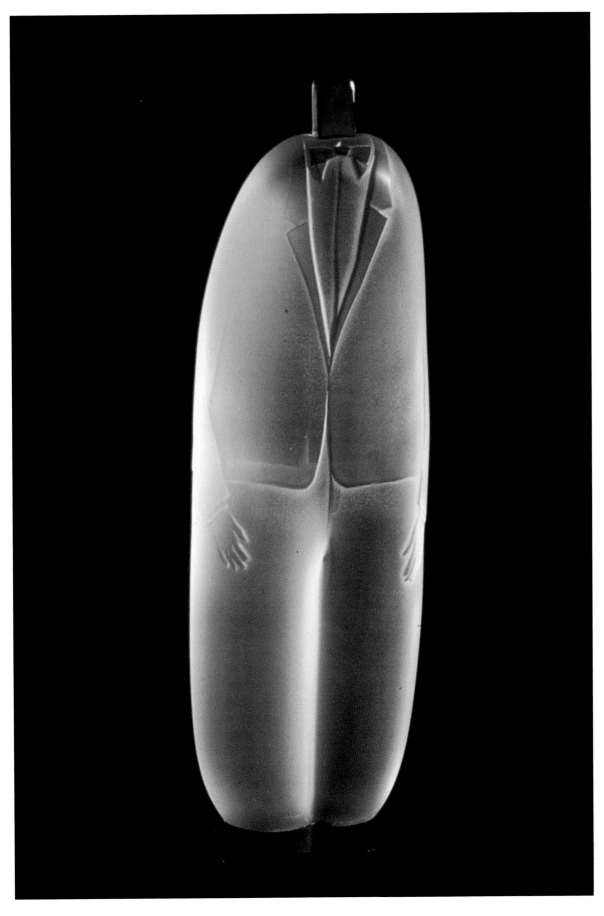

Yuri Masaki, Japan

Yuri Masaki's installations are a remarkable achievement. Besides the physical problems of handling the large, heavy sheets of glass used in her loosely-piled laminations, she also controls the environment in which they are exhibited. Synthesised music of her own composition is synchronised with computer-controlled lighting, to spectacular effect. 'The realm of arctic cold' is a huge environmental installation comprising crystal blocks, loose cullet and cut and sandblasted sheet glass.

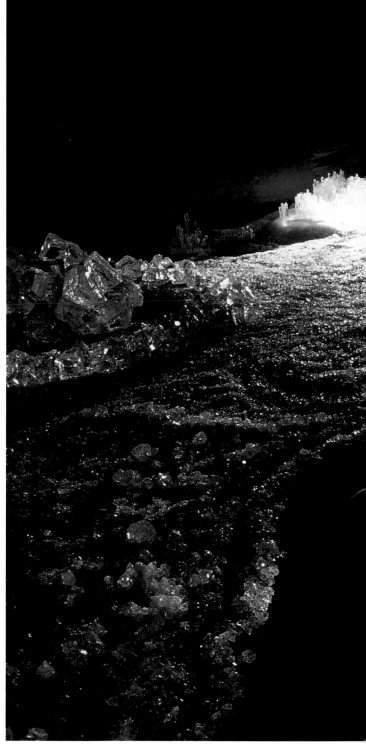

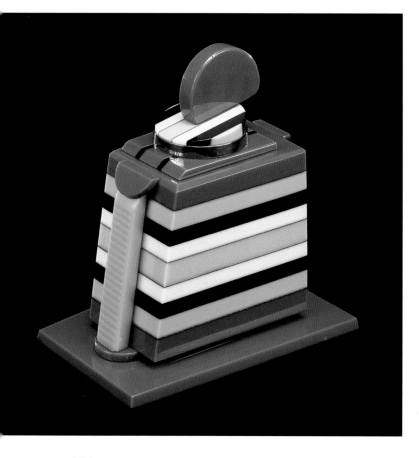

◀ **Karl Schantz**, Canada: *Stoppered Vessel*, 1981
10.9cm × 11.7cm high; cut Vitrolite, laminated, drilled
(© 1986 The Corning Museum of Glass)

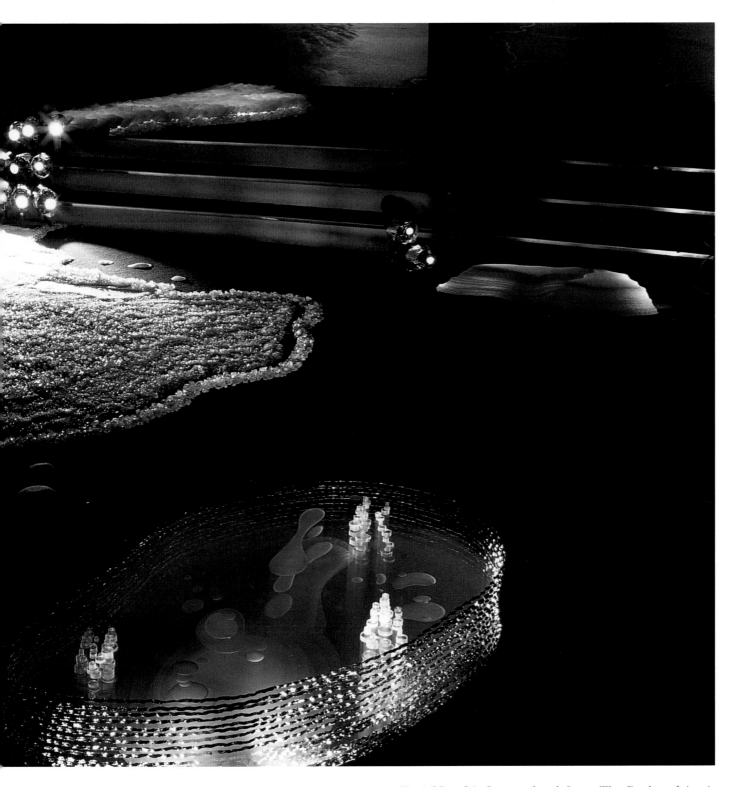

▲ **Yuri Masaki**, Japan: detail from *The Realm of Arctic Cold*, 1987
installation 5m × 10m

Materials and Techniques

The Nature of Glass

Glass is a unique material that is often referred to as Man's earliest 'synthetic'. In its simplest form it can be made from pure silica, which as one of the earth's most plentiful resources is found as sand, quartz or flint. However, these require very high melting temperatures (around 2000°C) which would restrict their use to specialised glasses and make them impractical for normal handworking processes.

Natural glass occurs as a product of volcanic action in the form of obsidian, a dense smoky black substance which, thousands of years ago, was found to be ideal for fashioning axeheads, knives and arrows, as well as amulets and other items of adornment.

There are infinite ways of formulating different types of glass according to the qualities required. The choice and proportion of the ingredients determine the visual and working properties of the resulting glass. Most glass formulae contain a high proportion of silica to which are added materials known as stabilisers (such as lime) and fluxes, which reduce the temperature at the fusion point (the most common of these being soda, potash, lead and borax). The mixture of raw materials is known as the batch, to which, say, 20–30 per cent of cullet (recycled glass of the same composition) is sometimes added to facilitate melting.

For our purposes we can classify glass into a few general types.

Soda lime glass (soda, lime, silica) is by far the most common, accounting for almost 90 per cent of all glass produced for everyday items such as bottles, jars, light bulbs and window glass. It often has a pale greenish tint that varies according to the iron content of the sand used.

A simple batch recipe for glassblowing might be:

sand (SiO_2)	65%
soda ash (Na_2Co_3)	20%
limestone ($CaCo_3$)	15%

Lead glass contains varying proportions of lead oxide and is often referred to as lead crystal. This is a denser, clearer and more brilliant glass, which is relatively soft and therefore ideal for cutting and engraving. Its main uses are in optics, and for high-quality tableware and cut decorative glass. A full lead crystal contains between 30 per cent and 40 per cent (by weight) of lead.

Borosilicate glass is made by the fusion of silica and boric oxide resulting in a highly durable product, very resistant to heat, corrosion and thermal shock, and therefore ideal for a wide variety of demanding industrial and domestic applications.

Pure silica glass demands exacting high temperature manufacturing processes. Although expensive, its outstanding optical qualities and resistance to radiation and thermal shock give it an increasing range of uses, principally in astronomical and space applications, e.g. laser-beam reflectors and space-borne mirrors

There has been relatively little change in the basic constitution of glass throughout most of its long history. However the twentieth century has seen a revolution in its science and technology and today industry has literally thousands of types of glass from which to select the most suitable for new and increasing uses: construction and engineering, optics, electronics, medicine, and information and space technology, to mention but a few. Glass of incredible purity can now be made by the vapour deposition of silicon tetrachloride, for specialised applications such as the windows of space craft or for optical fibres far thinner than a human hair that can carry ten thousand times more information than an ordinary telephone wire. These will provide levels of communication barely imagined and it has been widely postulated that the twenty-first century will be the new age of glass. Some 8 million miles of glass fibre currently carry telephone and television signals across the USA alone.

A hard brittle material when cold, glass becomes fluid when sufficiently heated. This transformation does not take place at a specific point as with water, but over a wide temperature span known as the working range and, if cooled at the appropriate rate, a particular shape can be 'frozen in'. Glass contracts during cooling and this sets up internal stresses between the outer surface, which cools faster than the inner mass, or between thick and thin sections of a piece. If the glass is simply allowed to cool at room temperature, the uneven tensions will cause it to crack and shatter. This inherent strain can be reduced to an acceptable level by a controlled cooling process known as annealing. This means that when a hot piece has been completed it is placed in a preheated chamber known as an annealing oven or 'lehr'. This is held at a constant temperature of, say, 500°C (over 900°F) for a given period and cooled at a predetermined rate to disperse or distribute the stresses. Annealing temperature, time and cooling rates depend on such factors as the type of glass and the thickness and shape of the pieces; for example, solid forms such as paperweights require different treatment from that for thin-walled goblets. A typical soda glass would normally have an annealing point somewhere in the range 500–600°C

Although this may sound complicated, finished work in Roman times was annealed in the hot ash and sand beneath the furnace and in Mexico today glassmakers work outdoors and anneal in chambers above the furnace to exploit the waste heat. Wares are stacked on top of each other and the temperature is controlled by timing how long it takes to ignite a piece of newspaper. For many years I used a well-insulated pottery kiln with a soak device that was simply switched off at the end of a work session allowing the glass to cool gradually overnight as the kiln cooled. Although this method may work adequately there is no real substitute for controlled cooling and there now exist for studio purposes highly sophisticated computerised controllers which can operate several different annealing programmes simultaneously. The industry tends to use continuously moving tunnel lehrs which, for certain types of ware, can cut annealing times to as little as 1½ hours. At the other extreme, the mirror for the Mount Palomar telescope, the largest piece of glass ever cast (some 200″ in diameter and 20 tons in weight) was made at Corning in 1934. It was cooled for more than a year with a temperature drop of

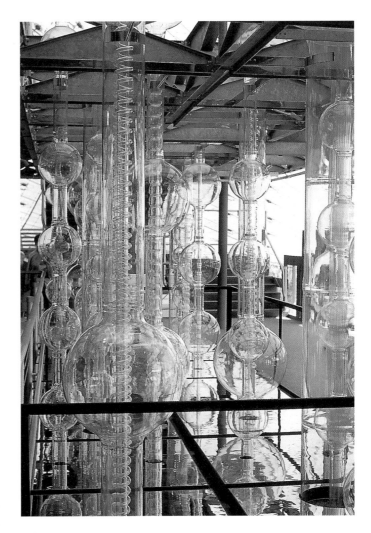

Scientific glassware photographed in the Czechoslovakian Pavilion at Expo-Montreal, 1967; lampworked at the lathe (photo: Peter Layton)

less than 2° per day, and even so the first attempt cracked.

Glass is often referred to as a super-cooled liquid for although it appears to have the physical characteristics of a solid it is actually amorphous, having no internal crystalline structure. After melting or vitrification its molecules do not generally revert to a crystalline pattern as with most other substances. Its viscosity, or resistance to flow, is so high that whereas at 1000°C it may be runny and syrup-like in consistency, it flows less and less as it cools until for all practical purposes it becomes a solid. It is said that glass never actually ceases to flow entirely and will deform imperceptibly over thousands of years. It is possible to cool glass in such a way that it devitrifies, so that a crystalline structure does develop. This is normally considered to be a fault and

cooling cycles are usually carefully controlled to avoid such an occurrence. However, in recent years controlled devitrification has been exploited to create a new family of substance known as glass-ceramic with extraordinary thermal shock resistant properties. Harvey Littleton's father helped to pioneer this work during the development of Pyrex. A number of artists have begun to explore controlled devitrification in fused and laminated work with impressive results, most notably Brian Blanthorn in the UK.

Many studios melt only cullet in preference to batch since remelted glass softens at a lower temperature than the original batch materials. This reduces fuel costs and wear and tear on the furnace. Batch, if properly melted, may give a cleaner, less cordy glass but the materials are toxic and also more noxious in melting. The pelletising of batch is a recent development for safer and easier handling. If the glass has an undesirable tint, most often from iron impurities in the batch materials, minute amounts of decolourisers such as oxides of manganese, selenium or arsenic can be added to the melt. The removal of air bubbles from the melting glass is known as 'fining', and is largely a matter of time and temperature. In the past this process was often hastened by plunging a green ash twig or potato deep into the molten 'metal', causing large bubbles that carried myriad smaller ones with them to the surface where they burst.

The most common way of making coloured glass is to stain the melt by the addition of small proportions of metallic salts to the batch or cullet as it is shovelled into the furnace. This may be too restrictive in a small studio, since it usually requires the complete 'working out' of the furnace prior to batching the next colour; an alternative is to use small colour pots in a secondary furnace. In order to achieve the greatest degree of flexibility many glassblowing studios melt only clear glass to which compatible colour can be added or introduced in various ways during the working process (see page 114).

Setting up a Workshop

The cost of establishing a glass workshop can vary enormously and must depend on the scale and type of operation, as well as the degree of 'self help' available. Depending on how elaborate the equip-

ment is, the cost can vary from a few thousand pounds or dollars to as much as a hundred thousand. A hot glass facility is more expensive to set up and maintain than a studio equipped only for fusing or coldworking. While there is no ideal size or shape for a workshop, 1000–2000 square feet can be divided into hot and coldworking areas, storage, packing, office and display. Less space will work adequately, just as bigger may well be better. Layout will be the outcome of practical, physical and aesthetic considerations to aid the flow of work. The workshop should be well ventilated – an extraction system to dispose of heat and fumes is advisable (some colourants give off toxic fumes). Ready access to water is essential for wetting and cooling tools in hot working and not least for safety purposes. Floors, if concrete or quarry tiled, can be laid to drain away water used in hosing down.

Both extremely basic and highly sophisticated studios exist and work. Peter Goss created a superb high-tech one-man set-up in a domestic garage in Queensland, Australia. Perhaps the most compact and yet best-equipped workshop that I have ever seen was that of Seiki Tanagawa, situated in a small room on the ground floor of an apartment block in central Tokyo, all white tiles, stainless steel and computerised controls. Another, that of Makoto Ito, surely has one of the best views – overlooking Mount Fuji.

At the risk of being taken for a travelogue I could ramble on about the beautiful, well-organised or simply quaint studios I have visited: David Kaplan and Annica Sandstrom's stunningly converted watermill at Lindean on the Scottish borders, with a furnace by Durk Valkema; the Glasshouse, originally in Covent Garden, London, and now in Islington, a showpiece with excellent equipment designed by David Taylor; the Monods' superb workshop high in the mountains above Cannes on the French Riviera; Claude Morin's basement in Dieulefit; Petr Novotny's sitting-room studio in Novy Bor, Czech Republic – one of the first 'private' studios in Eastern Europe; the vast 'factory' in Oakland, California, where John Lewis pours massive castings direct from a specially constructed furnace. Amongst the most idiosyncratic was Charles Ramsay's jungle of scaffolding at the old Marmite factory in London, not to mention my old workshop overlooking the Thames at Rotherhithe, which I was told had 'character' – a euphemism, I suspect. An advantage of being self-employed is that one

can choose one's working environment and possibly sacrifice proximity to the 'market' for often less expensive and more congenial surroundings. Penland, in North Carolina, the glorious setting for a host of studios and a thriving community of glass artists, is far from being the most accessible.

Furnaces

Furnace design has become a great deal more sophisticated since the 'historic' collaboration between Littleton and Labino at the Toledo Seminars of 1962, particularly in the areas of temperature control and insulation, with consequent energy cost saving.

Pot furnaces: Currently the majority of studios seem to favour 'pot' furnaces which employ a cast siliminite crucible or clay pot as the container for 150–300lb of glass in an average two or three person workshop. The pots are usually free-standing within a furnace structure of high-temperature insulating materials in a metal framework. Burners tend to be placed so that heat circulates and exhausts on the same side as the burner but at a lower level. Innumerable design variations are possible: one or two pots, up or down draught, the use of waste heat for annealing or to preheat the incoming air supply to the burner and so on. A possible advantage of the tank furnace is that it may last several years whilst pots have to be changed sometimes as often as every six months, at considerable cost in lost production time. However, a well-designed pot furnace, free of hot or cold spots and therefore less prone to variations in temperature, will generally produce a superior melt, with fewer defects running through the glass, such as cord (or striations).

Pot-changing in a factory is one of the most dramatic sights imaginable. A furnace may contain several pots and cannot therefore be allowed to cool, so the operation has to be carried out rapidly, at high temperatures. Figures completely swathed in protective clothing and starkly illuminated by the glare of the furnace evoke a scene of medieval torture and sorcery as the front wall of the furnace is dismantled, the broken pot removed, a new pre-heated pot installed and the wall quickly replaced.

Electric furnaces: Electricity is usually a more expensive fuel than oil or gas but a number of studios have turned to electric furnaces because they are silent and relatively fume-free. Mikko Merikallio of Finland is something of a technological wizard and a staunch conservationist. He has followed up his previous brilliant energy-saving efforts, which included growing, harvesting and pressing sorgum to obtain the oil for fuel, with a low-energy cullet-melter which is so well insulated that it uses roughly the same amount of power as an electric kettle to melt 150lb of glass. Using a space-age insulating material (Microtherm) he calculates that he can cut energy consumption from an already low 3kW per hour to a staggering 1kW – equivalent to under 0.82 therms of gas per 24 hours.

Usual designs have the elements surrounding the pot but Harvey Littleton has for some years been melting in an electric furnace which incorporates fused-tin electrodes which project into the glass itself. His furnace consists of two parts separated by a common perforated wall through which the molten glass flows from the melting chamber to the gathering chamber giving a continuous supply of high-quality crystal.

Gloryholes: These are reheating chambers and vary from heated brick boxes to, most commonly, 40 gallon oil drums lined with ceramic fibre. The working temperature will normally be 100–200°C higher than the furnace temperature.

Glassblowing

For centuries glassblowing has been primarily a team activity carried out behind closed doors in factories by groups of men working with balletic precision. The timing and dexterity of movement, the intensity of heat and colour provide a dramatic and fascinating spectacle. The choice of a glasshouse as an intimation of Hell in Joseph Losey's film version of Mozart's *Don Giovanni* is particularly apt, for such it frequently is. Yet the glow of the furnace, the glaring heat and sweat on one's face, the speed and rhythm of work, and the mounting tension as a piece nears completion, are addictive; these, together with the exhilaration (or otherwise) experienced on opening the annealer to view the previous day's work, contribute to its unique appeal

In the early days, at the outset of the studio glass movement, the ethic of truth to material as derived from studio pottery was fundamental. It was considered essential to handle the piece oneself from

beginning to end, thereby rejecting the traditional separation between designer and maker. Although there are many artists who continue to adhere to this principle a gradual shift back to teamwork has occurred as pieces have become more ambitious in scale and complexity. Assisted or collaborative work has become the norm. It has been said that to train a glassmaker to industrial standards can take ten years and even longer to become a 'gaffer', and this may well be true in the production of the repetitious, often dull, mechanical-looking articles that flood the market. Obviously as with other crafts, considerable practice in handling both the tools and the medium is required before one can develop the necessary skills to control shape and colour to the desired consistency of quality. Nevertheless when the intention is to explore ideas through this uniquely responsive material, rewarding experiences and exciting results can be achieved in a remarkably short space of time.

The term glassblowing causes some confusion in that it refers to furnace-worked glass and also to lampwork (or flamework) whose main application has traditionally been in the manufacture of scientific glassware, as well as of jewellery and glass animals. In recent years, fine decorative work has been made by lampworking techniques which are described in a later section.

In this book, 'off-hand' or 'free-blown' glass refers to that which is gathered from a furnace and manipulated while being rotated on a hollow blowing iron, although this does not preclude the creative use of a mould at some stage of the blowing process.

Over the last two thousand years glassblowing techniques and tools have altered very little, although there are considerable geographical and individual variations. In parts of Europe glassmakers work standing rather than sitting at a chair; in Scandinavia the parison is blocked while the blowing iron is rolled in one direction only, in Britain it is blocked as it is rolled back and forth, and in Egypt and Afghanistan the short blowpipes are rolled over the crossed legs of the blower as he sits on the ground; at least one Japanese has used a glass blowpipe, some makers prefer wooden blocks, others paper pads; sometimes, as in France, the marver is a small metal slab set chest high and sloping forward, elsewhere it is large, set lower and flat, and so on. The variations, combinations and developments in the basic areas of hot and cold-

working have multiplied in recent years to the extent where there now seem to be almost as many ways of working glass as there are people working with it. Highly sophisticated techniques exist for creating complex forms, patterns and colour effects, in some cases requiring the use of multiple blowing irons. The following is a brief introduction to basic technique.

Gathering
The heat, colour and fluidity of the material, its responsiveness and malleability are what make glass such an exciting medium to work with. Its behaviour when gathered from the furnace is difficult to describe; to say it is alive and has a will of its own may seem trite but I cannot think of a better way of expressing it.

The molten glass is toffee-like, almost syrupy in consistency so the first problem is how to gather it onto the blowpipe and once there, how to keep it from dribbling away onto the floor. The end of the iron (blowpipe or punty) is preheated to a dull red heat, otherwise the glass may either not adhere or may chill too quickly, making it difficult to blow the first bubble. The iron is dipped into the molten glass at a shallow angle so that it covers an inch or so up the pipe, which is simultaneously rotated, gently raised and withdrawn so that the glass spirals off the end of the ball-like gather. As it is being carried from the furnace to the marver or chair, the iron is held more or less horizontally and rotated continuously to overcome the gravitational pull on the glass.

Marvering
The gather is rolled from side to side on the marver, usually a polished steel slab, to centre and shape the parison. The marver has a chilling effect that creates a surface tension against which to blow.

Blocking
This is another way of keeping the gather symmetrical and centred and may be an alternative to marvering. In this case the pipe is rotated as it is rolled along the horizontal arms of the chair. The hand-held fruitwood forming block (a semi spherical cup-mould) cradles the glass, moving with it, at once shaping it and polishing the surface. The

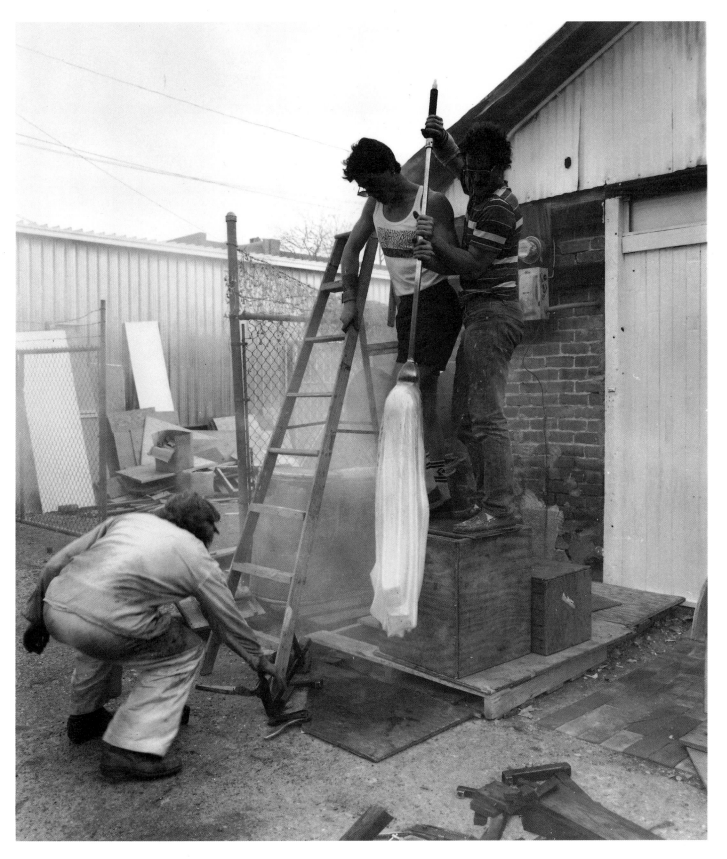

William Morris, USA (and team) blowing a large
Standing Stone form into a demountable wooden mould
(photo: John Baldwin, courtesy: Heller Gallery)

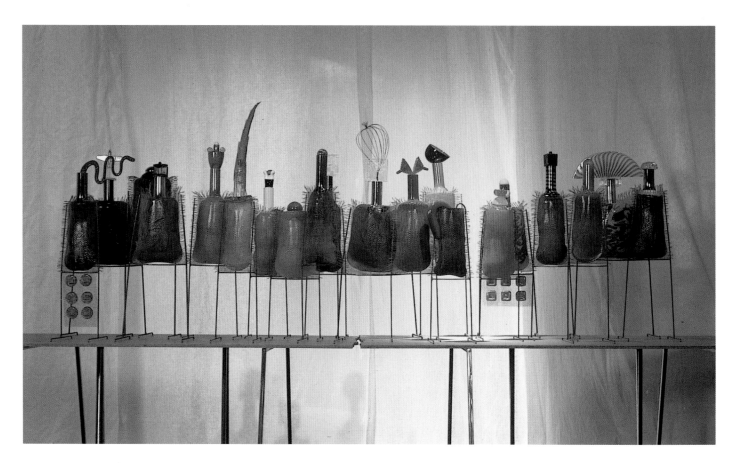

Markku Salo, Finland: *Still Going Strong*, 1991
glass blown into wire mesh

block is kept wet and has the same chilling effect as the marver. The parison usually becomes spherical or pear-shaped, whereas on the marver it tends to be cylindrical or conical. Pads of wet newspaper are more versatile and are often used in preference to wooden blocks and although one cannot actually touch the hot glass as in pottery, there are many occasions during the shaping of the piece when only a thin wet paper pad protects the palm of the hand from the molten glass.

Blowing

Glassblowing is entirely a matter of timing. It does not require a great deal of 'puff', provided that the glass is at the right temperature. Blowing up a balloon can be much more exhausting. The colour of the glass is a good indicator as to when to blow; generally when the initial bright orange glow has begun to fade and the 'gob' is a beautiful rosy colour. If it has lost its colour altogether then it is probably too cold and too difficult, perhaps even

impossible, to blow at all without considerable re-heating. If it is too hot then it will be hard to control and will blow out unevenly. A gentle steady blow should be enough to introduce the air bubble into the 'gob'. Another method is to seal the mouth-piece of the pipe with the thumb immediately after blowing; as the trapped air is heated it expands forming a bubble within the gather. Now termed the parison, the shaped glass should be allowed to cool and consequently stiffen to some extent before more glass is gathered, otherwise it may collapse. Keeping the parison 'on centre' is basically similar to centring clay in pottery – in that centrifugal force or gravity pulls the form off centre. In glassmaking, gravity is put to work. The speed at which the pipe is rotated is adjusted to correspond with the rate of sag so that in effect the glass continuously falls on-centre.

Necking or cutting-in

The neck of the parison is gently squeezed between the arms of the pucellas (tongs) or 'jacks' as it is being rotated. This creates a groove at the point, just off the end of the blowing iron where it is desired to 'crack off' the piece.'

Shaping

Shaping can be achieved in a variety of ways through a combination of gathering, marvering, blocking, blowing, swinging (the parison being held vertically so that the weight of the glass stretches the form), paddling (parts of the form are flattened with a bat-like tool), cutting in with the pucellas or 'jacks', applying hot glass 'bits' or taking small window gathers onto the surface to be manipulated with, say, tweezers or shears, or blown out. Moulds are sometimes used to provide certain basic shapes. The bottoms of forms are normally flattened with the paddle or pucellas, or made concave with a dimple or 'kick', as in wine bottles, to take the pontil or punty. During all these procedures it is essential to keep the parison at the correct working temperature. It can be reheated in the gloryhole or allowed to cool as necessary. If it is too hot it may blow out unevenly and if too cold it may crack or shatter, and perhaps drop off the punty iron altogether. Some of the 'best' pieces end up in the rubbish bin.

In order to work on the neck, to finish a rim or to open up a cylinder or sphere to form a bowl or plate, the shaped piece must be transferred to the punty. A small gather is taken on a preheated punty iron, marvered and attached to the centre of the base and the piece is then cracked off the blowing iron, with an opening that can be reheated to a workable state. The piece, now reversed, is returned to the gloryhole first, to 'warm in' gently. Again timing and, of course, the temperature of both the piece and the punty are critical. The neck or rim can be finished as desired by the use of finishing jacks (sometimes with fruitwood or paper dowels) to open or close the form. On completion a sharp tap to the punty iron close to the piece should be enough to release it for transfer into the annealing oven.

Dale Chihuly, USA: *Transparent Mauve Sea Form Set with Black Lip Wraps* (nine parts), 1987
23in. × 7in. × 18in. high; freeblown glass forms with dip-moulded colour and pattern (photo: eeva-inkeri; courtesy: Charles Cowles Gallery, Inc.)

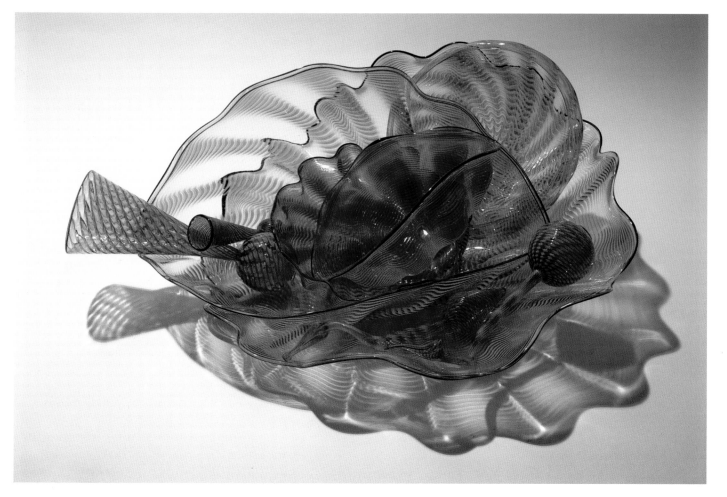

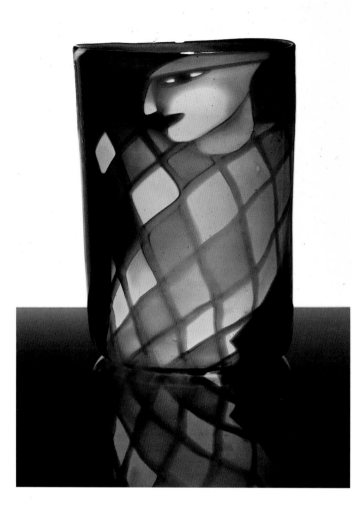

David Kaplan, USA/UK, and **Annica Sandstrom**, Sweden: *Harlequin and Cat Woman*, 1988
19cm diameter × 25cm high; Graal technique

Finishing

When the object has cooled it may require embellishment (see **surface techniques**), or 'finishing'. Some makers like to preserve the puntymark as a sign of authentic handworking, while others prefer to grind and polish it out using a flatbed or puntywheel grinder.

Colour

Glass rolling

Glass rolling powders, granules, fragments or shards, and canes are available in a vast range of beautiful colours and these can be picked up from the marver, dusted on or flameworked into the hot glass. Similarly, additions of melted colour can be applied as trails or prunts at various stages in the process.

Casing

Casing or 'underlay' entails gathering or melting a small amount of coloured glass on the end of a blowpipe. This is then gathered over or *cased*, with clear glass from the furnace and blown. The thin skin of colour so formed on the inside of the bubble creates the illusion that the glass is coloured throughout as the piece is fully blown out.

'Overlay'

'Overlay' is a technique whereby colour is over-gathered, or else preheated pads or cups of coloured glass are stretched and marvered to cover the parison. This technique can provide layers of colour within a thick or solid piece or over the outer surface as in cameo glass. One or more layers of compatible colour may be applied and these can be sandblasted or cut through when cold.

Graal glass

This is a process developed in 1916 by Simon Gate at Orrefors which has regained popularity amongst contemporary glassmakers. It involves making a small parison or embryo with colour overlays and annealing it. A design is then cut, sandblasted, etched or engraved through the layers of colour and the embryo is reheated in a kiln or lehr to a temperature at which it can be re-attached to the blowing iron. After being reheated at the furnace or gloryhole to soften and smooth out the design, it is gathered over and blown out. The design then expands and adapts as the desired shape is developed.

Ariel glass

This development of Graal requires even deeper cutting of the embryo; when more glass is gathered air traps (bubbles) occur in a predetermined design or pattern.

'Paint and blow'

David Hopper, a former partner in Orient and Flume, a Californian company that has specialised in reproducing Art Nouveau glass, developed a variant on the Graal technique, called 'paint and blow'. He discovered a range of high temperature enamels, designed for the steel industry, which, when applied to a cold embryo and reheated, could

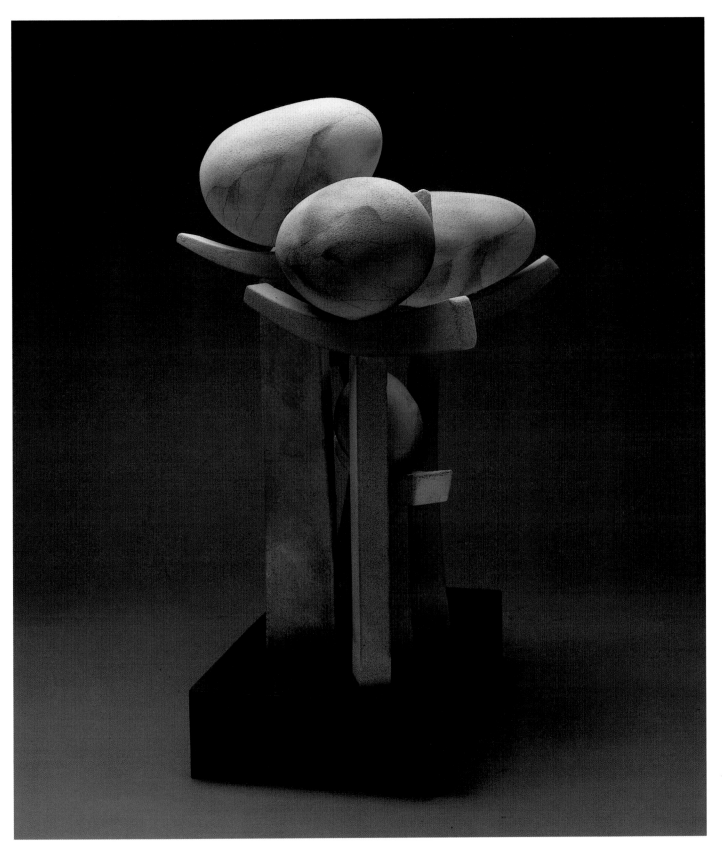

Tom McGlauchlin, USA: *A Wandering Tribe of Five*, 1986
20in. × 19in. × 26in. high; freeblown, dusted-on colours,
sandblasted, assembled

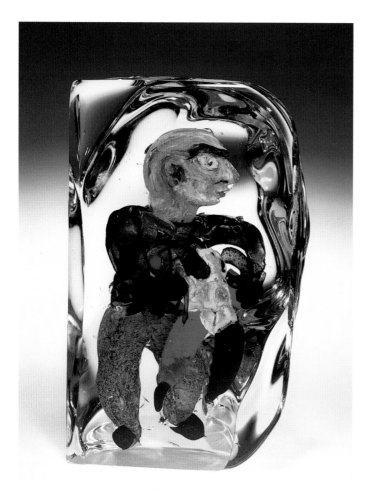

The most commonly-used salt is stannous chloride, sometimes combined with proportions of other salts such as ferric or barium chloride, bismuth, strontium or silver nitrates. All such materials are toxic and must be handled with caution. Skin contact should be avoided and adequate ventilation or preferably a fuming cupboard must be provided. Iridising or fuming is usually carried out at the final stages of the making process, with the piece being rotated in the vapours rising from a tray of heated crystals or the hot glass sprayed with a solution containing the salts dissolved in water or alcohol. The latter method is more efficient and controllable. Frequent reheating in a light reduction flame seems to produce the best results. A theory which I have not yet tested is that partial iridescence can be achieved by painting an acid solution of the salts onto certain parts of the cold piece and refiring. Iridescent glass is neither matt nor glossy and has a luxurious, quite opulent quality which, though very appealing, suffers in contemporary terms from a pervasive association with the Art Nouveau period.

David Hopper, USA: *Man with Terrified Female*, 1986 9½in. × 3¼in. × 14in. high; hotworked man's head and female figure pre-made (sandblasted, carved, painted, reheated and attached to man's body); gathered over in clear glass

be overgathered and blown. The painted image suspended within the mass of clear glass retains the quality of detail in the brushstrokes. Hopper markets these enamels as 'Paradise Paints'.

Iridescence

Delightful iridescent effects akin to oil on water or the colours of the wings of certain beetles and butterflies or excavated glass can be achieved through the brief exposure of hot glass to fumes given off by certain metallic salts. The vapours attack the glass surface, breaking it into myriad microscopic facets which cause a visual phenomenon known as thin-film interference, wherein the incident white rays of light are absorbed so that no single colour is reflected but rather the spectrum in a rainbow-like effect.

Lampwork

Until recent times the only contact that members of the public had with glassmaking was the occasional glimpse of little glass animals being made 'at the lamp'. Norman Stuart Clarke, a former colleague and a great romantic, used to say that he was inspired to take up glassmaking by his childhood memory of watching for hours, fascinated, a lampworker's magical production on Brighton pier.

In the flame of a blow-torch – not unlike that of a powerful Bunsen burner – lamp or flameworked glass is made by the constant reheating and manipulation of rods, tubes and canes of compatible glass. Nowadays these tend to be of borosilicate glass, e.g. Pyrex or 'hard' glass, which melts at a very high temperature and therefore requires sophisticated and efficient multi-jet gas-oxygen torches. Many of the commonly used colourants burn out at these temperatures, so there is a fairly limited range of colours. In many areas however, including Murano and parts of Bohemia and Thuringia (Germany), the glass rods contain high proportions of soda or lead and these 'soft' glasses allow for lower working temperatures and a far

greater variety of colour and detail. In the past, the 'lamps' were tin cups with a wick, fuelled by oil, tallow or hot coals and incorporating some form of bellows to create a more intense heat. These were in use until the gas blow-torch was introduced in the late nineteenth century.

During the years from 1887 to 1936 Leopold and Rudolf Blaschka of Dresden, father and son, together created the astounding Ware Collection of glass models of plants for Harvard University.

They devoted much of their working lives to making 847 incredibly accurate, life-size plant models, as well as 3000 examples of enlarged details of the flowers and anatomical sections of both floral and vegetative parts of plants for the collection which constitutes Harvard's greatest single public attraction with over 100 000 visitors annually. It has been said that they are 'an artistic marvel in the field of science'. Their packing for shipment was in itself considered remarkable.

Also of immense importance are the hundreds of marine invertebrate specimens they produced. Many of these are now the property of Cornell University where it is intended to display them as a collection. It has been observed that, as pollution threatens coral reefs and other habitats, the Blaschka models may one day provide posterity with the most accurate replicas of species that have become extinct. The same attention to minute detail lives on in a continuing series of fantastic paperweights by the American artist Paul Stankard.

During the nineteenth century the community of Lauscha, in the long-established glassmaking area of the Thuringian forest, became renowned as a lampworking centre. In every home, in scores of tiny workshops, every member of the family helped in the production of a vast range of artifacts that included dolls, animals and flowers, as well as a lucrative trade in Christmas tree ornaments, glass eyes and beads.

These activities were viewed with disdain by the scientific glassblowers in surrounding communities, who regarded their own specialised skills as superior, since the manufacture of highly-intricate apparatus for laboratory and industrial use clearly demanded great precision and craftsmanship. Nevertheless after decades in the shadow of such virtuosity, it was the ingenuity of the Lauscha glassworkers that ultimately gave rise to the exploration of the artistic potential of lampworking.

Leopold and Rudolf Blaschka, Germany: *Glass model of Winter Astor*, c. 1930
example of lampwork similar to that of the botanical collection at Harvard University (© 1984 The Corning Museum of Art)

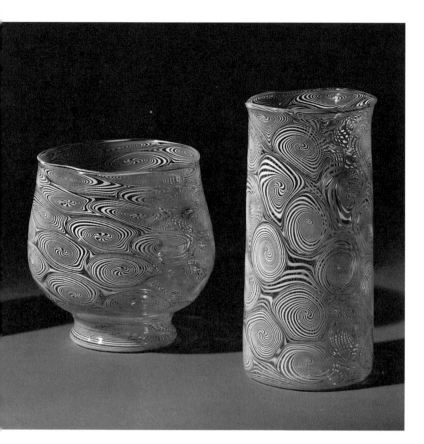

Albin Schaedel, Germany: *Vases*, 1977
left: 9.5cm diameter × 9.5cm high
right: 7cm diameter × 14cm high
lampworked: white threading applied by 'montage' technique (photo: Klaus G. Beyer, Weimar)

Much of the early lampworked Studio Glass continued the decorative tradition inspired by the exquisitely fragile goblets with attenuated stems of the Art Nouveau glassmaker, Karl Koepping.

However, Albin Schaedel, who lived and worked near Lauscha, had experimented during the late 1940s and pioneered methods of utilising twists and preformed canes with coloured threadlike inclusions. These were laboriously overlaid onto embryo vessel forms to create complex and delicate patterns which were, when blown, not unlike latticino in effect. This 'montage' technique inspired an entire generation of local talent that includes such established figures as Albrecht Grainer-Mai, Otto Schindhelm, Walter Baz-Dolle, Hubert Koch, Hartmut Bechman, Kurt Wallstab and many others.

Lampworking is a popular and accessible art form in Germany with many distinguished practitioners of whom Kurt Wallstab is the acknowl-

edged master, renowned for his bold and dexterous use of pure transparent colour.

When Volkhard Precht, an established lampworker, built his first furnace in 1963 he was unaware of the events that had taken place in Toledo the previous year. Others, including Günther Knye, followed his example. Both the Prechts and the Knyes have continued the Lauscha tradition of working as family units. Producing both lamp and furnace work they often combine the techniques in more individual pieces. A parison, decorated at the lamp, is picked up on the blowpipe, overgathered and completed at the furnace. Precht is well known for vessels with romantic landscapes while members of his family have developed in more experimental directions.

Theo Sellner and Pavel Molnar are amongst those who have worked extensively to combine lamp and furnace techniques. Sellner, whose current totemic sculptures are kiln-cast, achieved Graal-like effects in earlier blown works to express the mystical symbolism of the Bavarian forest.

Several artists in the USA, notably Mark Peiser, developed techniques of actually 'drawing' with coloured canes on the hot parison while blowing. He used a torch and thinly pulled canes in a lengthy process that looks rather like welding. The partnership of Flora Mace and Joey Kirkpatrick evolved a form of *cloisonné* by embedding copper wire 'drawings' into the glass surface as outlines and using the torch and cane method to fill in with colour.

Outstanding in terms of wit and skill are the elegant fantasies of Susan Plum (USA), Anna Skibska (Poland), Lucio Bubacco and Gianni Toso (Italy).

The relatively low cost of equipment, materials and fuel, and the intimate scale of operation and of the resulting pieces, make lampworking a rewarding and extremely fertile area for exploration and development.

Neon is an important aspect of lampworking that has become increasingly relevant in creative terms. Historically it has been used almost exclusively for advertising and display, functioning in the realms of folk art, especially in America where cities like Las Vegas seem to owe their very existence or, at least, their visual character to the pulsating several storey-high coloured light structures. Despite the apparent cultural and environmental overload and, in large part, because of it, a number of important artists and designers have chosen to explore its unique potential as a kinetic medium. To this end,

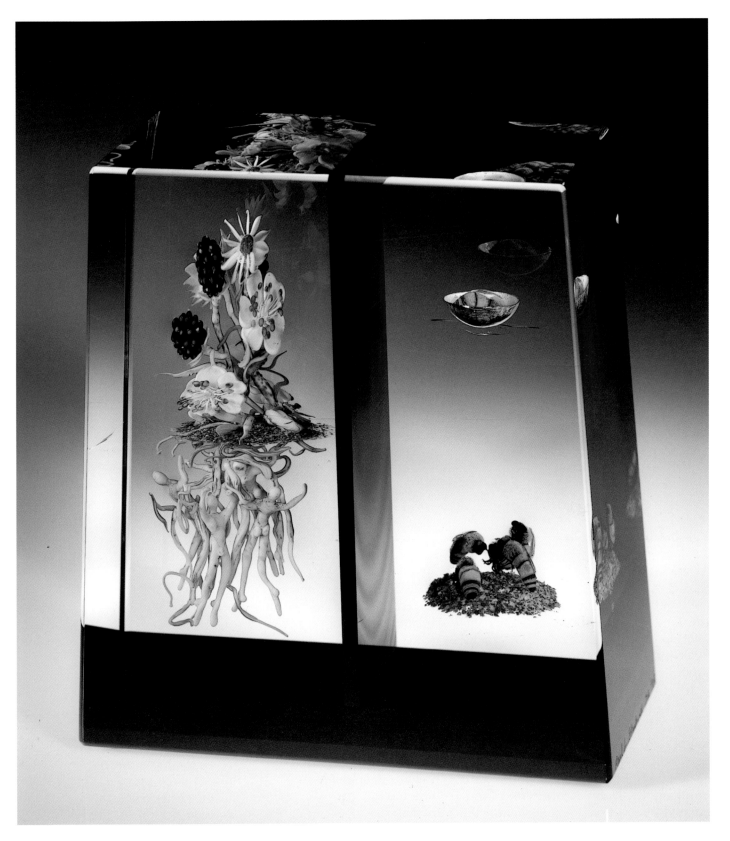

Paul Stankard, USA: *Diptych with Gold and Honeybees,*
1995
lampworked elements encased in clear glass (photo: Michel
Wirth, courtesy: Galérie Internationale du Verre, Biot)

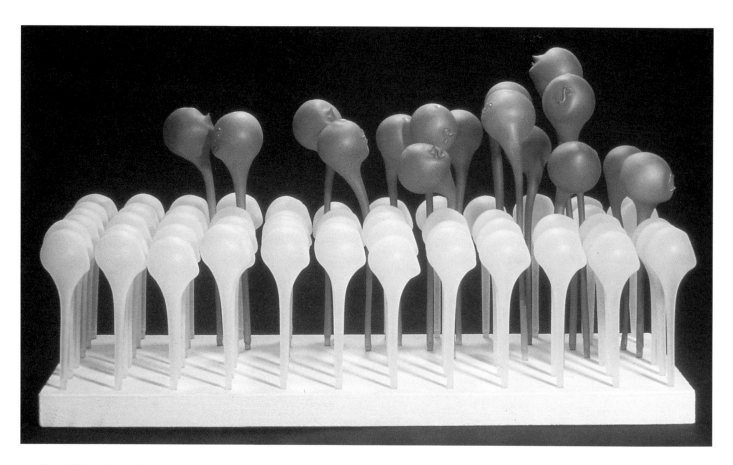

▲ **Eka Häberling**, Switzerland: *Some of us live*, 1987
59cm × 39cm × 45cm high; lampworked glass

Theodor Sellner, Germany: *Eoresta*, 1989 ▶
28cm wide × 37.5cm high; kiln-cast by *cire perdue* process
(photo: Christiane Sellner)

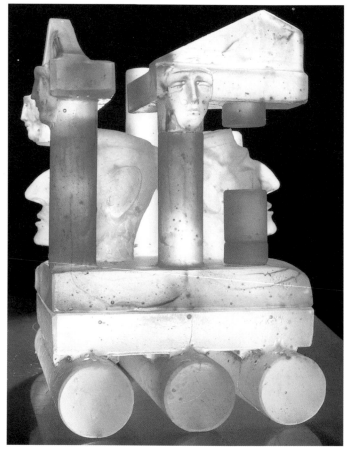

the facilities and tuition provided at Rudi Stern's neon workshop and at the New York Experimental Glass Workshop (now Urban Glass) have been pivotal.

In the early 1970s James Carpenter and Dale Chihuly incorporated neon and ice in large installation pieces. Chryssa, Stephen Antonakis, Ray King, Paul Seide and Brian Coleman have used the medium extensively, in highly sophisticated sculptural solutions to both domestic and architectural applications. Dante Leonelli and Fred Tschida have carried out radically experimental land art works. Peter Freeman is currently its main exponent in Britain, while Lilianne Lijn has successfully incorporated neon into large site-specific pieces in the past, as have Yan Zoritchak in France and Warren Langley in Australia.

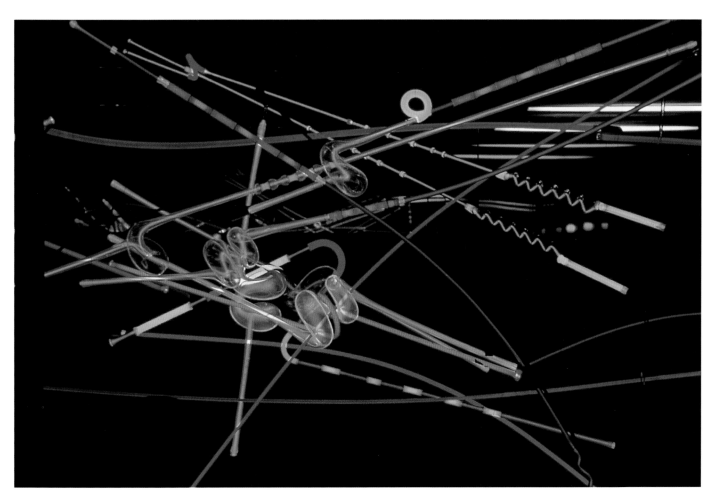

Brian Coleman, USA: detail from *Untitled Wallpiece*, 1992
borosilicate glass tubing, neon (photo: G. Erml, courtesy: Cathérine Vaudour, Région de la Haute Normandie)

Casting

The term casting covers several quite different techniques of forming glass in a mould; some involve pouring molten glass while others require the heating in a kiln of cold glass to fusing temperatures. The choice of casting method is personal and is governed by considerations such as the desired qualities of the finished piece, the type and complexity of the model (say, whether or not it has undercuts) and, of course, available facilities such as a supply of molten glass.

For poured castings the mould can be virtually any material that will withstand the high temperatures and contain the required volume and weight of glass. Sand, graphite, metal, clay or various refractory materials (e.g. carved insulating brick or ceramic fibre) are suitable.

Sand casting

This extremely exciting and immediate way of working was pioneered, developed and perfected by Bertil Vallien of Sweden. It is a simple process which allows great flexibility in design as each model can be pressed in the sand quickly and uniquely. Virtually any sand can be used mixed with the least possible amount of water to bind it; alternatively a more complex mix of sand with small additions of powdered clay or bentonite, ground charcoal and water, is sieved and packed into an open-topped container. Excessive water will create steam, causing large air bubbles when the glass is poured, while too little will cause the mould to crumble and collapse.

The model or stamp made from a rigid material without undercuts, possibly a 'found object', is pressed into the sand creating a negative impression

when removed. A light dusting of enamel or glass rolling powder prior to the ladling of the molten glass is a popular way of introducing colour. When the poured form has cooled to the point at which the coloured glow has almost disappeared, it can be released from the sand, wire brushed and placed in the annealing oven. Surface texture and form can be modified by coldworking when the piece has cooled.

The innovative Vallien now makes enormous and sophisticated pieces with coloured inclusions that require two- and three-part sand moulds.

Kiln-casting including *Cire perdue* ('lost wax')
Kiln-casting requires moulds prepared from an investment material which may be proprietary, or else a half-and-half mix of plaster and potter's flint.

The model can be made from any appropriate material: clay, plaster and wax are common, as are wood, metal and plastic. After investment the model is removed from the mould. If made of wax, the model can be steamed or burned away. For easy release of mould from model, primary moulds or master copies of the model can be made in a synthetic or silicone rubber that is flexible and easily separated or detached.

The refractory mould, with its aperture at the top, is set in a kiln. A funnel-like reservoir known as the spare is placed over the mould and packed with glass in granule, lump or block form. Glass colourants or reactive chemicals may be distributed through the glass to influence the visual appearance of the fired piece.

When heated to the appropriate temperature (usually between 800° and 1000°C) the glass settles and melts down, draining to fill the mould below. Pieces produced in this way are often solid or very thick in section and therefore need long and careful annealing. When cold, the mould material is carefully broken away and removed so that any detail or texture from the mould will be preserved. The glass form can then be finished. Entire surfaces or selected parts can be ground or sandblasted to alter the shape and then polished if desired, a process that often reveals surprising and quite magical internal effects.

Pâte de verre
A confusing tendency, particularly in France and Japan, has been to call all kiln-cast work *pâte de verre*. Literally translated as glass paste, it is achieved by mixing finely crushed glass with a binder, e.g. water and gum arabic, together with powdered colourants such as enamels. The resulting paste is applied in layers as a coating to the inner surface of a negative mould which is then fired in a kiln to the fusing temperature of the glass. When cool the mould is removed to reveal the glass form, thin and delicate or more substantial and solid, depending upon the application of the paste. A closely-guarded secret that was frequently lost, this technique, like so many others, has had to be re-invented from time to time in very personal and idiosyncratic ways.

Kilnforming

The early history of glass contains many examples of wares produced by kilnforming techniques such as fusing, slumping and sagging which are based on the principle that glass deforms (bends, stretches or flows) under the influence of heat and gravity.

These techniques were developed from ceramic and metalworking technologies by the Egyptians and Romans and were used to great effect in the making of fused cane inlays as details for furniture and jewellery, tiles and marvellously intricate mosaic bowls. With the advent of glassblowing and its subsequent dominance as a quick and economic means of production, the laborious and time-consuming heatforming processes fell into decline and disuse.

Creative techniques obviously demand an awareness of the behaviour of the materials in process. Less direct than glassblowing, kilnforming requires a careful approach to the preparation and organisation of components. Visual control of the firing cycle and an ability to predict the behaviour of the glass when heated are highly desirable for these processes.

Fusing
'Fusing' is the term applied when compatible vitreous materials are heated until they bond. At low temperatures they may simply sinter and stick and at sufficiently elevated temperatures the component parts will melt and flow together. Layered fused sandwiches of clear or coloured glass, enamel, metal foils, etc. are known as laminations, although confusingly this term applies also to assembled

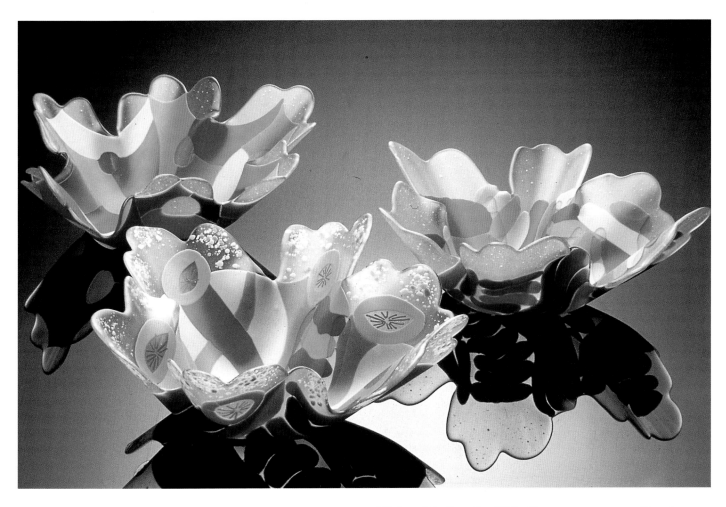

Richard LaLonde, USA: *Post-contemporary Vessels* 18in. × 18in. × 6in. high; glass fused and slumped; matt finish

work in which the layers are bonded mechanically with high technology glues or some system of bolting.

Fusing is often used in conjunction with other related techniques such as slumping, sagging, forming, bending, draping and moulding all of which variants derive from the ability of glass to deform under its own weight as the temperature is increased towards the softening point.

Slumping

'Slumping' is defined as 'bending without noticeable change of the thickness of the cross-section of the glass'. For this process, the glass is supported in the kiln by a positive or negative mould so that little or no stretching occurs.

Sagging

'Sagging' refers to 'the downward sinking of the glass' where not all the weight of the glass is supported as it softens when heated, and where the thickness of the cross-section changes noticeably because of stretching.

Richard LaLonde, USA

Over a number of years Bullseye Glass of Portland, Oregon, have developed a brilliant range of compatible fusible coloured sheet glass and they have been very active in promoting both their products and the fusing processes that use them, often referred to as Warm Glass.

Richard LaLonde has worked extensively with Bullseye Glass to develop and apply the materials. His output is prolific and has included an exciting series of slumped flower-form dishes and numerous architectural commissions. For some of these he developed new methods of colour application akin to American Indian sandpainting, using crushed granules of coloured glass fused into panels. His style is rich and exuberant with a flamboyant use of symbol and colour.

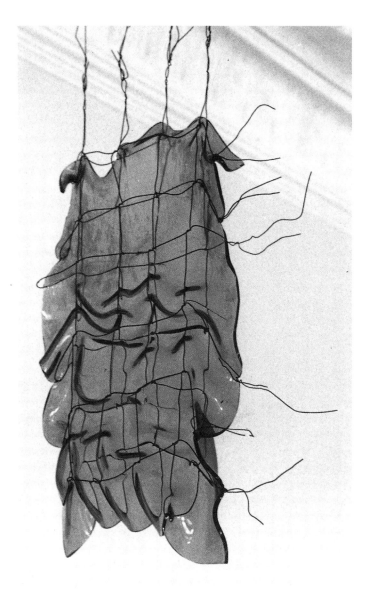

Mary Shaffer, USA

The 'pursuit of vision' seems a wonderfully apt credo for an exploration in glass, as too is the idea of freezing form and motion, which has a similar appeal to that of capturing a moment in history with a camera. Chance, control and timing are common factors while gravity is an additional element in the glass equation.

When Shaffer, a painter, needed a piece of shaped glass for a project, one of her instructors, Fritz Dreisbach, suggested that slumping might have possibilities. Since then, along with Sid Cash, though taking an entirely different path, she has done more than anyone to extend the vocabulary of slumping through her experimental and inventive use of metal armatures (wire, nails, coathangers, suspended webs and grids) – literally 'stretching limitations and risking flops'.

The scale of her sculptures varies from small hand-held pieces to vast 60ft high commissions. Among the most significant is a series of 'edge' pieces. In these the glass is gripped by its edge in a slot cut into a heavy metal upright and slumped. Results range from broken glass in the slot to full-length glass drapes – invariably the glass/metal coupling is compelling in its contiguity and tension.

Mary Shaffer, USA: *Hanging Piece*
53cm long; kilnformed; slumped over suspended wire armature (courtesy: Musée/Atelier du Verre, Sars Poteries)

Heat deformation may therefore occur into a negative or over a positive mould, or as a combination of the two, or else through apertures in a metal or wire former. Moulds can be made from a variety of materials including mixes of plaster and silica (e.g., potter's flint), fired clay, metalwork or refractory materials (e.g. proprietory investments), and ceramic fibre in paper, blanket or mouldable form. Most mould materials require the application of a separator to prevent the glass from sticking.

Amongst the pioneers of modern kilnforming practice in the late 1940s were Michael and Frances Higgins. Choosing what was then considered a very unfashionable medium, basically window glass, they developed slumping methods that combined fusing, gilding, enamelling and laminating techniques to produce handsome individual pieces, mainly in the form of shallow bowls, plates and plaques.

The Bullseye Glass Company of Portland, Oregon, was started in 1974 by three glassblowers and is one of several companies now producing high-quality hand-cast or rolled flat glass, primarily for stained glass work. During the 1980s the company researched and developed an extensive palette of compatible fusible coloured glasses. The enthusiasm of its directors, their support for artists in residence at their workshop, and their comprehensive primer *Glass Fusing*, have been instrumental in stimulating the revival of fusing as an artistic process. Access to kiln technology, lightweight re-

Christopher Williams, UK

A member of the Glasshouse co-operative (studio and gallery) in London, he utilises sandblasting and surface cutting techniques on coloured asymmetric mould-blown vessels. Previously employed as an industrial designer he has a penchant for moulded form and has in the past produced a most intriguing series from moulds with movable inserts which permit an unusual degree of flexibility of form.

Christopher Williams, UK: *Cut Melon Vase*, 1988 8in. diameter × 15in. high; mouldblown in 24% lead crystal, cased and overlaid colour, sandblasted and cut

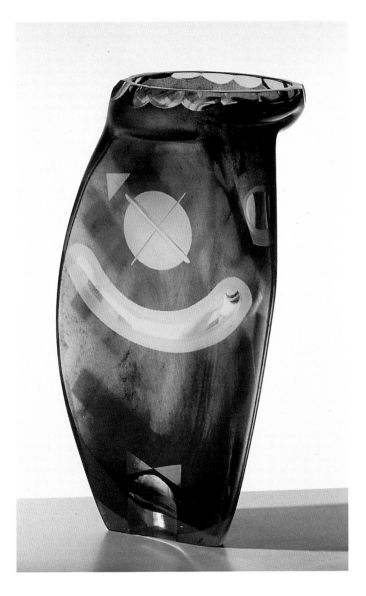

fractories, electronic control equipment and an excellent range of materials have all contributed to the growing popularity of this field. It does not require a large studio, expensive equipment, or high running costs. The glass departments at Sydney and Canberra Colleges of Art run respectively by Maureen Cahill and Stephen Procter are dedicated to exploring the potential of kilnforming techniques on both a domestic and an architectural scale.

Cutting

Most people equate glass cutting with the classic designs of Waterford and Steuben, or the factories of Bohemia and Stourbridge. Great skill and patience are required to hand-cut such traditional patterns on a lathe but increasingly this type of work is being carried out by computer-controlled cutting equipment.

The most suitable types of glass for this purpose, often referred to as crystal, are those with a high (20–40%) lead content which are therefore relatively soft and particularly brilliant when cut. While not entirely replacing sandstone, modern synthetically-bonded carborundum or diamond-impregnated wheels which come in different grades for roughing, smoothing and finishing, provide a most efficient alternative. Polishing wheels are made from a variety of materials including cork, felt, wood and composition rubber, and are used in conjunction with a slurry containing fine pumice powder or cerium oxide.

Artists who practise glass cutting employ basically the same working methods as the industry and have essentially similar concerns, namely the entrapment and intensification of light. However, the focus is different and emphasises the exploration of form and concept rather than applied decorative effects. At its best, this work is the product of intensive research into a range of visual phenomena associated with glass, the nature of light and the optical ambiguities of colour and space.

An early expression of contemporary cutting was seen in the work of Hans Model, a student of von Eiff and a patriarchal figure in German glass circles. His vessels are characterised by matt forms and surfaces, sculpted by the action of the cutting wheels, a theme carried on by Gerhardt Schechinger and in early pieces by Klaus Moje and Willi Pistor.

Most work, however, has tended towards transparent, minimal forms, abstract sculptures cut or shaped from flawless solid or laminated blocks of optical-quality glass. Precise, almost engineered, their cool perfection has tended to deny any tactile role, silently cautioning, 'Do not touch!'. The 'Optical School' as it came to be known has adherents in many countries, although it has been strongest in the Czech and Slovak Republics, where the conceptual works and teaching of Vaclav Cigler have had an enormous influence.

Surface Techniques

Glass, like clay, has infinite potential as a vehicle for graphic expression and additionally there are the challenges of transparency and the way in which the passage of light can be modulated. Graphic possibilities range between the extremes of opinion expressed by Erwin Eisch, on the one hand, who staunchly advocates that 'naked glass needs clothing' and Roberto Niederer, on the other, who always maintained that 'glass must always remain pure and unadulterated'. The case for purity of form is proven throughout cultural history but so, too, without doubt, is that for the integration of detail and embellishment to enhance or elucidate form. As in nature, ornament functions to focus attention, engage the viewer and stimulate the senses. So, too, the urge to communicate visually – to draw, scratch and make (graphic) marks recording and interpreting emotions and experiences, telling stories or illustrating fantasies – is innate in mankind. Scale, proportion and balance (not to be confused with symmetry), colour and texture are essential elements, while camouflage, or the conscious negation of form, is simply another aspect of the same concerns. Obviously the demands of fashion and commerce have always played a key role in this equation.

A number of techniques are described below which can be employed in various combinations and permutations to achieve desired effects. They are almost invariably used on cold glass.

Glass painting

Colours tend to be dense and strong when used on the surface, and have a softer, more diffused look when laminated or sandwiched between layers of glass.

Glass enamels consist of metallic oxides mixed with a flux to ensure low temperatures for melting and fusion to the glass surface. There are two main types of enamel: soft enamels, designed to fire at 540°C (1000°F) (lower than the temperatures at which most glasses deform) and hard enamels which mature at 710°C (1300°F) for use in conjunction with kilnforming techniques. As with ceramic glazes, firing cycles and temperatures are critical in the achievement of optimum fusion and quality.

Enamels usually come in powder form. For silk-screening direct or via transfer paper (decals), sponging, spraying or painting onto the cold glass, they are mixed with a variety of oil-based mediums. A range of intermixable water-based enamels also exists, providing greater ease of application.

Certain enamels, including some intended for jewellery or ceramics, can be used as rolling colours or inclusions for hot glassworking. These can be dusted through a sieve or stencil to provide an image.

Lustre decoration probably originated in Egypt. It was used extensively in Persia and was spread by the Moors through North Africa to Spain and from there to Italy. Lustres are prepared from metallic resinates dissolved in an organic vehicle such as turpentine or lavender oil. They are brushed or sprayed as thinly as possible onto the surface of the cold ware. Sandblasting or iridising the piece before it is lustred can give pleasing matt surface effects, particularly when used in conjunction with a resist to mask certain parts.

After drying in dust-free conditions the lustre is fired to its fusing temperature in a well-vented kiln that allows the medium to evaporate.

Greater variety and depth of colour can be achieved with progressive firings although care should be taken as lustres are highly sensitive to kiln atmosphere whether oxidation or reduction. Commercially-prepared lustres are readily available in a range which covers the spectrum and includes silver and gold.

There are historical precedents for an increasing tendency to overpaint glass with 'normal' (unfired) paints, e.g. acrylics, oils and automobile enamels. This stems partly from greatly improved paint technology and partly from a conceptual stance based on the ephemeral nature of art.

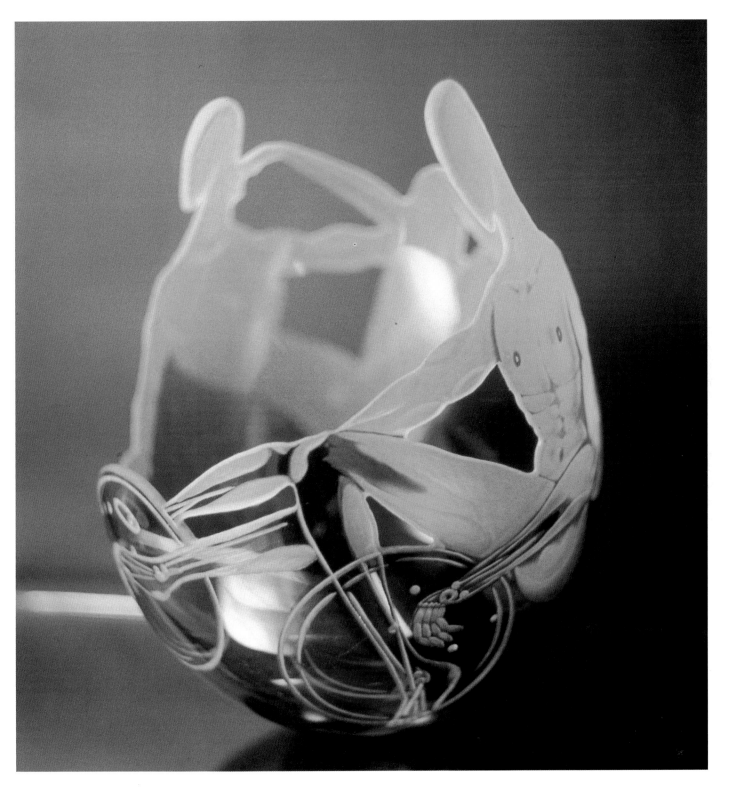

David Prytherch, UK

A motor accident that restricted Prytherch's mobility led to a more introspective approach. Complex Escher-like surface engraving has evolved into deep carving and the mature work has gained a new dimension.

David Prytherch, UK: *Life in the Slow Lane*, 1988 freeblown, cased colour; engraved, carved and pierced with flexible-drive equipment

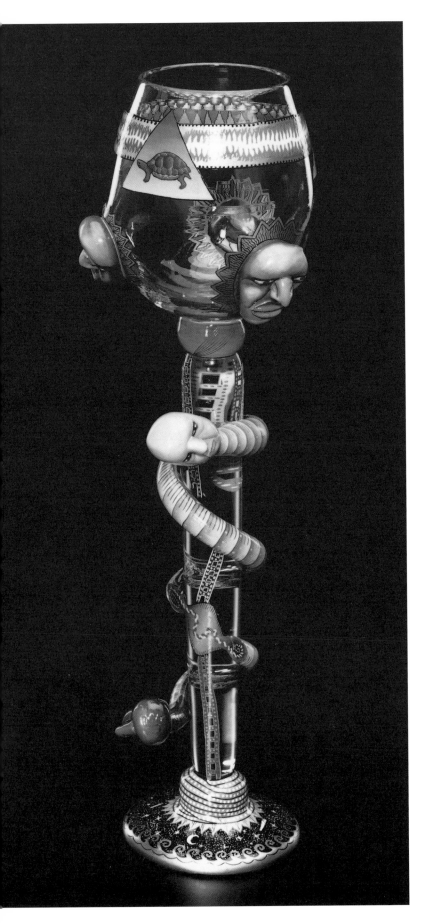

Robert Carlson, USA

Carlson's ornate vessels possess a symbolic and visual potency akin to votive or ritual artifacts. The richly-coloured paints (which are not fired in) are actually extremely durable enamels normally used in the automotive industry. The pieces are blown in sections in sandmoulds and assembled cold with ultra-violet light-sensitive glues.

Robert Carlson, USA: *Nehushtan*, 1988
8in. × 22in. high: blown glass, enamel paint, glue

Acid etching

This technique involves the controlled use of acid to eat away or cut the glass surface. Despite the considerable risk to health, it was used extensively during the nineteenth century for industrially-produced cameo-work, initially to supplement wheel engraving and later as an alternative to it. A thin layer of colour applied during the blowing process either to the outside of a form (overlay) or to the inside (underlay) or to both, or even several layers, one over another, may be etched to varying depths to reveal the layers that lie beneath the surface. Prior application of a resist material to certain parts of the surface will result in the exposure of those layers to a predetermined design.

Open forms such as bowls are very suitable for underlay etching since the resist application is more easily controlled and acid can be contained within the form. Care with the application of the stencil resist or mask material is essential. Wax, bitumen paint and leadfoil have traditionally been used, while latex, PVA glue or contact sheet (paper or plastic) work well in conjunction with etching paste. Progressive depths of cut or texture or the superimposition of one design over another require the removal, renewal or modification of the resist.

Hydrofluoric acid, which is normally used for etching glass, is an extremely unpleasant and hazardous material. Its fumes are highly toxic and acid burns can be very serious indeed since they usually remain undetected until considerable physical damage has occurred. The use of acid should be approached with the utmost caution and should not under any circumstances be attempted without full

Brian Hirst, Australia

One of the brightest stars on the Australian scene, he is fascinated by ancient hieratic cultures and has spent the past few years elaborating a series of richly lustred mould-blown vessels and wallpieces informed and inspired by Cycladic Art.

Brian Hirst, Australia: *Cycladic Series – Guardian II*, 1988
19cm × 9cm × 32cm high; mould-blown glass, cased colour, 24 carat gold lustre, engraved

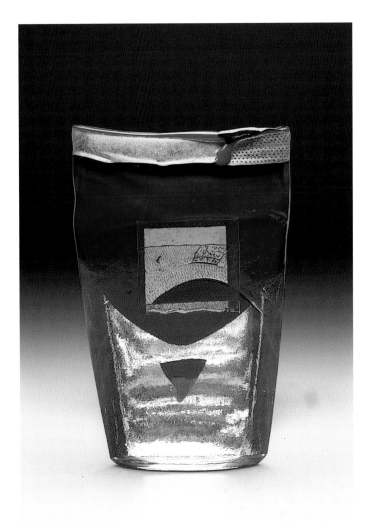

protective clothing (i.e. rubber gauntlets, boots and apron, masks for eyes and breathing). Proper ventilation or preferably extraction and the availability of running water in case of contact with the acid and for cleaning off the work are also essential, as are lidded plastic containers for the acid solutions.

Safer alternatives have been developed and there are now a number of proprietary etching fluids available which, though ineffective for deep cutting, are adequate when the requirement is simply for surface matting or frosting. Depth of cut and quality of finish, whether clear (polished), white matt or tones between, depend on the type, strength and temperature of the acid solution, the period of immersion or exposure, and the quality (e.g. hardness) of the glass. The acid can also be applied as a paste.

Sugar acid (or white acid) is a modified and relatively safe form of acid solution although it, too, should be treated with respect (masks and gauntlets are a minimum precaution). When used on its own, sugar acid gives a satin-matt surface quality after 5–10 minutes' exposure. Trial and error will establish the etch time required for a particular effect.

Sandblasting is now generally preferred as a safer and more convenient method of abrading the glass surface, although certain effects can be achieved only with acid, e.g. acid polishing. Specialist sign-makers with the facilities and expertise for etching glass and with experience of working to others' designs will often undertake this part of the process on behalf of an artist.

Sandblasting

Sand and shotblast techniques were originally developed for commercial and industrial purposes, e.g. as a viable alternative to handcarving for tombstones and as a means of cleaning building exteriors and metalwork. Nowadays, sandblasting is used extensively for the surface decoration of both vessel forms and architectural glass.

Basic requirements for sandblasting include an enclosed cabinet or booth with a built-in hopper system to catch and recycle the abrasive, a dust extractor and filter, a viewing window and an internal light, protective entry sleeves for access to the airblast gun and the work in progress. Compressed air draws the abrasive, usually silicon carbide or aluminium oxide, through the gun. According to the size and type of abrasive grit and the air pressure used, the high-velocity airborne particles will erode the glass surface to achieve a range of qualities from a delicate silky matt in a few seconds, to

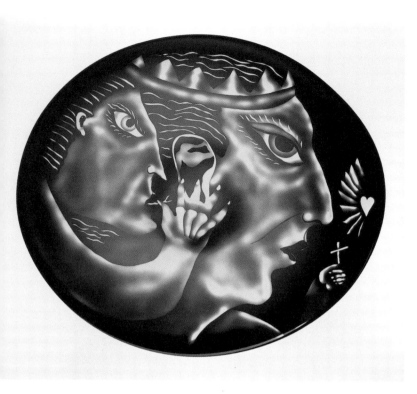

Steven Newell, USA/UK: *King's Counsel*, 1993
74cm diameter × 4cm thick; large freeblown disc, cased
colour, sandblasted (photo: Ed Ironside, courtesy: Arthur
Andersen Collection)

Steven Newell, USA/UK

An American by birth, Steven Newell came to
England to study with Sam Herman at the Royal
College of Art, London, and stayed on. Amongst his
contemporaries at the college were Jane Bruce, Dillon
Clarke and Annette Meech, and together they formed
a co-operative to manage the Glasshouse. Eventually
he moved on to a partnership with Simon Moore and
Catherine Hough to produce a range of fine, unusual
mould-blown wares alongside commissions and more
personal works.

For some years large cased bowls and platters have
provided the 'canvas' for his dreamlike narratives.
These are sandblasted through layers of colour or
iridescence, sometimes from both front and back for
greater depth or emphasis. Space and tone are used
boldly with imagination and humour, while his
enigmatic imagery becomes ever more subtle and
intriguing. Symbolic figures, mischievous chimera,
mythic beasts, fish and fowl float eternally, like the
Flying Dutchman, in idealised landscapes.

deeply-cut or textured within minutes. With more
time, solid blocks of glass can be carved or pierced.

The main skills involved are in stencil cutting
and controlling the depth of blast. Normally a con-
tact film or tape such as Fablon or 3M's Buttercut is
used, with darts cut to fit the resist smoothly to the
contours of a three-dimensional form.

Careful planning is essential, especially for elab-
orate multi-tone designs. Joan Irving, a talented
Californian artist who uses advanced sandblasting
techniques, has pointed out that the process does
not allow much room for re-working areas that
have already been blasted. A method she uses for
developing imagery and composition on her plates
is the application of photocopied parts of her draw-
ing to the masked surface. With a sharp blade she
then cuts the lines or the outlines of areas to be
blasted. Working with glass that has three layers of
colour, she begins by blasting to the deepest layer
(the background areas of deepest relief) and then
works through the many separate levels of resist to
the surface layer, highlighting details or shading as
required by adjustments to the flow of abrasive.
Some very delicate effects are achieved at low air
pressure with hand-held masking such as metal or
plastic mesh, or cardboard cut-outs that can be
positioned as desired.

Engraving

The term engraving covers various methods of
abrading the glass surface: drawing or stippling
with a hard point such as a diamond or tungsten
carbide tip; cutting and carving with profiled cop-
per, carborundum or diamond impregnated wheels.
Etching and sandblasting are now also included.

Wheel engraving is derived from lapidary
techniques which were well developed in the
Mediterranean region some thousands of years ago
and predated ceramic and metal-working tech-
nologies. Since the seventeenth century modern
wheel engraving has emerged as a strongly Euro-
pean tradition with principal centres in Venice,
Bohemia, Germany, Holland, England and France
at different times during the period.

This is a highly-skilled process in which the ware
is held against a small copper wheel mounted on a
horizontal shaft, a form of lathe that was originally
treadle-driven. It is fed with an abrasive mixture of
silicon carbide and oil that acts as both lubricant
and cutting agent. Depending on the profile of the

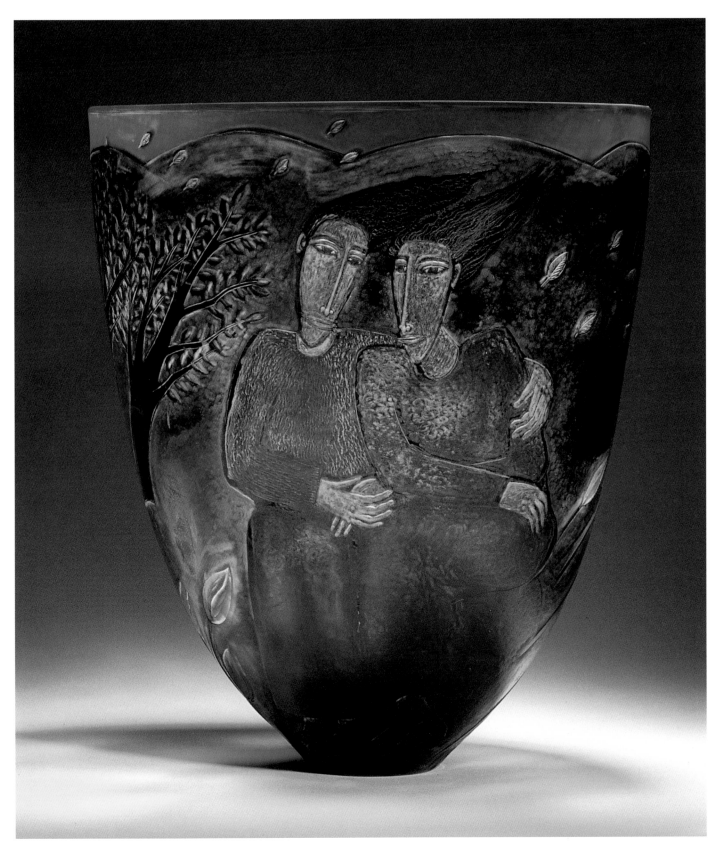

Clare Henshaw, UK: *The Marriage Bowl*, 1990
27cm diameter × 31cm high; blown with under and over-
lays; engraved and sandblasted

wheel and the artistry of the engraver a remarkable range of graphic cuts is possible.

Intaglio engraving refers to negative cutting into the glass, although the image may appear to stand out in relief. Relief engraving is the reverse, the background is cut away to varying depth to create an image standing proud of the surface, as in cameo glass.

A popular and more easily-controlled tool is the power engraver or flexible drive, rather like an old-fashioned dental drill, which is fitted with diamond or other abrasive burrs. The tool is applied to the glass and the main requirements for achieving a wide variety of graphic effects and depth of modelling are a willingness to draw and a reasonably steady hand.

The glass engraver John Hutton from New Zealand devised methods for using a large flexible drive shaft with grinding wheels and a scaling-up process which allowed him to draw freely on an architectural scale. His best-known work is the light airy glass window he produced for the entrance to Coventry Cathedral *c* 1960.

Over recent years there has been a great resurgence of interest in glass engraving, largely due to the efforts of Laurence Whistler who championed the revival of diamond-point or stipple engraving, virtually a lost art, and who has been its leading exponent for over half a century. He had to re-invent techniques, using a diamond or tungsten

Laurence Whistler, UK: *An Overflowing Landscape*, 1974: diamond-point engraving:
'The room with its framed picture is engraved on the inside of the bowl. Where the landscape overflows the frame it is engraved on the outside; as it curves round inside again, brambles extend across the floor.' (photo: Graham Herbert)

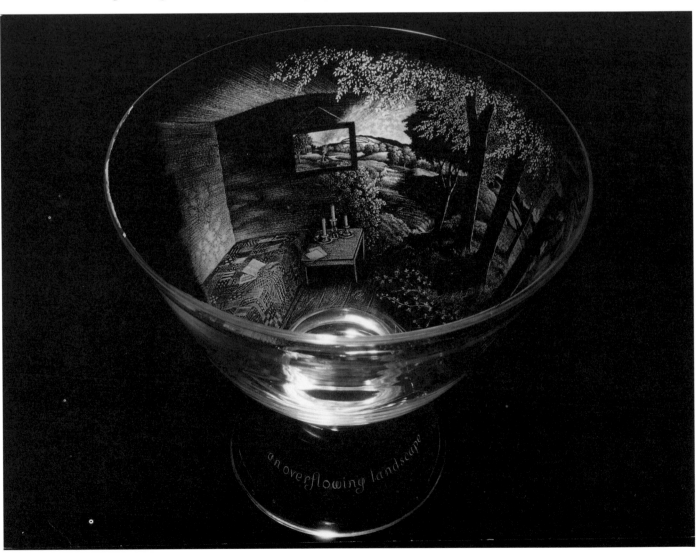

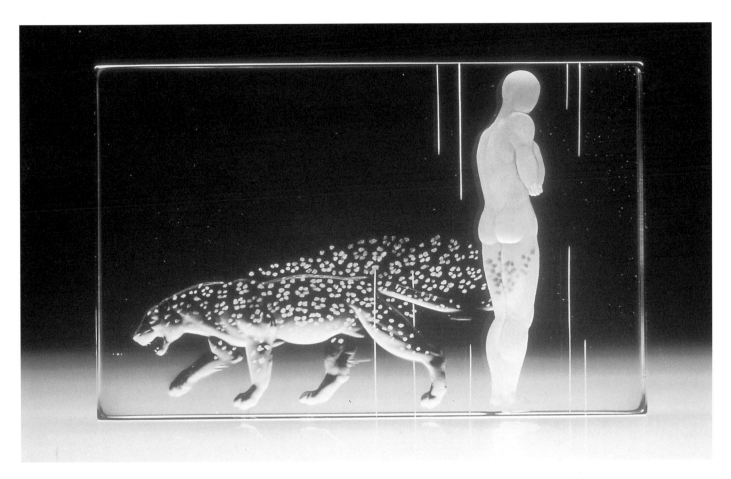

Alison Kinnaird, UK: *Leopard Woman*, 1991
5in. × ½in. × 4in. high: engraved optical crystal (photo: Ken Smith)

carbide tip mounted in a 'pen-holder' to draw or scratch lines, or to stipple a mass of fine dots for areas of delicate tonal and textural variation.

Initially he engraved verses on window panes and made small commemorative pieces, mainly as gifts. His designs were strongly influenced by the work of his brother, the painter Rex Whistler, whose untimely death in action during the Second World War affected him greatly. As his techniques evolved so, too, thematic complexity increased, the early architectural content and landscapes giving way to a more surreal imagery, redolent with fantasy and poetic symbolism. Both inner and outer surfaces, and the front and back of a vessel were engraved, the composition so arranged as to enhance the illusion of depth and perspective.

Amongst his many important commissions, several of them carried out for Royalty, are the Stations of the Cross on the windows of the Parish Church of Moreton in Dorset. His children Simon, Daniel and Frances are also highly accomplished engravers. In 1975 he was invited to become the first president of the Guild of Glass Engravers, now a thriving association of professionals and amateurs in the UK and overseas.

Alison Kinnaird, UK

Besides being one of Britain's foremost engravers, she is highly acclaimed as a leading exponent of the clarsach, a traditional Scottish harp – activities she finds complementary to one another. Of glass she says, 'It has the intrinsic character of water, light, air and ice. It is a mirror and a window, an elusive and illusory medium – there but not there. It has a spiritual dimension. Its purity and clarity can give another worldliness to the images that it holds, its transparency can be a metaphor for insight on the human soul'.

She sees her task as an artist to free the images 'trapped within the glass', one which she undertakes with great sensitivity, creating metaphysical allegories in crystal.

Electroforming

Electroforming is another interesting and unusual process for modifying a glass surface. Metal coatings with controlled variations of thickness and texture can be applied by deposition. Derived from commercial plating techniques, it involves passing a direct electric current through a bath of plating solution (or electrolyte) in which electrodes are suspended. The anodes, sheets of the metal to be deposited, are connected positively while the object to be plated, the cathode, is connected to the negative pole.

The object, previously painted or sprayed with a conductive paint such as Electrodag (a graphite solution) or copper or silver powder mixed in lacquer, attracts a flow of positively-charged metal ions. Prior sandblasting or some other form of surface abrasion will provide a key to facilitate paint adhesion, while selective 'stopping out' will resist plating in the masked off areas.

Plating is best at 15–48°C (60–120°F), so the solution should be warmed slightly and agitated continuously. In a modest set-up, aquarium equipment, e.g. heater pump and filter, is adequate for the purpose, while a car battery charger can be used as a simple rectifier, to control the direction and flow of the current.

Stephen Skillitzi visited my studio in 1981. During his stay he built a simple electroforming set-up using a plastic bucket, a battery charger, a light bulb as resistance and a length of copper piping as the anode. He also provided some basic 'rules of thumb'.

Surface qualities (smooth, textured, granular or with dendritic coral-like growths) will depend on such variable factors as:

1. *voltage and amperage* – in general, the lower the amps the more slowly the metal is deposited and the smoother the plating. In other words the speed of plating will influence texture.

2. *solution strength* – this will alter during prolonged use. Evaporation should be minimised by covering or sealing the tank, with the added advantage of reducing noxious fumes. An extractor fan is highly recommended.

3. *build-up of impurities in the solution or on the anodes.* Clean anodes are essential (wire brush and/or carborundum cloth).

4. *temperature of the solution* – greater deposition occurs around 80°F.

5. *circulation of the solution* – use of circulating pump.

6. *anode size, shape and distance from the cathode* – surface area should be at least that of item to be plated.

7. *length of time the cathode is immersed* – this will depend on the area and depth of plating required. Masking to resist plating also has the effect of concentrating the plating area.

Plating or forming is possible with a variety of metals, but solutions for gold and silver contain cyanide and are therefore very dangerous. All materials must, of course, be handled with caution, particularly acid solutions. (N.B. **never** add water to acid.)

For copper, the following solution is suitable for use with heavy gauge (say 20mm) sheet copper anodes:

copper sulphate	450g
concentrated sulphuric acid	100ml
distilled water	2 l

A rich build-up of copper will take several hours. The dull surface achieved can be polished and lacquered, patinated or further plated with other metals such as nickel, silver or gold.

Assemblage (or fabrication)

This term describes the process of assembling preformed elements into larger more complex structures in which blown pieces, castings, flat glass, mixed-media components and so on are juxtaposed in either permanent (fixed) or temporary composition, or frequently in combinations of the two.

Lamination

This is an increasingly popular method of assemblage. It involves gluing multiple layers of sheet glass into forms which can then be further integrated or enhanced by subsequent surface treatment. By and large, the transformation of flat

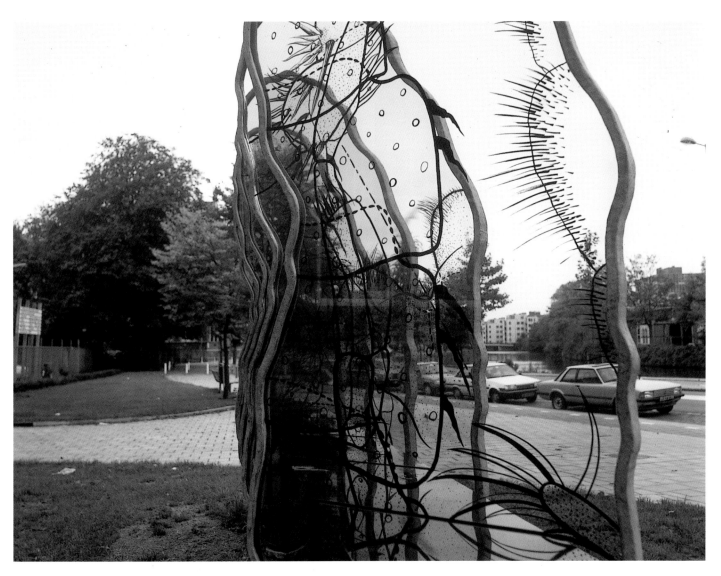

Bert van Loo, Netherlands: detail from [untitled outdoor sculpture], 1991–93
500cm × 95cm × 300cm high; bronze, granite and glass with 4.5cm sandwich of glass containing drawings (photo: Edward Jacobs, Amsterdam)

planes into abstract volumes, a constructive process, relies on a cool, intellectual approach to object making. Laminating demands precision and control particularly in pieces whose objectives include exploiting optical and prismatic effects. Brilliant kaleidoscopic images can be produced by the elusive reflections of internal planes, colours and linear inclusions. These latter may be textural or geometric, incised or applied (e.g. wire grids) or they may simply be visual effects created by the laminated surfaces in contact.

Bert van Loo, Netherlands

Throughout the many phases of van Loo's *oeuvre*, he has consistently impressed by his inventive and articulate approach.

Glass plays an important role in his poetic compositions which include lead, wood, paint, neon, stone or whatever serves the idea. 'Glass is not easy but it appeals – it is illusory, hard, impenetrable, dangerously sharp but also vulnerable and delicate. Seductively attractive, corrupt in its beauty, it provides tension if used discreetly.'

Invariably provocative, his ironic propositions challenge accepted notions of an object's social status and cultural validity. He views his pieces as 'openings', allegories of nature and civilisation, whose self-conscious ambiguities beg interpretation, reconciling opposites, in the 'tradition' of Marcel Duchamps and Mario Merz.

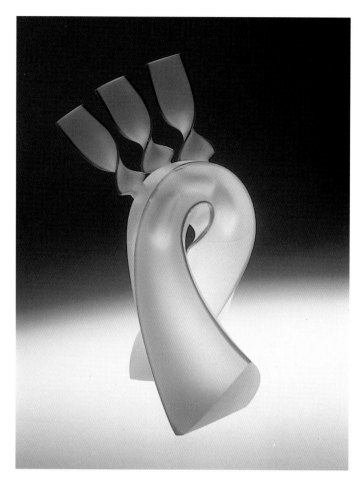

David Taylor, UK: *Carved Scent Bottle*
freeblown in 24% lead crystal with trailed-on colour;
carved, sandblasted and acid etched; hotworked stoppers

David Taylor, UK

A director of the Glasshouse studio in London, Taylor
is also one of the foremost designers of studio furnace
equipment in Europe, along with Durk Valkema
(Netherlands) and Peter Howard (UK). A hybrid
furnace he built for the Glasshouse, which operated
on both gas and electricity, was amongst the most
efficient and sophisticated in studio use.

He also creates exquisite small glass sculptures
which he nominally calls 'perfume bottles'; evolving
as they have from earlier more traditional versions.
Possibly they do actually function but the concept of
container serves mainly to provide a practical
structure for their design and manufacture, giving
rise to particular aesthetic considerations such as the
shape and articulation of internal voids and
appendages, e.g. 'stoppers'. The 'bottles' are
immaculately shaped and carved from unpromising
sausage-like blown blanks, by the use of grinding
wheels of varying size, shape and degrees of
smoothness.

These evocative and covetable objects enchant
from each new viewpoint, at once delicate, powerful
and sensuous, their subtle harmonies and curving
arcs demonstrating the skill and sensibility of their
maker. They are comical and sexy, too, without being
cute. As Taylor says, 'It's got to be fun, after all who
really needs glass?'.

Sylvia Vigiletti, USA

A wonderful series of veiled forms exploited a
technique known as 'steam-sticking', which is a way
of introducing a bubble into a mass of solid glass. It
involves piercing the hot glass surface with a sharply
pointed piece of wet wood. The steam so produced is
enough to inflate a bubble.

Concentric layers of colour were not overlaid but
gathered from a batch containing a minute amount
of silver nitrate. The colour varied with the
temperature and the atmosphere in the furnace, the
glass being oxidised during the melt and reduced
while working.

◀ **Sylvia Vigiletti**, USA: from the *Veiled Forms Duo
Series*, 1979
freeblown, multiple gathers of glass containing silver (col-
lection: Jean and Hilbert Sosin)

Joel Linard, France

For years the youthful Joel Linard has fought against a degenerative disease that confines him to a wheelchair. Undaunted, he works on with a lightness of touch, humour and courage that are utterly inspiring. Jan Walgrave, curator at the Museum of Applied Arts in Antwerp, describes him as 'a happy man, full of hope and wit' and so, too, is his art.

His friends, among them Jean-Pierre Umbdenstock, Véronique Lutgen and Killian Schurmann, have rallied to work under his supervision. Commenting on the task of actively interpreting another's ideas (and sketches), Umbdenstock writes, 'Here we go, a mongrel quartet of harlequin glassblowers wandering towards Utopia. You can't translate an idiom, you find an equivalent in your own language.' But the work's pedigree is never in doubt, childlike and funny, brilliant in colour and concept, it illustrates the charm of his poetic vision – pure Linard!

He has written, 'Glasswork always has one foot in dreamland. I am only interested in the unknown and I only work in order to be surprised. My sculptures are a joyful letting-go in which I invite you to join and contemplate the bird of our childhood which has flown away far too soon.'

Joel Linard, France: *La Femme du Centaure n'est pas une Amazone* [Centaur's wife is not an Amazon], 1992 49cm × 17cm × 22cm high; freeblown glass, cased with colour applications (photo: Michel Wirth)

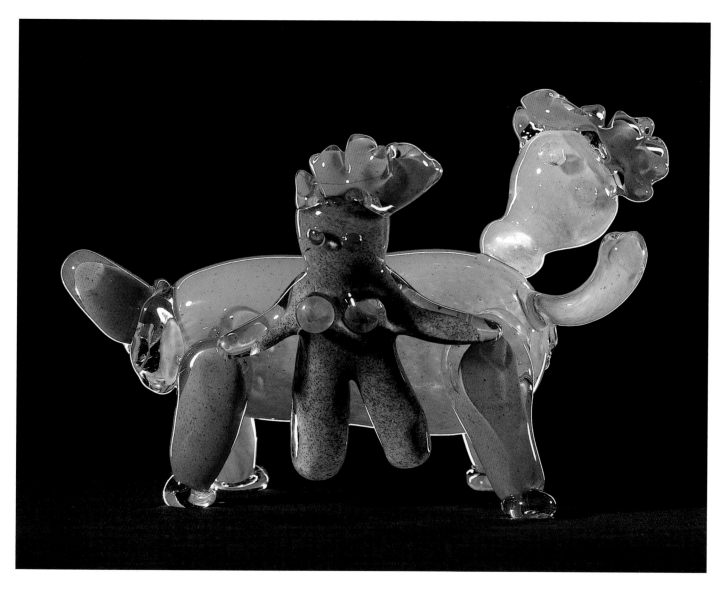

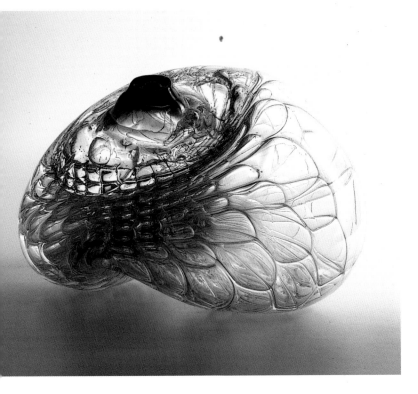

Jorg Zimmerman, Germany

For over twenty years, Jorg Zimmerman has been preoccupied with exploring the rich organic and seemingly infinite variable inner worlds of his free-blown forms. Blowing through and over woven wire meshes he creates complex internal lattices and honeycombs composed of countless bubble-like chambers.

Subsequent erosion by sandblasting and the discriminating use of a diamond saw expose the precious interiors. Walls disintegrate, revealing exquisite skeletal structures that suggest ancient coral growths, a notion often enhanced by their appealing colour.

Jorg Zimmerman, Germany: *Webenobjekt*, 1994 approx. 40cm diameter; freeblown with wire mesh inclusion, sandblasted
(photo: FotoDesign Schuhmacher)

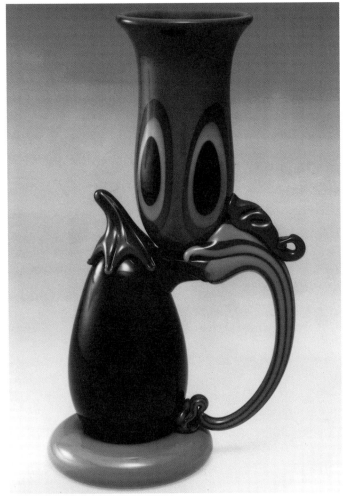

Rob Levin, USA

Rob Levin's playful assemblages are composed of mainly blown parts, purposefully and precariously asymmetric yet balanced. Brilliantly coloured bananas and vegetables humorously express a funky iconography that celebrates the making process and the personal and artistic evolution it engenders.

Rob Levin, USA: *Eggplant Cup*, 1983
9in. high; freeblown glass with applied colour (photo: Dan Bailey)

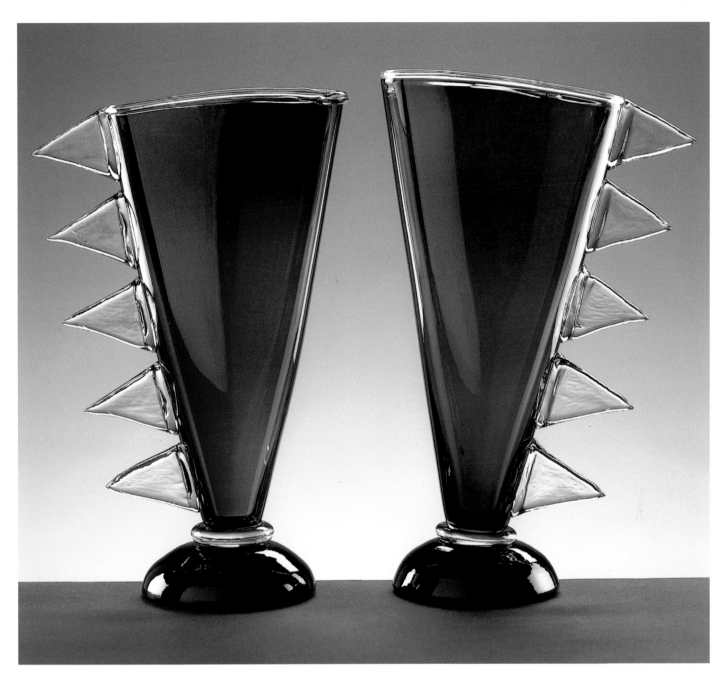

Simon Moore, UK: *Two Spiky Vases*
each approx. 24cm (widest) × 40cm high; freeblown, cased
colour, glued to bases (photo: Gareth Brown)

Simon Moore, UK

Simon Moore has worked variously at the Glasshouse
and in partnership with Steven Newell and Catherine
Hough and now runs his own 'shop' in London.
Considered one of Britain's foremost glassblowers
and an outstanding teacher, he has been described as
a 'spiky person who makes spiky glass'. While
obviously influenced by post-modern design, the
foregoing clearly belies the independence, skill and
vision required to produce the refreshing brand of
controlled asymmetry for which he has become
renowned.

Joel Philip Myers, USA

Trained in graphics as a packaging designer and intrigued by glass as a fascinating but inaccessible material, Joel Myers had the good fortune in 1963 to become Design Director of the Blenko Glass Company in West Virginia, and to learn about glass 'on the shop floor'. In fact, among those who were active at the 'birth' of the Studio Glass Movement, he is one of the few who was not from the Littleton 'school'. In 1970 he was invited to create a glass facility for the Art Faculty of Illinois State University in Normal, Illinois, which still remains his base. An excellent teacher, he has, over the years, consciously limited his own investigations to refining and redefining aspects of the vessel form, steadily varying the areas of research as part of an evolutionary process.

Strong, simple shapes, a favourite of which is the flattened ovoid, provide a 'neutral' canvas for his inventive use of rich colour and texture, aiding the exploration of scale, weight, contrasting qualities of light, shading and opacity, organic and hard-edged surface treatments, shiny or matt areas, cut and polished edges.

Myers builds surface complexity akin to Gallé's marquetry, through a collaging technique in which thinly-blown coloured and textured shards are applied to the hot parison, torched and tweezered into place to achieve the desired painterly and calligraphic effects, reminiscent of a Mark Tobey or Paul Klee. His spirited and atmospheric pieces stand as proud markers representing the continuity of a creative life.

A memory that I shall always treasure is of Joel Myers in action at Novy Bor, bandanna-clad, his boots on fire, standing and stamping on a wooden paddle atop the huge blown piece he was trying to flatten – a quite spectacular demonstration!

Joel Philip Myers, USA: *Smilegreen*, 1984
21in. × 2⅜in. x 7⅟₁₆in. high; blown glass, cased, blown colour shards hotworked into the surface, cut and polished

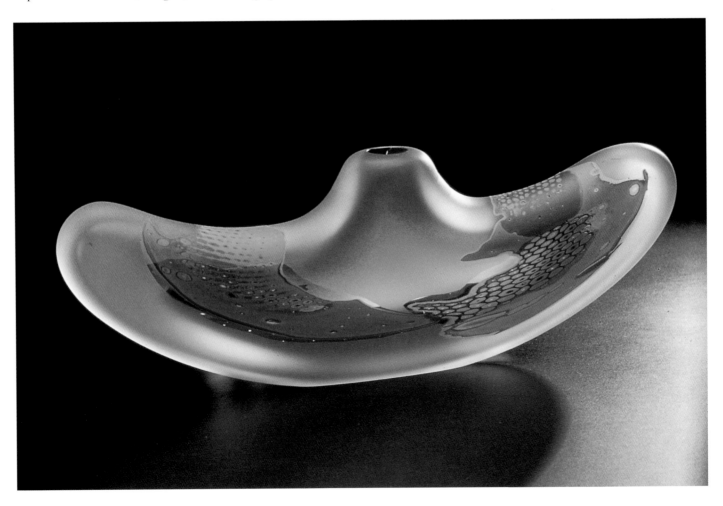

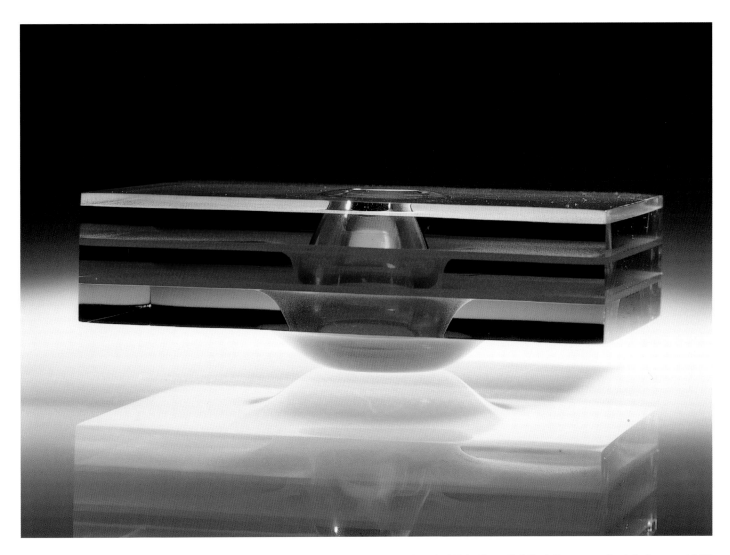

Tom Patti, USA

His small solid 'blow-laminated' containers are actually pure sculpture and, at best, they work brilliantly as spatial objects, powerful architectonic structures that express complete unity of concept and material. The hybrid technology Patti has created by combining seemingly unrelated techniques such as fusing and blowing, may bear some connection to certain ancient sand-core forming methods but his process is entirely personal and original.

Although he is equally at home with a variety of media including plastics and latex, Patti blithely exploits the greenish tints of commercial sheet glass, extending his palette with the subtle tonal modulations obtained from grey, blue and bronze solarised or coated glass. The thick glass sheet is cut into squares or rectangles and stacked into vertical blocks for heating in the kiln until the glass begins to soften. At this point a small bubble is introduced into the fused block subtly to alter and soften the form,

Tom Patti, USA: *Parallel Red Contoured with Green*, 1992 7in. × 3in. × 5in. high; laminated sheet glass, stacked, fused, blown, cut and polished (photo: Michel Wirth, courtesy: Serge Lechaczynski, Galérie Internationale du Verre, Biot)

the effect of the laminations remaining visible in the vestigial joins.

The articulation of planes and fin-like projections, induced bubble patterns and variations in the type and colour of the glass used (including wired and patterned), become active features, never as gratuitous ornament but invariably as intrinsic structural elements.

Patti's unique forms are elegant and classical, and colour is restrained, the whole endowed with great presence, at once calm and abstract yet disconcertingly intense, altogether a beautifully resolved and consummate statement of spatial values and visual relationship.

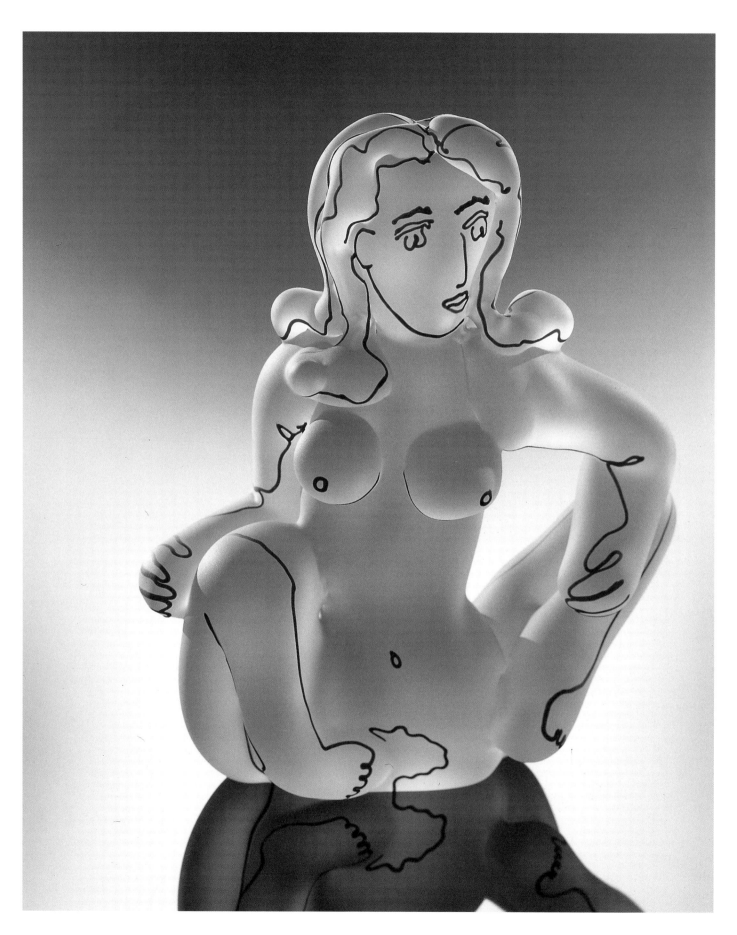

Richard Jolley, USA

Richard Jolley achieves the superb modelling of his
striking figures at the furnace by manipulating the
hot glass directly on the blowpipe. The features and
other details are applied with the torch and cane
drawing method, and their beautifully luminous matt
surface is achieved through acid etching.

◀ **Richard Jolley**, USA (with Tommie Rush): *Amber
Seated Female*, 1988
10½in. × 4½in. × 12½in. high; solid, hotworked molten
glass with colour applied by direct cane-torch drawing;
acid etched (photo: Don Dudenbostel)

Hiroshi Yamano, Japan

A recipient of the coveted Rakow Award from the
Corning Museum of Glass in 1990, his blown pieces
combine the qualities of classical Japanese vessel
form and decoration within a uniquely personal
idiom. A much vaunted series, 'East to West', begun
while he was studying and working in America,
incorporates silver leaf, electroplated and patinated
copper, and a recurring fish and mountain motif –
symbolising himself as a 'fish out of water'. Whatever
their genesis, his delightful pieces exude confidence
and purpose.

Hiroshi Yamano, Japan: from the *East to West Series*,
1990 ▶
20cm × 7cm × 50cm high; freeblown glass, silver leaf and
copper plating (photo: Akiyama Hirotaka)

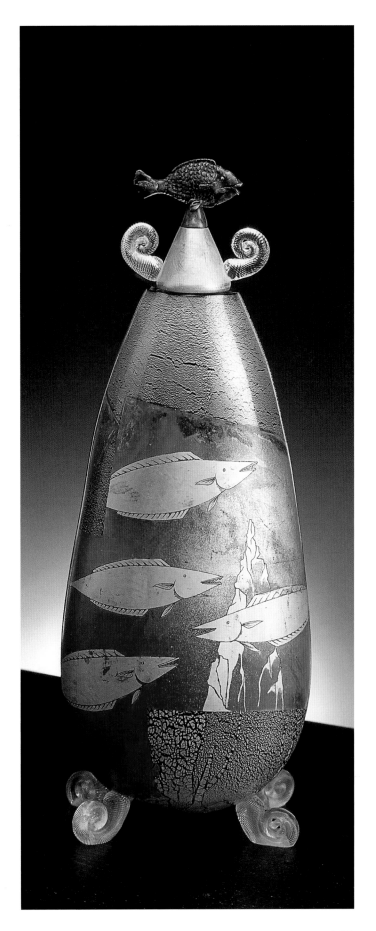

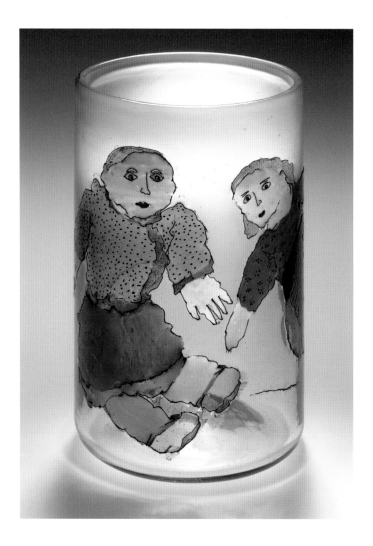

Flora Mace and Joey Kirkpatrick, USA

Flora Mace was brought up in a farming community and learned to weld at an early age. Later she majored in sculpture at the University of Illinois in Champaign where, having helped to construct the glass facility, she fell for the new medium. She adapted her welding skills to the new material, collaborating first with Dale Chihuly, creating the rich tapestries of drawn threads for his Indian Blanket series of the mid 1970s, and later with Joey Kirkpatrick whom she met at Pilchuck. Together they developed a sort of glass *cloisonné*, in which shaped copper wire and colour drawings were picked up from a hot marver and worked into the surface of the parison. Additional detail and colour were added by the torching-on of coloured canes. The blowing process was long and arduous, although the results achieved a lively gestural quality. More recent works are assembled, mixed-media pieces incorporating blown sections: poignant doll-like figurines that convey vulnerability and bewilderment at the absurd world in which they find themselves.

Flora Mace and **Joey Kirkpatrick**, USA: *Wishing Will* 7in. diameter × 13in. high; cased vessel with flameworked colour application

Paul Seide, USA

Inspired by the revolutionary English painter J. M. W. Turner, the Impressionists based their entire ethos on the exploration of the most ephemeral of phenomena – an instant of light. Indeed, artists have sought to capture and express its visual effect for centuries. Today, light as communication is commonplace (Morse, signboards, television, fibre-optic, laser), an essential technology for life in the twenty-first century. Nevertheless, the concept of pure light as substance, a mass or volume with which to sculpt, has few precedents and Dan Flavin's stark use of fluorescent tubes during the 1960s seemed the ultimate expression of both Pop Art and Abstract Minimalism. Since then, others like Chryssa, Fred Tschida and Ray King have explored the sculptural possibilities of neon while Stephen Antonakis has progressed from small three-dimensional compositions to geometric neon paintings on

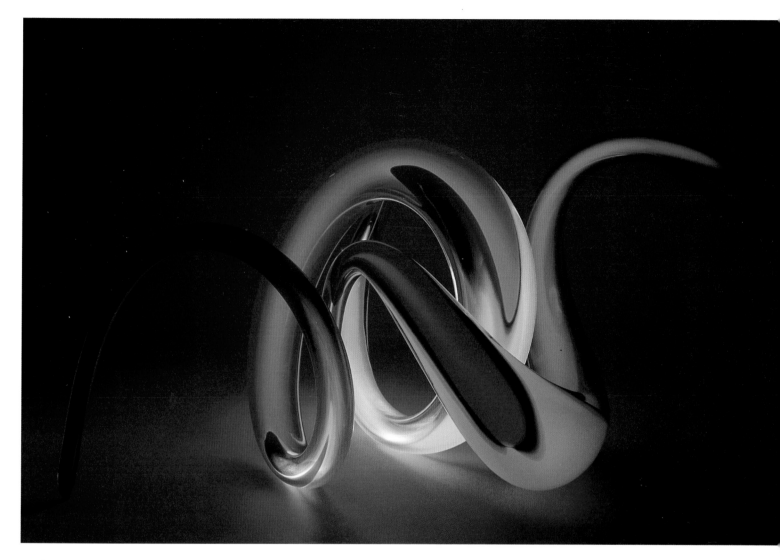

Paul Seide, USA: *Radio Light*, 1986
20in. × 20in. × 20in.; freeblown glass forms filled with
neon gas and mercury vapour, illuminated by a transmitted
short-wave radio field

architecture, vast exterior installations that function
as contemporary beacons.

In 1967 Paul Seide, watched a spectrometry
demonstration of Geissler tubes filled with various
gaseous elements. Since then he has singlemindedly
pursued the idea of using light as a malleable
sculptural medium. 'I'm involved in the study of light
as an interface between energy and matter,' he has
stated. The spectacular installations shown in 1970
by Dale Chihuly and James Carpenter, of neon-filled
free-blown glass and dry ice, provided further
impetus to his quest for the integration of light,
colour, form and surface through a marriage of art
and science.

Conventional neon uses basic lampworking
techniques to form the tubular gas-filled structures
through which an electric current is passed from
electrode to electrode. Seide's early pieces exploited
this system in furnace-blown loops, vacuum-pumped
with neon at low pressure. Eventually he found this

too limiting both in terms of formal possibilities and
the required maintenance. Avid research paid off
when he discovered that high-frequency waves from
a radio oscillator could be used to ionise, and thereby
excite, atoms of the inert gases contained within his
forms to the point at which they radiated light
spontaneously.

More recent sculptures consist of groups of
elegantly-serpentine spirals, or mould-blown forms
that are based on the crystalline structures that
constitute matter. Their special glass formulations,
contain rare earth oxides, e.g. ceranium and thulium,
that fluoresce when illuminated and produce
extraordinarily mysterious effects.

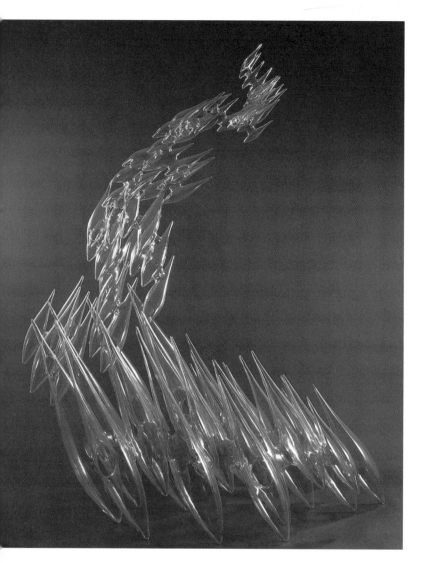

Vera Liskova (1924–1985), Czech Republic

Originally an accomplished designer in the field of domestic and tableware production, Vera Liskova was undoubtedly the *grande dame* of lampworked glass and pioneered its use as an art medium. During the 1960s she began to create light airy sculptures, fantasies based on abstract themes such as flight, space, movement, joy and harmony. Her method of fusing prefabricated elements constituted a major departure from the ornate lampwork of the period. The wit and complexity of her sculptural projects consistently broke new ground and her pieces are outstanding in scale and concept.

◄ **Vera Liskova**, Czech Republic: *Game of Drops*, 1980 135cm high; lampworked modules, assembled hot (photo: G. Urbanek, courtesy: artist's estate)

Rosemarie Lierke, Germany

To make her tiny delicate pieces Rosemarie Lierke developed an ingenious technique that she called 'craquelé'. By sandwiching leadbased coloured glass between layers of borosilicate glass she achieved a controlled crizzle or crackle effect, a fine lattice of light, in a range of delicate colours hitherto unknown at the high temperatures required to work 'hard' glass.

Rosemarie Lierke, Germany: *No. 0244*, 1987 ► 13cm high; borosilicate glass with inner layers of soft glass showing *craquelé* effect

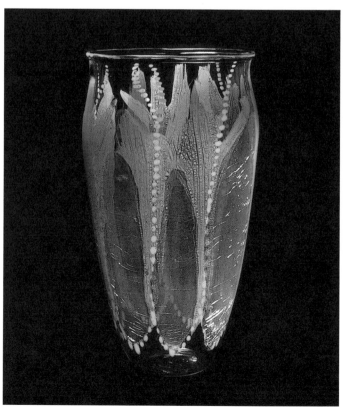

Ginny Ruffner, USA

Ginny Ruffner has an innovative and idiosyncratic approach to lampworking. She composes fantastic icons, allegories in which each potent element symbolises a response to both personal experiences and perceptions, or more universal and political issues. Her objects, which overflow with unexpected and provocative images in bizarre relationship, evoke the celebratory, baroque qualities of processional or carnival art.

Her 'narrative' pieces began after moving to Seattle in 1985. They each take from fifty to eighty hours to make from pre-formed parts which are assembled over the 'torch' and annealed frequently. The completed structure is sandblasted to provide a key for the paint (acrylic, enamel, whatever works) and this is followed by a final application of fixative.

A criterion of ambitious art is that it raises questions and her imaginative and enigmatic pieces certainly do this, as well as challenging preconceptions, a process intensified by her 'de-glassifying' use of paint.

These are fresh, bright and witty painted sculptures, or sculpted paintings, that simultaneously whoop and howl – poetic follies made concrete and heroic.

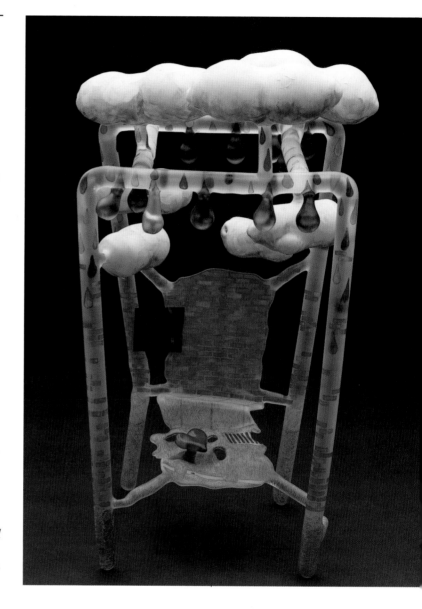

Ginny Ruffner, USA: *My Poor Little Heart Weathering All the Storms*, 1988
13in. × 15in. × 22in. high; lampworked borosilicate glass and mixed media (paint, pencil, ink) (photo: Mike Seidl)

Hubert Koch, Germany

Koch exploits the 'montage' technique to achieve moiré-like patterns on captivating asymmetric shapes, outstanding for their sensitive flowing rims and subtlety of colour and form.

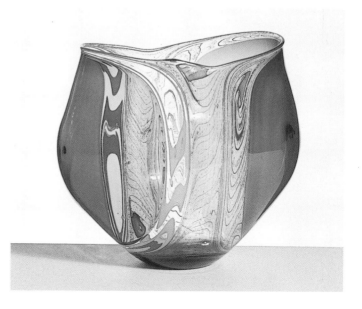

Hubert Koch, Germany: *Bowl*, 1990
14cm × 13cm × 15cm high; lampworked ('montage' technique)

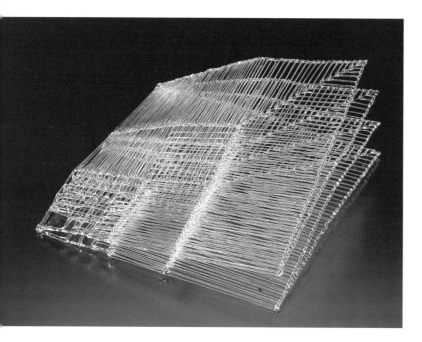

Yumiko Yoshimoto, Japan

Working primarily in clear lampworked borosilicate rod or tube, Yoshimoto creates pure sculpture, sometimes large composite mixed-media pieces as in the 180cm high 'Skyscrapers'. More often her elegant works are small and, although conceptually simple, they evoke the breathtaking structural complexity of leaf or plant skeletons – fusions of light and texture.

Yumiko Yoshimoto, Japan: *Linen Weave*, 1988
20cm square × 6cm high; lampworked borosilicate glass

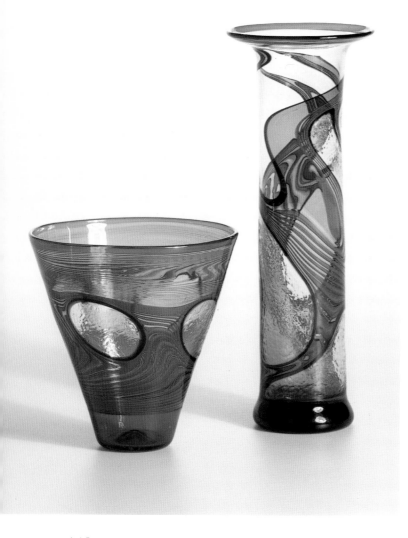

Kurt Wallstab, Germany

'It's not the cold, brittle, lifeless material I love but the challenges it provokes in the continuous process of trying to make it live, of bringing it to life.'

Choosing to change direction, after decades of successfully matching samples and specifications as a scientific glassblower of laboratory wares, was neither a whim nor a brave move for Kurt Wallstab; it was simply born out of a deep necessity to work more creatively.

He was used to sitting at a burner capable of temperatures in excess of 2500°C, constantly and dexterously rotating the glass tubes and rods from which the wares were formed, cold and solid in the fingers yet molten at the flame. He began to introduce working 'points' (predrawn rods of coloured glass), a delicate touch or prod with a tool, a tiny puff of air in a process repeated unceasingly until the desired shape and effect was achieved. It was a fabulous juggling act to control the differing viscosities, temperatures and compatibilities, as well as form, pattern and colour distribution.

Since 1975 he has become renowned internationally for his further development of the 'montage' technique, and in particular for his masterful use of colour.

Kurt Wallstab, Germany: *Vase and Beaker*, 1987
vase 5cm × 18.3cm high; beaker 13cm × 6.1cm high; lampworked ('montage' technique)

Gianni Toso, Italy/USA

It has been said that Gianni Toso was born with a silver blowpipe in his mouth. In any event a family history that includes centuries of Muranese glassmaking forms the backdrop to his legendary skills and he is equally at home at the lampworker's bench or at the furnace. The intricacies of complex Italian techniques (*latticino, reticello, filigrana* etc) are second nature to him and though renowned for his furnace-worked masks and collaborative work with other artists, he is nevertheless best known for his supremely witty lampworked figurines.

Toso has converted from Catholicism to Judaism which makes his chess set depicting Hasidim (ultra-orthodox Jews) and the Catholic priesthood in opposition doubly satirical and poignant. He has captured the gestures of the posturing figures in intimate and exquisite detail, a flawless and consummate work. A more recent variant illustrates an epic meeting of many of the leading protagonists of the Studio Glass Movement.

Gianni Toso, Italy/USA: *Chess Set – Rabbis v. Bishops*, c. 1981
50cm square (board) × 19.8cm high; lampworked figures on cut and assembled glass board (© 1981 The Corning Museum of Glass)

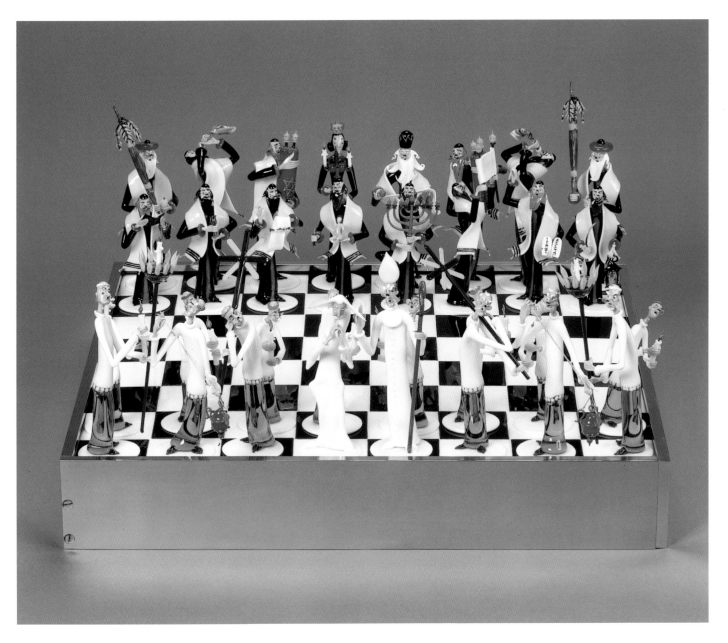

Mark Peiser, USA

Earlier works combined lamp and furnace worked glass and involved the application of colour to the *hot* parison by lampworking *during* the blowing process. One such piece with a landscape inside a paperweight vase took several hours to blow – a previously unheard of feat that gave Peiser the distinction, for a number of years, of having produced the most expensive piece of contemporary glass.

The later works are hot-cast, graphite moulds being used to pour his 'luminous volumes'. Peiser's moulds, so carefully conceived and beautifully 'engineered', might well be considered artworks in themselves. The resulting objects are precise and geometric, often containing inner forms and extraordinary blends of colour – veritable paintings in space.

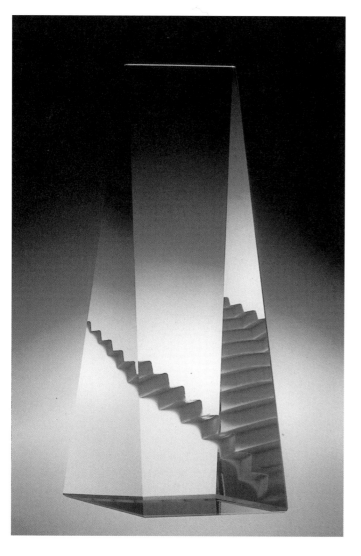

Pavel Molnar, Czechoslovakia/Germany

Pavel Molnar lives and works in Hamburg, in a marvellous old farm complex built round a central courtyard. The workshop is integrated with his home, and his co-workers form part of an extended family. He arrived in West Germany in 1965, having risked his life scrambling over the mountains to escape the repression that existed in Czechoslovakia at that time. He brought nothing other than his skills as a scientific glassblower and a quiet determination to prosper. Despite great difficulties he soon established himself as a major influence in lampworking circles, largely through his extensive and imaginative research into colour application. Early works explored subtle and delicate colour combinations, often demonstrated in landscape, sky and cloud formations.

These evolved naturally into combined furnace and lampworked vessels and 'solids', e.g. paperweights, with inclusions or surface drawing. Thinly-pulled canes, or threads, were torched onto the glass and reactive colourants or chemicals were applied in a carefully-controlled flame atmosphere (oxidation or reduction) to produce a variety of graphic effects and images which could then be modified by selective sandblasting prior to taking the final gather. By 1980 he had installed a furnace to work in parallel with his lampworked production, allowing a more ambitious approach to sculptural form.

More recent pieces have taken the form of cast monolithic blocks that are poured in stages, so that intricate lampworked symbols and attenuated figures with classical and mythological overtones can be added and sandwiched between the layers. These images float in the glass, dreamlike and surreal, exhorting mankind to behold itself anew, as if through divine eyes.

Pavel Molnar, Czechoslovakia/Germany: *Object-Head*, 1988 ▶
17cm × 26cm high; combined lamp-blown and furnace-worked glass; metal and colour inclusions hot-cast; metal frame (photo: Frehn and Baldacchino)

◀ **Mark Peiser**, USA: from the *Parnassus Series*, 1985 8in. high; hot-cast (poured), cut and polished (courtesy: Judy Youens Gallery)

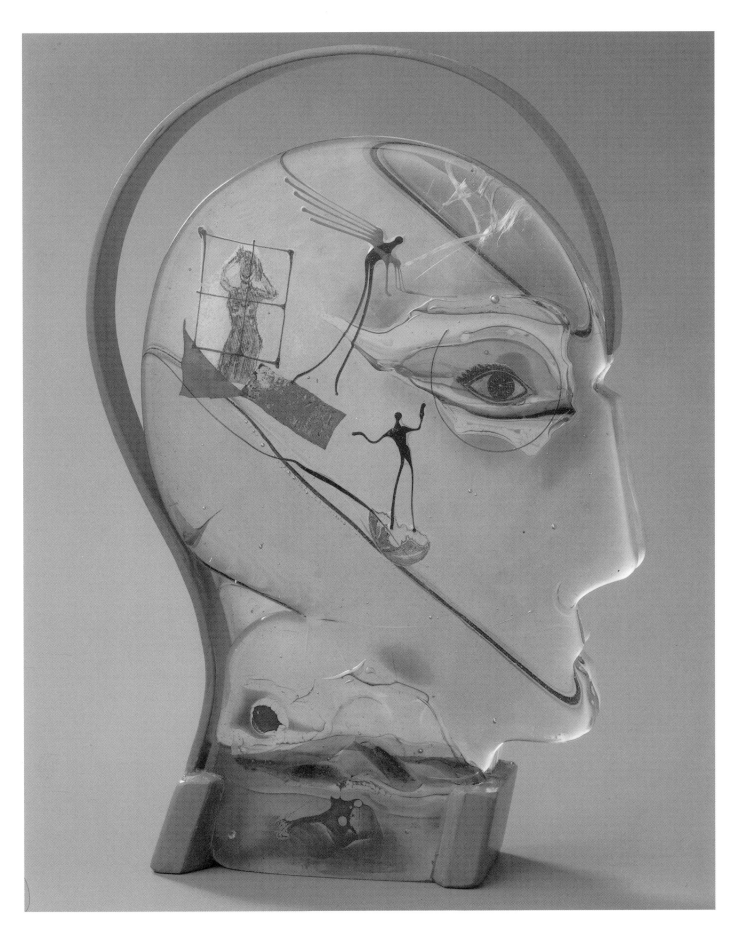

Dalibor Tichy 1950–1985, Czech Republic

Only thirty-five years old when he died, Tichy had worked in industry and was currently exploring the potential of geometric solids cut and laminated from sheet glass. However, he is best remembered for his ingenious use of hot casting. Immobilised by a long illness, he devised special pronged tools to draw out and stretch the molten glass into delicate frond-like growths. The simplicity of his process contrasts with the fragile intricacy of the frozen forms, graceful, dancing, fantastic, brimming with light and movement, like wind-blown grasses or coral, a wistful tribute to his flair.

Dalibor Tichy, Czech Republic: *Water Plant*, 1984 18cm high; hot-cast and drawn glass (photo: G. Urbanek, courtesy: Umprum, Prague)

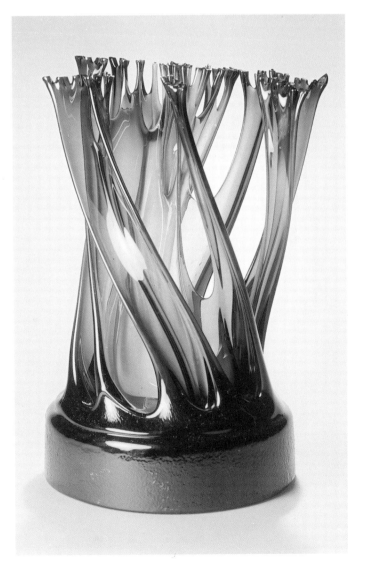

Howard Ben Tre, USA

One of the most serious and highly regarded artists currently working in glass, Ben Tre uses metal-casting techniques and chemically bonded foundry sands to produce his large and complex glass castings. His initial experiments in this technique were traumatic, for he lost 80–90 per cent of the small (10–15cm high) container-like objects he created. However, he persisted and now confidently casts forms weighing several hundreds of pounds and a metre or more in height.

Ben Tre hires industrial facilities, e.g. the Super Glass factory in Brooklyn, paying several thousands of dollars per session, during which he will complete a number of pieces. He usually works with a constructed wooden model which is suspended upside down inside a fabricated steel casing. Sand is packed tightly round the model and, when treated chemically, sets concrete hard. The model or former is then carefully removed and the molten glass poured in.

Having seen Ben Tre pour a relatively small piece at the Glass Centre in Sars Poteries, France, I find it easy to visualise the drama of filling a full-sized mould with a dozen or so ladlefuls of white-hot molten glass. When the temperature of the glowing mass has dropped sufficiently, the mould is moved by fork-lift truck to a specially designed annealer where, depending on its size, it will cool gradually over a two to three-week period.

The colour of these pieces is influenced by their massive thickness and the type of glass selected. The use of copper foil inlays which are later patinated, together with rich craggy textures and occasionally fortuitous cracks give the monolithic pieces a beautifully archaic yet timeless quality. These architectonic fragments express a classic monumentality, reminiscent of Standing Stones, stately relics of urban and industrial decay.

Howard Ben Tre, USA: *Structure 23*, 1984 ▶ 41in. high; sandcast glass with patinated copper (courtesy: Charles Cowles Gallery, Inc.)

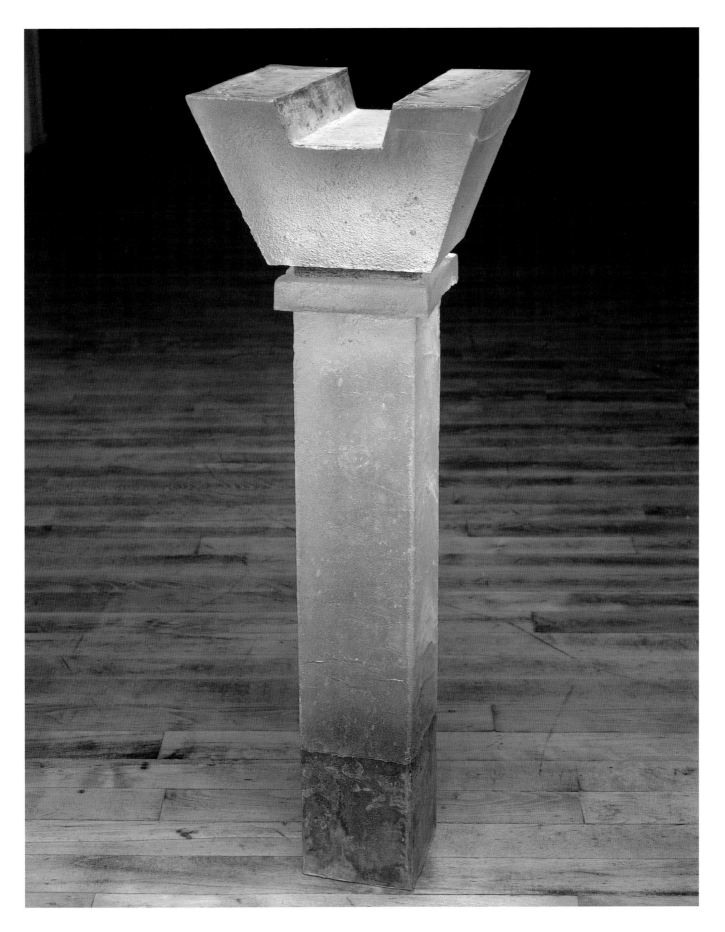

David Reekie, UK

David Reekie's kilnformed and kiln-cast sculptures are moody, surrealistic compositions that parody human attitudes and predicaments with ironic humour.

Anonymous figures, originally Lilliputian within their constructed environments, have evolved to the point where they are the major focus, gleefully portraying situations that epitomise the iniquitous frustrations and perplexities of modern life.

Tessa Clegg, UK

For some years Tessa Clegg developed a series that originally derived from a paper-folding exercise. This has evolved into impressive large kiln-cast bowls whose subtle gradations of colour and apparently simple relief belie the complexity and strength of their forms.

Amanda Brisbane, UK

Her powerful organic forms comprise sandcast wing-like elements joined by a blown section. They are large in scale and dynamic in concept with strong formal and textural qualities. Bold colour is added to the glass batch or clear glass is poured into a mould already dusted with enamels. In common with others who favour the same technique, Amanda Brisbane's sandcastings often derive from found objects.

David Reekie, UK: *The Lookouts*, 1987
38cm × 10.5cm × 28cm high; kiln-cast by *cire perdue* process with enamel colouring in the glass; painted wooden base, bamboo cane

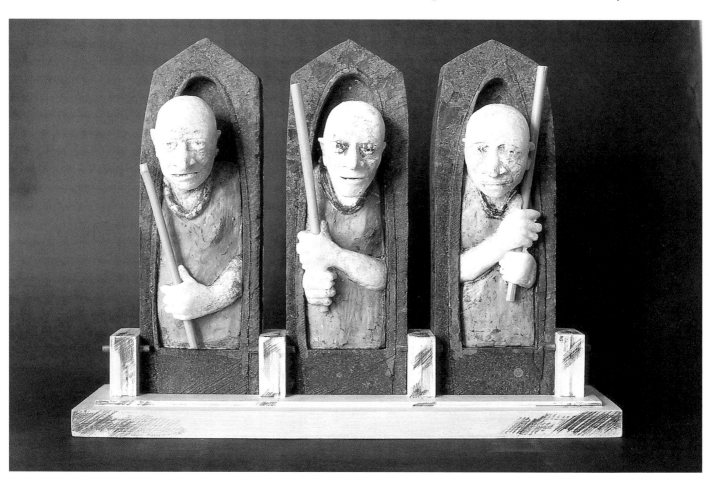

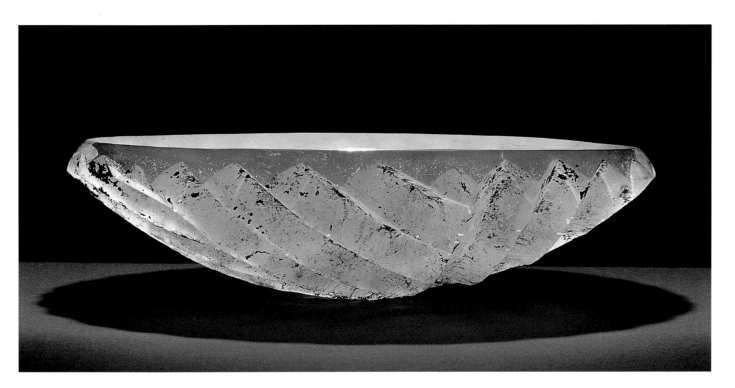

▼ **Amanda Brisbane**, UK: *Dancing Seahorses*
52cm wide × 48cm high; three elements, two sandcast and
one blown, joined hot

▲ **Tessa Clegg**, UK: *Bowl*, 1994
15in. diameter; kiln-cast by *cire perdue* method

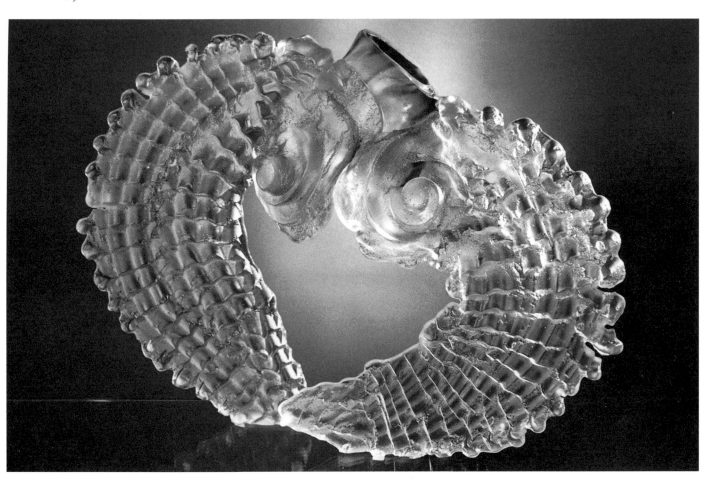

Pavel Jezek, Czech Republic

Pavel Jezek's powerful hot-cast glass and metal combinations frequently imply some esoteric function. There is none, other than as enigmatic emblems of the great glassmaking machine in the sky – wheels, cogs and counterweights on which to anchor fleeting dreams.

Jezek is tutor in charge of the Vocational Glass School at Zelesny Brod. His wife, the printmaker Eva Vlasakova, also works in glass, producing sandcast objects that retain the childlike immediacy of an exuberant vision.

Pavel Jezek, Czech Republic: *Wellenbrecher* [wave-breaker], 1983
30cm high; cast (poured) glass, cut and polished; stainless steel (photo: Jaroslav Barta)

Colin Reid, UK

While studying at Stourbridge College of Art (now part of the University of Wolverhampton) with Keith Cummings, Colin Reid became aware that kiln-casting by the 'lost wax' process offered infinite possibilities. By taking moulds directly from a variety of natural sources such as tree bark, molehills, fungi and Cotswold stone, he developed a vocabulary of forms and textures with which to 'play', dissecting and re-assembling as desired.

With a masterly control of formal and organic elements, he explores the natural movement and flow of cast glass in elegant, archetypal shapes. Crosses, triangles and spirals contain beautiful veils of colour and minute bubbles that are trapped as the glass melts and flows into the mould during the kiln firing, ultimately to be revealed by lengthy and painstaking grinding and polishing.

He describes his working methods in the following statement:

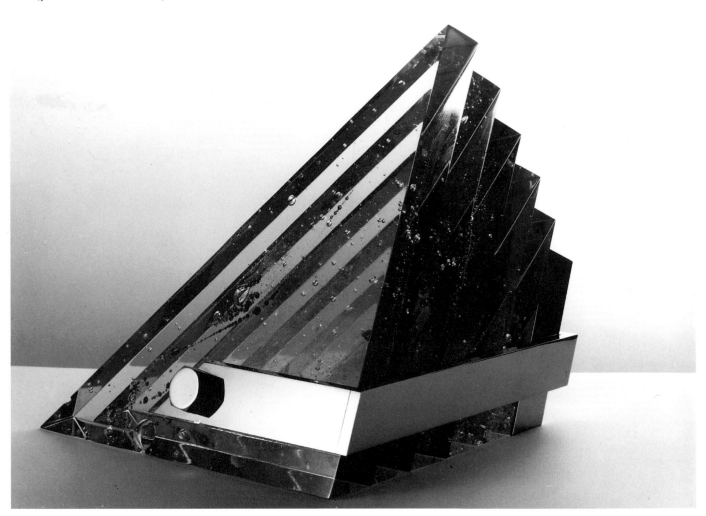

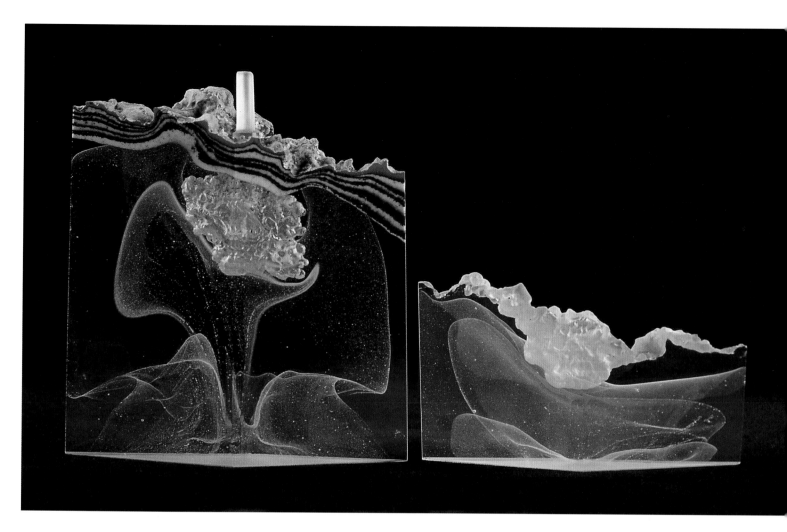

'I make quick rough drawings of many different ideas until one develops that works, or sometimes I see the finished pieces clearly from the start and drawing is the first step toward realising it.

'I'm much happier when I get into three dimensions. I make paper or cardboard maquettes, working quickly to get an idea of scale and proportion. Then I start casting.

'Before I cast in glass I make a full-size model of the finished piece, usually in plaster, from which I cast rubber moulds for the 'lost wax' casting process by which the glass pieces are made, and also to see the finished form in another medium. The piece must work as a form in a bland material like plaster and not rely on the beauty and magic of glass to enhance it and make it work.

'Making the model is a lengthy process. I cast from natural sources – bark, soil, sand, anything that gives the textures and forms I am after. I do a great deal of casting back and forth, positive to negative and back, using a variety of materials, rubber, plaster, clay, glue, cutting and re-assembling as required.

Colin Reid, UK: *Perfume Bottle* (two parts), 1985
13cm × 20cm high; kiln-cast by *cire perdue* method

'When the model is complete I make rubber moulds of it and I am now ready to translate the form into glass using the 'lost wax' process. First I make a wax impression from the rubber mould, cast this in a high-firing refractory mould mix (e.g. one part flint to one part plaster by weight, mixed in the proportion 1½lb dry material to 1 pint of hot water) and then I melt out the wax. The mould is charged with crushed glass and colour, fired to 850°– 900°C and annealed for two to seven days. The mould is then broken away from the piece which is finished by a lengthy process of sandblasting, grinding and polishing.'

Visually and technically brilliant, Colin Reid's pieces articulate diverse influences such as Japanese calligraphy and Aboriginal art, assimilated and transformed into a rich and personal language that sensitively expresses the intrinsic qualities of glass.

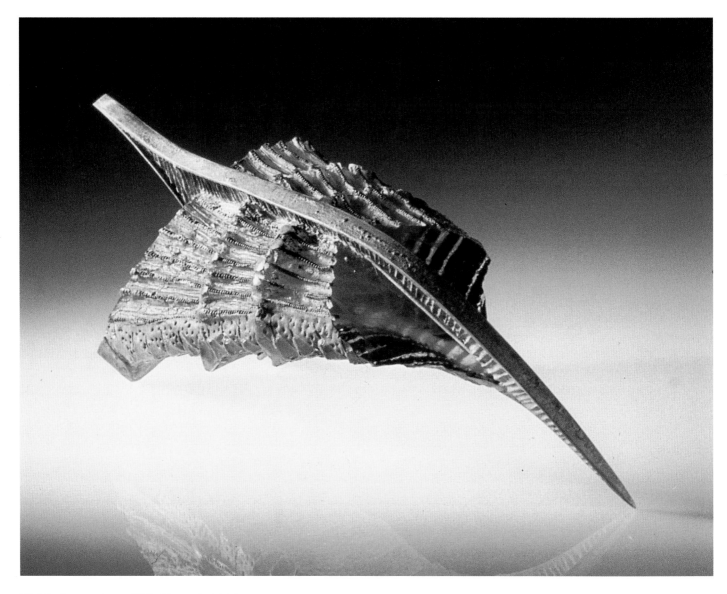

Keith Cummings, UK: *Skate 1*, 1988
35cm × 14cm × 14cm high; kiln-cast by *cire perdue* process with metal inclusions; cast bronze elements patinated

Keith Cummings, UK

During the mid 1960s Keith Cummings was working with Alfred Fisher in the stained glass department at the Whitefriars Glass Company and experimenting with fusing clear and coloured glasses for large-scale window and mural applications. My own first contact with glass as a medium arose while I was studying ceramics at the Central School of Art, London (now Central St. Martin's), when he kindly assisted me with a project to produce a light-transmitting screen constructed from fclay and fused-glass modules. I continue to be grateful for his generous encouragement.

Keith Cummings is the author of an excellent textbook entitled *The Technique of Glass Forming* and is a highly respected artist and teacher. Many of Britain's leading glass artists began their careers under his tutorship and his influence has been a major factor in the growth of interest in kilnforming as a viable means of expression. His own objects are complex mixed-media pieces that reflect and synthesise various sources of inspiration from Victorian ironclads to deep-sea or sky creatures. These are composed as 'lost wax' kiln-castings, parts of which are covered by metallic inclusions that adhere during the firing process. Other areas are polished to allow visual access to the interior of the form. Cast and patinated bronze elements are frequently integrated to complete the pieces.

Bertil Vallien, Sweden

Humour plays an essential part in the life and work of Bertil Vallien, arguably one of the most popular and versatile figures on the international glass scene. A highly successful designer, he works for Kosta Boda for six months and is encouraged to use the factory facilities for his personal work during the rest of the year. The designer's role in industry can often be difficult and frustrating because of commercial constraints, but Vallien is amongst a growing number who successfully manage to integrate their personal aspirations as artists with those of their company.

As both artist and teacher his contribution has been considerable. Sensitive, sceptical and passionate, with a restless curiosity and driving imagination, he experiments and improvises, constantly seeking new and unconventional perceptions of form and technique. Normal mould-making techniques demand a major investment in time and cost which restrict the opportunities for spontaneous creative development during the casting process. Sandcasting provided the solution to Vallien's long search for a versatile and, above all, direct method of glassforming.

In his exploration of heroic and symbolic themes, images recur, in both two and three dimensions. Winged and top-hatted figures and fallen angels (implying power and its frequent abuse), are symbols of human and spiritual frailty. Other series consist of solid sandcast forms: bridges, staircases, houses and a fleet of boats with anthropomorphic and overtly sexual protrusions. These mysterious and contemplative vessels, reminiscent of Egyptian or Viking burial ships, bear small colourful trail-wrapped inclusions like strange Mummies or foetuses floating within the luminous depths of the translucent solids; they evoke the eternal, the voyage from birth to death, and beyond.

Bertil Vallien, Sweden: *Silent Journey*, 1986
100cm long; hot-cast into sandmould with pre-formed coloured glass inclusions; suspended (photo: Markus Vallien)

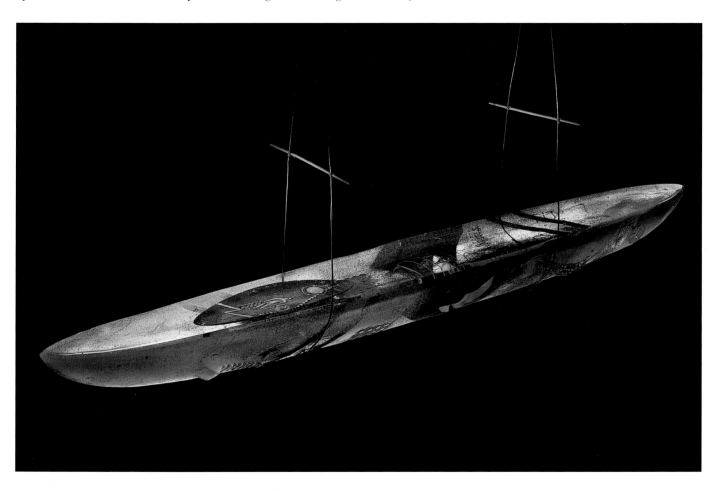

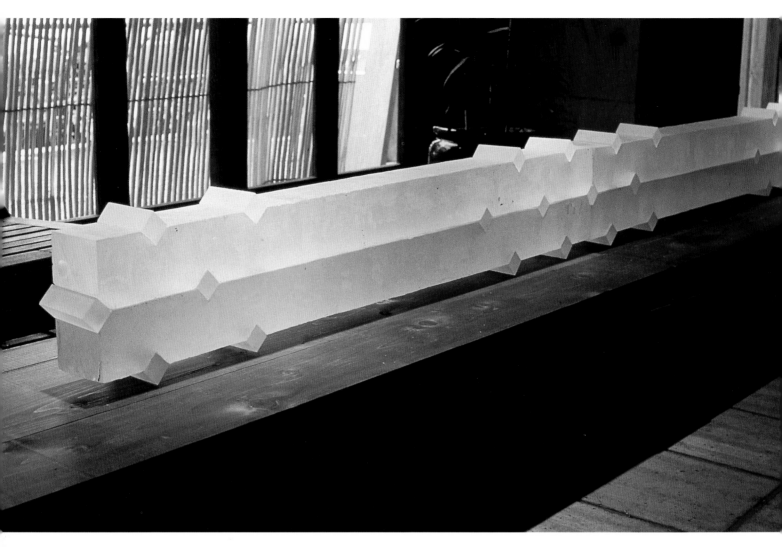

Ruri Iwata, Japan

Iwata's grandfather was Japan's first glass artist and both her parents have been pivotal in forging the acceptance of glass as a valid and 'respectable' medium in Japanese artcraft circles. Representing the third generation of an impeccable 'glass lineage' can also have drawbacks. Essential as it may be for any artist, Iwata has found it imperative to establish her aesthetic and philosophical independence and, during the past two decades, her work has evolved through a number of important phases.

Flowerforms gave way to arrangements of long rods of bamboo and glass, sometimes tied and counterweighted; they in turn were followed by an outstanding series of massive kiln-cast floor sculptures, interlocking slabs that build into three or four metre long rectangular monoliths. The spare minimalist approach and the eerie luminous quality of translucent soda glass give the pieces a mysterious and immutable presence.

Ruri Iwata, Japan: [untitled – no. 899252], 1989 300cm × 45cm × 53cm high; kiln-cast modules, assembled (photo: G. Erml, courtesy: Gallery Ghibli)

James Watkins, USA

James Watkins' *pâte de verre* pieces evoke the calm surreal presence of a Morandi still-life painting. Intellectual and spare without being austere, they possess a metaphysical humour that enhances the subtle tension of these potent and authoritative works.

James Watkins, USA: *Ewer with Avocado and Goose*, 1994–95
17in. high; kiln-cast by *cire perdue* process (photo: Michel Wirth, courtesy: Galérie Internationale du Verre, Biot)

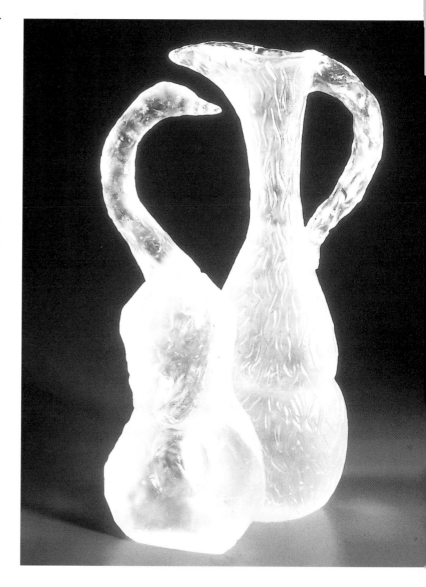

Karla Trinkley, USA

Karla Trinkley's work in *pâte de verre* often displays the complex organic architecture of diatomic fossils or ice crystals. Skeletal cages are constructed around an inner core to protect the secret spaces within. Small and precious, with a sugary texture and colour, these pieces seem almost edible, and yet their inherent strength and sense of scale make it easy to envisage them as monumental structures.

Karla Trinkley, USA: *'X'*, 1986
9in. × 7in. high; *pâte de verre*

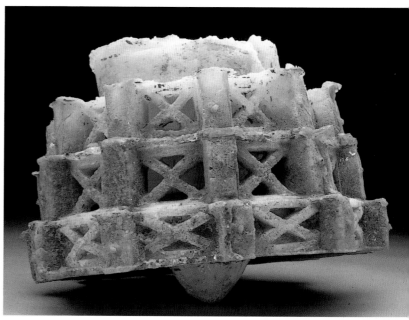

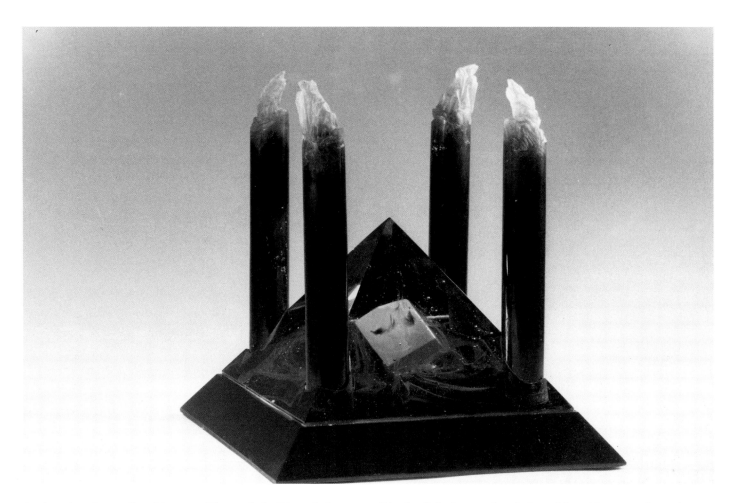

▲ **Antoine Leperlier**, France: *Silence de la Pierre* [silence of stone], 1988
25cm × 25cm × 29cm high; kiln-cast by the *cire perdue* process

Gizela Sabokova, Czech Republic: *Honey Defence* ▶
25cm × 50cm × 50cm high; kiln-cast by *cire perdue* process (photo: Karel Bartonicek)

Antoine and Etienne Leperlier, France

Following in the footsteps of their illustrious grandfather François Décorchement, the doyen of nineteenth-century French art glass, and attempting to recreate his lost art of *pâte de verre*, can hardly have been easy. Nevertheless the brothers Antoine and Etienne Leperlier have become specialists in the technique and are highly regarded as artists, each in his own right.

Composed from solid kiln-cast polychrome elements, their objects comprise multipart assemblages that symbolise intervals in time and space – 'memories of suspended moments'.

Antoine has described his process 'as similar to the alchemist's ceaseless striving to produce gold, to fulfil his ever-present dreams of self knowledge and discovery, and at the end of his search, the secret of immortality'.

Gizela Sabokova, Czech Republic

Gizela Sabokova is yet another of Libensky's brilliant protégées who works equally well in a variety of media and techniques, like her former classmate Jaromir Rybak, with whom she often collaborates on large architectural projects. Her personal work follows two main strands: powerful and disquieting abstractions of the human figure painted on autonomous panels, and the coloured kiln-cast sculptures for which she has become well known in recent years.

The latter, moulded directly from clay extrusions and retaining the deformations and movement of process, take the form of massive blocks supported by slender columns.

Despite rich contrasts one senses a dark humour at work, an introspective soul responding to oppressive portents.

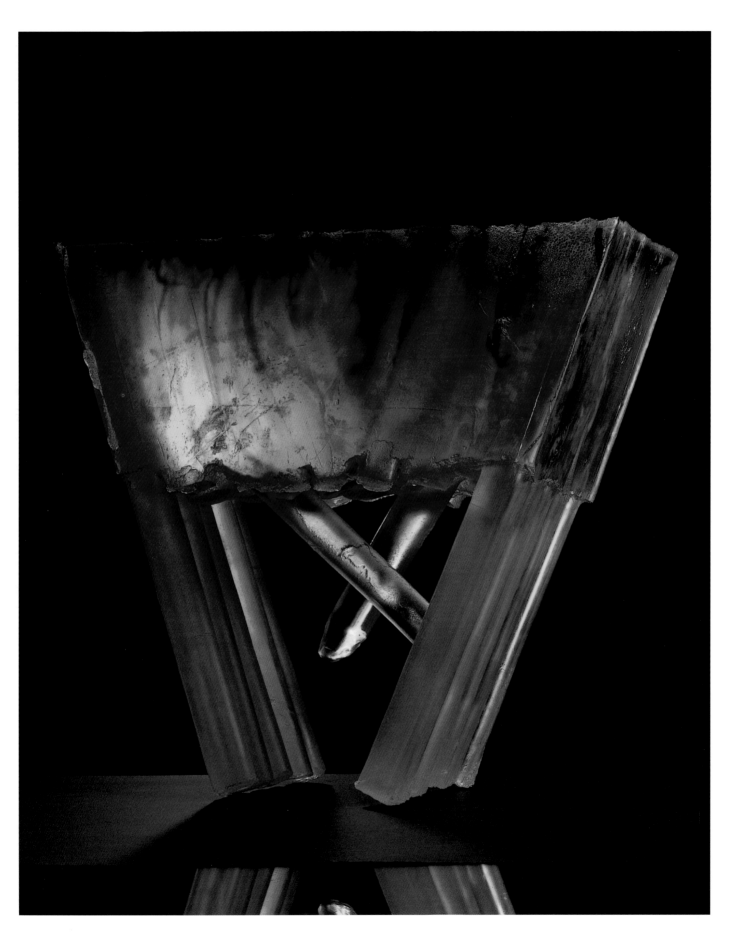

Keith Brocklehurst, UK

There are several thrusts to Keith Brocklehurst's work which ranges from a delightful series of small kiln-cast boxes in bright, primary colours, where the base of the box serves as a plinth for the sculpted lid, to relatively large mixed-media sculptures which incorporate *pâte de verre*. Another evolving series of footed bowls in *pâte de verre* appears, like the boxes, to pertain to ceremonial or ritual functions – as though they were present-day reliquaries.

Keith Brocklehurst, UK: *Awaiting Bowl*, 1988
14cm diameter × 14.5cm high: *pâte de verre*

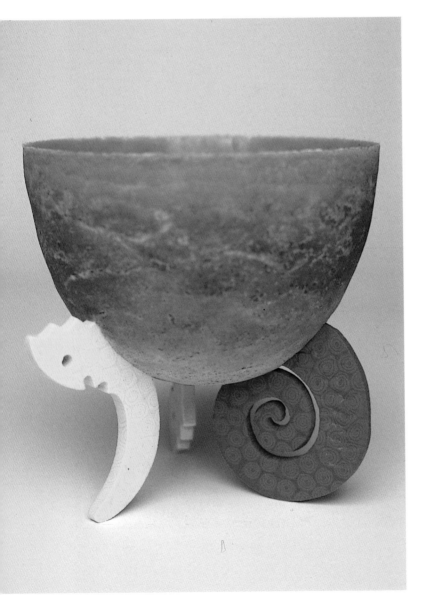

Steven Weinberg, USA

A bluff, bristling individual, Steven Weinberg makes wonderfully intricate and elegant objects which, despite their intimate scale, are cool and monumental. Like others, he volunteers, 'All my best work stems from happy accidents' – like stumbling upon the line of visual research that has preoccupied him since graduating under Dale Chihuly at Rhode Island School of Design.

Taking a 9in. cube as his primary form he has explored and elaborated complex internal voids whose negative spaces function visually as positive shapes within kiln-cast crystal blocks. Normal casting techniques reproduce a positive or relief equivalent of the model from a negative mould, but Weinberg effectively reverses this procedure, using a box-like enclosure containing an inner core over which to melt and fuse the glass, completely filling the mould. After annealing for a week or so, the plaster core is cleaned out with a high pressure water jet and the resulting void is sandblasted. The exterior surfaces of the block are then meticulously ground and polished on a reciprocating lap.

The resulting highly polished solid, contrasts with the icy frosted structures within. Arresting light-filled geometries become strange futuristic landscapes and architectonic labyrinths, Escher-like ambiguities that defy reality. Later pieces also exploit veiling to create beautiful mist-like effects that drift and flow through the glass.

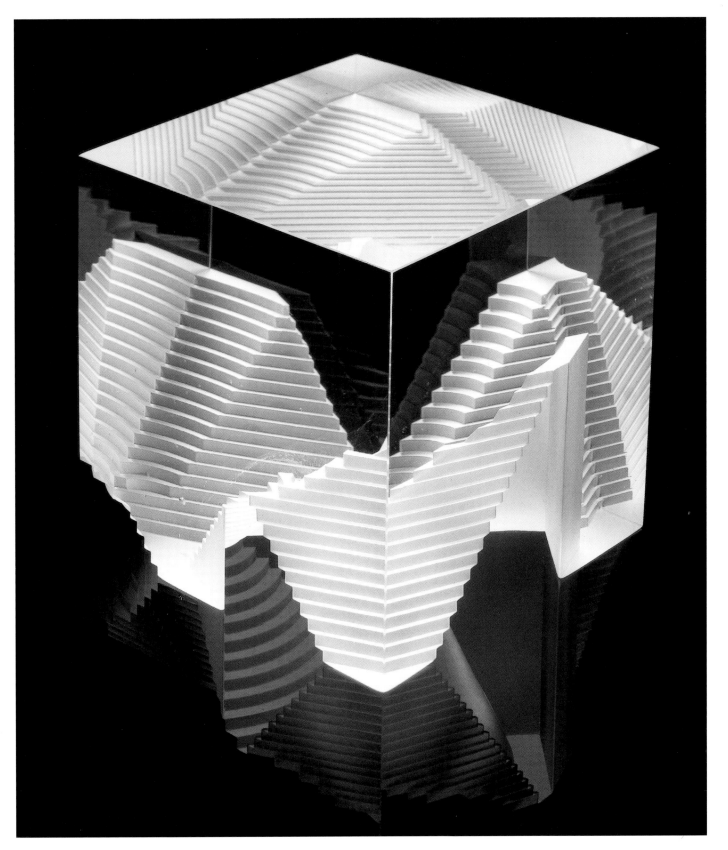

Steven Weinberg, USA: from the *Cube Series*, 1986/87
9in. cube; kiln-cast, sandblasted, cut and polished (cour-
tesy: Heller Gallery)

Diana Hobson, UK

Diana Hobson has evolved a particular method to create her exquisite and fragile vessels. Their unlikely beginning involves pulverising glass (even light bulbs) with a hammer, after which the glass powder is sieved and mixed with a binder (e.g. gum tragacanth or, in the past, a 2 or 3% solution of sodium silicate or waterglass). The resulting paste is painstakingly brushed or tamped onto the interior walls of a mould, that has been taken from a clay positive and made from a mix containing plaster, flint, china clay and ceramic fibre.

Hobson first lays down patterns by painting the interior surface of the mould. In early works the colourants consisted of bright jewellery, glass or ceramic enamels. Recently, more subtly coloured pastes and non-glassy found elements such as shells, fragments of copper mesh, sand or brick dust, have been used to add rich and unusual textures. The process of building up the colours and layers to the desired design and thickness takes many hours of laborious work, although the resulting fired vessel forms have paper-thin walls so as to achieve the translucence and fragility for which she strives and which make her work so precious.

Brought up in Stoke-on-Trent, she started work in the Potteries as a painter for Clarice Cliffe, the brilliant designer of 'Bizarre Pottery', later training in the jewellery and silversmithing department of the Royal College of Art, London. She stumbled on *pâte de verre* almost by accident, while participating in the 'Hot Glass' symposium, immediately responding to it as a natural extension of her previous experience in enamelling.

Although she had few sources of reference, innumerable experiments and extensive testing of materials together with an exceptionally disciplined and well-ordered approach to her work have helped in the continuing struggle against the technical difficulties that beset the making process at every stage. Although pieces are dried gradually and thoroughly, prior to a careful even firing, cracking remains a constant and often fatal hazard.

Technical and aesthetic development has been accompanied by a steady growth in confidence. Whereas initially only one piece in ten survived, Diana Hobson's extraordinary commitment and patience have enabled her to achieve a fifty per cent success rate. Her production is necessarily slow and is further limited by the totally uncompromising standards she sets herself. Though small and extremely delicate, her pieces display a rare monumentality and tension.

Recent works take a more sculptural approach and involve contrasting media. *Pâte de verre* is combined with stone, cast bronze and feathers, introducing a new range of form, colour and texture, each element carefully selected for the unique energy it contributes. Diana Hobson's objects possess a powerful and timeless spirit and above all express a delicate balance and wholeness that reflect her own humanity.

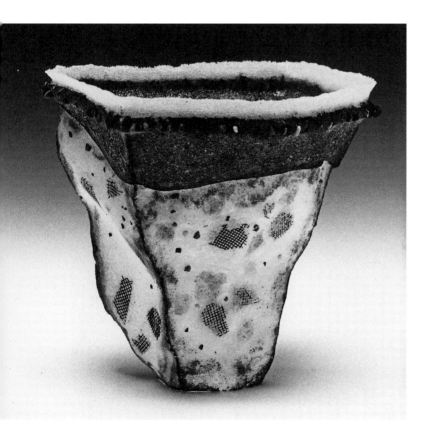

◀ **Diana Hobson**, UK: *Freeform 7*, 1987
14cm high; *pâte de verre* – crushed glass and found materials layered into a mould and fused (photo: Phil Sayer)

Etsuko Nishi, Japan: *Lace Cage* ▶
32cm diameter × 25cm high; *pâte de verre* (photo: Taku Saeki)

Etsuko Nishi, Japan

Etsuko Nishi makes beautifully sculpted vessels whose calm restraint and delicacy render function obsolete. Two major sources of inspiration have led to her current work: first, an abiding interest in the textile arts of quilting and lacework; second the miraculous cage-cups of Ancient Rome.

Glass takes many forms, invariably hard and cold, of which the most subtle and delicate is *pâte de verre*. It is composed of myriad tiny air bubbles that 'hold' light, imparting the 'soft-focus' translucence that she requires to create her basket-like 'lace cage' pieces. These multi-layered forms comprise carefully fashioned spaces and complex filigrees through which to glimpse a silhouetted inner core. Such works demand an extraordinary level of experimentation in developing a moulding technique to support the inner and outer layers of her objects. A mould material is required whose rate of shrinkage corresponds with that of the glass being used, otherwise cracking occurs at some stage in the making or firing process. Ceramic fibre paper with additives has, among other advantages, the capacity to 'wet down' after firing, aiding its removal. The firing cycle is in itself also a critical factor in achieving the soft colours and silken surface qualities for which she strives.

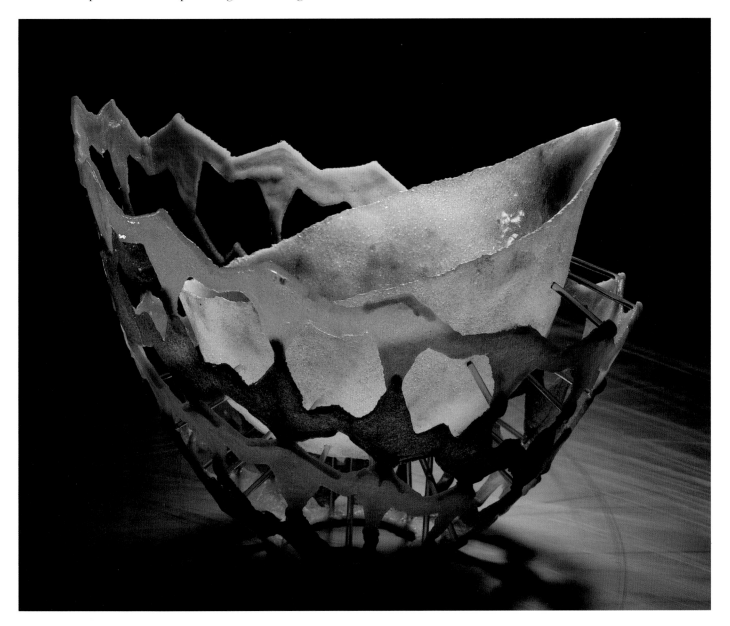

Warren Langley, Australia

A versatile and prolific artist of prodigious energy, Warren Langley began with stained glass and progressed through the entire gamut of hot and coldworking techniques, combining them innovatively in his continuing search for a unique Australian imagery. Contrasting surface textures derived from fusing and slumping into sandmoulds are juxtaposed with inlaid areas of bright laminated colour. He seeks to achieve visual rhythms that will express the dazzling light and space of the landscape, and the raw vitality of a young and dynamic society.

He frequently works on large-scale architectural projects combining glass with other media, e.g. painted aluminium with neon.

Warren Langley, Australia: *Druid Site 42*, 1986
80cm wide; glass slumped in a sandmould inlaid with fused glass

Florian Lechner, Germany

This German artist uses kilnforming techniques on a huge scale and for a wide range of applications. His forms are fused and laminated from vast (10ft × 5ft/300 × 150cm/20mm thick) sheets in a ceramic fibre 'top-hat' kiln made to his own specifications. Air bubbles and other imperfections are often trapped in the glass to exploit its beautiful organic qualities and to achieve effects similar to those of ice with water flowing over or under it. His monumental installations have great affinity with water and he has carried out several public commissions for large-scale fountains; also some meditational installations in which the sounds and sight of dripping water accompany and extend the visual perception of space and time. These are contemplative pieces made with great concern for the environment in which they are to be viewed as, too, is his church 'furniture' (baptismal fonts, altars and so on) which is having considerable influence on contemporary European ecclesiastical style.

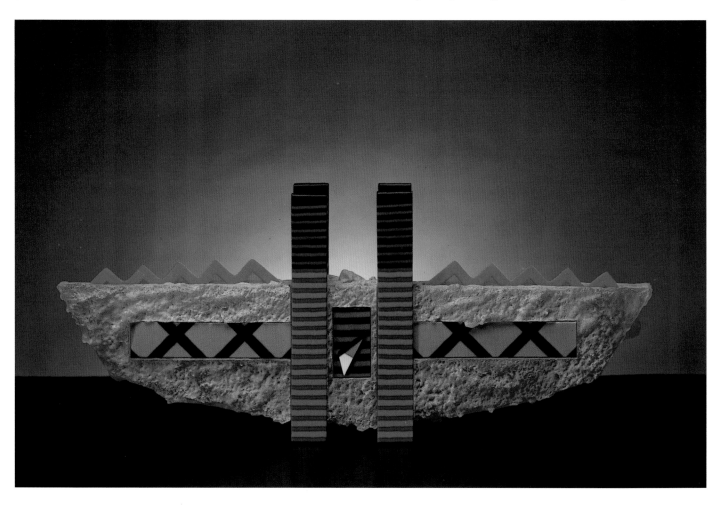

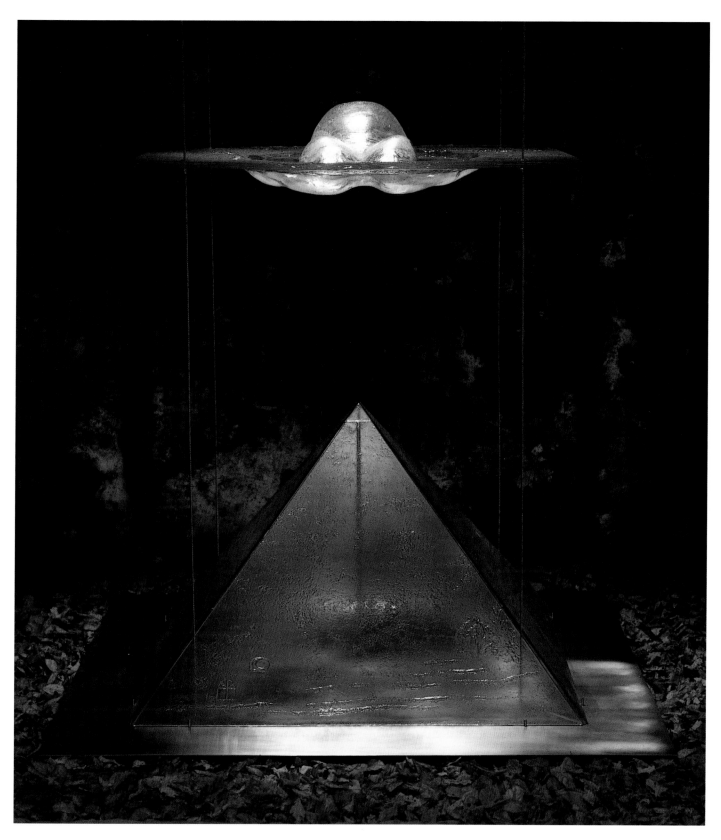

Florian Lechner, Germany: *Pyramide und Leben* [pyramid and life] four-sided pyramid with torso of pregnant woman suspended above, 1976–80

150cm × 150cm × 150cm; sheets of 20mm thick glass are slumped over fireclay moulds; temperature and time in the kiln determine the intensity of the light refraction, form, structure and colour

169

Kimiko Kogure, USA

Some readers will know the game that begins with one hand behind the back; when the hand is presented it appears as a fist, or an open palm, or two fingers extended in a V. A fist represents rock, an open palm a piece of paper and the two fingers a pair of scissors. Rock blunts scissors; scissors cut paper; paper wraps up the rock. The idea of rock submitting to paper is intriguing – very Zen!

Kogure's composite sculptures capture this feeling. They combine the tissue-like delicacy of slumped glass with the ponderous weight and solidity of stone. They radiate mystery and serenity, and speak of secret, sacred places.

Kimiko Kogure, USA: *Rock Strata*, c. 1986 34cm square × 25cm high; slumped float glass, sand-blasted and glued; lacquered wood, rock and twine (courtesy: Musée des Arts Décoratifs de la Ville de Lausanne, Switzerland)

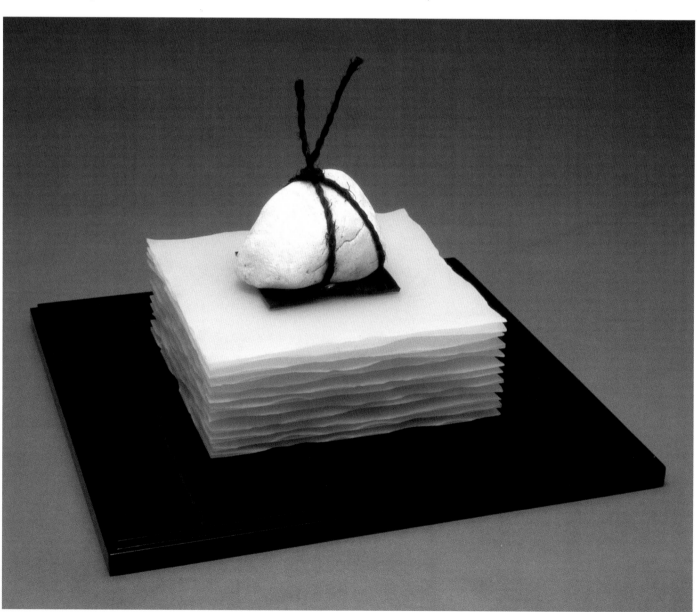

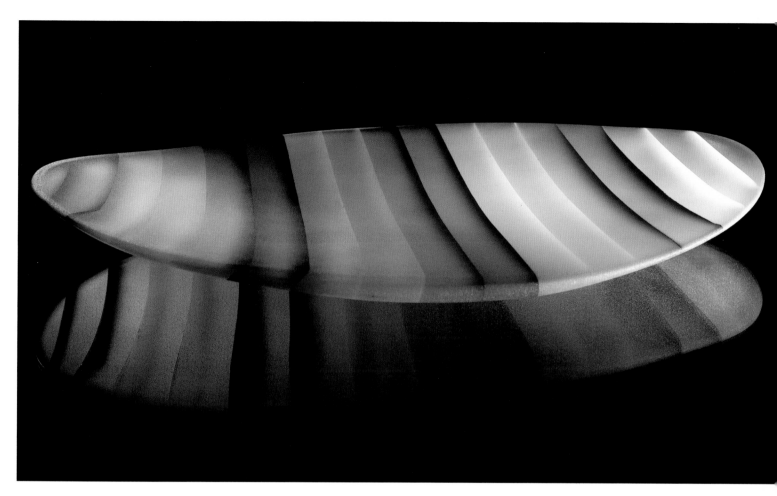

Brian Blanthorn, UK: *Dish*, 1983
17in. × 13¾in. × 1½in. high; kilnformed float glass enam-
elled, laminated and hand finished (photo: Frank
Thurston)

Brian and Jenny Blanthorn, UK

For many years, obsessed by the colour, pattern and
texture of stratified geological formations, Brian
Blanthorn has worked consistently to refine his basic
idea. Stripes, in multiple and glorious guises, form
the basis of his unwavering aesthetic vocabulary.

His lamination technique involves fusing strips of
thick float glass into slabs. By applying a black stain
to one surface of each strip, or developing a
controlled devitrification – a milky white crystalline
growth between strips – he creates an integrated
organic pattern related to the desired shape and
structure of his bowls.

The edges are cut and ground to provide the exact
shape required and the slab is then slumped into a
metal dish mould. The inner and outer surfaces are
subsequently hand-ground and polished with
abrasive diamond pads. More recent collaborative
work has incorporated quite vivid colours, deep
transparent blue and yellow stripes inspired by
tropical fish, and, most recently of all, pebbleforms
whose roughened surfaces veil spectacular opal-like
interiors revealed through polished facets.

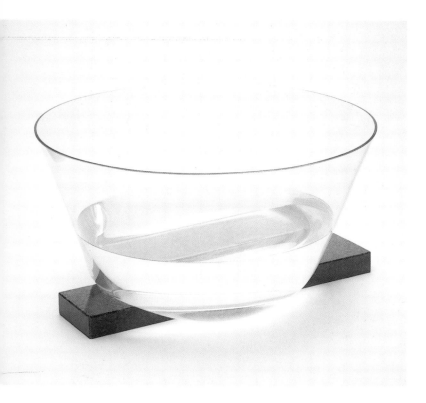

Bert Frijns, Netherlands/Japan: *Soft glass with stone and water*, 1987
49cm diameter × 27.5cm high; window glass, slumped
(photo: F. André de la Porte)

Bert Frijns, Netherlands

The disconcertingly simple kilnformed pieces by Bert Frijns display a highly sophisticated though subtle wit together with a singular economy of means. Early works consisted of stacks of slumped-glass sheet 'bound and held' in tension by encompassing wire threads. Another thought-provoking series consisted of sections lifting scroll-like from the surface of a platter. More recent pieces have ingeniously explored aspects of containment, weight, stress and balance. Bowls are softened and distorted to sit astride granite blocks – prosaic articles transformed into serene and contemplative objects.

Sydney Cash, USA

Movement is the common thread connecting Cash's researches over the past two decades, from his early interest in distorting mirrors, through the exquisite flowing forms of his slumped pieces to the optically kinetic sculptures of recent times.

The slumping developed as a result of accidentally overheating glass he was attempting to bend over wire armatures. It could have happened to anyone – though perhaps Cash's lack of formal training in the medium enabled him more quickly to recognise the potential of his discovery.

The elegance of his stunning tableaux of delicate silken folds of glass arrested in full flow, and the sophistication of the later graphic works, in which illusory movement is perceived or stimulated as the viewer moves, seem to defy reason. In recent pieces, intricate computer-generated linear patterns are screenprinted onto sheets of glass which are then cut to shape and assembled, with silicone glue, into three-dimensional structures. Any change of viewpoint will generate breathtaking and elusive moiré patterns, vibrating energy verging on the ethereal.

Sydney Cash, USA: *Tender Force*, 1988 ▶
13in. high; slumped glass, mixed media (courtesy: Heller Gallery)

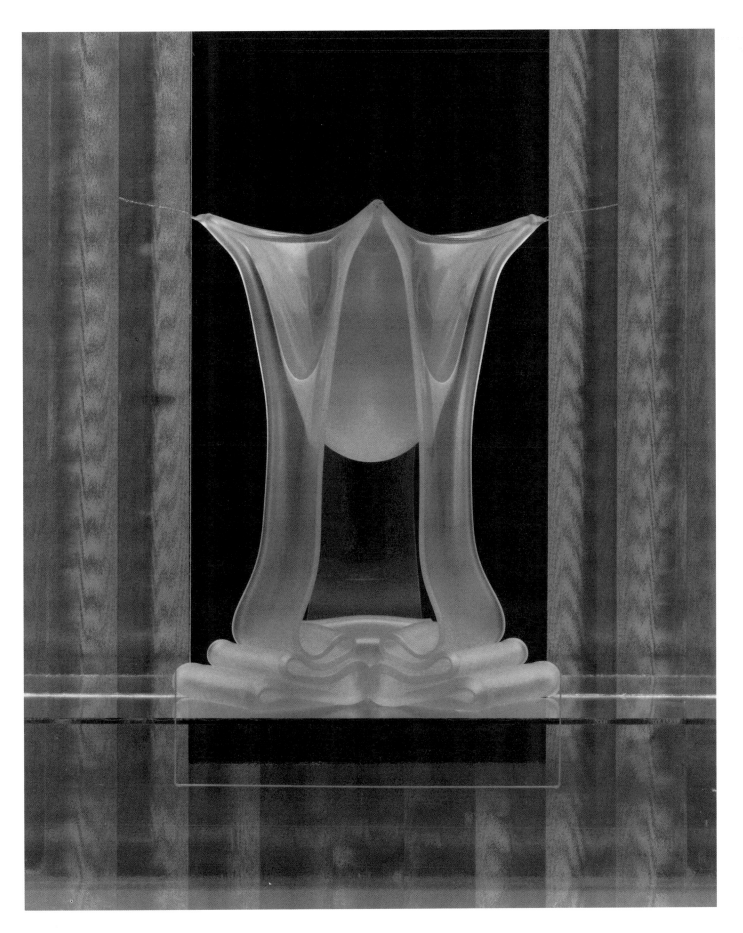

Karl Berg, Germany

Karl Berg works in the 'classical' manner of the Czechoslovakian Optical School – cutting from the solid to create impeccable stereometric forms. His shapes are developed intuitively rather than as the result of mathematical process, as independent, self-contained objects. Highly reflective, they immediately engage the viewer in exploring their prismatic universe.

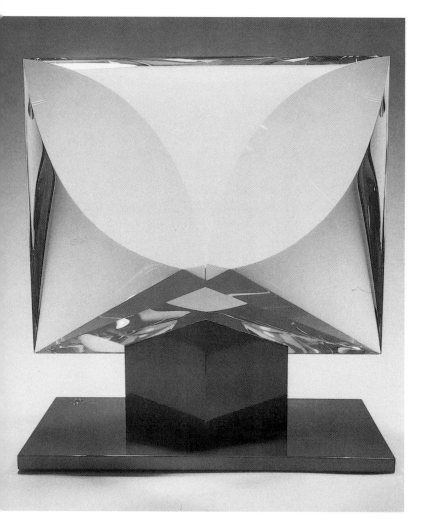

Karl Berg, Germany: [untitled], 1988
25.5cm × 12cm × 27.8cm high; yellow optical glass, cut and polished, anodised aluminium base

Peter Aldridge, UK

For a number of years, Peter Aldridge, along with Eric Hilton and David Dowler, worked for part of each year in a design team at Corning for Steuben Crystal whose declared aim it is to produce the finest crystal in the world. In any event Aldridge had at his disposal a flawless material from which to sculpt his geometric abstracts. Although minimal in spirit they articulate his preoccupation with forms of language, music and mathematics, and particularly with numerology in relation to both modern physics and ancient mysticism. Indeed Aldridge regards glass as having mystical properties and thus the perfect medium to express his perception of the nature of reality and the passage of time – to encapsulate 'frozen moments in space'.

Aldridge has written, 'I work with light in sculpture in much the same way as a musician uses sound. The underlying mathematical progression of individual notes, the multiplicity of overlaid rhythms, tonal range and chromatic intervals, all have their parallels when composing with light. I do not want my sculpture to exist merely in relation to its environment – rather it must provide within itself a focus for its environment.'

He has combined the use of high technology milling equipment with specially devised diamond cutting tools to achieve an exceptional degree of precision and to exploit fully the prismatic qualities of glass. His commemorative *Peace Crystals*, among the most publicised pieces of contemporary glass, were presented to President Sadat and Prime Minister Begin at the signing of their historic peace treaty in 1979.

In 1993, he returned to Britain to become course leader of the Glass Department at the Royal College of Art, London.

Peter Aldridge, UK: *Harmonic Sequence 3- 3- 3-*, 1988 ▶
15in. square × 11in. high; cut, ground and polished lead crystal (courtesy: Steuben Crystal)

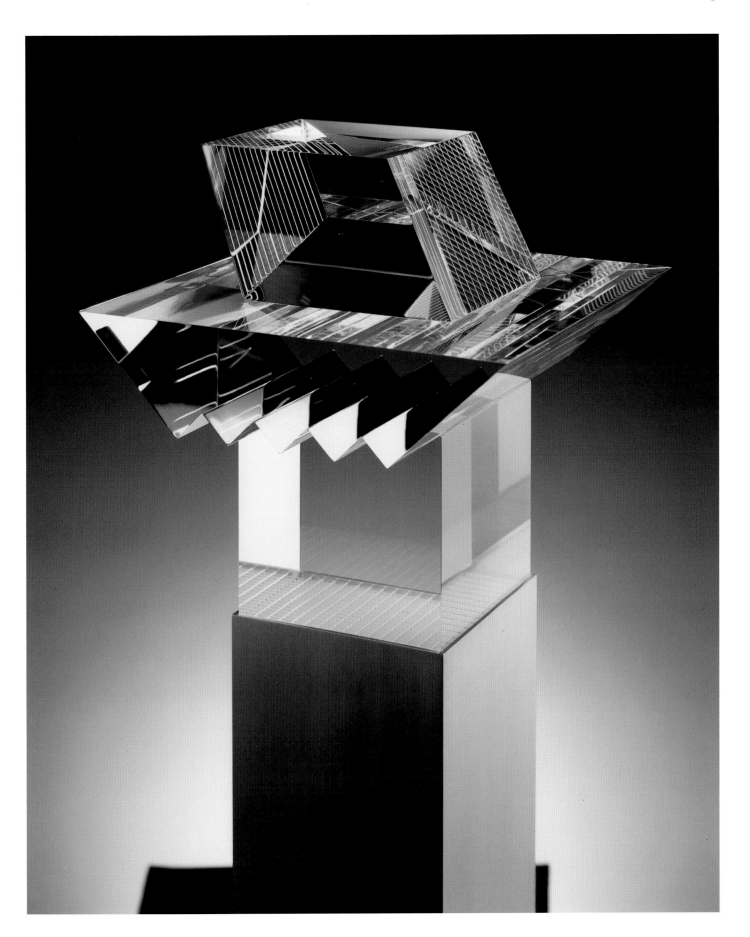

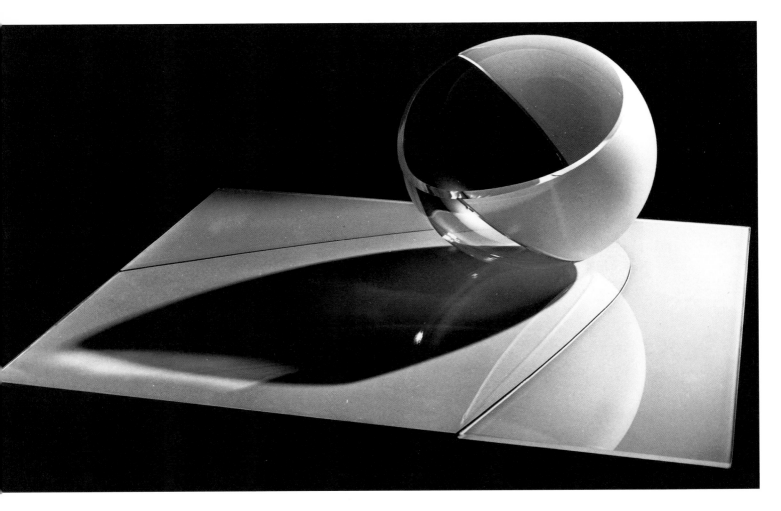

Stephen Procter, UK: *Touchpoint*, 1986
base 84cm × 76.5cm, piece 31cm high; blown and cut
rocking form with prismatic cutting and sandblasted sur-
face, resting on flat glass base (photo: Mick Bruce, courtesy:
Royal Museum of Scotland)

Stephen Procter, UK

Stephen Procter's contemplative pieces often
comprise forms derived from the sphere or ellipse,
delicately balanced, occasionally stirred into gentle
motion by the air currents in a room. Their edges are
carved and polished, their surface sometimes
sandblasted or cut to bring out the prismatic
qualities of the crystal, 'refracted light breaking
rainbowlike or as a flash of fire'.

His pieces are deceptively direct, their apparent
simplicity masking a symbolic approach to
fundamental questions of art, life and philosophy.
They are explorations of the natural order of things:
energy and rhythm, harmony and balance,
movement and stillness, light and shadow. Each
represents but a step along the path to a greater

understanding of self and an awareness of the unity
of life, space and time. Procter is deeply inspired by
nature, his love of the land imbuing the work with a
serenity and wholeness that in a cacophonous age
reaffirm the existence of a still centre.

Procter has written, 'A piece grows from a thought
into a series of sketches, each one a preparation to
understand better parts of the whole composition, so
that gradually everything comes together quite
naturally at a point way beyond the initial
self-conscious effort.

'Working with a material is the way of learning to
be sensitive to it. There is a special rhythm one
strives to achieve. It requires a constant dialogue,
feeling through the hands and fingertips, observing,
listening, communicating not just with senses, but
with the mind also. Experience develops intuition.

'Beginning with blowing the form from molten
glass, the piece is carefully shaped by gravity and
hand, to obtain the correct thickness, balance and
flow.

'After the cooling, it is opened, using a traditional
glass cutting lathe with stone wheels. For final

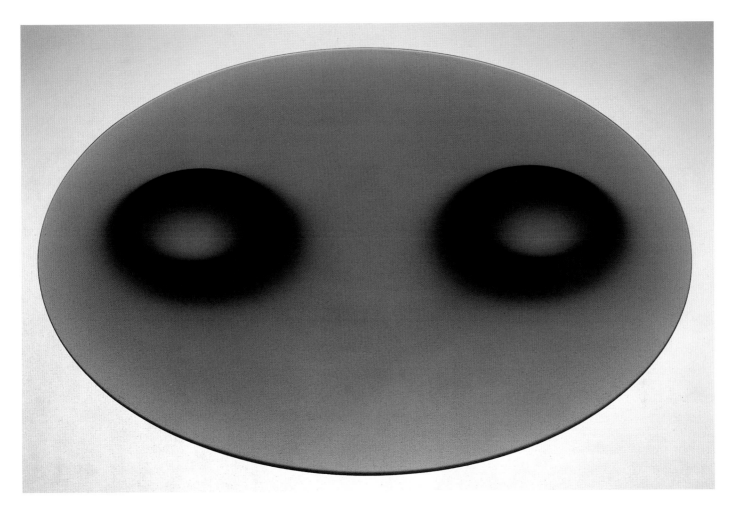

Frantisek Vizner. Czech Republic: *Cut Plate*. c. 1984 approx. 35cm diameter; wheel cut from kiln-cast disc and etched

shaping I use softly-backed carborundum or diamond bonded wheels which cause no vibration, quite crucial on the larger forms. Again I use traditional wheels with appropriate profiles for simple cut lines and prismatic cutting. One needs to work steadily with the wheel to sense its motion through touch and sound. Listening attentively, altering the angle and pressure, the wheel itself tells one the correct approach.

'Stipple engraving, as in the earlier work, is achieved through gently striking points of light into the glass using a hand-held diamond pen. Gathering these points into an intricate order produces the image. Light is the key.

'Each way of working gives its own particular quality, influencing the character of the whole. Sometimes the surface is richly worked with a combination of cutting and sandblasting and engraving, intercepting and breaking up the light, while in other pieces only a finely-cut edge is worked, to express pure form as a line of light.'

Frantisek Vizner, Czech Republic

Frantisek Vizner's objects, although totally different in their resolution, display essentially similar concerns to those of Stephen Procter – the achievement of absolute 'rightness' of balance and harmony. The monumental simplicity and the subtle form of the objects are deceptive; the solid rough-cast shapes require many painstaking hours of wheelcutting. All superfluous detail is eliminated in pursuit of the very essence of container form; functional references are vestigial. Colour is generally muted, tempered from the depth of the piece to its translucent edges. The surface is often treated with acid to give a beautiful even-textured velvet-matt finish. The work expresses a sophisticated but natural geometry and a classical elegance, as well as a rare integrity of purpose.

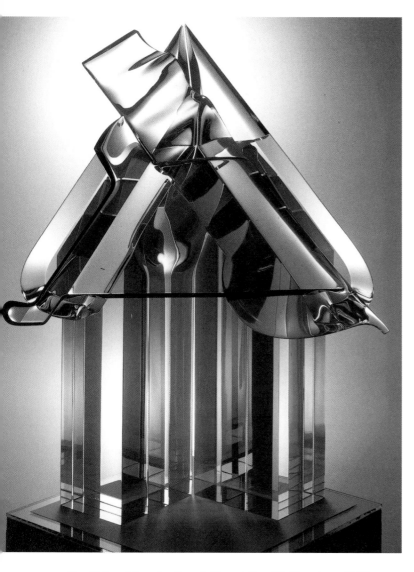

Bretislav Novak, Czech Republic: *Civilization*, 1988
68cm high: composite piece of 10 cut parts in optical and
light blue glass (photo: Foto-Hilger)

Bretislav Novak, Czech Republic

Bretislav Novak's father pioneered the use of optical
cutting techniques to produce exquisitely refined and
subtle objects that wholly express the fluidity of glass.
Novak has pursued his own vision to arrive at
multi-form totems or composite abstracts that fit
together neatly, attaining heights of up to three
metres. The parts are immaculately ground and
polished from precast forms and tinted sheet glass.

Kazumi Ikemoto, Japan

Makoto Ito credits Ikemoto, one of his instructors at
Tama Art University, with having a vital influence on
his students and in helping them to find their
personal vision – surely the most significant role for
any teacher worth his salt.

He first captured public attention with a
marvellous series of 'stained' glass panels whose
unique style and mysterious 'fairytale' atmosphere
shocked his audience. Exquisitely painted, the
extensive use of airbrushing techniques imparts a soft
luminous quality to the colour, shading and
modelling of illusory 3D images. Strange rabbit and
ram-like creatures, reminiscent of Brueghel or
Tenniel (*Alice in Wonderland*) inhabit imaginary
landscapes, somewhere between medieval urbanity
and science fiction.

The three-dimensionality has become actual in
more recent painted objects, supporting a growing
belief among glass artists that painting provides the
most potent means of expressing emotions and ideas.

Kazumi Ikemoto, Japan: *Scene 9506*, 1995 ▶
24cm × 13cm × 57.5cm high; float glass, cut (laminated),
glued, sandblasted and enamelled

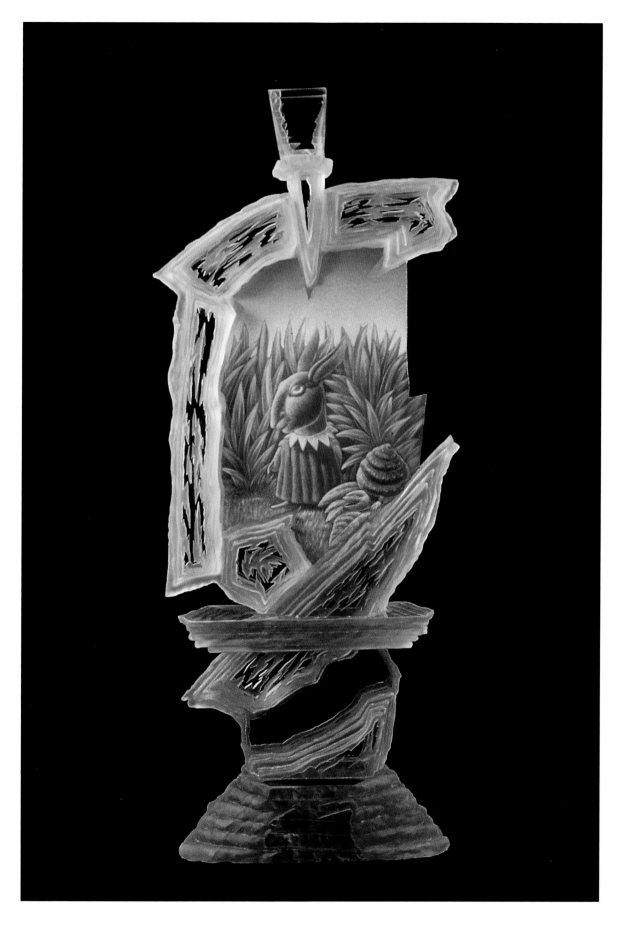

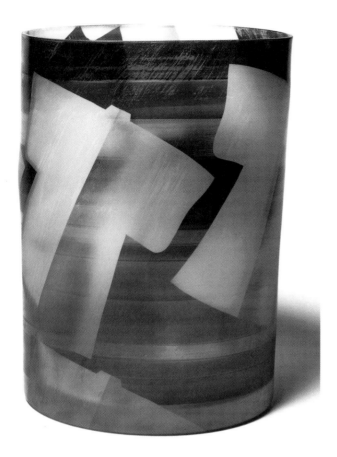

Isgard Moje Wohlgemuth, Germany

The exquisite colouring and surface qualities, for which Isgard Moje Wohlgemuth is renowned, are the outcome of long years of intensive research and purposeful refinement of her working processes. One of the pioneers of German studio glass, she maintains an experimental and open-minded approach, constantly seeking to extend an already comprehensive palette.

Using metallic resinate lustres she paints onto blanks, usually lead crystal, blown to her design. By sandblasting, repainting, refiring and then repeating the whole process over and over, layer upon layer, she can build up a depth and complexity of colour, shades and nuances, unattainable by other means.

Pieces are sometimes fired above normal lustre temperatures and this causes some deformation of the glass resulting in more organic and asymmetric forms, as well as extending the range and intensity of colour and imparting exceptional silken surfaces. A potter's banding wheel, a variety of brushes and some masking tape are the basic tools required to produce infinite geometric patterns composed of interwoven strands of rich and delicate colour. Diamond-point engraving and sandblasting add further textural qualities.

Isgard Moje Wohlgemuth, Germany: *Kimono Cylinder*, 1988
approx. 24cm diameter; mouldblown and painted with metallic resinate lustres in layers; fired, sandblasted, re-painted and refired several times (photo: Jörg Andermatt, Asendorf)

Yoshiko Takahashi, Japan

A former student of Makoto Ito, he has inherited Ito's sensitive approach to form, colour and material. During a two-year workshop period in Germany with Udo Edelmann, he acquired the iridising techniques that he has employed to subtle effect in combination with contrasting areas of sandblasted texture. More recently he has been experimenting with painting on glass and combining cast and blown elements. His refined pieces convey a wonderfully refreshing wholeness of spirit and a quiet calm sophistication.

Yoshiko Takahashi, Japan: [untitled], 1988 ▶
42cm high; freeblown, iridised and sandblasted

Ann Wolff, Sweden: [untitled], c. 1987 ▶
approx. 35cm diameter: freeblown with multiple coloured
underlays, acid-etched lines and brush strokes, sandblasted
(photo: FotoWeber, Bodenmais, courtesy: Galerie
Herrmann)

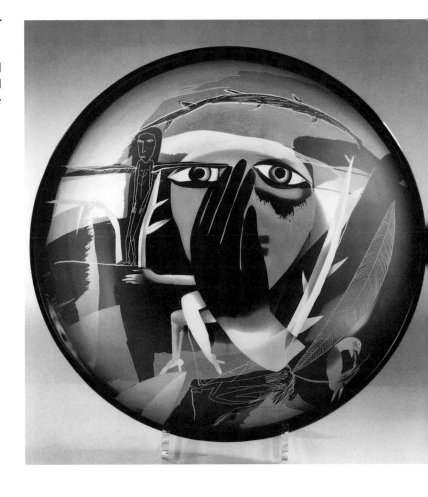

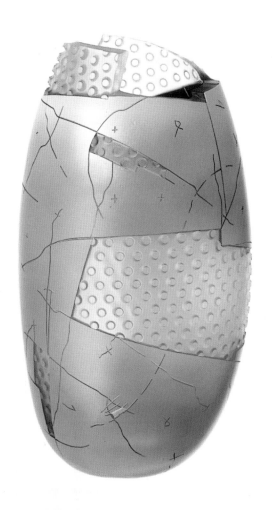

Ann Wolff, Sweden

Ann Wolff once wrote quite beautifully, 'Glass carries
my scattered thoughts into the light,' and so it has,
for years. And all the while she has reminded us that
glass can be so much more than a mere commodity,
rather one among many ways to explore possibilities.

In 1978, with her reputation firmly established as
an outstanding designer, she left Orrefors and
together with Wilke Adolfson set up her own studio.
He has since gone his own way and she has
collaborated with various other masters, including
Jan Erik Ritzman, to produce the multi-layered
coloured blanks she requires to create her graphic
objects. Using acid etching and sandblast techniques
she depicts her dreams, memories and fantasies.
Images recur as raw, powerful and poetic motifs –
improvised in the haunting manner of jazz or blues.

Bowls are a favourite symbolic form but panels
and roundels as well as prints, paintings and
sculpture serve as vehicles in the search to express
personal truths. Hers is a thoughtful and sensitive art
whose integrity and insight have challenged accepted
mores and won her deserved respect.

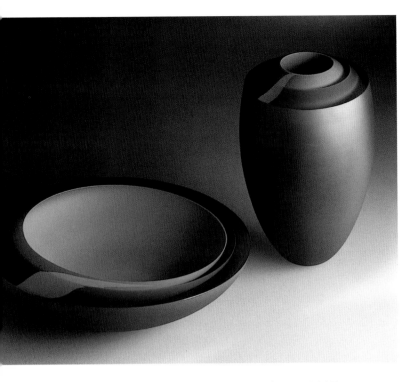

Rachael Woodman, UK: *Bowl and Vase*, 1987
bowl 28cm diameter; vase 22cm high; freeblown, cased and
overlaid colour; cut, sandblasted and acid polished

Rachael Woodman, UK

One way or another, for most of her career, Rachael
Woodman has worked in collaboration with Neil
Wilkin, an outstanding glassmaker who also
produces blanks for many other artists, including
Floris Meydam, Anna Dickinson and Clare Henshaw.

Together they blow the thick bowls and vases,
built up from layers of clear glass with cased and
overlaid colour, that she requires for coldworking.
The rims are roughly sawn, then painstakingly
ground and polished, carved in effect. Internal layers
of colour become visible through the polished edge,
seeming mysteriously to 'float', a sensation that is
enhanced by the convincing choice of shape and
colour, and the precision of the wide, bevelled,
asymmetric rims. Woodman is one of several studio
glass artists who have designed for Dartington
Crystal; others include Neil Wilkin, Jane Beebe and
Charlie Meaker.

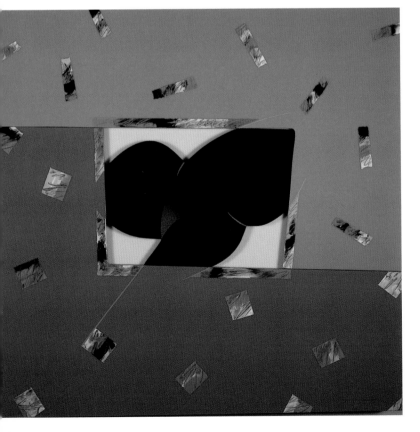

Henry Halem, USA

One of the most outspoken and dynamic
campaigners on the American glass scene, Henry
Halem has made an immense contribution towards
its development, as a passionate educator, as a
longstanding GAS (Glass Art Society) council
member and, not least, through his constantly
evolving work. In recent years he has concentrated
on a series of wall panels and reliefs, exploiting the
solid colour grounds provided by Vitrolite, an opaque
structural glass that was very popular during the
1930s and of which Halem unearthed considerable
stocks in a marvellous range of colours. His
compositions reflect a conceptual approach and
painterly concerns, and have increasingly employed
enamels and paint.

◀ **Henry Halem**, USA: *Black Nude*, 1984
69cm square; Vitrolite, sandblasted and painted with glass
enamels

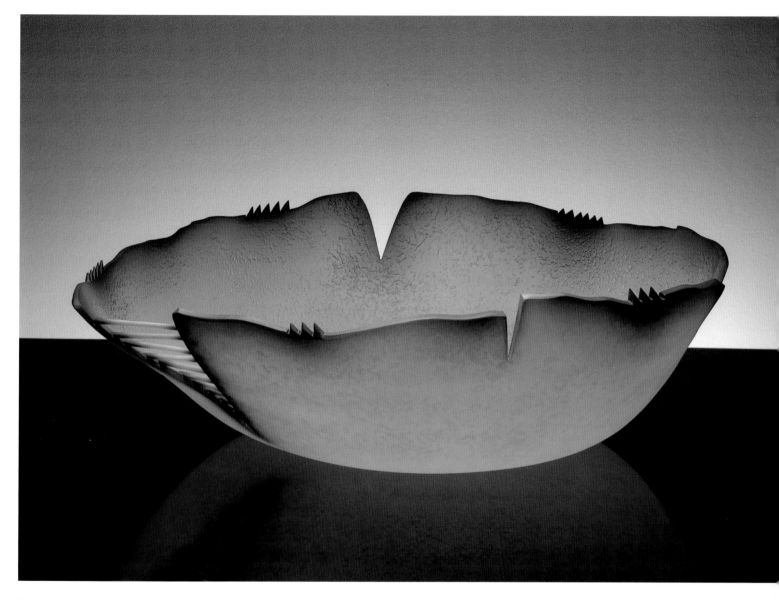

Jay Musler, USA

Paul Hollister's observation that Jay Musler 'has an apocalyptic vision' and makes work that is 'sublime yet menacing' says it all really, and needs little elaboration other than to try to convey some sense of the impact engendered by his enigmatic objects.

One of the adventures in Rudyard Kipling's *Jungle Book* describes how Mowgli is thrown into a snakepit – an experience that one might liken to encountering Musler's glass, eliciting shock, horror, fear and loathing while instantly recognising its inordinate power, beauty and presence. His pieces, although visually and technically direct, possess great depth and sophistication, and evoke jarring gritty images of Desolation Row, Auschwitz, Hiroshima and the like, as with the slumped *Ugly Bowls* or the spectacular *Cityscape* – a huge luminous orange bowlform blown

Jay Musler, USA: *Flesh Pot*, 1982
20in. × 15in. × 6½in. high; blown Pyrex, cut, slumped and sandblasted; oil paint (courtesy: Heller Gallery)

in Pyrex glass, sandblasted and airbrushed with oil paint, its jagged cut black rim as bleak as Dresden or Coventry after wartime bombing.

Other later series, of 'boats' and 'masks', are built up from intricate lattices of sliced and glued sheet glass, not unlike matchstick construction. Caustic and symbolically arid colour is rubbed, brushed and sprayed on, heightening aesthetic tension while denying the 'glassiness' of the objects.

One wonders what Musler will do next. Perhaps he will confirm that the light at the end of the tunnel is in fact a train, and that it is long overdue.

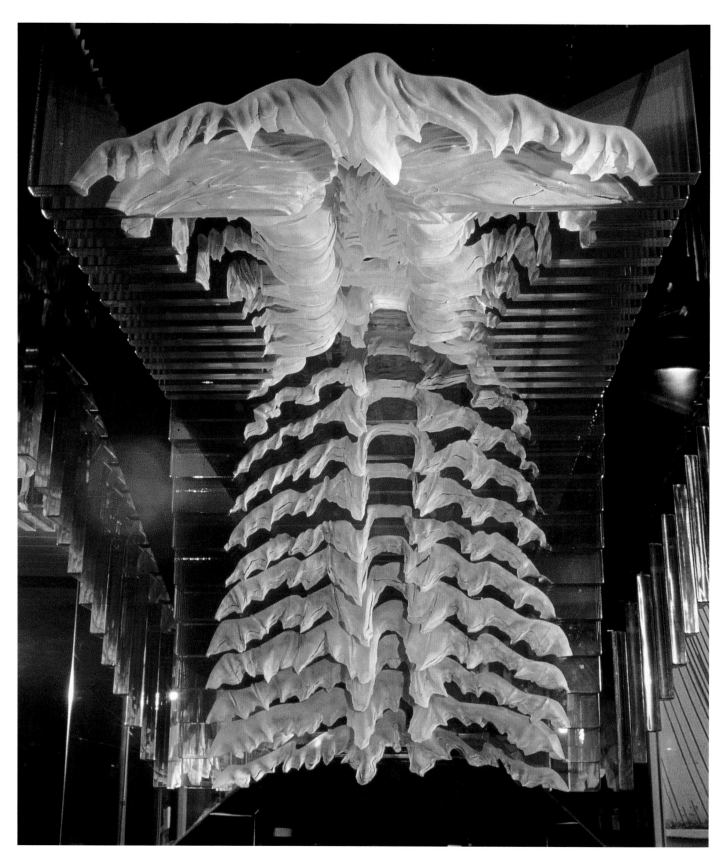

Jutta Cuny, Austria (work completed by Francesco Somaini): *Fountain* in the foyer of Saint Gobain Vitrage headquarters, Paris, 1983–84

380cm high: 27 suspended sheet glass elements, sandblasted; with water and stainless steel (courtesy: Saint Gobain Vitrage)

Jutta Cuny, Austria

One of the most outstanding and innovative exponents of the sandblasting technique was the young artist Jutta Cuny, who died so tragically in a motoring accident in 1983. During her all-too-short career she pioneered its use on glass sculpture, creating ambitious works of great intensity and power.

Born during the Second World War in Berlin and brought up in Austria, she became a brilliant linguist, travelling extensively for her work as a translator and absorbing a variety of cultural influences. During the late 1960s she studied drawing and painting and became deeply immersed in the surreal work of the Viennese School of Fantastic Realism. In the mid 1970s, already an accomplished painter, she began to sculpt in a variety of media.

Working in Italy with Francesco Somaini, and under his direction, she began in 1976 to experiment with sandblasting as a method of direct carving, going far beyond its previous applications in surface treatment. Reversing the masking process, she investigated negative images cut into plate glass sheets and, by 1982, was carving into massive blocks of optical glass to create deep internal volumes. Apparitional and embryonic, they appear to float, mysteriously impalpable, suspended within the glass. Exploiting the refractive qualities of glass, she explored concepts of metamorphosis and the ambiguities of internal-external space, seeking and achieving a rare and consummate degree of unity. In some cases negative volumes were also cast as positives in resin or bronze for juxtaposition with the glass original.

To create a living memorial, her mother has generously endowed the Jutta Cuny-Franz Prize as a biennial, international competition for young artists, especially women artists, whose work in the field of glass art shows exceptional promise.

In the period preceding her death she was preoccupied with vast and monumental projects including studies for a glass fountain at the headquarters of Saint-Gobain-Vitrage, in a building known as 'Les Miroirs' in the Défense area of Paris. This was completed posthumously on her behalf and as a tribute to her, by her teacher and friend Francesco Somaini.

Ronald Pennell, UK

Experience of engraving gems and medallions provided the background for his work in glass. As so often with others who have changed medium the transition was 'accidental' – in this case, a lull while waiting for a late delivery of rock crystal.

An animated and inveterate storyteller, Pennell's impish humour enlivens even the most mundane of subject matter as he amiably yet incisively explores the absurdity of daily circumstances. Through caricature, full of self-mocking wit, loving detail and a deceptively childlike imagery, he pokes fun at the establishment while affirming that good will invariably triumph over evil. Monty, his ubiquitous Jack Russell dog, often symbolises 'our hero' seen overcoming the lurking dangers and pitfalls of life (monstrous crocodiles, snakes and octopi), that lie in wait for the unwary.

Ronald Pennell, UK: *All in This Together*
20cm high; wheel-engraved glass (green tint) (photo: Cliff Guttridge)

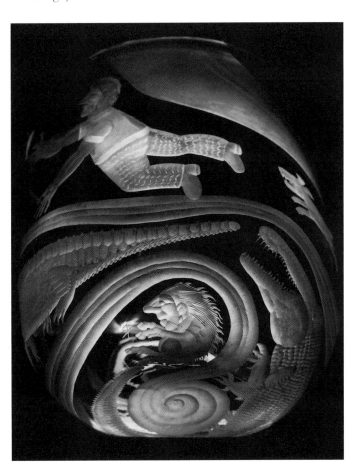

Kristian Klepsch, Germany

An exceptional engraver, his themes explore the classic dualities of male and female, the physical and the psychic, time and space, inner and outer worlds, the subconscious and the supernatural.

He has also devised a method of kiln-casting that employs multi-part clay models and moulds; this enables him to embed finely detailed images both within glass forms and on their surface, akin to deep, intricate engraving. A technical and aesthetic *tour de force*, this process has added further dimensions to an already enigmatic imagery. Klepsch has written, 'When you take a clear, transparent vessel and "wound" its surface by engraving, you experience light on the skin of the glass – an impulse or thought changed to light'.

Kristian Klepsch, Germany: [untitled], 1983
kiln-cast with internal core-formed figures, engraved

Jiri Harcuba, Czech Republic

There can be little doubt that Jiri Harcuba is the world's leading copper-wheel glass engraver. He has virtually single-handedly 'rehabilitated' portrait engraving, and using traditional techniques given the medium an entirely individual and contemporary meaning.

Since 1971 when he engraved a homage to Dominik Biemann, the great nineteenth-century engraver, Harcuba has created hundreds of brilliant intaglio portraits, of writers, musicians, philosophers, scientists, artists and friends, all of whom he admires at some level. His vision is spare, indeed austere; he concentrates almost exclusively on the face, usually in profile, as the mirror of personality, seeking to capture the very essence, the essential humanity and perhaps divinity of his subject. A designer and engraver of medallions for many years, he tends to favour thick circular discs whose shape and movement contribute to the intensity of the image.

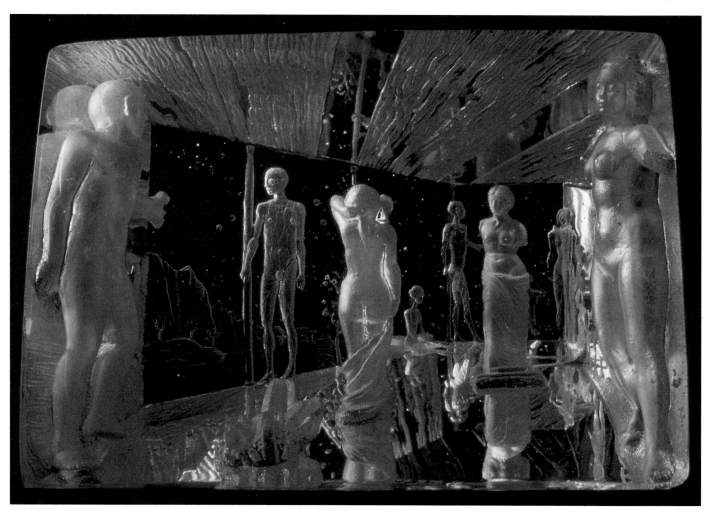

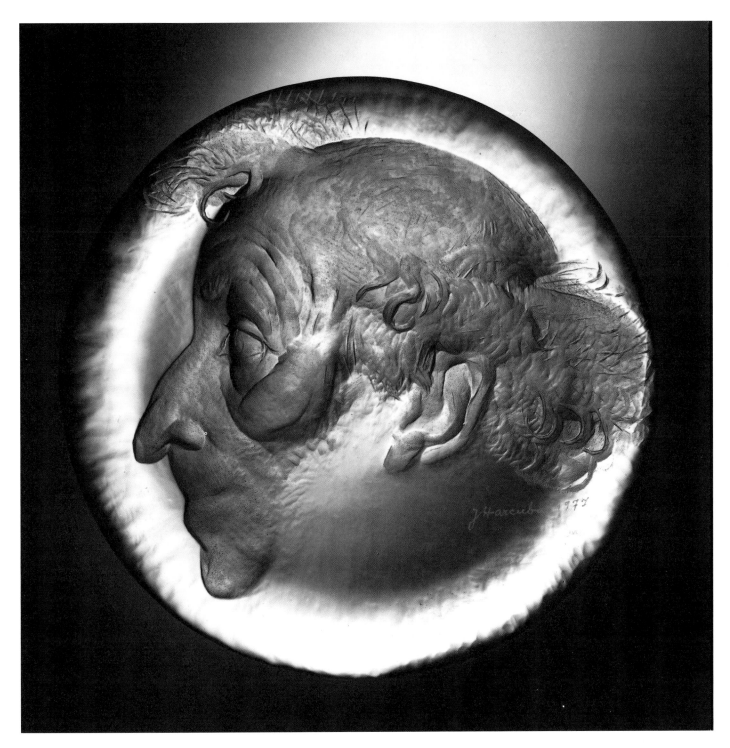

The depth of modelling and the luminosity are sometimes enhanced by work on the reverse of the glass slab and by a sensitive use of contrasting matt areas.

Persecuted by the previous political régime, his election as the Rector of the Prague Academy of Applied Arts following the Velvet Revolution was a clear vindication of his stance and a mark of the esteem in which his work is held.

Jiri Harcuba, Czech Republic: *Marc Chagall*, 1977
14cm diameter; engraved glass (photo: Jindrich Brok)

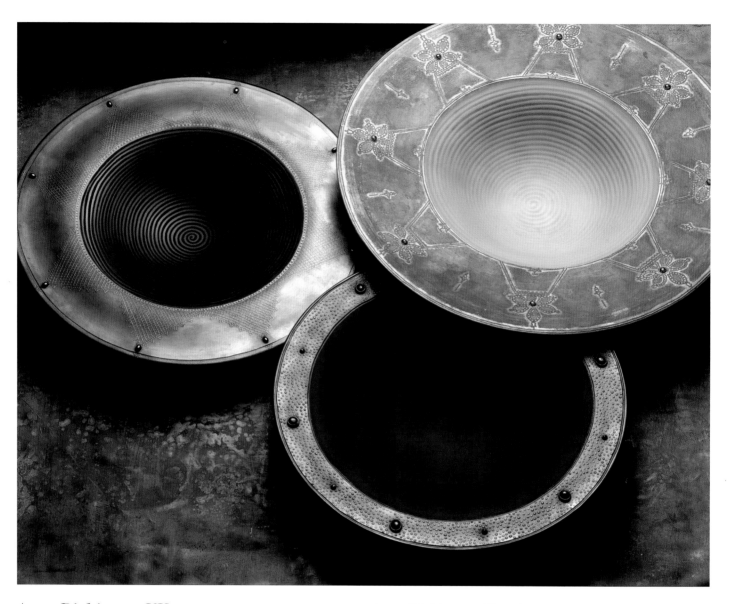

Anna Dickinson, UK

A timeless and unforced simplicity, a quiet conviction and a wonderful balance of colour, texture and material are amongst the host of virtues combined in Anna Dickinson's electroformed pieces. Her form and decoration are inspired by ethnic art and although visual references abound, they never detract, even in the most opulent pieces in which semi-precious stones are set into gilded metal. The blown pieces are often exquisitely carved (wheel cut, sandblasted and etched) prior to electroforming. The slow build-up of metal on the glass surface and its subsequent treatment demand a painstaking and precise craftsmanship that draws on her early training as a metalsmith. It also allows time to contemplate the design as it evolves, for it may take several weeks to complete a single piece.

Anna Dickinson, UK: *Three Plates*, 1990
left: 35cm diameter; bottom 40cm diameter × 9cm high; right: 32cm diameter;
left: *Haematite Plate* blown in black glass, spiral sandblasted and etched; rim electroformed with copper and set with haematite stones; copper then oxidised black with pattern achieved by polishing, masking and replating
bottom: *Ethiopian Plate* blown in clear glass, spiral sandblasted underneath; inside sandblasted and etched; rim electroformed with copper and set with garnets; copper then gold plated, patinated and waxed
right: *Diopside Plate* blown in black glass with inside sandblasted and etched; rim electroformed with copper and set with black diopside stones; copper then oxidised and waxed with pattern achieved by cutting and plating over spots of glue (photo: Kevin Summers)

Michael Glancy, USA

Inspired by the work of Maurice Marinot, Michael Glancy set out to master the dangerous and time-consuming processes required for deep-cutting (etching) with acid. He soon found that he could achieve greater depth and precision in a fraction of the time using a sandblaster fitted with a pressure-pot. Another major breakthrough was the accidental discovery of some primitive electroforming equipment. This led to an exploration of the process as a method of combining glass with metal and to a crucial new dimension in his work.

Individual vessels have evolved into tableaux where bases have been integrated with the vessel forms, establishing and exploiting complex visual relationships. They display an attention to fine detail and craftsmanship that pushes concept and medium a stage further with each unique piece.

These are complex objects, evoking the intricacies of coral or micro-crystalline structures, often probing contradictory, even conflicting attributes: the rich contrasts between the geometric and the organic, inner and outer space, classic and baroque form, subtle or vibrant colour, opulent in its jewel-like settings. Their allure suggests the Medusa whose beautiful markings beguile the viewer before she strikes.

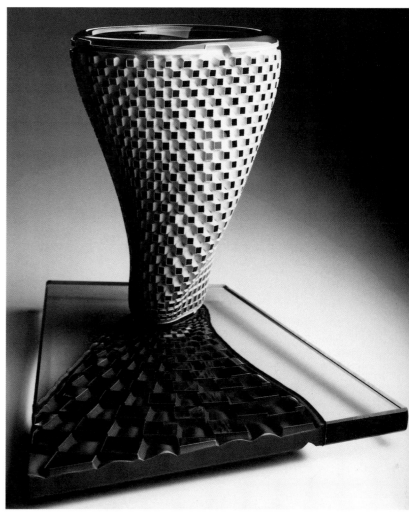

▲ **Michael Glancy**, USA: *Whirling Golden Reflex*, 1988
11in. × 17in. × 11in. high; blown glass and industrial plate glass; carved (sandblasted) electroformed copper and gold plating on blown piece

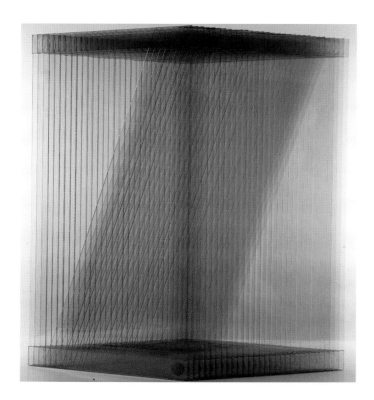

Dewain Valentine, USA

Valentine builds large-scale laminated structures, impressive spatial systems whose contiguous edges and overlaps create complex linear rhythms and correlating tonal progressions.

◄ **Dewain Valentine**, USA: *Open Diamond Diagonal*, 1982
72in. high; strips of float glass cut and glued (photo: Thomas P. Vinetz)

189

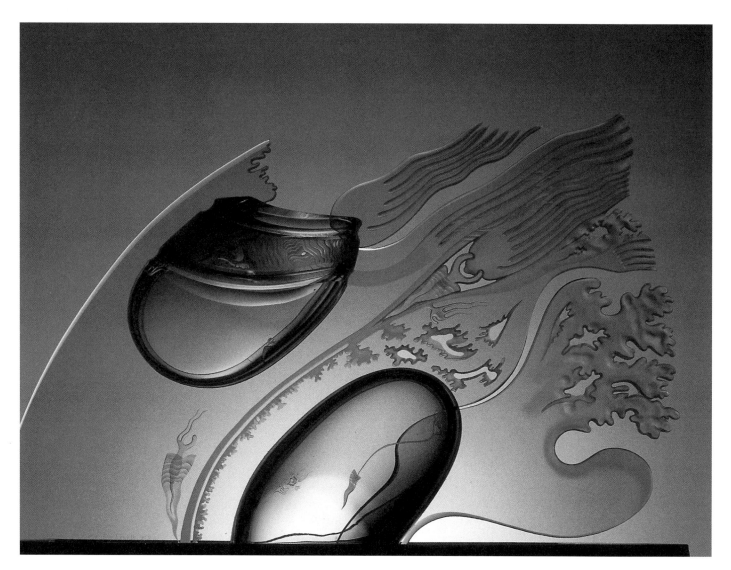

Ray Flavell, UK

As teacher, author and maker, Ray Flavell has had a considerable influence on British Studio Glass. He established a facility of international standing at West Surrey College of Art and Design at Farnham, and is currently restoring the famous department, started by Helen Munroe Turner at the Edinburgh School of Art (Heriot Watt University) to its former glory. He taught pottery before attending the Orrefors Glass School in 1969/70.

Flavell makes unique vessels, laminating precise yet fluid blown forms with shaped flat glass. Edges, which are cut and polished, effectively carved, are invariably satisfying, as is the restrained use of colour and organic surface treatment, with cutting and sandblasting applied in limited areas.

Ray Flavell, UK: *Fantasy*, 1993
65cm × 14cm × 45cm high; two blown elements of (internally) cased pink and green, bonded to flat glass; blown glass sandblasted inside and out; flat glass pierced and modelled by sandblasting, wheel cut, bevelled and polished

Renato Santarossa, Italy/Germany

Renato Santarossa is a tall, playful man who wields an ordinary glass cutter with extraordinary skill. He builds up complex graphic structures by cutting and laminating overlapping modular elements whose cut edges and linear scoremarks attract and reflect light. The illuminated edges and resulting shadows achieve subtle and ephemeral effects and in some pieces these delicate linear traceries have evolved into hieroglyphic symbols which, with a hint of painted colour and gilding, take on a rich iconographic quality. In others sheet lead is applied to provide areas of contrast, dull in texture and opaque.

One is struck, on viewing the body of work, by Santarossa's ingenious and fertile imagination. His basic theme is expressed through a variety of architectural applications, as wall panels, screens, windows, light fittings and free-standing sculptures. Among the most ambitious and potent of these are large complex installation pieces investigating the dilemmas of real and illusory space.

One such, *Utopoli*, is an enormous multi-part undertaking inspired by the discovery of the tomb of Shih Huang Ti, the first emperor of a united China, who died in 210 BC and was buried near Sian surrounded by an entire army of life-sized terracotta guards. Santarossa's version, a mixed-media composition, stands as a symbolic witness, silently imploring its public, as the real guardians of the present and the future, to protect our cultural and ecological heritage.

Renato Santarossa, Italy/Germany: *La Tavola Rotonda* [round table], 1992
800cm × 600cm × 230cm high; float glass cut, bent, painted and laminated, with metal bases; programmed neon beneath crushed glass (photo: G. Erml, courtesy: Cathérine Vaudour, Région de la Haute Normandie)

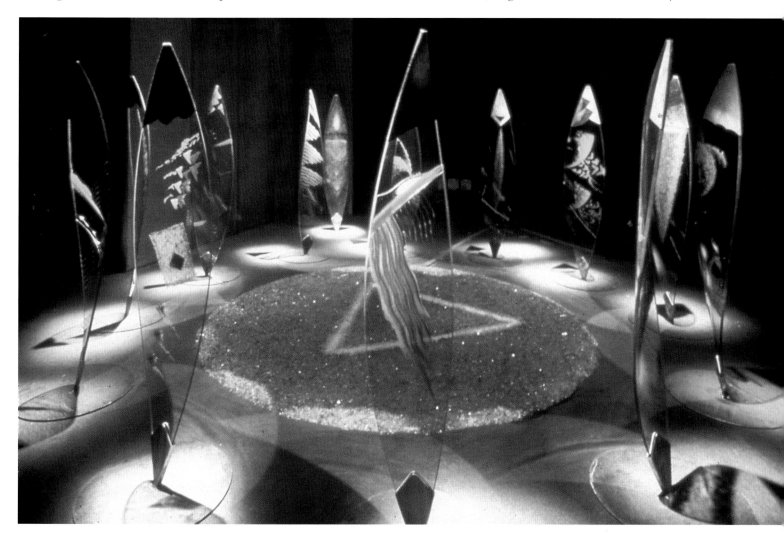

David Huchthausen, USA

The discovery of a disused furnace on campus brought David Huchthausen's architectural studies to an abrupt end. Highly professional and with a wide range of expertise, he took charge of the glass programme at the Appalachian Centre for Crafts in Smithville, Tennessee, in 1980. He has devoted himself to a series that explores a range of strong visual contrasts. His 'Leitungs Scherben' or 'fragments', consist of hard-edge grids laminated in vibrant, opaque Vitrolite, set against coloured transparent areas. These are supported table-like by jagged slabs that have been made by controlled fracturing from thermal shock lines caused when hot glass is poured onto their surface. The illuminated structures stand in sharp contrast to the soft coloured shadows that they cast and which form an important and integral part of the complete object.

Such pieces are meticulously planned and executed. Precision cutting on the diamond saw, an immaculate assembly process, optical-quality polishing and pinpoint lighting contribute to an overall effect that is sophisticated and slick.

In conjunction with the Lee Yawkey Woodson Museum, Wisconsin, Huchthausen was responsible for initiating a major biennial exhibition, 'Americans in Glass', to document the growth and development of American glass art. In 1985 it was also shown in several European venues.

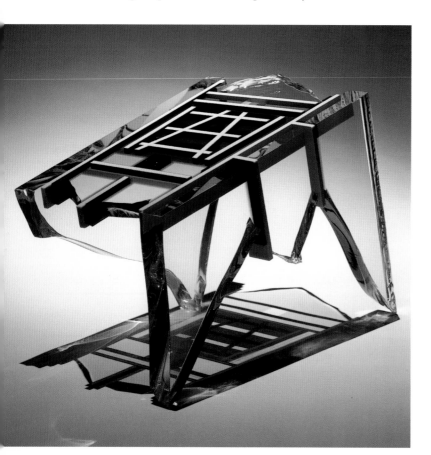

David Huchthausen, USA: *Leitungs Scherbe Series SSD*, 1988
22in. × 13in. × 15in. high; fractured, laminated and optically polished dichroic neodymium glass and Vitrolite with projected light and reflection (photo: Rob Hoffman)

William Carlson, USA

William Carlson's two or three-part polychrome sculptures stem directly from early thickly-blown perfume bottles that were faceted and polished to reveal complex and mysterious interiors of layered millefiori. Although the forms have changed radically and now comprise precise sophisticated assemblages of laminated granite and optical glass, the relationship of inner space to outer volume and the juxtaposition of boldly contrasting visual elements are still his primary aesthetic concerns. The choice of shape, materials (e.g. Vitrolite) and colour occasionally imparts a somewhat 'Deco-ish' look to the work but Carlson has few qualms about using industrial materials and technology when required. Even with the aid of an extensive range of lapidary equipment to achieve impeccably polished surfaces, it can take many months to complete a single piece.

Carlson has also carried out several highly successful architectural projects, notably a large internal screenwall for the Chicago Board of Options building.

William Carlson, USA: from the *Contrapuntal Series*, 1989 ▶
22in. high; granite and kiln-cast glass, laminated

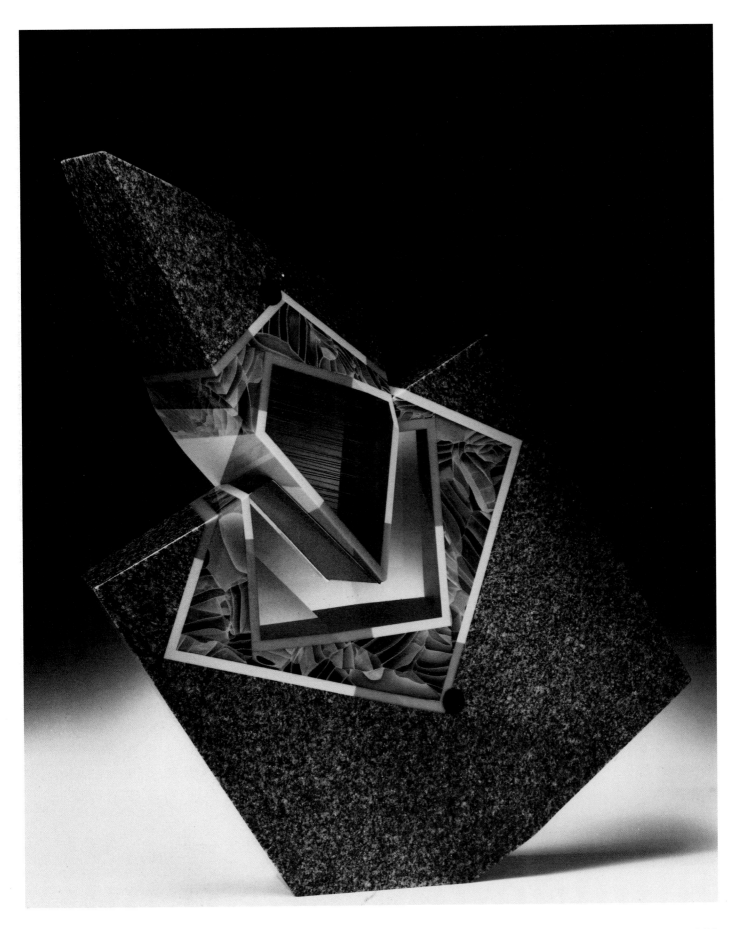

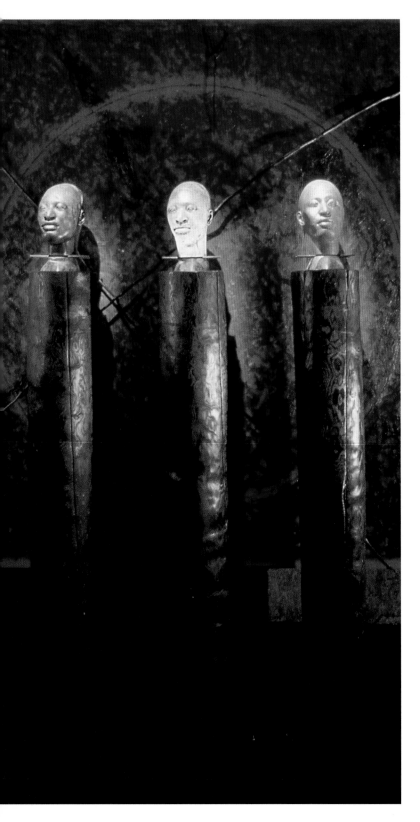

Clifford Rainey, UK

Clifford Rainey's restless energy and intensity belie the introspective nature of his pieces. A superb draughtsman and an avid and eclectic traveller he gathers popular icons for his repertoire, seeking out the mysteries of other civilisations, of mythology, shamanism and primitive symbolism.

The ubiquitous coke bottle, temple pillars, a martyred saint, a Benin warrior's head are amongst cultural references that recur, altered, reconstructed and combined with the same catholicity with which he selects his materials. Glass, plaster, marble, bronze, steel, paint, rags, twigs, anything may be requisitioned in the service of a powerful and disquieting visual purpose that probes social, political and metaphysical layers of meaning.

Marian Karel, Czech Republic

The minimal sculptures of Marian Karel are amongst the most abstract in glass; their rigorous economy of means ranks them with the works of such luminaries of the international art scene as the sculptors Larry Bell and Daniel Buren. Karel's elemental forms range from small cut and glued geometric volumes to vast installations that employ tensioned cables to hold series of large glass sheets in arrangements that actuate reflections, and brilliantly exploit the dynamic ambiguities of real and illusory space and light.

He currently shares the responsibility for running the Glass Faculty at the Academy in Prague with Vladimir Kopecky.

Clifford Rainey, UK: *I came like water and like the wind I go*, 1990–91
250cm × 60cm × 300cm high; kiln-cast glass, patinated; wood, paint on canvas (photo: G. Erml, courtesy: Cathérine Vaudour, Région de la Haute Normandie)

Marian Karel, Czech Republic: [untitled], 1992 ▶
1200cm × 170cm × 170cm high; sheet glass and stainless steel cables (photo: George Erml, courtesy: Cathérine Vaudour, Région de la Haute Normandie)

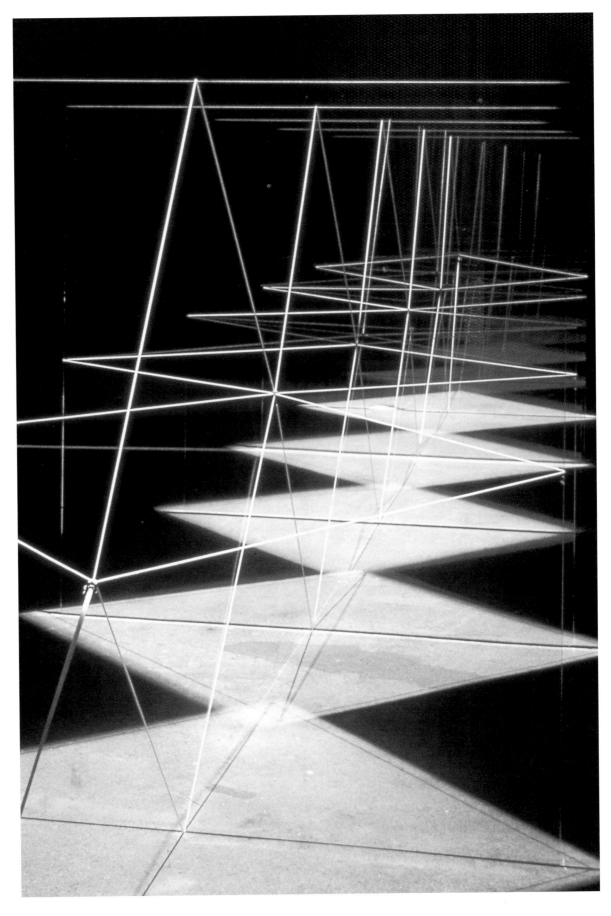

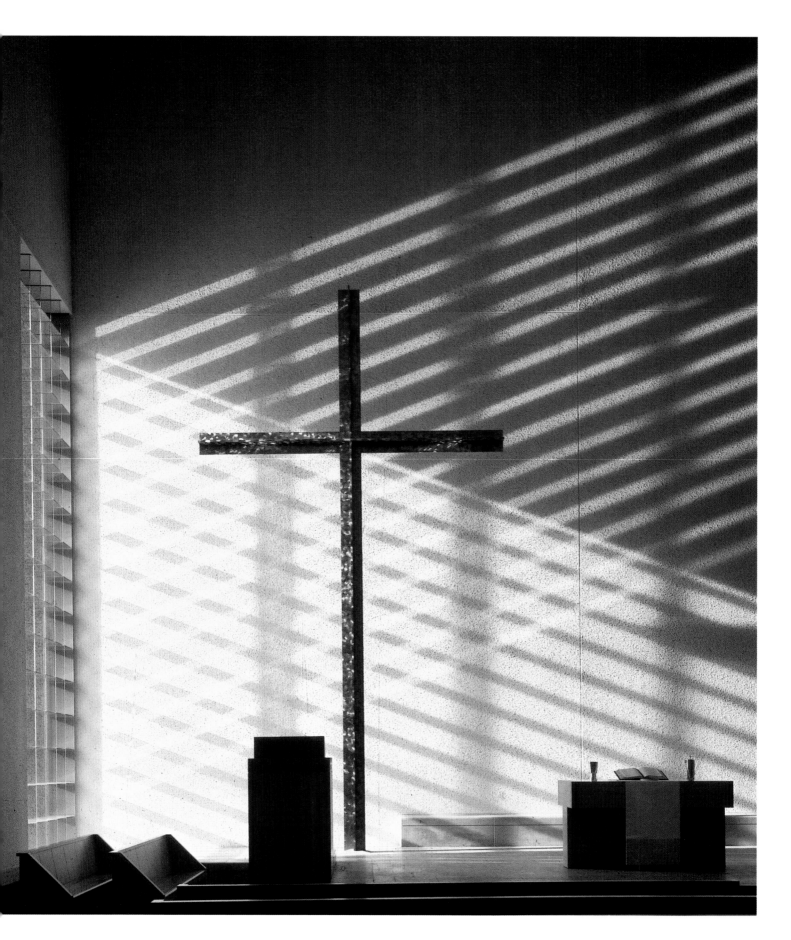

Architecture

The preference for glass as a major element in construction has been a singular feature of modern architecture since the Bauhaus period. Historically, with the exception of the magnificent medieval windows, its main function has been as a light-transmitting weather-proofing screen. The advent of buildings like Paxton's Crystal Palace hastened the decline of massive walls with small openings in favour of the vistas of glass currently popular. These not only encourage the visual flow of space and light but they have also begun to function as environmental control devices.

It was fascinating to learn while attending the conference 'Glass in Architecture' held at the Royal College of Art, London, in 1986 that exterior glass cladding can now incorporate printed circuitry and microprocessors to operate as 'multifunctional-intelligent surfaces'. In short, it can act as a sensor, with the capacity to monitor and control the flow of energy and information (heat, light, sound and services) both inside and outside a building, automatically providing the optimum conditions for its inhabitants, relative to climatic conditions and the time of day or season.

Modern architecture presents marvellous opportunities to integrate thoughtful and imaginative artworks into new buildings. In fact, several countries, including Sweden, Holland, the Czech and Slovak Republics and the USA, have successfully operated systems whereby a mandatory percentage (usually around 1 per cent) of projected construction costs is allocated to 'artistic content'. Unfortunately no such law exists in Britain, so that decorative and sculptural installations are all too often treated as expendable luxuries rather than essential elements of the building fabric.

Architectural glass is a vast subject that is well documented in its own right and lies beyond the general scope of this survey. However, the expanding involvement of 'studio glass' artists in large, site-specific projects makes it too significant an area not to mention.

'Traditionally', studio glass has tended towards small, vessel-oriented objects. Clearly, bigger does not necessarily mean better, but the question of scale is a fundamental aspect of object and picture-making and there is an undeniable trend to explore the problems of increased scale as a means of challenging both the artist's and the viewer's perceptions. The opportunity to alter and enhance interior or exterior public spaces is very appealing, and has the added virtue of reaching a much wider audience.

New aesthetic and technical applications mean that work in 'flat glass' has found a new context and now constitutes a major and essential part of contemporary glass art activity. The expanded use of flat glass in mixed-media work has widened the range of two-dimensional and three-dimensional applications to include screens, fountains, furniture, lighting, free-standing sculpture and autonomous panels. Access to new and varied technologies, modern tools and materials, and the development of stronger, clearer 'space-age' adhesives, as well as the availability of sophisticated advice regarding the tricky problems of mounting, suspending or sealing installations, has made hitherto inconceivable applications for glass quite feasible.

At the same time, many artists whose primary medium is stained glass are actively identifying with the contemporary glass movement. Stained glass has long been regarded as a 'noble art' – synthesising painting and sculpture – but despite extensive secular use since the late nineteenth century its popular association is primarily with ecclesiastical buildings.

Fine works by Charles Rennie Mackintosh, Tiffany and their followers during the Art Nouveau period, by Frank Lloyd Wright in the 1920s, and by Paul Klee and Josef Albers as part of the Bauhaus experiment, paved the way for a modern movement; nevertheless until recently the Church

◀ **James Carpenter**, USA: *West Window, Sweeney Chapel, Columbus, Indiana* (chapel designed by Edward L. Barnes), 1985–87
10ft × 2ft × 30ft high; structural glass prisms, dichroic coating

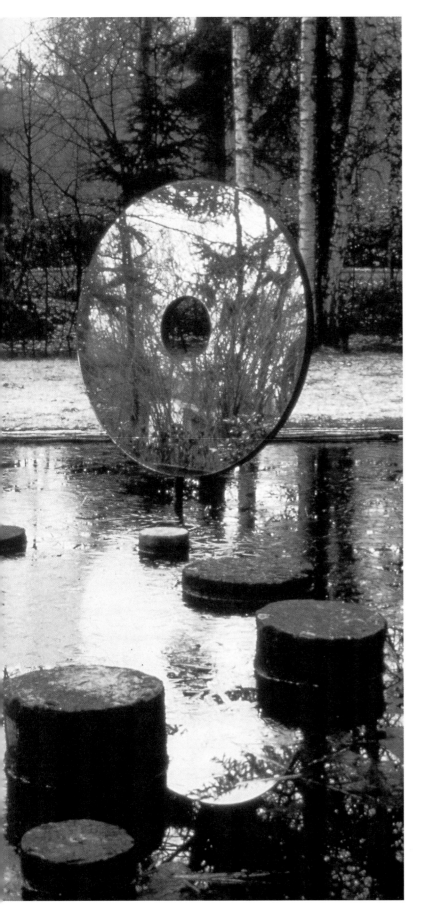

Michel Martens, Belgium

Martens developed his interest in autonomous stained glass panels through his early work in church window restoration. Having introduced mirror glass as a constituent element he became obsessed by its illusory and kinetic properties and fascinated by its potential as a medium for expressive work.

His windows, wall reliefs and sculptures explore the interaction of reflected light and the environment, the continuous formation and dissolution of reflected image, space and colour revealing unlikely and dramatic blends of 'Op' art and Magrittian fantasy.

Michel Martens, Belgium: *Large round mirror object*, 1982
180cm diameter; float glass, cut and silvered

has continued to be the major patron of new and important work. During the 1950s spectacular windows were designed in France by Matisse, Rouault, Léger and Chagall, while in England John Piper's designs for Coventry Cathedral were brilliantly interpreted in stained glass by Patrick Reyntiens. The rebuilding of post-war Germany demanded especially bold new solutions that would ensure the necessary schism with a recent and horrifying past. This gave rise to a generation of stained glass artists who established a distinctly modern visual language based on a linear graphic use of the lead line in virtually monochromatic compositions. These sought to exploit the interplay of transparency, texture and ambient colour. Staining, glass-painting, and even coloured glass were no longer essential prerequisites of the 'stained glass' window.

In recent decades the German School has dominated the international architectural glass scene, and its major figures have had an enormous influence on contemporary glass circles. A factor in maintaining German pre-eminence in the field has been the outstanding technical support provided by specialist studios, of the calibre of Derix at Taunuston, near Wiesbaden, who carry out the as-

semblage and installation of many of the larger, more complex projects, including several in Britain by Brian Clarke and Alex Beleschenko.

Many of the major American artists working in flat glass and closely allied to the Studio Glass Movement are located on the West Coast. To the north, Paul Marioni is a consummate storyteller, also well known for his surreal blown and cast objects incorporating enamels and photographic material. Richard Posner, a master of the visual pun, possesses a remarkable ability to involve his audience, the community, in his windows and installations. Ed Carpenter has broken new ground with ambitious and innovative solutions to the problem of light modulation and its effect on interior space. Robert Kehlman and Narcissus Quagliatta, who also work in a more painterly idiom, are based further south in the Bay area.

Some of the most radical and interesting work is being done by James Carpenter (New York), a former collaborator of Dale Chihuly, who is himself currently producing large exuberant architectural installations. One of Carpenter's specialities is in the modular applications of Dichroic glass which, thinly coated in order to filter out parts of the spectrum, changes colour according to the viewpoint. The 10ft × 30ft west window of the Sweeney Chapel in Columbus, Indiana, is a masterful use of Dichroic glass, allowing sunlight to project changing spectra across the nave of the Chapel. Both in Germany and America, where 'stained' glass is used extensively in both ecclesiastical and secular buildings, the concept of the autonomous panel or relief has gained a considerable measure of acceptance. These portable glass pictures allow the artist to work freely, as in painting, unrestricted by the demands of a particular client or site.

It is, however, important to point out the immense value of commissioning and patronage. Ideally, commissions provide the artist with the opportunity (and income) to carry out more ambitious projects. The client's brief or the site itself will stimulate challenges, inspire solutions and reveal new areas of exploration that might otherwise never have been contemplated. In a world of changing values, ever preoccupied with economic efficiency and conformity, genuine efforts to enhance and enrich the fabric of our environment deserve the utmost encouragement.

Dale Chihuly, USA

Dale Chihuly is a popular and charismatic figure whose energy and vision, audacious handling of blown form, colour and scale, and enterprising approach to education and the media have had an enormous influence in shaping the contemporary international glass art movement.

His involvement with glass began in 1964 when he chose to incorporate glass threads into a wallhanging as part of a weaving assignment at the University of Washington, an act of some initiative since there was little or no advice to be had regarding the medium at that time.

After attending Harvey Littleton's new glass course at the University of Wisconsin, he helped create a new glass facility at Rhode Island School of Design which, under his direction, became a major department attracting outstanding students from all over the country.

In 1968 there followed a period of travel in Europe on a Fulbright Fellowship during which he visited Stanislav Libensky in Czechoslovakia and Erwin Eisch in Germany, and completed a period of workstudy at the Venini factory in Murano, an experience that has greatly influenced his perception of form, colour and technique.

He also taught at Haystack, the crafts summer school on Deer Island, off the coast of Maine, whose dynamic atmosphere and idyllic setting were to inspire him to establish his own, now internationally renowned, glass school at Pilchuck, near Seattle in the state of Washington. In 1971, with a $2000 grant and the goodwill of a wealthy couple, the Haubergs, who generously donated funds and land on one of their timber farms, Chihuly together with some friends and students founded a summer school entirely devoted to glass. Initially under canvas, it was, with the continuing generosity and help of John Hauberg, soon to develop into a beautifully designed complex of timber buildings, residential and workshop spaces which arguably provide the best educational facility for glass anywhere in the world. Annually it attracts an exceptional international teaching and student body. It is often said that the intensity of a single three-week session of the legendary 'Pilchuck experience' can be of more value than a year of conventional study at college.

By nature a firm advocate of teamwork, Chihuly

has an outstanding ability to attract talented and dedicated partners and collaborators, many of whom are established and important artists in their own right. Among them have been James Carpenter, Flora Mace, William Morris and Ben Moore.

The loss of sight in one eye due to a motoring accident in 1976 reinforced his attitude to teamwork, a practice he had appreciatively observed at the Venini factory. Unable to handle the glass himself he embraced the role of director in orchestrating the skills of others to complement his own unquestionable talents, thereby reversing the ethic of 'do it yourself' studio glassmaking. The distinguished painter and critic Paul Hollister has noted 'what Chihuly couldn't see (after the accident) because of his eye problem, he couldn't see before, because he was too close to the piece'.

It has further caused him to place special emphasis on such procedures as drawing – his 'maps for working', and on creating the most favourable conditions during his legendary work sessions (good food, drink, music and rates of pay for the team), in order to achieve an ambience in which virtually anything could happen and in which the exciting and unexpected often do occur. In the area of professional practice, his demands are similarly rigorous. He insists on impeccable lighting, display and promotion for exhibits and, in particular, on first-class photography. Controversially, he has said that he considers good photographs to be ultimately more important than the piece on exhibition, since they are likely to be seen by more people.

Chihuly's work has tended to develop as ongoing series in distinct phases. In the spirit of the 'happenings' in the late 1960s and early 1970s, in a period when much of the 'art world' was concerned with large site-specific and conceptual work, he and Jamie Carpenter, at that time one of his most talented students, produced several large-scale installations and environmental projects. Mainly in blown glass and neon, and sometimes incorporating dry ice, such work gained considerable media attention while also establishing significant new parameters for the glass art movement.

His 'blanket cylinders' form the next major series. Flat patterns or compositions, inspired by Navaho blankets, were constructed out of thinly drawn threads of richly-coloured glass and picked up from the marver onto the surface of a hot parison, marvered and reheated until smooth and then blown into a cylindrical form. These threads were made from the excellent range of solid colours supplied originally by Klaus Kugler of Augsburg in Germany, which have been used almost universally in studios for a number of years, although other manufacturers now produce equally impressive and generally compatible ranges of colours.

This formal, though by no means static style of decoration gave way in later series to a more organic mode of expression. Originally inspired by the sight of old woven Indian baskets sagging and warping on a museum shelf, his thin crumpled glass 'Baskets' achieve an extraordinary delicacy and lightness of form and colour as, too, do the subsequent elegant and ephemeral groupings of 'Sea and Shell Forms'. In these, rhythmic contour-like coloured threading is used extensively, in conjunction with deeply ridged optical moulds that distribute and integrate the colour, influencing shape, modulating light and chronicling aspects of process and movement.

The subsequent 'Maccia', 'Venetian' and 'Ikebana' series represent bold forays into a more voluptuous and extravagant territory.

Chihuly is prolific by nature and necessity. His philosophy of 'work as an arena of discovery' is manifest in the intense energy and commitment of his blowing sessions. Ideas flow, dictating processes which in turn generate new directions and vice versa. His exciting use of glass in public places, including theatre sets, has caught the imagination and gained the appreciation of a wide public.

Dale Chihuly, USA: *Monarch Window* for Tacoma Union Station, Washington State, 1994 ▶
40ft × 3ft × 22ft high; freeblown glass forms, dip-moulded colour and pattern (photo: Russell Johnson)

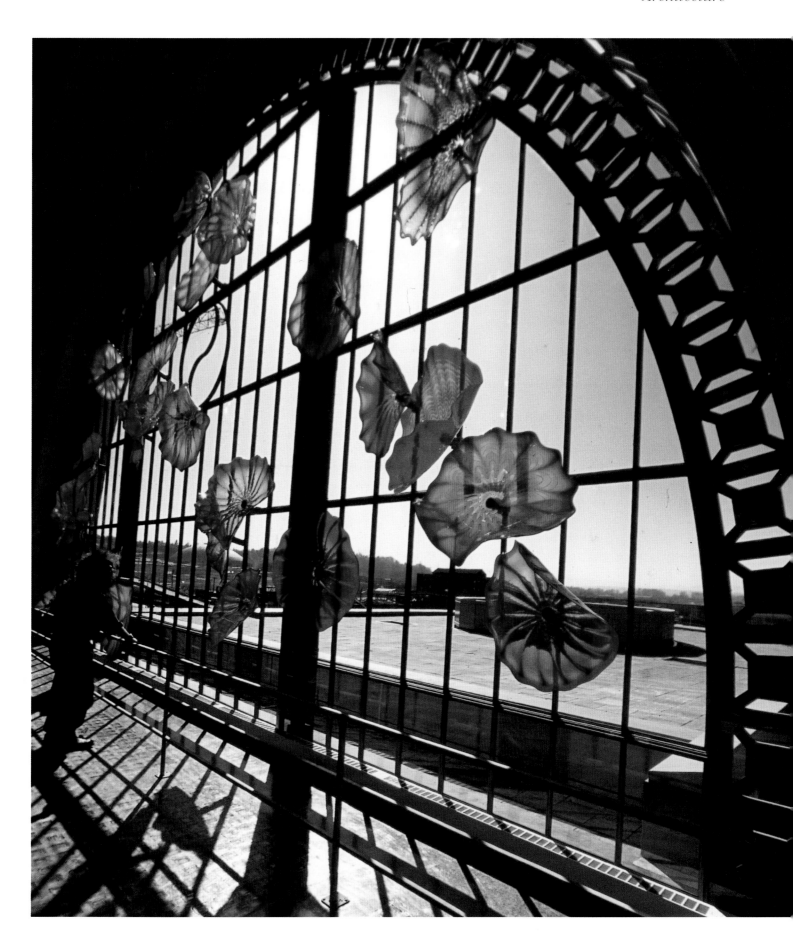

Afterword

Over the years of my own involvement in studio glass there have been many 'peak' moments, the most satisfying and stimulating of which were possibly also the most harrowing.

In 1988, Marvin Lipofsky, Finn Lynggaard and I were invited to participate in the Novy Bor *Interglas* symposium for the third time. By then this triennial event had assumed an air of friendly competition and been dubbed the 'Glass Olympics' by Stanislav Libensky.

On this occasion I was excited and nervous about my own project. It was on a much larger scale than usual and there were so many things that could go wrong: the variable metal mould might not function properly; the thick hot-cast modules might not survive the fast annealing cycle (about one and half hours, the time normally taken for wine goblets); the modules might not fit together as planned. There could also be language or communication problems when co-operating with a new team, lack of time and so on.

In the event there were hiccoughs, of course, but it all worked out. As Jiri Suhajek, who is taller than I am, put the final piece of my 2.5 metre high pyramid in place, I experienced enormous pleasure and relief.

It was just as nerve-wracking when, in December 1992, Simon Moss and I were constructing a 7 metre high suspended glass column for the exhibition *Le Verre* in Rouen, especially as we crouched

under a ton or so of swinging sheet glass. All around us vast projects were taking shape: Renato Santarossa's standing circle of huge laminated forms, Steve Tobin's amazing 'river' of white filaments cascading down from a balcony opposite, Florian Lechner's massive slumped floor pieces, Marian Karel's brilliant minimal structure and a great wall of splinted and bandaged glass limbs by Vietnam veteran Michael Aschenbrenner artfully juxtaposed with Sybille Perretti's tiny but terrifying indictments of violence and war.

And more recently, after two weeks of solid labour installing an enormous stainless steel and glass sculpture on board the cruise liner *Legend of the Seas*, Simon and I were working through the night again, some twenty metres up on scaffolding that was to be removed at 5 a.m. About midnight the lights went out and we were forced to finish routing the fibre optics with only a pencil torch – held in the mouth. Yet none of the problems we had experienced mattered a jot when the scaffolding came down and we finally saw the completed installation for the first time – a moment of sheer magic and bliss.

The agonising questions always recur: will this work? or, more crucially, does this work? visually, aesthetically, actually? Any conclusion will be subjective but what seems to be true is that the greater the challenge or leap into the unknown, the greater the sense of fulfilment.

Peter Layton and **Simon Moss**, UK: detail from *Janus*, 1995 (arch. Njal Eide) ▶
approx. 11m × 5m × 9.5m high; stainless steel, brass, glass and fibre optics (photo: Simon Moss, courtesy: Royal Caribbean Cruise Lines)

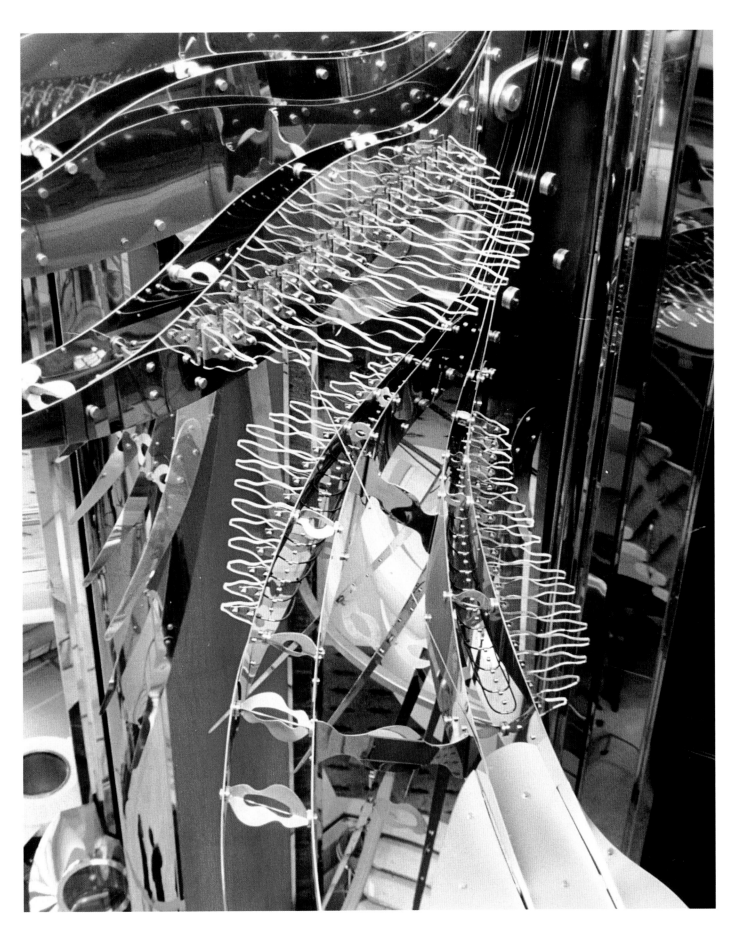

Where to See Contemporary Glass

Since it is impossible to list more than a few of the many important collections of contemporary glass, I recommend consulting museums, national craft organisations or magazines such as *Neues Glas* and *Glass Magazine* for fuller information on museums and specialist galleries.

Vital support for the development of the Studio Glass Movement has come from commercial galleries, whose commitment and enterprise have provided the contact and focus for artists and their public. Among the most active and visionary have been the prestigious Heller Galleries (New York and Florida), Habatat Galleries (Michigan, Colorado and Florida), Clara Scremini and Daniel Sarver in Paris, Rob Van-den Doel in The Hague and also in Prague – the major centre of glass art in Europe.

NORTH AMERICA [USA: American Crafts Council, 72 Spring Street, New York, NY 10012; Glass Art Society, Box 1364, Corning, NY 14830.
Canada: Canadian Crafts Council, 189 Laurier Avenue East, Ottawa, Ontario K1N 6P1]
The Corning Museum of Glass, 1 Museum Way, Corning, NY 14830 (the world's foremost glass collection, of both historical and contemporary work)

Purpose-built after the previous building was flooded, the beautifully designed museum is unsurpassed as a visual and academic resource. It is recognised for its outstanding presentation of exhibits and for the superb Rakow Library which houses copies of virtually everything ever published on glass, as well as the most comprehensive slide collection in the world. I would urge anyone interested in glass to make a pilgrimage to Corning. The city, home of Corning Glass and Steuben Crystal, also boasts the Rockwell Museum with its excellent collection of Art Nouveau glass, notably Frederick Carder's designs for Steuben. There are several working studios in the area and the Corning Book Exchange is a must for any glass lover.

Seattle has become the Mecca of the contemporary glass world. Its close proximity to the famous Pilchuck Glass School has attracted over 300 artists to live and work in the area. Several good galleries exist, serving the active glass community of the North-West with exhibitions of international standing.

The Bay Area (San Francisco/Oakland) and the cities of Los Angeles, Boston, Philadelphia, Providence, Detroit and New York, to name but a few, all have major concentrations of glass art activity. Of special interest are the Urban Glass workshops (formerly the New York Experimental Glass Workshop) in New York and the Creative Glass Centre of America in Wheaton Village, an old glassmaking community in southern New Jersey. Both offer excellent working facilities, fellowships, classes and demonstrations. Wheaton also houses the excellent Museum of American Glass.

There are many excellent collections in museums throughout the USA and Canada. Details are given in a Corning Museum of Glass publication listed in the bibliography.

UNITED KINGDOM [Crafts Council, 44a Pentonville Road, London N1 9HE]
Broadfield House Glass Museum, Compton Drive, Kingswinford, nr Stourbridge, West Midlands
Victoria & Albert Museum, London (its new glass gallery was opened in 1994)
The National Glass Centre, Liberty Way, Sunderland (from 1997), with three major collections in the area at Sunderland, Gateshead and Newcastle
Accrington: The Haworth Art Gallery, Accrington, Lancashire (Tiffany)
Belfast: The Ulster Museum, Botanic Gardens, Belfast
Cardiff: National Museum of Wales (Marinot)
Edinburgh: Royal Scottish Museum
Glasgow: Glasgow Museum, Kelvingrove
Leicester Museum (Marinot)
Liverpool: Pilkington Glass Museum, Prescott Road, St Helen's, Lancashire
Nottingham Museum

EIRE
The National Museum of Ireland, Dublin

AUSTRALIA [Crafts Council of Australia, 35 George Street, The Rocks, Sydney, New South Wales 2000]
City Art Gallery, Wagga Wagga, New South Wales
Adelaide: Art Gallery of South Australia
Melbourne: Victoria Art Museum
Perth: Art Gallery of Western Australia

AUSTRIA
Steirisches Glaskunstzentrum und Glasmuseum, Bärnbach

BELGIUM
Musée du Verre, Charleroi
Liège: Musée Curtius

CZECH REPUBLIC
Umeleckoprumylove (UMPRUM) Muzeum
 (Museum of Decorative and Applied Arts), Prague
Jablonec nad Nisou: Museum of Glass and Jewellery
Novy Bor: Lemburg Castle, near Novy Bor

SLOVAK REPUBLIC
Slovak National Gallery, Riecna 1, 81513 Bratislava

DENMARK
Glasmuseum, Ebeltoft
Copenhagen: Danish Museum of Decorative Arts

FINLAND
Finnish Glass Museum, Riihimaki

FRANCE
Centre du Verre, Musée des Arts Décoratifs,
 Palais du Louvre, 107 rue de Rivoli, 75001 Paris
Nord: Musée/Atelier du Verre, Sars Poteries

GERMANY
Glassmuseum, Frauenau, Bavaria
There are also very important collections at Coburg, Düsseldorf, Frankfurt, Hamburg, Immenhausen, Lauscha and Rheinbach

ITALY
Museo Vetrario, Murano (Venice)

JAPAN
Hokkaido Museum of Art, Sapporo
Kyoto: National Museum of Modern Art
Notojiima: Museum of Contemporary Glass Art
Tokyo: National Museum of Modern Art
Tokyo: Suntory Museum of Art

NETHERLANDS
Stichting National Glasmuseum, Lingedyik 28, 4142 Leerdam
Rotterdam: Boymans Museum

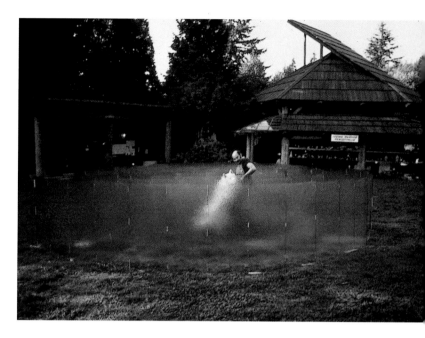

Pilchuck Glass School with Ray King's *Glass Labyrinth* in the foreground, 1982; *labyrinth* 30ft diameter × 4ft high

SPAIN
Centro del Vidrio de Barcelona, FAD, Comtes de Belloc 192, 08014 Barcelona
Fundacion Centro Nacional del Vidrio, La Granja de San Ildefonso

SWEDEN
Smalands Museum, Sodra Jarnvagsgatan 2, Box 102, S-35104 Vaxjo

SWITZERLAND
Musée des Arts Décoratifs, Lausanne
Musée Bellerive, Zurich

Glossary

annealing *see* page 107

Ariel *see* page 114

assemblage/fabrication *see* page 134

batch the mixture of raw materials which are heated and melted in a furnace to make glass (*see* page 106)

binder the medium or vehicle used to bind materials for application: various oils for the painting of enamels and lustres; gum arabic or casein for stained glass paints; gum tragacanth, gum arabic or sodium silicate for *pâte de verre*

block, blocking cup shaped fruitwood or graphite blocks (or use of) to centre and shape the glass gather – nowadays many glassmakers prefer a pad of wet newspaper held in the hand

blowing iron or blowpipe hollow steel tube – stainless steel is preferred, usually fitted with a special end or 'nose' of high temperature alloy on which to gather the glass

casing refers to glass blown in more than one layer, of which at least one is coloured (*see* page 114)

casting 1. ladling and/or pouring hot glass from the furnace into a mould, e.g. sandcasting
2. kiln or fuse casting by *cire perdue* ('lost wax') method (*see* page 121)

chair glassmaker's bench fitted with two arms: the blower sits between the arms and rolls the 'iron' along them while centring, blocking or shaping the glass; can also refer to the glassmaking team

cire perdue ('lost wax') metal and glass casting technique in which a wax model is encased in a mould-mix of plaster and flint and subsequently burnt or steamed out; this leaves a void that can be filled by metal or glass to replicate the original model (*see* page 122)

copper-wheel engraving *see* wheel engraving

cord, cording striations in the glass caused by uneven heating or melting of the batch or cullet

crizzle or crizzling defect in the form of fine cracks caused by an excess of alkali in the batch formula or by inadequate melting; a crackle effect can be induced if the hot piece is dipped in cold water during the blowing process

cullet waste or scrap glass used in conjunction with batch to lower the melting point or, in many studios, on its own to produce the glass melt

devitrification faulty cooling of softened glass causing it to crystallise and turn milky; this has been converted into a virtue in the creation of entirely new types of glass

diamond-point engraving *see* stipple engraving and page 132

electroforming *see* page 134

etching *see* page 128

filigrana (filigree) originally Venetian style of glassware involving the use of white or coloured threads encased in clear glass to create patterned decoration; patterns include *retro a retorti* (twisted lace), *retro a reticello* (crisscross threads, often with trapped air bubbles) and *retro a fili* (spiral or helix)

fining the latter part of the melting (founding) process during which small air bubbles (seed) are induced to rise to the surface

gathering the taking of glass from the furnace on an 'iron' (*see* page 110)

gob the mass or 'gather' of hot glass on the end of the 'iron'

Graal a decorative method, originally devised by Simon Gate at Orrefors, Sweden, in which clear glass is overlaid with colour and blown into a small bubble (or embryo); when the glass has been annealed and cooled, an image or pattern is cut, sandblasted, etched or engraved through the layer of colour; the embryo is then reheated, picked up on a blowing iron, cased in clear glass and blown out (*see* page 114)

investment the material or mixture of materials used to make moulds for casting glass or metal

iridescence *see* page 114

iron(s) steel rods or tubes used at various stages during the blowing process, e.g. blowing iron (*see* blowing iron), bit iron (for carrying small bits, trails, prunts, etc.), pontil or punty iron (for attaching to the base of the blown piece in order to work the top or neck), gathering iron (for making large gathers for casting, handles, etc.)

lampwork or flamework term applied to the process of manufacturing glass (e.g. laboratory wares) at a gas/air or oxygen torch (*see* page 116)

lap flat (horizontal) grinding plate or wheel; a reciprocating lap is a semi-automatic oscillating flat grinder

latticino term often interchanged with filigrana, though it specifically refers to the use of white (milky) threads

lehr oven or kiln for annealing glass; industrial lehrs have slowly moving conveyors that move the wares through a controlled temperature programme to reduce the stresses in the cooling glass

marquetry *see* page 20

marver, marvering polished steel plate (or use of) to shape the glass gather or parison (*see* page 110)

metal glassblower's term for the glass in the furnace

millefiori Italian for 'a thousand flowers', this is a Venetian decorative technique in which small slices or sections of multi-coloured canes (fused, cased and pulled

out) are picked up from the marver (as in paperweight making) or fused as in the 'mosaic' technique

montage technique *see* lampwork, page 118

mosaic glass pieces of coloured canes are fused together to form a flat sheet which is then slumped; the surface can be ground and polished

murrini the small cane sections (millefiori) used for mosaic glass

necking *or* **cutting in** *see* page 112

paddle, paddling batlike tool in hardwood or graphite (or use of) to flatten or shape the glass as it is being worked

'paint and blow' *see* page 114

paperweight method technique for making thick or solid forms, usually with internal decoration, by a series of gathers

parison (paraison) the initial gather, centred, shaped and blown into a bubble ready for further shaping and working

pâte de verre glass paste made from crushed glass mixed with a binder; because it is then laid in a mould the term is often used (erroneously) to describe kiln cast objects in general (*see* page 122)

patination *see* page 20

prunt glassmaker's term for small bloblike additions to the surface of a form, originally to provide a grip in the absence of a handle but more usually as decoration

pucellas (tongs, jacks) twin-bladed metal tongs for shaping, opening, closing or cutting in (*see* page 112)

punty (French: pontil) *see* irons

reciprocating lap *see* lap

reduce, reduction exposing glass in a furnace or gloryhole starved of oxygen, possibly through an excess of fuel; this creates particular colour effects by reducing metallic oxide to metal, e.g. copper in glass can appear green in oxidation and ruby in reduction

refractory, refractories ceramic material(s) manufactured to withstand high temperatures for use as furnace linings and insulation

relief cutting a decorative cutting technique in which areas of the surface are removed leaving the image or pattern in relief

resist materials (or use of) to protect areas of glass surface from acid etching or sandblasting: traditionally wax, bitumen or lead foil; nowadays plastic film, tape or paints which are often simpler to use

reticello *see* filigrana

sagging *see* slumping (and page 123)

sandblasting *see* page 129

silk-screening (decalcomania) a printing method that transfers graphic images by the passing of colour inks or paints through a textile mesh to transfer paper or direct to the surface of glass or ceramics

sinter a light surface fusion of glass granules, as in some fragile *pâte de verre* work

slumping heat treatment that bends or deforms glass into or over a corresponding mould

stipple engraving a type of engraving in which the hard point of a hand tool or drill (diamond or tungsten carbide) strikes the glass to create an image, the gradation or density of the dots or lines dictating the image (*see* page 132)

'stopping out' the application of a resist or mask to areas not to be abraded when glass is sandblasted or acid etched

striation *see* cord (and page 108)

sugar acid an etching fluid that is less dangerous to handle than hydrofluoric acid

typical recipe:

ammonium bifluoride	1kg	
sugar	1kg	
barium sulphate	250g	
demineralised water	1l	

trail, trailing (threading) threads of hot glass (clear or coloured) wound round a form; they may be combed when hot

wheel engraving a method of abrading a glass surface for decorative purposes with small copper wheels mounted on a lathe and an abrasive slurry; alternatively, the wheels themselves may be abrasive (*see* page 130)

For more comprehensive information and fuller descriptions, see Charles Bray: *Dictionary of Glass*, published by A & C Black, 1995

Bibliography

Historical and reference

Adlerova, A., *Contemporary Bohemian Glass*, Odeon, Prague, 1979

Arwas, Victor, *Glass: Art Nouveau to Art Deco*, Academy Editions, 1977

Bacri, Clotilde, *Daum*, Thames & Hudson, 1993

Battie, David, and Simon Cottle, *Sotheby's Concise Encyclopedia of Glass*, Conran Octopus, 1991

Bloch-Dermant, Janine, *The Art of French Glass (1860–1914)*, Vendome Press, 1974/Thames & Hudson, 1980

Bloch-Dermant, Janine, *French Glass* (Gallé to the present), Les Editions de l'Amateur, 1988

Charleston, Robert J., *Masterpieces of Glass*, Harry N. Abrams, 1980

Couldrey, Vivienne, *The Art of Louis Comfort Tiffany*, Bloomsbury Publishing, 1989

Diderot, Denis, and Jean d'Alembert (eds), *L'Art du Verre* (facsimile edition of section from *L'Encyclopédie*, 1751–80), Inter-Leaves, 1989

Gardner, Paul V., *The Glass of Frederick Carder*, Crown, New York, 1971

Garner, Philippe, *Emile Gallé*, Academy Editions, 1976

Glass Collections in Museums in the United States and Canada, The Corning Museum of Glass, 1982

Klein, Dan, and Ward Lock, eds, *The History of Glass*, Orbis Publishing, 1984

Langhammer, Antonin, *Bohemian Glass: tradition and present*, Crystalex, 1995

Newman, Harold, *An Illustrated Dictionary of Glass*, Thames & Hudson, 1977

Petrova, Sylva, and Jean-Luc Olivie (eds), *Bohemian Glass*, Flammarion, 1990; includes contemporary glass as well

Pina, Leslie, *Fifties' Glass*, Schiffer, 1993

Polak, Ada, *Modern Glass*, Faber & Faber, 1962

Tait, Hugh, ed., *Five Thousand Years of Glass*, British Museum Press, 1991

Contemporary

Beard, Geoffrey, *International Modern Glass*, Barrie & Jenkins, 1976

Frantz, Susanne K., *Contemporary Glass*, Harry N. Abrams, 1989

Grover, Ray and Lee, *Contemporary Art Glass*, Crown, 1975

Hampson, Ferdinand, ed., *Glass – State of the Art I / II*, Elliot Johnston, 1984 / 1989

Herman, Lloyd E., *Clearly Art: Pilchuck's Glass Legacy*, Whatcom Museum of History and Art, 1992

Klein, Dan, *Glass – a Contemporary Art*, Collins, 1989

Lechaczynski, J. and S., *Contemporary Glass: a selection*, Galérie Internationale du Verre, Biot, 1991

Miller, Bonnie J., *Out of the Fire: Northwest Glass*, Chronicle Books, 1991

Moor, Andrew, *Contemporary Stained Glass*, Mitchell Beasley, 1989

Restany, Pierre, *Chryssa*, Harry N. Abrams, 1977

Ricke, Helmut, *New Glass in Europe*, Verlagsanstalt Handwerk, 1990

Stennet-Wilson, R., *Modern Glass*, Cassell/Collier Macmillan, 1975

Stern, Rudi, *Let There be Neon*, Academy Editions, 1980

Vaudour, Cathérine, *The Art of Contemporary Glass*, Armand Colin, 1993

Voronov, Nikita, ed., *Soviet Glass*, Aurore Art Editions, Leningrad, 1981

Techniques

Bray, Charles, *Dictionary of Glass*, A & C Black, 1995

Cummings, Keith, *The Techniques of Kiln-formed Glass*, second edition of *The Technique of Glass Forming*, A & C Black, 1997

Elskus, Albinus, *The Art of Painting on Glass*, Routledge & Kegan Paul, 1981

Flavell, Ray, and Claude Smale, *Studio Glassmaking*, Van Nostrand Reinhold, 1974

Halem, Henry, *Glass Notes*, Halem Studios, 1993

Hammesfahr, James E., and Clair L. Strong, *Creative Glass Blowing* [lampwork], W. H. Freeman, San Francisco, 1968

Kulasiewicz, Frank, *Glassblowing*, Watson-Guptill/Pitman, 1974

Littleton, Harvey, *Glassblowing – a search for form*, Van Nostrand Reinhold, 1971

Lundstrom, Boyd, and Daniel Schwoerer, *Glass Fusing*, Vitreous Publications, Portland, Oregon, 1983

Lynggaard, Finn, [Danish] *Glas Handbogen*, Clausens Forlag, Copenhagen, 1975
[French] *La Verrerie Artisanale*, Dessain et Tolra, Paris, 1981

Matcham, Jonathan, and Peter Dreiser, *The Techniques of Glass Engraving*, Batsford, 1982

Peace, David, *Glass Engraving – Lettering and Design*, Batsford, 1985

Reyntiens, Patrick, *The Technique of Stained Glass*, Batsford, 1977

Wigginton, Michael, ed., *Glass Today* [architecture], Crafts Council, 1986

Selected periodicals

American Crafts
Craft Arts, Australia
Crafts, Crafts Council, UK, bi-monthly
Form, Scandinavia
GAS Journal, USA, annual
Glass Art, Japan
Glass Art Magazine, USA
Glass Magazine, USA, quarterly
Glass Review, Czech Republic, monthly
Kunst und Handwerk, Germany
Neues Glas, Germany, quarterly
New Glass Review, Corning, USA, annual – now published in *Neues Glas*
Revue de la Céramique et du Verre, La, France
Verre et Création, France

Catalogues and monographs

The range is so wide that I list only a few.

Americans in Glass, Leigh Yawkey Woods Art Museum, Wisconsin, annually 1976–86
British Studio Glass, Sunderland Arts Centre, 1983
Chihuly: Color, Glass and Form, Kodansha International, 1986
Contemporary British Glass, Crafts Council of Great Britain, 1993
Contemporary European Sculptures in Crystal and Glass, Joseph Philippe, Liège Triennale
Jutta Cuny-Franz: 'Magic Glass', Jutta Cuny-Franz Foundation, 1990
Czechoslovakian Glass 1350–1980, Corning Glass, Dover, 1980
Finnish Glass, Sunderland, 1979
Emile Gallé: Dreams into Glass, William Warmus, Corning Museum of Glass, 1984
Geschichte des Studioglases, Christiane Sellner, Bergbau und Industriemuseum, Ostbayern Theuern, 1982
Glaskunst '81, Sussmuth-Immenhausen, 1981
The Glass Flowers of Harvard, Botanical Museum of Harvard University, Cambridge, MA, 1982

Glass Sculpture [English/Dutch], ed. Kees Broos, Veen-Reflex, Utrecht, 1986
Glass 1959, a special exhibition of International Contemporary Glass, Corning Museum of Glass
Glass of the Caesars, Olivetti, 1987
Frank van den Ham: Glass Fusing, Museum for Art and Cultural History, Lübeck, 1991
International Directions in Glass Art, Art Gallery of Western Australia, 1982
Littleton/Fujita, Glasmuseum Ebeltoft, Denmark, 1989
Moje/Chihuly, Glasmuseum Ebeltoft, Denmark, 1991
Claude Morin [German/French], F. and W. Kermes, Arnoldsche, 1993
Benny Motzfeldt, Universitetsforlaget, Oslo, 1984
Joel Philip Myers, Glasmuseum Ebeltoft, Denmark, 1993
Matei Negreanu, Editions Vers les Arts, 1993
New Glass Review, published annually in *Neues Glas* magazine
New Glass in Germany, Helmut Ricke, Kunst und Handwerk, 1983
New Glass – a worldwide survey, Corning Museum of Glass, 1979
Nomades du Verre, Barcelona, Glass Centre, 1991
Archimede Seguso, ed. Umberto Frangoi, Arsenale Editrice, 1991
Thirty Vases pour le CIRVA, 1989
Bertil Vallien's Sandcast Glass, Moberg/Terje, Kosta Boda, 1983
Ulrica Hydman-Vallien, Mailis Stensman, Edition Apel, 1991
Verriers Français Contemporains, Musée des Arts Décoratifs, 1982
Laurence Whistler: The Image on the Glass, John Murray, 1975
World Glass Now, Triennale, Hokkaido Museum of Modern Art, Sapporo
Young Glass '87, Glasmuseum Ebeltoft, Denmark, 1987
Jorg F. Zimmerman, Arnoldsche, 1993
Yan Zoritchak, Editions Vers les Arts, 1992

Index of Artists

Page references to reproductions of artists' work are given in **bold**. A list of illustrations is given on pp. 6–7.

General Index

DATE DUE

DEC 02.2002			
APR.22.2003			